# VISUAL SCIENCE AND ENGINEERING

# OPTICAL ENGINEERING

*Series Editor*

**Brian J. Thompson**
*Provost*
*University of Rochester*
*Rochester, New York*

ml

**Additional Volumes in Preparation**

# VISUAL SCIENCE AND ENGINEERING
## MODELS AND APPLICATIONS

**EDITED BY**
## D. H. KELLY

**Marcel Dekker, Inc.**          **New York•Basel•Hong Kong**

**Library of Congress Cataloging-in-Publication Data**

Visual science and engineering : models and applications / edited by
  D.H. Kelly.
      p.   cm. — (Optical engineering ; v. 43)
    Includes bibliographical references and index.
    ISBN 0-8247-9185-1 (alk. paper)
    1. Vision.  2. Computer vision.  3. Visual perception.  4. Optics.
  5.  Optical systems.  I. Kelly, D.H. (Donald H.)
  II. Series: Optical engineering (Marcel Dekker, Inc.) ; v. 43.
    [DNLM: 1. Vision—physiology. 2. Optics.  3. Biomedical
  Engineering.  4. Models, Theoretical.  WW 103 V8312 1994]
  QP475.V59  1994
  621.36'7'019—dc20
  DNLM/DLC
  for Library of Congress                                         93-46484
                                                                      CIP

The publisher offers discounts on this book when ordered in bulk quantities. For
more information, write to Special Sales/Professional Marketing at the address
below.

This book is printed on acid-free paper.

**Marcel Dekker, Inc.**
**270 Madison Avenue, New York, New York 10016**

Current printing (last digit):
10 9 8 7 6 5 4 3 2 1

PRINTED IN THE UNITED STATES OF AMERICA

# About the Series

I was particularly struck some years ago by the title of a very interesting book called *Seeing the Light* (1). This book's subtitle was "Optics in Nature, Photography, Color, Vision and Holography" and it struck me then that we take for granted that we see the light but do not always recognize it when we are designing optical systems. At the time of writing this introduction I have just finished reading Arthur Zajonc's book, *Catching the Light* (2), subtitled "The Entwined History of Light and Mind." Perhaps I should not be commenting here on other books, but they were important in my thinking about the current volume in our series and, in particular, this introduction.

In this series, we have so far omitted any detailed consideration of how a human being interacts with optical systems. One very special and important way is that the output of many optical systems presents information directly to the human observer and the observer receives that information through his eyes. This is obviously true for output images whether they be directly formed through an optical system or indirectly formed through an optical and electronic system. Many of these images have been processed in particular ways before the human observer receives the final image. Thus, I would hope that the system designer takes into careful consideration that the human being becomes an integral part of the total system. To achieve that result requires some detailed understanding of the human visual system

and its properties—properties that can be quite complex and often non-linear.

While it might be obvious to think of the human observer as the recipient of an image, it is often the case that information is presented to the observer in other forms—coded images, speckle patterns, and interferograms are but a few examples. It is clear that both the spatial and the temporal properties of the human visual system are important.

D. H. Kelly has done an excellent job of bringing the topic of visual science and engineering into the context of optical engineering in a way that will be valuable for those who design optical systems for the human observer. The contributing authors have brought both experience and expertise to bear on this important topic.

*Brian J. Thompson*
*Series Editor*

## REFERENCES

1.  D. S. Falk, D. R. Brill, and D. G. Stark, *Seeing the Light*, Harper & Row, New York, 1986.
2.  A. Zajonc, *Catching the Light*, Bantam Books, New York, 1993.

# Preface

Visual science is among the most multidisciplinary enterprises in modern science. Electrophysiology, biochemistry, experimental psychology, physiological optics, image processing, geometrical and physical optics, psychophysics, molecular biology, systems analysis, information theory: these are some of the many disciplines that can be involved in understanding the visual process. That diversity helps make it attractive and challenging to many young minds inclined toward science. This book presents a significant and representative sample of that enormous challenge.

Vision has always been an important topic in optical science and engineering. One reason for this is that the human eye is often the ultimate consumer of the images produced by traditional optical systems. Of course, today's instrumentation and display systems go well beyond classical optics, requiring the viewer to deal with all kinds of graphic, nonpictorial information. This breadth lends even more importance to the traditional designer's dictum that the eye is part of the system—its properties should affect the overall design. But the study of vision is not a closed book. The visual system uses some very subtle forms of signal processing that we are just beginning to learn about. The designer of optical systems who wants to keep abreast of these developments, and see some examples of how they have been applied, will find much of interest here. But that is not the *raison d'être* of this volume.

An important theme of the book is *interactions*—that is, interactions

among the dimensions of vision. It has recently come to be recognized by many in the forefront of our discipline that color perceptions depend on the spatial and temporal properties of the stimulus – spatial appearance depends on its temporal and chromatic properties, and temporal responses depend on its chromatic and spatial properties. Every logically possible interaction is important: three two-way interactions and one, grand three-way interaction. The realization of this and a gradual appreciation of its importance are among the most exciting current developments in vision.

Each chapter in this book is probably unique in the literature of visual science or its engineering applications, perhaps both in some cases. Many things in the book may eventually fall by the wayside, or even be proved wrong, but that is the price of admission to good science. The authors, each a world-class expert in his own subfield, were given a completely free hand through the first-draft stage. After that, the editor tried only to arrange the individual contributions into a more or less unified, coherent story, while doing as little violence as possible to each contributor's intent.

Although each of the chapters was written independently, they relate to one another in myriad ways. The optics of Chapter 1 was applied to the instrument design of Chapter 2, and those instruments were used to collect the data of Chapter 3. Chapters 3 through 7 all have some relation to color vision, and the extensive glossary in Chapter 6 may be useful for any of them. The multiplexing theory of Chapter 4 accounts for the spatiotemporal-chromatic data of Chapter 3, and the psychophysical inhomogeneity data of Chapter 7 are explained by the brain mapping of Chapter 8. The models of Chapters 4 and 8 neatly complement each other, and each leads to a quite different application in image compression. Chapters 9 and 10 deal exclusively with current and anticipated commercial applications derived from basic research in human vision.

The various ways in which the visual system entwines the physical dimensions of its input are the key to important applications in the coding, decoding, transmission, and reproduction of visual information. Perhaps the first such application, less than 30 years old, was the NTSC system of color television broadcasting. It was a pioneering achievement at the time, but it was cobbled together empirically with little understanding of the visual mechanisms that made it work. Even more impressive applications of visual information processing wait in the wings. (The "visual information" discussed in this book includes only what the unaided eye can perceive. We will not consider the coding of radar, acoustic signals, MRI, nonvisual wavelengths, and so on. The new ideas in vision are of course useful in the display of such signals, but we must draw the line somewhere!)

Continuing the aim of this preface, I have written a brief introduction to each chapter, giving my view of how that piece of work relates to the field

as a whole, or at least to other parts of this book. (The astute reader will probably see still other relationships that I haven't thought of!) In these "mini-prefaces," I have also tried to give, where I could, a few personal details about the authors. That was fun, because I know many of them fairly well. The ubiquitous computer notwithstanding, science and engineering are still done by people. The work of each chapter has a human face behind it, and I have tried to share my impressions of some of these authors with our readers.

Obviously, this is not a handbook. Many things a vision researcher might look up won't be there. Nor is it a textbook, at least not an elementary one, but it might be required reading for bright students. By casting its net so widely, I hope it will earn a place on every advanced worker's bookshelf.

No recent books have attempted such a broad sampling of the field. Well over a century ago, Hermann von Helmholtz wrote a three-volume textbook in vision. (He called it *Physiological Optics*, but it included much more than just the optics of the eye.) As a one-man feat of scholarship, it has never been surpassed. Helmholtz was a genius, but his feat was possible only because scientific knowledge was meager in many of the subfields required today; several of them did not yet exist. Many authors have tried to follow in his footsteps over the years, but none have really succeeded, for the simple reason that, as scientific knowledge explodes, interdisciplinary fields like vision explode even faster. It is no longer possible to produce a complete textbook of vision in three volumes; perhaps not in thirty. Nevertheless, it is my conceit that Helmholtz would have enjoyed this book.

If the book achieves its goals, it will shake some readers up, give them fresh insights, perhaps even cause a few to change their subfield. At the very least, it should remind us that — (even though there is no such department in any university) — the proper study of mankind is man.

*D. H. Kelly*

# Contents

# Contents

# Contributors

**Hewitt D. Crane**   SRI International, Menlo Park, California

**William E. Glenn**   Communications Technology Center, Florida Atlantic University, Boca Raton, Florida

**D. H. Kelly***   Visual Sciences Program, SRI International, Menlo Park, California

**Eugenio Martinez-Uriegas**   Visual Sciences Program, SRI International, Menlo Park, California

**Thomas P. Piantanida**   Sensory Science and Technology Center, SRI International, Menlo Park, California

**William F. Schreiber**   Departments of Electrical Engineering and Computer Science, Massachusetts Institute of Technology, Cambridge, Massachusetts

**Eric L. Schwartz**   Departments of Cognitive and Neural Systems, Anat-

---

*Retired.

omy and Neurobiology, and Electrical and Computer Systems, Boston University, Boston, Massachusetts

**William H. Swanson**   Retina Foundation of the Southwest and Department of Ophthalmology, University of Texas Southwestern Medical Center, Dallas, Texas

**Gerald Westheimer**   Department of Molecular and Cell Biology, University of California, Berkeley, California

# Introduction to Chapter 1

As a famous physicist once said, we stand on the shoulders of giants. Thus, even though this book is by no means a comprehensive look at its subject, it seemed to me *de rigeur* to begin with a visual scientist of the first rank who is also known for his scholarly understanding of the history of this multidisciplinary field. I can think of no one who fits that description better than my longtime friend, Professor Westheimer. So I was very pleased that he agreed to provide the introductory orientation for this rather eclectic set of topics. Those who ignore the lessons of history, it is said, are doomed to repeat them — so where do we stand, in time and space?

Gerald has chosen to begin where the study of vision began, with the optics of the eye (physiological optics in the narrow sense). In the beginning, that was about all there was to visual science. Long before the advent of lasers, holograms, or fiber optics (and without the aid of computers), the known principles of geometrical and physical optics were applied to the structure of the eye. Being reminded of these optical properties of the eye should enrich the reader's appreciation of the instrumentation design feats described in Chapter 2 and many other chapters in this book. As Professor Westheimer points out, most modern-day *optikers* don't learn much about physiological optics any more.

It was not always so. At the tender age of 18, I was privileged to take a course called Physiological Optics from the incomparable Brian O'Brien (who died in 1992, at 94). He was already modeling retinal cone cells as

1

waveguides when I was a sophomore. Physiological Optics was not an elective; it was a required course for all undergraduates at the Institute of Optics in Rochester, back in the days when our likely employment would be in the design of periscopes, binoculars, theodolites, gunsights, viewfinders, and other visual instruments. (Perhaps it should still be required.) Fortunately for us, O'Brien was a superb teacher; that course, as much as any other influence, steered me into a career in vision.

Gerald Westheimer is another great teacher in the O'Brien tradition, but of the next generation. In addition to many other accomplishments in visual science, he has made important contributions to modern physiological optics. He will now give you a guided tour over this fascinating landscape. Enjoy!

# 1

# Optics in Vision

**Gerald Westheimer**

*University of California, Berkeley, California*

## I. INTRODUCTION

An optical scientist coming to the study of the optics of the eye is in for a few surprises [1].

Not that a biological optical system is beyond the pale of the physical scientist or engineer. But, for a beginning, the materials employed by nature, although in general characterizable in terms of the physical parameters customary in man-made optics, differ in many ways from those familiar to the scientist. This has to do mainly with their provenance. They don't come from the smelting oven, nor have they even grown in the manner of crystals. They are assembled from the ultimate recipe, the DNA of the genome, using organic molecules. Yet they have ordinary optical properties, such as a refractive index that varies in an unsurprising manner with wavelength. The significant property, which is commonly taken for granted but should be a never-ending source of wonder, is transparency.

The main refractive media of the eye, the cornea and the lens, shown in Figure 1, are made up largely of living cells with all that this implies: they have a membrane and cytoskeleton; they started off with a nucleus and its complex apparatus of synthesizing elaborate organic molecules; and they maintain ionic and other equilibria and have metabolism. The features that allow the electromagnetic disturbance impinging on them to be propagated with little if any scatter are highly unusual and not generally found in animal cells. Moreover, and this remarkable feature can never be stressed

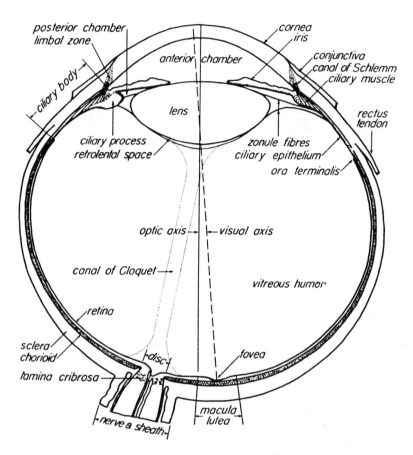

**Figure 1**   Horizontal cross section through a human eye. (From Ref. 1.)

enough, they are designed to last a lifetime, which in the case of the human is the best part of a century. Hence there must have inbuilt self-repair mechanisms, a feature well beyond anything that can be expected from our engineers and materials scientists for quite a while.

## II.  THE SCHEMATIC EYE

The usual beginning descriptors of an optical system are the radii of curvature of the surfaces, their positions, and the refractive index of the media separating them. From them can be deduced the position of the focal,

nodal, and principal points, and the magnification. For the human eye this was done in the nineteenth century using the newly developed theory of Carl Friedrich Gauss for a multisurface optical system. In fact the concept of nodal points seems first to have appeared in connection with the eye. It is associated with Listing, who also was the first to understand the rules according to which the eyes move as ball-and-socket joints. (Listing is also credited with coining the term "topology.") Once it was understood that the eye's pupil is the limiting aperture, the positions and sizes of the entrance and exit pupils could be calculated. Thus arose what is known as the "schematic eye," familiar to all first-year optometry students.

When all the calculations had been done on the schematic eye, it became clear that the eye has a special property: the two principal points virtually coincide, as do the two nodal points. This makes possible a further simplification: to estimate the geometrical retinal image, the ray from the object to the first nodal point can just be extended to reach the retina. This means that in theory the optics of the eye can be replaced by a single surface separating air from water, because the vitreous humor has the refractive index and dispersion of water. This surface would have its apex in the position occupied by the mean location of the two principal points (i.e., just a millimeter or two behind the corneal vertex). This hypothetical surface would have a radius of about 5.5 mm (Fig. 2).

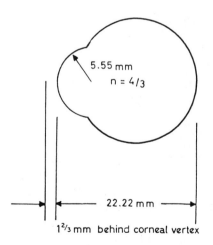

**Figure 2** The reduced eye. Using optical parameters typical of human eyes, a model can be developed to show a single surface separating air from a waterlike medium. The surface would be situated about 1.67 mm behind the corneal vertex and would have a radius of curvature of 5.55 mm. (From Ref. 1.)

It should be remembered what a struggle was involved in generating a schematic eye. Because the integrity of the biological materials of which the eye is composed is compromised by postmortem dissection, as much as possible of the data had to be assembled by what are now so appropriately called noninvasive means. The methods employed by the pioneers in this area, notably the British polymath Thomas Young and the Czech physiologist Purkinje, are really elegant. They include such artifices as immersing the eye in water (to see what happens when the cornea is essentially eliminated as an optical surface) and the use of clever methods of identifying and measuring the size of the images formed by reflection in the various optical surfaces of the real eye. One can just imagine the excitement felt by Purkinje when he saw that the image of a candle as reflected in the posterior surface of the eye's lens was inverted and this result matched the fact that the lens was a concave surface.

## III.  THE LENS

When the calculations for the schematic eye were worked out, it appeared that, for the image to be focused on the retina, the crystalline lens of the eye needed to have a refractive index unreasonably high for biological materials. The first models had a two-component lens: a central core of a higher refractive index surrounded in front and back by a cortex of somewhat lower refractive index. Later, still in the nineteenth century, a more sophisticated model of the human crystalline lens was developed with a gradient refractive index. This was more in keeping with the biological situation, where lens fibers are continually generated and the older ones compacted toward the middle. It also opened up the mind of optical theorists to the interesting situation of rays passing through media of gradually changing refractive index, hence following a curved trajectory.

The crystalline lens is, however, a more interesting structure still. It is capable of changing shape to allow the formation of sharp retinal images of targets at various distances in front of the eye. Thomas Young, at the turn of the eighteenth century, showed, by immersing the eye in water, that refractive changes could still occur, hence that the accommodative facility resided not in the cornea but the lens—the cornea, although its refractive index is slightly higher than water, loses most of its optical power in water. The ancient biological method of changing lens power by flexible surfaces and viscous rather than solid media, in the cause of focus change, has yet to be implemented effectively in modern technology. Not surprisingly, the facility for accommodation starts to fail with age, so that by the time most people reach middle age, they have severe deficits in focusing on near objects. There are as yet no biological remedies in sight for presbyopia.

Major strides have been made in creating spectacle lenses with aspherical surfaces with gradually varying surface power to which many people are able to adapt. The ingenuity of optical designers and engineers is now taxed to the maximum in trying to figure out how to convey more than one optical power through the small available aperture of contact lenses.

The loss of corneal power upon immersion of the eye in water, incidentally, highlights the added problem of the ability of aqueous animals to produce sharp retinal images. The fish lens is almost spherical, with steep gradients of refractive index reaching surprisingly high values in its center.

## IV. THE PUPIL

There is one aperture stop in the eye, the pupil. Looking at an eye, we see it imaged by the cornea. This entrance pupil is about 10% larger than the actual pupil, but because the latter is ordinarily inaccessible, the pupillary measurements are always those pertaining to the eye's entrance pupil. Since the pupil functions as an aperture stop, one might expect its diameter to have a strong inverse relation to the prevailing light level. The pupillary area can change by a factor of perhaps 10, but the range of light levels to which the eye can be exposed and within which it can function reasonably well is actually at least 1 million to one. The adaptation to light is accomplished largely at the level of the retina, and there have often been speculations that the pupil's major function is to provide depth of focus. Indeed there is an involuntary contraction of the iris when attention is directed to close-by targets.

If the eye had no aberrations, the size of the pupil would give a clue to the minimum image quality: diffraction would then provide the limit. Actually the aberrations of the eye are small enough to be negligible when the pupil diameter remains below 2.5 or 3 mm. In young eyes and low light, the pupil can be as large as 8 mm, and then the eye is certainly not diffraction limited. There would be major spherical aberration if the cornea, which is the principal refractive surface and provides more than two-thirds of the total optical power of the eye, were perfectly spherical. Its deviation from sphericity, while welcome in this context, does however become significant in contact lens fitting.

The chromatic aberration of the real eye is very close to that of the reduced eye (i.e., that of a single surface separating air from water). Since in practice it is mitigated greatly by the limited acceptance curve of the eye as a function of wavelength, ordinarily it is not of great consequence. The greater availability of more intense monochromatic sources of light in a great range of wavelengths may, however, introduce situations of manifest chromatic aberration.

In discussing the limits of the eye's imagery, diffraction is, therefore, the primary topic. A perfect optical system with a 2.5 mm pupil diameter, using light having a wavelength $\lambda$ of 555 nm, to which the retina is most sensitive, would have a resolution limit, using the Rayleigh criterion, of $1.22 \times \lambda/a$ radians, or 0.9 minute of arc. This means that two stars can be resolved if they have this separation. To the extent that the eye's point-spread function can be estimated in the living state, it does indeed have a half-width close to this value. For smaller pupils, which do not usually occur naturally, the expected point-spread function would be that given by diffraction. For larger pupils, aberrations begin to kick in, and one is brought back to point-spread functions with values near those for a 3 mm pupil. However, we may ask how the eye might perform if perfect images could be created for larger pupils. This question is no longer merely of theoretical interest because there are in fact ways of reaching the retina with images better than the eye's optics usually can deliver. We will deal with some of these below; the more general topic of measuring the wave-front deviation of the eye's optics and compensating for them by adaptive optics is a subject for future research and implementation.

## V. IMAGING

This brings us to the most challenging aspect associated with the optics of the living eye, and one that is essentially unique to it. In the living state, the eye and the visual system are presented to us as a package. The image is formed on the retina, and, though it is possible for us to manipulate the incoming beam by lenses and other devices, the actual light distribution thus created at the image plane is inaccessible. Probing the spatial limits of vision presents us with the dilemma of untangling the roles played by the imaging process in the optical media, the nature and grain of the receiving surface, the retina, and the limits on the performance imposed by the neural processing in the visual pathways.

Take visual acuity as an example. Conventionally it is measured by the angle subtended at the eye of the smallest letters of the alphabet that a patient can make out. But why can a patient not read smaller letters yet? Is it because the optical quality of the retinal image does not contain sufficient detail? Or is it that the elements of the retinal mosaic responsible for the photochemical transduction of the image are too large or are scrambled? Or perhaps there is nothing wrong with either the image or the retinal mosaic, but rather the functional integrity of the neural processing of vision is somehow not up the job. Optical engineers have no such problems. They can disassemble the device and test the image by an arbitrarily fine detecting

process, and, conversely, examine the detecting components by means of arbitrarily sharp light probes.

Vision scientists have risen to the challenge with which they are evidently confronted.

Rayleigh's criterion for two-point resolution is satisfied when the image of one point falls on the first minimum of the second point. So under the usual conditions, one might expect the eye's resolution limit to be just under one minute of arc and that, indeed, is the value usually quoted for normal visual acuity.

This amazing concordance between optical theory and visual performance had lulled vision scientists into a smug self-righteousness for the best part of a century. However, the subject of visual resolution has recently received renewed attention that is now leading to deeper insights. Two pioneers, LeGrand in the middle 1930s and Byram in 1944, had been pointing the way to modern studies, but for a variety of reasons, which themselves deserve study, their work had not entered the mainstream.

The problem can be simply stated: Is it possible that if the limitations of the eye's optics were lifted, the retina and visual pathway could do even better? Although diffraction theory sets an absolute physical limit to the fineness of the patterns that can be created on the retina, there are loopholes. For one thing, diffraction is the bottleneck only when the pupil is small; for larger pupil diameters that are still anatomically and physiologically possible, it is the eye's aberrations that prevent the achievement of perfect imagery. Complete correction of the eye's optics for a large pupil is a difficult undertaking, in particular because in the typical young observer there is a continuous fluctuation of focus. On-line correction by adaptive optics, a heroic procedure, is now feasible but has yet to be attempted. Short of this, there are a couple of ways to handle the problem of delivering to the retina imagery that contains detail better than ordinarily is available.

The crux of the matter is the reciprocity, in the realm of electromagnetic wave theory, between the aperture of an optical system and the concentration of light in the image plane. The two are related by the Fourier integral. In theory, to get a point image from a point object, one needs an infinite aperture. A simple way of looking at the question is to think of a spatial frequency (i.e., a sinusoidal light distribution of a given frequency) as being represented by a point pair in the pupil plane: the higher the spatial frequency (i.e., the finer the spacing of the lines), the further from the pupil center. This visualization immediately provides the clue to the experiment I introduced in 1959: limit the beam entering the pupil from a monochromatic point source to two points in the pupil and you have a grating on the retina, and, the greater the distance between these two points, the finer the spacing on the retina. I arrived at this understanding after studying the

Fourier optics that came of age after World War II primarily as a result of Duffieux's brilliant and clearly written monograph [2]. In two afternoons spent with Ed O'Neil, then at Boston University, in the summer of 1957, I received some of the most helpful tutorials I have had in all my academic life. My difficulty in implementing these ideas in those days before lasers defies description (a high pressure mercury lamp, interference filters, a pinhole that had to be made successively smaller until effective coherence was achieved because I was only vaguely familiar with the van Cittert–Zernike ideas of partial coherence, etc.).

Nevertheless I was able to show that the spatial frequency cutoff of the retinal mosaic and visual pathways more or less matched the visual acuity measured by conventional ways. The work has since been extended, notably by Campbell and Green, and more recently in David Williams's laboratory at Rochester, where investigators could take advantage of the ease of producing coherent beams by lasers. Only much later did I run across the two-page note in the *Comptes Rendue*, describing how LeGrand had had the same idea in 1935 [3]. I might add parenthetically that it was unfortunate that there was so little interaction and communication between the English-speaking world of physiological optics and the very able groups working in Paris around LeGrand at the Natural History Museum and Arnulf at the Institut d'Optique. LeGrand's talks and writings were always crystal clear, but the writings of the more productive workers at the Institut d'Optique, Arnulf, Dupuy, Flamant, and their colleagues, were not and still are not easily accessible, and not only because these authors wrote in French in their own specialty journals.

The consensus now is that the retina, even in the fovea, cannot do better than the optics of the eye as it usually performs in the living eye. Once, however, you can introduce into the eye grating patterns of very high spatial frequency, a variety of interesting phenomena involving Moiré fringes between the retinal receptor and optical light patterns present themselves visually.

There is, however, one reservation about all the techniques and findings because they utilize gratings (i.e., repetitive optical images). Vision starts with local processing of images and a grating is, therefore, not the ideal element with which to probe it. A quick look at the histology of the retina underlines this limitation: light transduction takes place in very many small receptors, each of which has an indivisible local signature. The neural circuitry into which these receptors feed their signal is again made up of individual cells. Though there is heavy interconnection between these cells at many levels and in innumerable ways, the passage of signals takes place almost entirely in discrete steps. Because this is biological material, there are nonlinearities at every step.

The best analysis of such a system ensures that the probe is properly matched to its structure. If the disturbances through a system are propagated physically in the form of waves, Fourier theory is, of course, the appropriate way of analyzing the structure, even if there are nonlinearities. If the processing is at the outset local and discrete, one looks for a more compact and less distributed probe. These problems become acute only insofar as the system is nonlinear; in a linear system the actual mode of analysis does not matter in the least.

## VI.  LINEAR AND NONLINEAR SYSTEMS

The foregoing considerations underline the fundamental differences between working on a characterization of the eye as an optical system and working on it as a part of an animal's visual process. In the former, we are satisfied by and large with the view of the imaging process in terms of the propagation of electromagnetic disturbances. Nonlinear optics, as fascinating as it is, has not yet been shown to enter the picture. So we can deal with the relation between the light sources in the animal's field of vision and the retinal images that result from them in terms of electromagnetic theory; wavefronts, pupil aperture functions, amplitude and intensity distributions in the image planes. These allow linear operations, even in the case of defocusing, aberrations and, to a large extent, scatter. Because the equations governing these relations are in effect in the Fourier domain, it is mathematically more convenient to use Fourier theory. And until nonlinearities raise their ugly head, one can use as the probing element the basis function of Fourier theory, which is the grating. (Sometimes, unfortunately, vision researchers need to be reminded that gratings have not only spatial frequency and amplitude, but also phase—only in the somewhat artificial concept of power spectrum are there no longer phases.) Hence it is a perfectly acceptable procedure to work on the optical performance of the eye with sinusoidal gratings and describe it in such terms as the optical transfer function (where again it must not be forgotten that it is a complex function, which has both amplitude and phase). It was, therefore, natural that in modern tests of the eye's optical performance one looked for the sinusoidal grating with the highest spatial frequency that could still produce an effect.

But under highly nonlinear operating conditions, a system is best analyzed with a good knowledge of the internal processing pathways. The history of the Wiener kernels illustrates this point: during World War II, sonar was developed to search for submarines, using not sine waves but individual pulses as the probe. To handle the problems of nonlinearities in the superposition of pulse responses, Norbert Wiener developed his kernel

approach, because the standard way of treating nonlinearities in sinusoidal stimuli (cross-modulation, saturation, etc.) was obviously not adequate. We have here a case study of the need to tailor the analytical probe to the particulars of the system one has to work with.

Because, as we have seen, vision is primarily a local process, it is advantageous to probe the spatial sense with local rather than spatially distributed stimuli. That is why clinicians prefer Snellen letter visual acuity to the modulation sensitivity curve. Using some refinements of coherent imagery, Dr. Liang and I have recently been able to produce a line pair on the retina with 100% contrast and arbitrarily narrow separation [4]. This pattern satisfies the need to bypass the eye's optics and yet have a narrowly confined stimulus. Early results confirm that resolution at the retinal level is limited by the mosaic of the receptors and that the optical and neural stages of vision have evolved around these anatomical bounds. It will be interesting to see these ideas applied to other species, notably the predatory birds, which are said to have better visual acuity than man.

For an understanding of the normal functioning of the human visual system and for the diagnosis and ameliorations of many of its disorders, optical theory has been indispensable. Will this continue into the future? All the indications are that it will. Almost none of the diagnostic tests performed by ophthalmologists and optometrists as yet involve lasers, computers, or nonlinear optics. There is no quick evaluation of corneal or lenticular scatter, or index change in the lens, or optical image quality on the retina, or reflectivity of the fundus, or a host of other eye signs amenable to optical analysis. Lasers are beginning to be used in therapy, but not gradient index optical material or lenses in which a single bundle of rays can have its focus or prism power changed on-line. And given the pace of development in the field in the last three decades, optics can be expected to play an ever-increasing role in vision research and ocular diagnosis and therapeutics.

## REFERENCES

1. G. Westheimer, Image quality in the human eye. *Opt. Acta 17*: 641–658 (1970).
2. P. M. Duffieux, L'integrale de Fourier et ses applications à l'optique. *Rennes*, 1946.
3. Y. LeGrand, Sur la mesure de l'acuité visuele au moyen de franges d'interference. *C. Rend. Acad. des Sciences, 200*: 490–491, 1935.
4. J. Liang and G. Westheimer, *Journal of the Optical Society A10*: 1691–1696, 1993.

# Introduction to Chapter 2

As in other biological fields, the relation between visual science and engineering is a two-way street. Good science can have useful applications in image processing, transmission, and display, some of which are described in later chapters of this book; and good engineering can provide unique and important tools for basic research in vision. I was privileged to be associated with the development of two of these research tools: digitally controlled TV techniques for generating visual stimuli, and a noncontact method of sensing eye movements, which we have used for stabilizing the retinal image.

The first was developed and/or adopted by many other laboratories in due course. Indeed, it is a rare vision lab today that does not have one or more CRT display systems, often customized to some degree. Since that tool is now so well known, it need not be described further here.

The second, while not ubiquitous, is equally important, in my view. The eye-tracking technology developed over many years at SRI International is a *tour de force* of electro-optical engineering, and its use has helped to revolutionize our view of some important visual functions, as illustrated in the next few chapters of this book. That development project was guided, from its inception to its ultimate commercialization, by my colleague, Dr. Crane. Although he and his collaborators have published numerous papers about various aspects of the technology at various stages of its development, this is the first time he has told the whole story in one place, in

logical (if not always chronological) order. It is a story that no one else could tell.

The eyetracker story is particularly appropriate for this book. First, it describes some elegant and often ingenious devices now used in the laboratory. (In addition to the eyetracker applications mentioned in this and the following two chapters, many others can be found by following up the footnotes.) Second, Dr. Crane's story supplies some insight into the amount of effort and dedication often required to pursue the twists and turns of optical engineering development work which, like the path of true love, seldom run smooth.

When Hew and I first planned this chapter, it was going to describe the workings of a plain vanilla eyetracker and stabilizer — sort of a Methods section for the chapters to follow. But like other revolutionary technologies, the eyetracker work has led to many unexpected places where, we ultimately agreed, this report had to follow. Together with its several Appendices, Chapter 2 is now a veritable compendium of sophisticated visual instrumentation and techniques for everything from basic research to clinical diagnosis and treatment.

I hope most of our readers are as fascinated as I am by ingenious tricks of optomechanical design. For those who are not, Hew has provided guides to briefly sampling his chapter. But unless you read the whole chapter, you will miss out on a remarkable saga of bio-optical engineering.

It also seems relevant to note here that Hewitt Crane is something of a Renaissance man. Although his doctorate is in electrical engineering and he worked on several of the earliest digital computers, he has published on a wide array of human-related topics, from audition to sociology. Only with this kind of breadth, perhaps, could he have shepherded the eyetracker work to its successful conclusion.

# 2

# The Purkinje Image Eyetracker, Image Stabilization, and Related Forms of Stimulus Manipulation

## Hewitt D. Crane

*SRI International, Menlo Park, California*

## I. INTRODUCTION

This chapter describes the design of an instrument usually known as the dual Purkinje image (DPI) eyetracker, sometimes as the Purkinje image eyetracker, or even just the Purkinje or SRI tracker. This instrument, along with several major accessories, was under continuous development at SRI International (formerly Stanford Research Institute) from 1965 to 1988. During that time the form of the basic instrument passed through five stages—denoted as generations I, II, III, IV, and V. Many eyetracker systems, some arranged in monocular and some in binocular configurations, and including various combinations of accessories, were built at SRI for vision laboratories across the United States and for some abroad. In the fall of 1988 this technology was licensed by SRI to Fourward Technologies,* which has continued its development and marketing.

The DPI eyetracker had its beginnings in a project that began at SRI in 1965 and grew out of an earlier research program by the author at SRI on autofocus optical techniques. An autofocus system under study at the time used a wide-area, nonlinear photocell on which the target image fell. The state of focus of the image was detected by vibrating the photocell along

---

*Fourward Technologies, 1939 Friendship Drive, Suite E, El Cajon, CA 92020 (619/258-8789; fax 619/258-8840); Attn: Warren Ward.

the optical axis of the system and analyzing the resulting signals [1,2]. Shortly thereafter, the author encountered physiological data showing that under certain conditions the lens of the human eye oscillates in focal length at a frequency of 1–2 Hz (such an oscillation is optically equivalent to keeping the eye lens fixed and vibrating the retina back and forth along the eye's optical axis). This observation suggested that the vibration in focal length might have the same autofocus function in the human eye as the axial vibration of the wide-area photocell did in our autofocus optical system.

At the same time that SRI was exploring this vibrating-photocell autofocus system, some people at NASA were becoming concerned with reports that pilots had experienced visual blurring as a result of the serious buffeting that sometimes occurs when flying at high speed and low altitude. We discussed with NASA the possibility that buffeting of the pilot might cause mechanical interference with the postulated oscillatory component in the human autofocus system. Those discussions led to a NASA contract at SRI to prepare a theoretical analysis of accommodation (i.e., human autofocus) from the perspective of mechanical lens vibration.

The resulting report generated a great deal of interest and led to another contract from NASA to SRI to study the automatic focus system of the human eye. (The muscular physiology of accommodation was already well known, but not the neural signal processing that underlies automatic focus [3].) A major hypothesis of the study was that accommodation depends on the state of focus of the portion of the image falling within an area approximately 75–150 $\mu$m in diameter in the center of the fovea, which corresponds to an angular diameter of approximately 15–30 minutes of arc. The kind of experiment necessary to prove such a hypothesis required a convenient means for stimulating and measuring eye focus in real time as well as the ability to place and hold a target image accurately within this small area of the central fovea. Given the relatively large and continuous movements of the normal eye, the only way to achieve such accuracy was to develop an accurate eyetracker that could control an optical system through which the subject viewed a target.

In short, it became clear that a major instrumentation program would be required to conduct the proposed research—in particular, the development of:

An accurate optometer (to measure eye accommodation in real time)

An accurate eyetracker (to measure both horizontal and vertical components of eye movement in real time)

An optical instrument (ultimately known as a stimulus deflector) through which a subject could view a target that was stabilized at selected retinal locations under eyetracker control.

The instrumentation eventually developed was so powerful that it changed fundamentally the way that much advanced research is conducted today in many different areas of visual science.

Evolution of the eyetracker can be summarized briefly as follows. The Generation-I tracker was functional but very difficult to use. The Generation-II tracker was usable but still very crude compared to later versions. The Generation-III tracker was the first practical instrument, and it evoked a great wave of interest within the vision community. By the mid-1970s it was clear that an even smaller, more advanced, and still easier to use instrument could be developed. A second phase of NASA support, starting in 1978, was critical to this next phase of development, which led to the much more powerful and easy to use Generation-IV and then the much smaller and even more advanced Generation-V instruments.

NASA support starting in 1965 was a critical component of this long-term development program. Equally important was grant support from the National Eye Institute (NEI) of the National Institutes of Health (NIH) from 1969 through 1982. Also important was the revenue derived from building increasingly more advanced instruments for a wide range of end users. Many of these machines have been in service more or less continuously ever since they were built. By the time SRI stopped "production" in 1988, it had built a total of 5 Generation-II, 21 Generation-III, 9 Generation-IV, and 32 Generation-V instruments for vision laboratories, mainly within the United States, but also for some in Canada and Europe. Since 1988, an additional dozen Generation-V eyetrackers have been delivered by Fourward Technologies, with still more advanced instruments in progress (see Sec. III. E).

For the reader who may want to skip some of the text, the general plan of this chapter is as follows:

Section II presents the basic principle of dual Purkinje image eyetracking.

Section III traces the evolution of the eyetracker to its present form.

Section IV describes the stimulus deflector system.

Section V illustrates how the eyetracker and the stimulus deflector can be coupled to achieve accurate image stabilization.

Section VI shows how the stimulus deflector can be altered to simulate a scotoma of arbitrary shape and position while viewing a target normally.

Appendix 1 describes the optometer, a device for measuring visual accommodation.

Appendix 2 shows how the optometer and eyetracker can be merged into a single, three-dimensional eyetracking instrument.

Appendix 3 describes a noncontact laser photocoagulator, a clinical instrument for retinal surgery.

Appendix 4 shows how an eyetracker was added to the photocoagulator to stabilize the laser beam. The result is a general-purpose fundus illumination and monitoring instrument (FIMI), which offers the potential of safer and more precise retinal surgery and is useful for other purposes as well.

Appendix 5 describes how a modified FIMI can be used for accurate laser Doppler blood flow measurement.

Appendix 6 is a list of patents on this technology.

## II. DUAL PURKINJE IMAGE PRINCIPLE

A major goal of the dual-image system was to eliminate artifacts due to eye translation relative to the measuring instrument, which is the most troublesome limitation of other eyetracking instruments. This is achieved by tracking a pair of Purkinje reflections from two anterior surfaces of the eye—namely, the front surface of the cornea and the rear surface of the eye lens. The relevant optics of the eye are described in Section II.A, and the movement of these images in response to eye movement is described in Section II.B. The text and figures for both sections are taken primarily from Reference 4.

### A.  Formation of the Purkinje Images

The virtual image formed by the light reflected from the front of the cornea is referred to as the first Purkinje image (Fig. 1). A second Purkinje image, formed by the light reflected from the rear surface of the cornea, is almost exactly coincident with the first Purkinje image.

The light that is not reflected from either of these surfaces passes through the cornea, passing in turn through the aqueous humor and then the lens of the eye. The third Purkinje image, a virtual image formed by light reflected from the front surface of the lens, is much larger and more diffuse than the others and is formed in a plane far removed from the plane of the other images. The fourth Purkinje image is formed by light reflected from the rear surface of the lens, at its interface with the vitreous humor that fills the bulk of the eyeball. This rear surface of the lens acts as a concave mirror, forming a real image of the source.

The fourth Purkinje image is almost the same size, and is formed in almost exactly the same plane, as the first Purkinje image. However, because the change of index of refraction at the back of the lens is much less than at the air–cornea interface, the intensity of the fourth Purkinje image is less than 1% of that of the first Purkinje image.

If the eye undergoes translation (e.g., as a result of a lateral head move-

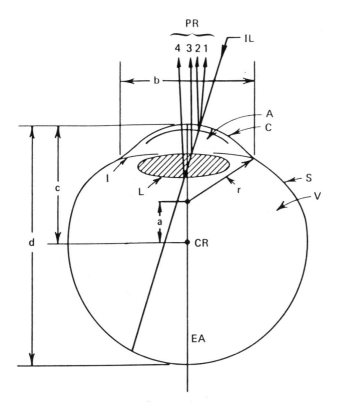

**Figure 1** Schematic diagram of the eye: *PR*, Purkinje reflections; *IL*, incoming light; *A*, aqueous; *C*, cornea; *S*, sclera; *V*, vitreous; *I*, iris; *L*, lens; *CR*, center of rotation; *EA*, eye axis; $a \approx 6$ mm; $b \approx 12.5$ mm; $c \approx 13.5$ mm, $d \approx 24$ mm, $r \approx 7.8$ mm. (From Ref. 4.)

ment), the first and fourth Purkinje images move together through exactly the same distance. If the eye rotates, however, the two images move through different distances and thus change their separation. The physical separation of these two images, therefore, yields a measure of the angular orientation of the eye that is uncontaminated by translational movements.

The instrument described here provides a pair of continuous electrical signals whose magnitudes are proportional to the horizontal and vertical components of separation between the first and fourth Purkinje images of an input source of light. This, in effect, provides continuous monitoring of the angular position of the eye, or of the point in space at which the gaze is directed. Errors caused by translation are substantially eliminated; the

accuracy is limited principally by quantum fluctuations in the very low intensity fourth Purkinje image.

## B.  Movement of the Purkinje Images

To understand quantitatively how the first and fourth Purkinje images are formed, note that the first Purkinje image is formed by light reflected from the front surface of the cornea, which has a radius of curvature of about 7.8 mm. For a distant source, the (virtual) corneal image would be in the plane indicated by the solid dot in Figure 2a, that is, at a distance $r/2 =$ 3.9 mm from the front surface of the cornea. The fourth Purkinje image is formed by light that is refracted by the cornea and the lens, reflected from the rear surface of the lens, and then refracted again by the lens and cornea. A single mirror that would form the identical real image is shown by the heavy line in Figure 2a. The radius of this mirror is about 5.8 mm and its center $C_4$ is close to the corneal surface. The position of the (real) fourth Purkinje image is shown by the open dot in Figure 2a, and we see that the planes of the first and fourth images are almost identical.

For purposes of explanation, it is convenient to use the approximation that the equivalent mirror for the fourth Purkinje image has the same curvature as the cornea and that they are separated by exactly their radius of curvature. This configuration resembles a clamshell arrangement (Fig. 2b), $C_1$ being the center of curvature for the cornea (first Purkinje image) and $C_4$ the center of curvature for the fourth Purkinje image.

From Figure 2b, we see that the distance each image moves as a consequence of eye rotation is directly proportional to the distance from the center of rotation to the center of curvature of the surface that forms it. These distances are approximately 6 and 13 mm for the first and fourth images, respectively. Thus, when the eye rotates through an angle $\Delta$, with respect to the input axis, the two images, as viewed from the input axis, will move in the same direction and will separate by a distance $S \approx 7 \sin \Delta$. With respect to eye space, however (i.e., as viewed from the optic axis of the eye), the images actually move in opposite directions. This is because one image is in front of its center of curvature and the other is behind its center of curvature.

If the eye undergoes translation, both images move through the same distance and direction as the eye. If the eye rotates, however, the two images change their separation. The change of separation between these two images yields a measure of the angular rotation of the eye, and the measurement is uncontaminated by lateral movements. The basic action of the eyetracker is to monitor continuously the separation of these two images. (See Fig. 6, below, for examples of actual waveforms.)

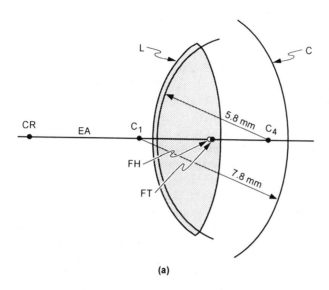

(a)

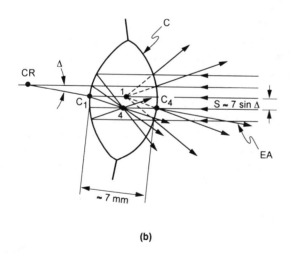

(b)

**Figure 2** Location of the first and fourth Purkinje images for (a) collimated light on the eye axis and (b) collimated light at angle $\Delta$ from the optic axis of the eye: *EA*, eye axis; *FT*, first Purkinje image; *FH*, fourth Purkinje image; *L*, lens; *C*, cornea. The dark section of arc is the equivalent mirror for the fourth Purkinje reflection. (From Ref. 4.)

## III. TWO-DIMENSIONAL EYETRACKER

The first instrument built to track these Purkinje reflections was little more than a proof of principle. It involved reimaging the Purkinje reflections in space and a specially designed spinning disk to chop and facilitate detection of these real images [5]. Although this first-generation instrument was extremely difficult to use, it demonstrated the principle and provided the impetus to develop more practical versions.

This section describes the evolution of the instrument from its first usable, though very elementary form (Generation II), through the final SRI design (Generation V), which is far more sophisticated in both design and performance. But just as the instrument evolved in stages, so will the reader find it easier to advance from one stage to the next rather than trying to understand the requirements and solutions of the final design directly. To aid this process, the description of each major design change is followed by a listing of the limitations of that design. Each subsequent section begins with a listing of how those limitations were overcome in the next design.

The instruments described in this section are referred to as two-dimensional inasmuch as they track the horizontal and vertical movements of the eye. More precisely, they track the angular orientation of the *optic* axis of the eye in three-dimensional space. But the *visual* axis of the eye (i.e., the direction of gaze) differs from the optic axis of the eye by an angle that varies from person to person. It is necessary to compensate for this angular offset in applications where it is important to know the absolute position in space on which the eye is fixated.

But knowing the "point" in three-dimensional space on which the eye is focused requires knowing not only the two-dimensional angular orientation of the line of sight but also the distance from the eye to that point (i.e., the level of accommodation). Measuring the subject's accommodation is the task of an instrument we refer to as an optometer. Appendices 1 and 2 describe the design of an optometer that works together with the dual Purkinje image (DPI) eyetracker to form a three-dimensional instrument (i.e., an instrument that measures simultaneously the angular orientation of the eye plus the level of accommodation).

### A. First Usable Instrument (Generation II)*

The basic optical system of the Generation-II system is shown in Figure 3. Light source $S$ is a GE DFW 500 W projection lamp, which is imaged by lens $L_1$ onto stop $S_1$. $S_1$ is located in the focal plane of lens $L_2$ and is imaged

---

*The text and figures of this section are taken primarily from Reference 4.

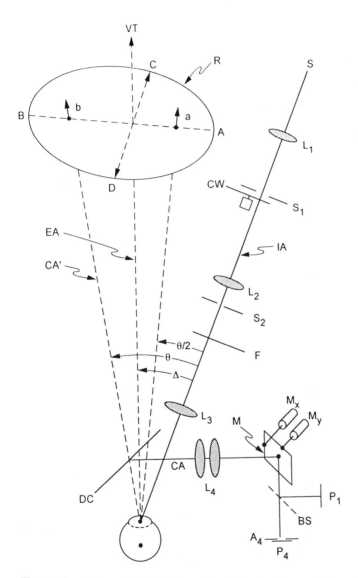

**Figure 3** Schematic of the Generation-II eyetracker optical system: *VT*, visual target; *R*, allowed range of eye movements; *IA*, input axis; *CA*, collecting axis; *CA'*, extension of collecting axis; *S*, light source; $S_1$, artificial pupil imaged at pupil of eye; *CW*, chopper wheel; $S_2$, source of Purkinje pattern, imaged at infinity; *DC*, dichroic mirror; *M*, front surface mirror; $M_x$ and $M_y$, motors that drive *M* in *x* and *y* direction, respectively; *BS*, beam splitter; $P_1$ and $P_4$, quadrant photocells; $A_4$, aperture in front of $P_4$. Focal lengths of lenses $L_2$, $L_3$, and $L_4$ are 60, 150, and 90 mm. (From Ref. 4.)

in the plane of the pupil of the eye, which is located in the focal plane of lens $L_3$. Stop $S_2$, which contains a 2.2 cm round hole, is located in the focal plane of lens $L_3$ and therefore appears to the eye at optical infinity. All the light that appears to emanate from stop $S_2$ passes through the image of $S_1$ formed at the eye. This input light also passes through a filter $F$ with a pass band between 0.8 and 1.1 $\mu$m, and is chopped at 1200 Hz by a chopper wheel $CW$, which contains alternating open and closed sectors.

First and fourth Purkinje images of stop $S_2$ are formed approximately in the plane of the eye pupil. These images are reduced in size by the ratio of the focal lengths of lens $L_3$ and the equivalent Purkinje mirrors and thus are about 0.57 and 0.43 mm in diameter, respectively. Light from these images is in turn reflected by a dichroic mirror $DC$, reimaged by lens $L_4$ (a pair of back-to-back 180 mm focal length $f/3.1$ achromatic lenses), reflected by mirror $M$, and divided by a beam splitter $BS$, to form two separate pairs of images. At $A_4$ is a diaphragm that forms a small round hole positioned to pass the fourth image on to quadrant photocell $P_4$. The diaphragm, which is attached to $P_4$, blocks the light from the first Purkinje image. The beam splitter reflects about 10% of the incident light toward another quadrant photocell $P_1$, where another pair of Purkinje images is formed.

Mirror $M$ is pivoted at its center and is driven in altitude and azimuth by two separate motors, to maintain the first Purkinje image centered on the stationary photocell $P_1$. The control signals $M_x$ and $M_y$ that drive these two motors are derived from signals from the four sectors of $P_1$, arranged so that $P_1$ functions simultaneously both as a horizontally oriented split-field cell and as a vertically oriented split-field cell, as shown in Figure 4. The position of photocell $P_4$ is controlled by two separate motors, $P_x$ and $P_y$, to keep the photocell centered on the fourth Purkinje image. The control signals that drive these two motors are derived from the four quadrants of $P_4$ in a similar manner to that of photocell $P_1$, shown also in Figure 4. In sum, mirror $M$ is servo-controlled to maintain the first Purkinje image stationary on photocell $P_1$, which is spatially fixed, and photocell $P_4$ is servo-controlled in two dimensions to track any movement of the fourth Purkinje image that remains after mirror $M$ has removed the movement component that is shared with the first Purkinje image. The position of $P_4$ thus indicates the distance between the first and fourth Purkinje images, which is a measure of the angular position of the eye.

If the eye is translated, mirror $M$ is automatically repositioned to maintain the first Purkinje image centered on $P_1$. The same movement properly repositions the fourth Purkinje image as well, and no movement of $P_4$ is required. In other words, there is no change of output. However, if the

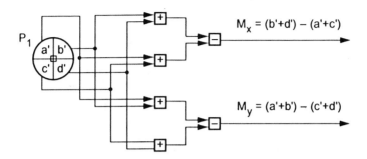

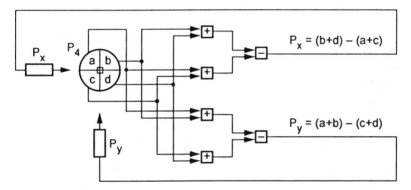

**Figure 4** Photocell connections: $M_x$ and $M_y$, signals that drive the two-dimensional mirror in $x$ and $y$; $P_x$ and $P_y$, motors that drive $P_4$ in $x$ and $y$ directions. (From Ref. 4.)

eye rotates, the images move differentially and the output signal changes accordingly.

The four servo motors used in the Generation-II instrument are Pye-Ling type V-47 shake-table motors; two of the motors drive mirror $M$ and two drive photocell $P_4$. To obtain good high frequency response, each motor control loop incorporates an accurate motion sensor $MS$ (Fig. 5), which has a position accuracy better than 1 $\mu$m. Signals from these motion sensors are fed back to form high gain internal loops within each major drive loop. All four drive circuits are flat to about 100 Hz (corner frequency).

The subject is positioned by means of a standard chin rest/forehead rest combination, or a dental impression plate. He views the visual target

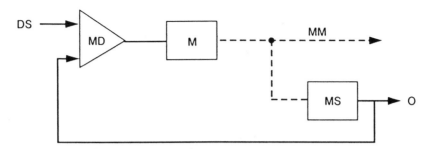

**Figure 5** Feedback circuit around each motor: *DS*, drive signal; *MD*, motor driver; *M*, motor; *MM*, mechanical motion; *MS*, motion sensor, Hewlett-Packard DCDT displacement transducer; *O*, output signal. (From Ref. 4.)

through the dichroic mirror *DC*, which transmits visible light and reflects the infrared. The angle between the eye axis and input axis is labeled Δ in Figure 3. The angle between the light-collecting axis and the input axis is labeled $\theta$ and is typically about 30° (i.e., $\theta = 30°$ in Fig. 3).

The instrument has a tracking range of the form sketched in Figure 3. As the eye rotates toward the input axis (i.e., toward *A*), the angular separation Δ decreases and the first and fourth Purkinje images move closer together. (At Δ = 0, the two images would be superimposed and therefore inseparable.) Tracking in this direction is eventually limited when light from the very-much-brighter first Purkinje image enters photocell $P_4$ (through the aperture $A_4$). As the eye moves away from the input axis (i.e., increasing Δ), the horizontal separation of the images increases. Tracking in this direction is eventually limited when the fourth Purkinje image is cut off by the pupil of the eye.

Vertical rotation of the eye (i.e., in the direction *C–D* in Fig. 3) results in corresponding vertical separation of the first and fourth images and is again limited by occulation by the pupil. In other words, the range of the instrument is primarily limited by the eye pupil on the boundaries away from the input axis, and by confusion from the first and third Purkinje images with the fourth Purkinje image in the direction of the input axis.

Figure 6 shows the horizontal motion of the eye during steady fixation, and during two horizontal rotations of 3° each. The top record is the horizontal motion of the two-dimensional mirror (driven from the first Purkinje image photocell) and the bottom record is the horizontal movement of the fourth Purkinje image photocell. The first record is identical with that obtained from a typical corneal image tracker (i.e., it contains the usual wandering baseline that results from translation-induced errors),

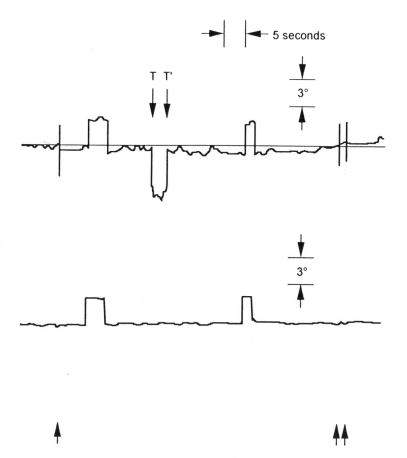

**Figure 6**   Upper, horizontal eye movements recorded from first Purkinje image tracker; lower, horizontal eye movements recorded from fourth Purkinje image tracker. The upper trace shows the wandering baseline, typical of corneal image trackers. Both traces record two 3° horizontal eye movements. During the interval $T$–$T'$, the subject's head was translated 0.5 mm horizontally, which shows in the upper trace but not the lower. Arrows at the bottom indicate eye blinks. (From Ref. 4.)

whereas the signal from the fourth cell is translation insensitive, as explained earlier.

While the record in Figure 6 was being taken, the head was held rigidly by a tight-fitting dental impression plate, with the extra support of a forehead rest. (Translation-induced effects may be attributable to translation

of the eye within its socket.) To test for sensitivity to translation of the eye, the dental plate and headrest were translated horizontally by 0.5 mm at the point marked $T$ in the record and returned at point $T'$. As can be seen, the upper record deflected strongly, whereas the lower record is almost completely insensitive to even such a large movement. Thus the fourth Purkinje output provides a measure of eye rotation that is essentially uncontaminated by translation.

Conversely, by subtracting the fourth Purkinje output from the first Purkinje output (which contains rotation plus translation signals), we can obtain a measure of eye translation, undisturbed by rotations (the two signals must be properly scaled, however, before subtraction).

### 1.   Limitations of the Generation-II Instrument

*Alignment.* A major limitation of the Generation-II instrument was the procedure required to align it to each new subject. For this alignment the instrument was mounted on a three-axis adjustable base. The operator cranked each axis by hand in sequence, while observing the subject's eye with an IR viewer. The goal of the alignment was to center the input IR light with respect to the subject's pupil until the output servos began tracking. This procedure was very tedious for both the operator and the subject.

*Artifact.* It was not appreciated initially that 90° rotation of the optical axis by mirror $M$ in Figure 3 would lead to significant rotation of the eyetracker's field of view with eye movements, hence to coupling of the $x$ and $y$ outputs and a resulting pincushion type of distortion in the field plot.

*Frequency Response.* Although the frequency response of the center-pivoted-mirror servo of the first Purkinje system was quite high, the frequency response of the two-axis, photocell-driven servo was relatively low. It was also difficult to prevent mechanical coupling between the horizontal and vertical drivers, which resulted in still further field distortion artifact.

## B.   First Production Instrument (Generation III)*

The Generation-III eyetracking system is shown in Figure 7. This version, which combines many substantial improvements over the Generation-II instrument, greatly extended its performance and was much easier to use.

---

*As noted in Section I, 21 copies of the Generation-III eyetracker were produced, and at the time of publication many were still in use at a number of vision research laboratories. (Although five copies of the Generation-II eyetracker were also produced, they were so difficult to use that they hardly qualify as production instruments.)

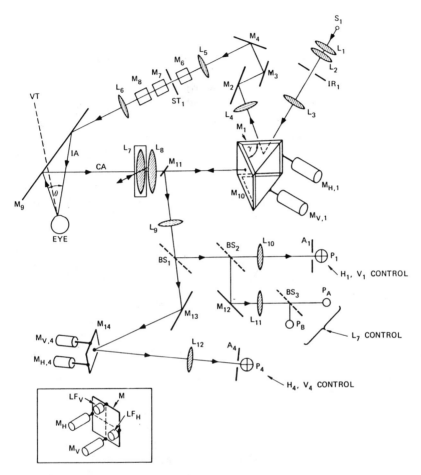

**Figure 7** Schematic of the Generation-III eyetracker systems: $S_1$, IRED source; $IR_1$, adjustable iris conjugate with eye pupil; $M_1$, and $M_{10}$, coupled front-surface mirrors under control of motors $M_{H,1}$ and $M_{V,1}$; $\gamma$, angle between mirrors $M_1$ and $M_{10}$; $M_2$, $M_3$, $M_4$, $M_6$, $M_7$, $M_8$, $M_{11}$, $M_{12}$, and $M_{13}$, front-surface mirrors (mirrors $M_2$, $M_3$, $M_4$, and $M_5$, not shown, are used in different combinations to alter the angle $\theta$ of the incoming illumination); $M_{14}$, front-surface mirror driven by motors $M_{V,4}$ and $M_{H,4}$; $M_9$, dichroic mirror; $BS_1$, 90/10 pellicle beam splitter; $BS_2$ and $BS_3$, 50/50 beam splitters; $P_1$ and $P_4$, quadrant photocells; $A_1$ and $A_4$, apertures in front of $P_1$ and $P_4$, respectively; $P_A$ and $P_B$, photocells in automatic focus–detection circuit; $VT$, visual target; $IA$, input axis; $CA$, collecting axis; stop $ST_1$, source of Purkinje image pattern; $LF_H$ and $LF_V$, linear followers. (From Ref. 6.)

The limitations of the Generation-II instrument were overcome in the Generation-III tracker in the following ways:

Alignment of the subject was greatly simplified by arranging the input light path to automatically track lateral movements of the eye. This was accomplished by adding a servo-controlled mirror in the input path, which was under control of the first Purkinje system (see mirror $M_1$ in Fig. 7). The instrument also tracked forward and backward movement of the eye, by incorporating an automatic focus system (see photocells $P_A$ and $P_B$ in Fig. 7, which controlled the position of lens $L_7$, the first lens in the output optical path).

Field distortion artifact was substantially reduced by arranging the mirror in the optical output path to reflect the optical axis by 180° rather than by 90° — that is, back on itself (see mirror $M_{10}$ of Fig. 7) — which required adding another small stationary mirror, $M_{11}$.

Greatly improved frequency response was obtained by using a mirror deflector in the fourth Purkinje optical path instead of moving the quadrant photocell directly (see mirror $M_{14}$ in Fig. 7).

The text and figures of this section are taken primarily from Reference 6.*

### 1. Input Optics

$S_1$ is a solid state light source with a narrow spectral band centered at 0.93 $\mu$m wavelength. (It was a great advantage that high powered, solid state light sources at this wavelength had become available as we began the design of this instrument; chopping the light source electronically eliminated the need for a chopper wheel and also made it easier to shape the illumination waveform.) Light from $S_1$ is electronically chopped at a high frequency (4 kHz) to avoid the effects of room light and to use ac-coupled amplifiers in the Purkinje image servosystems, thereby improving stability and decreasing noise.

Lenses $L_1$ and $L_2$ image $S_1$ into the plane of an iris diaphragm $IR_1$, which is conjugate with the pupil of the subject's eye. Lens $L_3$ is positioned one focal length from the iris so that the light emerging from $L_3$ is collimated. This light is reflected from servo-controlled mirror $M_1$ and imaged by lens $L_4$. Assume for the moment, however, that mirror $M_1$ is fixed.

---

*In Reference 6 this newer instrument is called Generation II, ignoring the first, proof-of-principle instrument. Later, however, as these instruments continued to evolve, the generations were relabeled, assuming that the first instrument was Generation I, as is done here. Thus, the instrument described in this section is called Generation III, as it has been known by the eyetracker community for many years.

Lens $L_5$ is positioned one focal length from the image of the light source formed by lens $L_4$. The required pathlength ($f_4 + f_5$) between lenses $L_4$ and $L_5$ is obtained by the multiple reflections provided by mirrors $M_2$, $M_3$, and $M_4$. An odd number of reflections from these mirrors provides an inversion of the horizontal component of the input light path. This inversion is necessary for the proper functioning of mirror $M_1$, by means of which, as described later, the input light is made to track automatically any change in eye position.

Mirrors $M_6$, $M_7$, and $M_8$ form a Dove mirror system to provide an inversion of the vertical component of the illumination system, which is also necessary for proper tracking of input light. Within the Dove mirror system is a stop $ST_1$, a circular aperture approximately 2.54 cm (1 in.) in diameter. This aperture determines the size and shape of the Purkinje images formed at the eye and is in the focal plane of lens $L_6$. Thus, light emerging from lens $L_6$ is collimated with respect to the image of the aperture. The eye is in the focal plane of lens $L_6$ and is illuminated by the light coming from the light-emitting diode. Dichroic mirror $M_9$ reflects both the input illumination light and the light reflected from the first and fourth Purkinje images that form in the subject's eye.

## 2. Output Optics

The Purkinje images are formed in the pupil plane of the eye, which is in the focal plane of output lens $L_7$. Thus, light from the Purkinje images is collimated between lenses $L_7$ and $L_8$. The light that passes through lens $L_8$ is reflected from mirror $M_{10}$ onto mirror $M_{11}$, which is in the focal plane of lens $L_8$. Because lenses $L_7$ and $L_8$ have the same focal length, a unity magnification image of the pupil plane of the eye is formed at mirror $M_{11}$.

Mirror $M_{11}$ is in the focal plane of lens $L_9$. Therefore, the light emerging from lens $L_9$ is collimated. Beam splitter $BS_1$ reflects approximately 10% of the incident light toward beam splitter $BS_2$. The remaining light passes through $BS_1$ to front-surface mirror $M_{13}$. Beam splitter $BS_2$ reflects and transmits approximately equal amounts of light. The transmitted light is imaged by lens $L_{10}$ onto the four-quadrant detector $P_1$, which is the focal plane of $L_{10}$. $P_1$ is therefore in a plane conjugate to mirror $M_{11}$ and the pupil plane of the eye; aperture $A_1$ defines the size of field seen by $P_1$. Thus, when the Purkinje image is at one particular point on mirror $M_{11}$ (or in the pupil plane of the eye), it will fall on the center of the four-quadrant photodetector. If the image tends to move away from this point, the image at the detector will move, and the resulting error signals will drive servomotors $M_{H,1}$ and $M_{V,1}$ to reposition mirror $M_{10}$ (and mirror $M_1$). The mirror is repositioned in yaw and pitch to bring the first Purkinje image to its initial

point on mirror $M_{11}$ and thus on the photodetector. In this way, the image of the eye formed at mirror $M_{11}$ always has it corneal reflection in the same location.

The light reflected from beam splitter $BS_2$ reflects from front-surface mirror $M_{12}$ and is imaged by lens $L_{11}$ (and split by a 50/50 beam splitter $BS_3$) onto two focus-detecting photodiodes $P_A$ and $P_B$. These photodiodes are displaced axially approximately 0.5 cm on either side of the plane of focus of the first Purkinje image and, being small, measure light flux density along the axis of the imaging system. When the eye is in the correct axial position, each of these photodiodes receives the same amount of light. If the eye moves axially, one or the other of these photodiodes receives more light, and the difference in light level generates an error signal for a servomotor that drives the carriage containing lens $L_7$. As described later, lens $L_7$ is repositioned so the two photodetectors continually receive equal amounts of light. This ensures that the first Purkinje image is always in focus on $P_1$ in spite of axial eye movement.

The light transmitted by beam splitter $BS_1$ reflects from mirror $M_{13}$ onto the servo-controlled mirror $M_{14}$ and is collected by lens $L_{12}$. At the focal plane of lens $L_{12}$ is a second four-quadrant photodetector $P_4$, which receives the fourth Purkinje image; aperture $A_4$ defines the size of field seen by $P_4$. Signals derived from quadrant cell $P_4$ control motors $M_{H,4}$ and $M_{V,4}$. These motors move mirror $M_{14}$ in yaw and pitch to keep the fourth Purkinje image centered on $P_4$.

Opposite each mirror motor is mounted a linear motion follower $LF$ with a sensitivity better than 1 $\mu$m (inset of Fig. 7). These motion sensors are used in a local internal servo feedback loop in each driver circuit to achieve high frequency response and to minimize hysteresis and dead zone. Signals from $LF_{H,1}$ are used in the servo loop that drives motor $M_{H,1}$, and signals from $LF_{V,1}$ are used in the servo loop that drives $M_{V,1}$. Similar motion sensors are used in conjunction with drive motors $M_{H,4}$ and $M_{V,4}$.

The direction of the eye's optical axis is derived directly from $LF_{H,4}$ and $LF_{V,4}$ signals, as described earlier. Signals from $LF_{H,1}$ and $LF_{V,1}$ represent the horizontal and vertical positions of the first Purkinje image, which moves in response both to eye translation and eye rotation. By properly combining the signals from $LF_{H,4}$ and $LF_{V,4}$ with those from $LF_{H,1}$ and $LF_{V,1}$, one can also accurately track the translational position of the eye.

### 3.  Automatic Input Path Tracking

The Generation-III instrument was designed to permit up to a centimeter of variation of eye position in all dimensions: horizontal, vertical, and axial. For a large axial variation to be tolerated, it is necessary to incorporate automatic focus into the eyetracker (see next section on automatic

focus). For large lateral variations to be tolerated, either a large input beam must be used (so that the eye never moves out of the beam) or the input light path must track eye position automatically (in which case a source of small dimensions can be used). The latter option was chosen because it offers many advantages: less total light energy directed toward the eye; a crisper fourth Purkinje image because of less stray light; and improved automatic capture because the first Purkinje tracker can incorrectly lock onto the iris if it is illuminated.

For automatic input path tracking, mirror $M_1$ (in the input path of Fig. 7), which was assumed fixed in the earlier discussion, is used to keep the illumination beam centered on the pupil. For this purpose, mirror $M_1$ is rigidly connected to, and therefore moves in synchronism with, mirror $M_{10}$.

To understand how the input light is made to track eye position, note that if the eye moves upward, the corneal reflection tends to move upward on detector $P_1$. Error signals generated by this photodetector reposition mirror $M_{10}$ to maintain the corneal image centered on $M_{11}$. Motion imparted to $M_{10}$, however, also repositions mirror $M_1$; this automatically deflects the illumination beam upward to track the corneal reflection. The illumination tracking cannot be perfect with respect to the pupil of the eye because $P_1$ tracks the corneal reflection, which moves with respect to the eye pupil when the eye makes rotational movements. However, the design is such that the tracking error is less than 1 mm with eye translation of $\pm 0.5$ cm in any direction and with eye rotations of 15° in all directions (30° diameter field), that is, the input illumination beam tracks the center of the pupil to within 1 mm over this range.

A critical requirement of the input light tracking system is that a shift in the input light path must not cause any change in the angle of the input axis $IA$ with respect to the eye axis. Any such change would alter the separation of the Purkinje images and therefore would be interpreted as an eye rotation. This situation is avoided as follows.

Figure 8 shows the light entering the eye directly at an angle $\theta$ to the collecting axis. (For simplicity, the dichroic mirror is not shown.) The input system consists essentially of lens $L_6$ located at its focal length from the eye and stop $ST_1$ located one focal length away from $L_6$. Stop $ST_1$ therefore appears to the eye to be at infinity. Stop $ST_1$ is illuminated by $S_1'$, which is an image of iris $IR_1$ and is in the focal plane of lens $L_5$. The light cones emerging from each point of $ST_1$ are collimated by lens $L_6$, and their intersection at the eye is an image of $S_1'$ and therefore of iris $IR_1$. If iris $IR_1$ were translated in its own plane, its image $S_1'$, and hence the image of $S_1'$ at the eye, would similarly translate, but the collimated ray bundles from each point of $ST_1$ would not change their angular orientation, as desired. It is therefore possible to achieve the desired input tracking simply by translat-

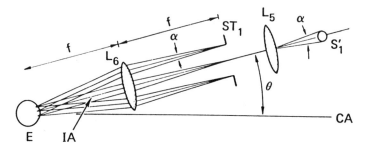

**Figure 8**   Translation of the source $S_1$, or source image $S_1'$, moves the image at the eye but does not change the angular separation $\theta$ between the input axis $IA$ and collecting axis $CA$. A cone of size $\alpha$ will emerge from each point of the pattern of stop $ST_1$, where $\alpha$ is the angular size of the source image $S_1'$ as seen from lens $L_5$. (From Ref. 6.)

ing the iris. However, that would require yet another two-dimensional servosystem. Instead, the same effect is achieved by placing mirror $M_1$ in the collimated light path between lenses $L_3$ and $L_4$ (in Fig. 7) and attaching it rigidly to mirror $M_{10}$, as described above. The required movement sensitivity in the input light path is obtained by the proper choice of angle $\gamma$ (see Fig. 7) between mirrors $M_1$ and $M_{10}$.

### 4.   Automatic Focus

To obtain the desired 1 cm of allowed axial variation in eye position, an automatic focus system tracks the axial position of the eye. Without automatic focus, intolerable blurring of the Purkinje images would occur at the quadrant photocells, thereby making proper setup and alignment conditions difficult to achieve.

The automatic focus system must meet two stringent requirements. First, any change in focus must not cause any change in optical magnification. A change in magnification would result in a change in separation of the two Purkinje images and, therefore, would be interpreted as an eye rotation. Figure 9 shows the eye and the two output lenses $L_7$ and $L_8$; again, for simplicity, the dichroic mirror is not shown. The Purkinje images are in the focal plane of lens $L_7$. Because the light between lenses $L_7$ and $L_8$ is collimated, the eye and lens $L_7$ can both move along axis $CA$ without any change in magnification in the final image, as long as the distance between the eye and lens $L_7$ remains constant. The first step in automatic focus, therefore, is to have the axial position of lens $L_7$ track the axial position of the eye.

The second requirement is that the input light not shift if the eye trans-

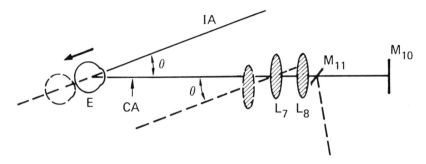

**Figure 9**   Focus adjustment by translating lens $L_7$ along a path parallel to the input axis $IA$. This method of focus adjustment maintains constant optical magnification over the focus range and maintains a constant final image position when the eye translates along the input axis: $CA$, collecting axis; $\theta$, angle between $CA$ and $IA$. (From Ref. 6.)

lates along the input light axis $IA$, since the input light is already aimed directly at the eye. In other words, the automatic focus system must be designed to prevent eye translation along the input axis from causing any shift in mirror $M_{10}$, which in turn requires that there be no change in the position of the first Purkinje image. This is achieved by shifting lens $L_7$ not along axis $CA$, but along the path parallel to the input light path $IA$, as shown by the dashed line of Figure 9. Again, because the light between lenses $L_7$ and $L_8$ is collimated, an equal lateral component of shift of the eye and lens $L_7$ will not change the position of the final image formed by lens $L_8$. A shift in eye position along any other axis will, however, shift the input light path appropriately as well as activate the automatic focus system.

In Figure 7 we noted that the signal that drives the focus servosystem derives from the difference in signals from photocells $P_A$ and $P_B$. This signal is zero when the first Purkinje image is in focus on quadrant photocell $P_1$.

Output from the servosystem that drives $L_7$ provides a direct measure of the axial position of the eye. Combined with the horizontal and vertical eye position signals described earlier, the three-dimensional position of the globe can thus also be accurately tracked separately from the angular orientation of the globe.

### 5.   Automatic Search

An automatic search of the field is made whenever the first Purkinje system becomes unlocked for a fixed period of time, as indicated by an improper light level falling on photocell $P_1$. In this case, the first Purkinje mirror is

made to sweep in an increasing spiral from the central position, and the focus servosystem returns to its central position. On the average, recapture occurs about 0.5 second after the initiation of a search action. When successful capture has been achieved by the first Purkinje system, the focus servosystem is reactivated, and a small-field spiral search is initiated by the fourth Purkinje system. (With the first Purkinje system locked, the fourth Purkinje image falls within a small, well-defined area.) Again, the average capture occurs about 0.5 second after initiation of a search action, for a total average search-and-capture time of about 1 second. Separate light level detectors in the fourth Purkinje system indicate when the fourth system is operating normally. A search for the fourth image is automatically initiated whenever the fourth light level is out of range.

A separate output signal indicates whenever the first or fourth Purkinje tracker is unlocked for any reason. This signal can be used to ignore those portions of the eye records in manual or automatic processing of the data.

### 6. Limitations of the Generation-III Instrument

*Frequency Response.* The frequency response of the fourth Purkinje system was significantly increased in the Generation-III instrument. However, replacing the simple mirror $M$ of the Generation-II tracker by the complex $M_1$–$M_{10}$ mirror system of the Generation-III tracker resulted in a *lower* frequency response of the first Purkinje system — because of the heavier load and moment of inertia of the $M_1$–$M_{10}$ arrangement.

*Alignment.* Aligning the instrument to a new subject involves basically two steps: getting the eye into proper position so that all the servos are tracking simultaneously, and moving the subject until, with the eye fixated on a standard target location, all the servos are in the center of their respective ranges. The automatic tracking system in the input path of the Generation-III instrument greatly improved the first step. After some practice, an experienced operator often could get by without using an IR viewer for the first rough alignment. But this automatic search system did not help in the second step. To obtain final centering after all the servos were locked, the operator still had to crank the subject manually, in three dimensions.

## C. Major Improvements in Ease of Use (Generation IV)*

The Generation-III instrument was readily usable and gave us the confidence to try to design a machine that was still easier to use, which turned

---

*As noted in the Introduction, nine copies of the Generation-IV instrument were produced before development of the Generation-V instrument was begun, and many are still in active use.

out to be the Generation-IV instrument. The major changes in going from Generation III to Generation IV were as follows:

*Frequency Response.* To improve frequency response — in particular of the first Purkinje system — major changes were made in the shape of the webs on which mirrors $M_{14}$ and $M_1$-$M_{10}$ (see Fig. 7) are mounted; also, the material of the webs was changed (from aluminum to magnesium) and improved shaker motors were incorporated.

*Alignment.* To further simplify the alignment procedure, the entire instrument was mounted on a three-axis, motor-driven stage that provided for automatic and optimum alignment to a subject. For the first time, a subject could align himself in the instrument without assistance by using an optical target, and this represented another major step forward in ease of use.

No specific description of the Generation-IV instrument has been published. Since, however, the optics of the Generation-III and Generation-IV instruments are basically the same, there is no need to go over them again. The only major changes, apart from the mechanics of the servomotors, were in the three-axis, motor-driven stage and in the size of the optical platform. The staging system was used again in the Generation-V design, and will be discussed in the Generation-V description (Sec. III.D).

## 1. Limitations of the Generation-IV Instrument

The Generation-IV instrument represented another major advance in ease of use — indeed, as noted above, with a little experience a subject could put himself in the eyetracker simply by placing his eye in approximately the correct position (which was easy if his fixation mark in the viewing path had previously been aligned with respect to the eyetracker axis). The scan circuits would search for the eye and the stage motors would then automatically engage to optimally center the instrument on the subject's eye. In fact, whereas earlier instruments generally required a tight-fitting biteboard to keep the subject's eye fixed in position, the Generation-IV instrument could even be used in conjunction with a simple chin cup/forehead rest combination for gentler maintenance of position.

*Miniaturization.* With the confidence gained from this major advance in ease of use, it seemed time to pay attention to some of the more cosmetic features — such as the size of the instrument, which was still quite large and cumbersome (especially for clinical applications). Miniaturization of the eyetracker became a major goal of the next instrument.

*Frequency Response.* Good image stabilization requires excellent frequency response (see Sec. V). Although the Generation-IV tracker already achieved quite good image stabilization, design of the Generation-V in-

strument had further improvement of frequency response as another major consideration. As explained in Section III. D, miniaturization and improved frequency response were achieved by the same design change.

*Subject-to-Subject Variation in Alignment.* Although the major alignment problem was solved in Generation IV, there remained one fine point whose solution would still further enhance the ease of use of the instrument. This problem derives from the significant variation from subject to subject between the visual and optic axes of the eye.

## D.   Final SRI Design (Generation V)*

The major changes in going from Generation IV to Generation V were as follows:

1.   We undertook the development of new servomechanisms, designed specifically for use in the eyetracker. This resulted in a major reduction in the size of the eyetracker (to approximately 20% the volume of the Generation-IV instrument) as well as major improvement in frequency response (500 Hz), slew rate (2000 deg/s), and resolution (20 seconds of arc rms).

2.   Because the new servomechanisms were simpler and less expensive, in addition to being much smaller, it was possible to replace the rigidly linked $M_1$–$M_{10}$ mirror system of the Generation-III and -IV trackers (Fig. 7) with two separate mirror systems, $M_1$ and $M_{10}$, in the Generation-V tracker. This separation increased frequency response even further and greatly reduced the complexity of the optical design.

3.   Automatic lateral positioning of lens $L_{12}$ (see Fig. 7) eliminated the remaining alignment problem caused by subject-to-subject variation in the angular offset of the visual and optic axes of the eye.

The figures and text in this section are taken mainly from Reference 7.

### 1.   Basic Arrangement of the Generation V Instrument

Figure 10 illustrates the basic configuration of the input and output optical paths of the Generation-V instrument in general terms.

*a.   Input Optical Path*

An infrared source $S_1$ is imaged on a stop $ST_1$, which is imaged in the pupil plane of the subject's eye. A stop $ST_2$ in the input path is at optical infinity with respect to the subject's eye and defines the shape of the first and fourth Purkinje images. The input path is folded back on itself at mirror

---

*As noted in Section I, SRI produced 32 copies of this instrument before production was taken over by Fourward Technologies, which had produced another dozen or so by early 1993.

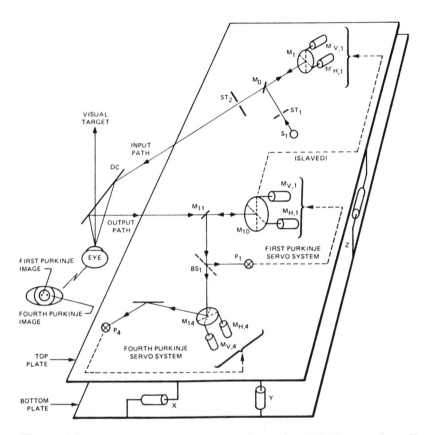

**Figure 10**  Simplified schematic of the Generation-V DPI eyetracker. (From Ref. 7.)

$M_1$, whose horizontal and vertical rotation angle is under the control of a pair of motors. This two-dimensional servosystem keeps the input radiation centered on the pupil of the eye even as the eye moves with respect to the instrument. $DC$ is a dichroic mirror, which reflects infrared radiation for the eyetracker but transmits visible light for the subject's task.

### b.  Output Optical Path

The output optics are basically similar to those shown in Figure 7 for the Generation-III tracker and require no further explanation.

### c.  Three-Axis, Motor-Driven Stage

The entire instrument is mounted on a three-axis, motor-driven stage, as illustrated schematically in Figure 10 in terms of three motors labeled $X$, $Y$, $Z$. This three-dimensional adjustment system is a critical aid in aligning

the instrument to a subject. After the operator makes an approximate alignment of the instrument by manual control of the three motors, the instrument moves automatically to align itself to the exact optimal three-dimensional position. (Earlier instruments required that the operator find this optimal position, which was difficult as well as time-consuming.) If this three-dimensional autostaging system is left in the auto mode, the instrument will move in space with the subject during actual eyetracking, provided the subject does not make large, abrupt head movements. (For most applications, the autostaging model is switched off after initial alignment.)

### 2. Detailed Optical System Description

Figure 11 is a more detailed schematic diagram of the optics of the Generation-V eyetracker.

#### a. Input and Output Optical Paths

In Figure 11, $S_1$ is a source of high power infrared radiation, which is attached to a thermoelectric cooler $TC$. $S_1$ is amplitude modulated with a haversine waveform at a frequency of 4000 Hz. This source is imaged in the plane of stop $ST_1$ by lenses $L_1$ and $L_2$. $ST_1$ is imaged on the surface of mirror $M_0$ by lenses $L_3$ and $L_4$ and is reimaged in the pupil plane of the subject's eye by lenses $L_5$ and $L_6$. Thus, the shape and size of $ST_1$ determine the shape and size of the illumination spot at the pupil plane of the eye.

Mirror $M_0$ is attached to the surface of $L_5$ and is only slightly larger than the image of $ST_1$ at that point. This image, in turn, is in the focal plane of lens $L_5$. However, the rays that reach $L_5$ are first reflected by the beam steering mirror $M_1$. This mirror is driven by servomotors $M'_{H,1}$ and $M'_{V,1}$ which are slaved and scaled to the outputs of servomotors $M_{H,1}$ and $M_{V,1}$, respectively. $M_{H,1}$ and $M_{V,1}$ are used in tracking the first Purkinje image, as discussed earlier. Appropriate gain and offset adjustments are applied to the signals that drive $M'_{H,1}$ and $M'_{V,1}$ to keep the illumination spot properly positioned at the subject's eye during tracking.*

Input radiation passing through $L_5$ is collimated and completely fills stop $ST_2$, which is in the focal plane of $L_6$. This stop, which determines the shape and size of the Purkinje images, thus appears at optical infinity with

---

*Separate drive systems for mirrors $M_1$ and $M_{10}$ lead to great simplification of the input optics. In the earlier instruments, accurate tracking of the subject's eye position required accurate design of the multiple optical path lengths and was further complicated by the need for the input and output optical paths to merge at the compound ($M_1$, $M_{10}$) mirror assembly. In the new design, it is only necessary to adjust the electrical gains and offsets of the (slave) signals that drive motors $M'_{H,1}$ and $M'_{V,1}$.

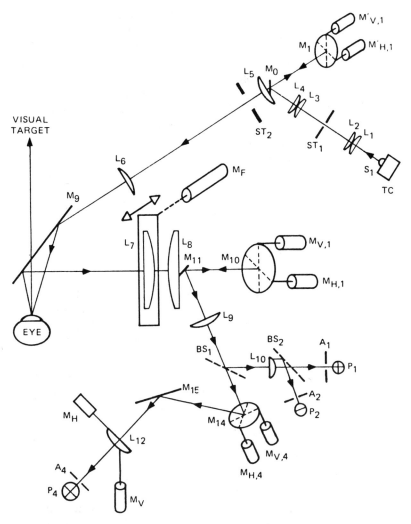

**Figure 11** Detailed schematic of the optical paths of the Generation-V DPI eyetracker. (From Ref. 7.)

respect to the eye. Lens $L_6$, in turn, focuses the illumination stop $ST_1$ at the pupil of the subject's eye, after reflection by the dichroic mirror $M_9$. $M_9$ is a "hot" mirror that reflects the infrared radiation but is nearly transparent to the subject.

Infrared light reflected from the eye is collected by lens $L_7$, which deter-

mines the speed of the optical system. The lens diameter ($\sim 7.6$ cm) has therefore been given the largest feasible size, to ensure the collection of a maximum amount of reflected radiation. The focal length of lens $L_7$ ($\sim 21.6$ cm) has also been designed to provide as much distance as possible between the subject and the eyetracker, consistent with its large diameter. Movement of lens $L_7$ by linear motor $M_F$ along a path parallel to the direction of the input illumination keeps the optical system in focus, should the eye move relative to the eyetracker so as to change its distance from $L_6$.

The rays that pass through $L_7$ and $L_8$ are reflected by mirror $M_{10}$ and, as noted in connection with Figure 7, the Purkinje images, along with portions of the eye in the immediate vicinity of the pupil, are imaged at the surface of mirror $M_{11}$. In fact, the output optics from this point on are similar to those described in connection with Figure 7, except for the automatic focus system described in the next section and the drive motor system attached to lens $L_{12}$, which is described below (Sec. g).

*b. Automatic Focus*

Beam splitter $BS_2$ is a 50/50 beam splitter that reflects IR radiation to the focus servosystem. This radiation passes through aperture $A_2$, and the first Purkinje image is imaged onto split-field photodetector $P_2$. Because $A_2$ is an off-axis aperture, there is lateral shifting of the image with axial motion of the subject's head or eye. When the subject's eye is properly located axially, the first Purkinje image is symmetrically positioned on split-field cell $P_2$. However, if the focus is either ahead of or behind $P_2$ as a result of axial eye motion, different amounts of light fall on the two halves of the cell, and this difference produces an error signal to servomotor $M_F$. $M_F$ responds by moving $L_7$ (together with $L_6$ and stop $ST_2$) in a direction that brings the image back into focus on the surface of $P_2$ and thus refocuses the entire optical system of the eyetracker.

*c. Autostaging*

During the search mode, the first and fourth Purkinje image servomotors are driven to create a raster scan in an attempt to capture their respective images, and the focus servomotor is simultaneously driven back and forth; simultaneously, the operator manually controls the stage motors ($X$, $Y$, and $Z$) for an approximate visual alignment of the instrument to the subject's eye. After the first Purkinje image servos have been locked, the $X$, $Y$, and $Z$ drive motors automatically move the instrument in three dimensions to center all three servo systems (i.e., $H_1$, $V_1$, and focus). The instrument is now optimally aligned to the subject.

During tracking, the autostaging follows only changes in eye translation and can be inactivated or used in a three-dead–band quasi-servosystem

mode that keeps the tracker located continually in an optimal position even as the (translational) position of the eye changes in time.

*d.   Two-Dimensional Mirror Assembly*

Figure 12 compares the two-dimensional drive assembly used in the Generation-V eyetracker and the assembly used in earlier instruments. The latter was designed around a Ling model 102 motor, which was among the smallest commercially available linear drive motors with the necessary force-generating capability. Obtaining a smaller assembly required a new, completely in-house design. This new drive assembly is not only much smaller but also has significantly higher frequency response than the earlier assembly (see below: Sec. *f*).

*e.   Noise Level*

The ultimate angular resolution of the eyetracker is determined by the signal-to-noise ratio at the fourth Purkinje image detector. The higher this ratio, the higher the resolution obtainable. In the Generation-V tracker this ratio has been improved partly by increasing the input illumination power — by the introduction of a new, smaller infrared-emitting diode (IRED) source that has the same surface intensity at room temperature but lower total radiated power (also lower total input power) than the IRED used before. The lower power dissipation made it feasible to cool the IR emitter by a small (two-stage) Peltier cooler, thereby improving the efficiency of radiation compared to an uncooled source. In addition, all the optics in both the input and output paths are antireflection coated to minimize transmission losses, and all mirrors are either gold, which has a high reflectance in the near IR, or multilayer dielectric reflectors, which also have a high reflectance.

At the low audio frequencies at which the eyetracker operates, the input noise is determined not by the equivalent noise power of the quadrant detector, but by the Johnson noise of the feedback (load) resistor of the preamplifier. For a given photodiode current, the output voltage of the preamplifier is proportional to the magnitude of the preamplifier feedback resistor. Because resistor noise is proportional to the square root of the resistance, the signal-to-noise ratio improves as the magnitude of the feedback resistor increases. Ultimately, the preamplifier feedback capacitance (capacitance between the output and input) limits the usable size of this resistor because the product of feedback resistance and feedback capacitance determines the preamplifier bandwidth. This bandwidth must be sufficient to handle the carrier frequency of the IRED (4 kHz) plus the modulation sidebands. In the Generation-V system, the preamplifier has been physically redesigned to minimize output-to-input capacitance. With this

**Figure 12**  (A) Generation-V and (B) earlier version of the two-dimensional mirror servo assembly. (From Ref. 7.)

design, feedback resistance has been increased by a factor of 2 over that in the Generation-IV instrument.

With increased surface radiance of the IR source, antireflection coating of all optical surfaces, high reflectivity of all mirror surfaces, and the special preamplifier design, the noise level of the fourth Purkinje image servosystem has been reduced to a peak-to-peak value of about 1 minute of arc or 20 seconds of arc rms, as compared to about 1 minute of arc rms in the Generation-IV instrument.

*f. Frequency Response*

The frequency response of the servosystems determines the delay through the system. Delay is a critical feature when using the eyetracker in an image stabilization mode (especially in the presence of saccadic eye movements). For ideal retinal image stabilization, the eyetracker output should change simultaneously with eye rotation. In the latest design, frequency response has been significantly improved through redesign of the servomechanisms. In particular, the servomotors are much smaller in physical size; they also drive smaller mirrors. The limiting frequency response is usually determined by secondary mechanical resonances in the servo structure. Phase shifts that occur in the servo position signals as a result of these resonances limit the total feedback gain and thus the bandwidth of the servos. These resonances are inherently higher in frequency in the new design because of the reduction in size.

A direct benefit of improved bandwidth is tighter servo tracking. As a result, the error signals at the input of the servo integrators remain more linear even during large eye movements. (Without tight tracking, either Purkinje image can slip far enough on its respective quadrant photocell to partially fall off the active area; this is a serious source of error signal nonlinearity.) Error signal linearity permits effective use of a feed-forward technique in which the servo error signal is added to the servo position readout to minimize servo readout delay. This does not mean that the servo's mechanical motion delay has been reduced, but rather that the high frequency portion of the input signal, which is lost because of the low pass characteristics of the servo, is reentered, after proper scaling, into the servo position readout. For this technique to be successful, however, two conditions are necessary. First, the servosystem's error signal must be linear; the improved high frequency characteristics of the new servo design help in this respect. Second, the high frequency noise components must be small, since they are no longer filtered out by the servosystem; the significantly lower noise characteristics of the latest design help here. With this form of feed-forward, the eyetracker time delay is approximately 250 $\mu$s, as seen in Figure 13.

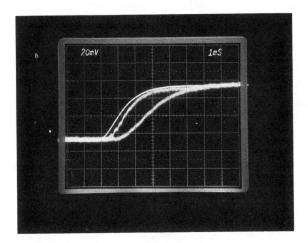

**Figure 13** System delay characteristics. Trace furthest left is actual motion of the artificial eye (1° step). Trace furthest right is eyetracker output without feed-forward. Intermediate trace is eyetracker output with feed-forward (showing ≈ 250 μs delay). (From Ref. 7.)

Figure 14 shows the frequency response characteristics of the Generation-V eyetracker. For small eye movements, the response is nearly flat to 500 Hz. Above this frequency the response begins to be influenced by structural resonances. (All servos exhibit this resonance, although the $Q$ and frequency vary slightly from unit to unit.) Also shown in Figure 14 is the large-signal frequency characteristic, which determines the system's slew rate. This curve shows that for a 10° peak-to-peak sine wave, eye movement response becomes nonlinear at 90 Hz. That is, the fourth Purkinje image starts to fall outside the defining aperture at the fourth Purkinje image detector. A sinusoidal eye movement at 90 Hz with a peak-to-peak amplitude of 10° has a peak slew rate of 2800 deg/s, which is about four times the peak slew rate of the human eye.

#### g. *Autopositioning of the Fourth Purkinje Image*

There is significant variation from one subject to another between the visual and optic axes of the eye. A major improvement in the Generation-V eyetracker is the ability of the fourth Purkinje image servosystem to center itself automatically during alignment for each subject by using motors $M_H$ and $M_V$ to move lens $L_{12}$ laterally (see Fig. 11, lower left-hand corner). This movement allows the output from $P_4$ to be nulled (i.e., to be of zero value)

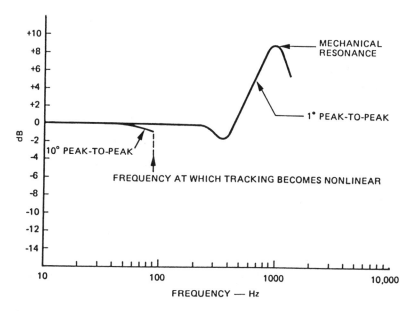

**Figure 14** Frequency response characteristics of the Generation-V eyetracker. (From Ref. 7.)

when the eye is fixated on a central target. This nulling permits the fourth Purkinje servosystem to operate in its optimal range for all subjects.

## E. Improvements by Fourward Technologies (Generation V.5)

Fourward Technologies has further improved the overall reliability and performance of the Generation-V instrument by adding the following features and functions:

Ruby pivot bearings are used in the motors for smoother servo control.
Video images are provided of the pupil, first, and fourth Purkinje images for alignment and subject monitoring.
Front panel fine-tuning of the position of the input beam minimizes contamination from iris illumination for various sizes of pupil.
The focus servoelectronics can be locked off in its central position.
Digital readout of focus lens position is provided.

The basic performance characteristics of the instrument are unaltered by these changes, although flexibility and reliability are greatly improved.

## IV. TWO- AND THREE-DIMENSIONAL STIMULUS DEFLECTOR

To test the human visual system in a clinical or research setting, it is often necessary to stimulate certain types of eye movement in the subject or patient by moving a target in specific ways. The instrument described here can move the target (or any stimulus pattern) horizontally and vertically over a large range with very high frequency response.

One major use of such a stimulus deflector is in connection with an eyetracker, where the eyetracker signals control the stimulus deflector in such a way that the stimulus is stabilized on the subject's retina, regardless of the subject's normal eye movements (see Sec. V).

It is also useful to be able to stimulate the focus, or accommodation, muscle system of the eye. This is achieved by controlled changes in the apparent distance to a target. The stimulus deflector described in this section can, under servo control, stimulate all three muscle systems of the eye in any combination.

It would have been possible in this section to describe only the horizontal and vertical deflection systems—just as we described only the two-dimensional aspects of the basic eyetracker system in Section III. However, not only was the focus component developed first, but design of the two-dimensional (horizontal and vertical) stimulus deflector components is so intimately tied to the design of the focus component that it is simpler to describe all three aspects at the same time, as is done in this section.

This material was taken primarily from Reference 8.

## A. Evolution of the Three-Dimensional Stimulus Deflector

### 1. Basic Principle of Focus Corrector/Stimulator

In the optical system sometimes referred to as a Badel optometer, the eye views an object through a lens located one focal length from the pupil of the eye, as illustrated in Figure 15. (More specifically, the lens is placed one focal length from the first nodal point of the eye, which is approximately in the pupil plane of the eye.) Viewing through lens $L_1$, the eye sees the object, located a distance $d$ on the far side of the lens, imaged at a distance $f + g$ from the lens. As illustrated by Figure 15,

$$\frac{1}{g} = \frac{1}{d} - \frac{1}{f} \tag{1}$$

or

$$g = \frac{fd}{f - d} \tag{2}$$

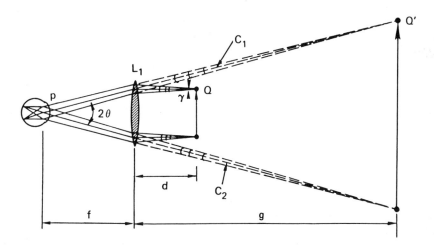

**Figure 15** Schematic representation of a simple Badel optometer. The pupil plane of the eye is placed one focal length $f$ from lens $L_1$; the object, a distance $d$ from $L_1$, subtends a visual angle $2\theta$; a virtual image of the object is formed at a distance $g$ from $L_1$; note the backward projection of central rays $C_1$ and $C_2$; $p$, pupil diameter. (From Ref. 8.)

and therefore

$$f + g = \frac{f^2}{f - d} \tag{3}$$

The distance to the image in diopters $D_E$ is

$$D_E = \frac{1}{f + g} = \frac{1}{f}\left(1 - \frac{d}{f}\right) = D_0\left(1 - \frac{d}{f}\right) \tag{4}$$

where $f$ and $g$ are measured in meters, and $D_0 = 1/f$ is the dioptric power of the lens. If $d = f$, the object appears at infinity, and the relative power of the eye $D_E$ required to focus the object is zero. If $d = 0$, the lens has no optical effect, and the object appears to the eye at the distance of the lens. The accommodation power required to focus it is therefore $1/f$, or $D_0$, diopters. If $d > f$, the object appears beyond infinity, and the required eye power is negative. Note that the relationship expressed in Eq. (4) between eye diopters and distance $d$ is linear.

The angular size of the object is independent of $d$ because the backward projection of the central rays from each point of the object—for example, rays $C_1$ and $C_2$ from the two extreme points of the object—are independent of $d$. Image brightness is also independent of $d$ because the fan of rays accepted from each point of the object is independent of $d$. To see this,

note that the fan of rays accepted at the pupil from object point $Q$ has an angular extent $\gamma$ as viewed from the object point. Using the small angle approximation, we have

$$\gamma = \frac{pg/(f + g)}{d} \tag{5}$$

where $p$ is the pupil diameter. Substituting Eqs. (2) and (3) into (5) results in

$$\gamma = \frac{p}{f} \tag{6}$$

which is independent of $d$. This result is true for every point of the object. For this reason, image brightness is also independent of the focal power of the instrument.

With these elements of basic theory, let us now trace the evolution of the three-dimensional stimulus deflector instrument.

Figure 16 illustrates our original focus stimulator device, which did not require the object to be moved to change the virtual distance $d$ [9]. An image of the object to be viewed is formed by a lens $L_2$ in the space between $L_1$ and $L_2$. The distance from this real image to lens $L_1$ (distance $d$) is smoothly varied by means of a four-component mirror system. With the eye fixed in the focal plane of lens $L_1$, an image of the eye pupil is formed in the focal plane to the right of lens $L_2$. For this method of imaging, the light coming to focus at $AP$ is collimated between the lenses, and the image of the eye pupil is therefore unaffected by movement of the mirrors. Hence, an artificial pupil $AP$ can be used in this image plane.

Horizontal and vertical mirror deflectors could have been added to this

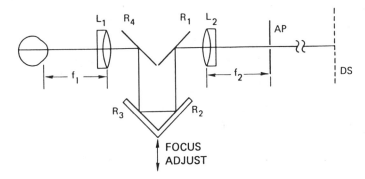

**Figure 16**   Crane and Cornsweet focus stimulator: *DS*, display screen; *AP*, artificial pupil plane. Mirrors $R_2$ and $R_3$ are moved orthogonal to the optic axis to change the optical distance to *DS*. (From Ref. 8.)

variable-focus system, to form a three-dimensional stimulus deflector, except for one problem: field of view. It turned out that achieving a large field of view required a somewhat different tack, although using the same elements of theory outlined above.

## 2.  Large Field of View

Using spherically corrected doublets, a system of the form shown in Figure 16 can operate well only over a viewing field up to about 10°. To increase the field of view requires camera quality optics. To understand the optical requirements, let us simplify the drawing by straightening out the path between the lenses of Figure 16, as shown in Figure 17a, in which the eye is shown focused for infinity and the image of display screen *DS* is also at infinity (i.e., $d = f$). In effect, the eye views the target through the entrance pupil formed by lenses $L_1$ and $L_2$. There are two conflicting requirements for good imaging in this case. First, zero field distortion requires that the chief rays (bold lines in Fig. 17a) passing through the center of the real pupil also intersect at the center of the pupil image. (In this case, the field

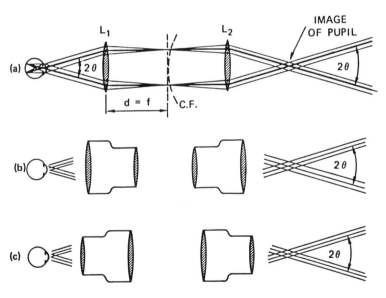

**Figure 17**  (a) Schematic diagram of a relay lens pair with a visual field $2\theta$. The pupil plane of the eye is placed at the focal plane of $L_1$. Assume that the eye is focused at infinity (i.e., $d = f$). C.F. depicts curvature of field. (b) Camera quality lenses arranged for minimal blurring of images at the retina. (c) Camera quality lenses arranged to minimize spherical aberration. (From Ref. 8.)

angle, labeled $2\theta$, would be the same whether seen from the real pupil or from the pupil image.) This requires zero spherical aberration in the plane of the pupil. Second, note that a real image of the infinitely distant scene is formed in the plane between the two lenses. This real image serves, in turn, as the virtual object for lens $L_1$. Any curvature of field in this image plane, as suggested by curved line C.F., would cause off-axis blurring of the image at the retina. These requirements—zero spherical aberration and flat-field imaging—generally conflict for doublet lenses.

Camera lenses substituted for lenses $L_1$ and $L_2$ should be arranged as shown in Figure 17b to minimize blurring of the target at the retina. That is, they should be arranged as though the plane between the two lenses were the normal film plane; camera lenses are specifically designed for flat-field imaging in this direction. On the other hand, to minimize spherical aberration in imaging the eye pupil, the lenses should be reversed, as shown in Figure 17c. Recall that with respect to the pupil, the rays are collimated between the lenses. The design discussed here is based on relatively symmetric 50 mm Olympus $f/1.7$ and $f/1.4$ camera lenses, which can be used almost equally well in both directions, although the configuration of Figure 17c provides a significantly wider field of view.

The difficulty with camera lenses, whether used in the configuration of Figure 17b or c, is that they are too large to use with the four-mirror scheme of Figure 16. The only practical arrangement is to move the lens itself, as illustrated in Figure 18a. The disadvantage of moving the lens is that unless the display screen is at optical infinity, the distance from the screen to the lens is then variable, and the image formed between the lenses is no longer constant in size. The situation can be remedied with an extra fixed lens if the display screen can be placed directly in the focal plane of the extra lens. By using two extra lenses, $L_3$ and $L_4$—as shown in Figure 18b, where $L_4$ generates a real image of the display screen in the focal plane of lens $L_3$— the system can accommodate a continuous range of distances between the device and display screen. That is, for a given position of the display screen DS, lens $L_4$ is adjusted axially until image $DS'$ is in the focal plane of lens $L_3$. This places the image $DS'$ at infinity with respect to the eye, making the image size for the subject independent of subsequent focus adjustments. This satisfies the requirements for a focus stimulator device—namely, a device that can alter the optical distance of a target without altering its size or brightness.

## 3. Adding Horizontal and Vertical Deflection Control

To supply horizontal and vertical target deflection, in addition to focus control, two separate images of the eye are required as locations for two single-axis mirror deflectors (Fig. 18c). A first deflector mirror, $M_V$, is used

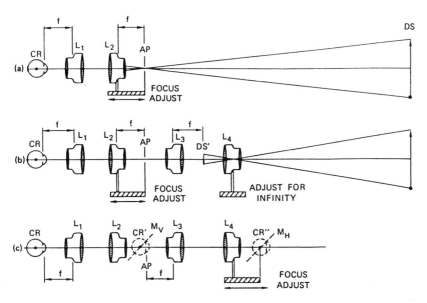

**Figure 18** (a) Simple focus stimulator. Lens $L_2$ moves axially to vary dioptric power; artificial pupil $AP$ eliminates any effects caused by changes in the eye pupil; $DS$, display screen. (b) Focus stimulator that compensates for variable axial position of the display screen. $L_4$ is moved axially to create an image of $DS$ in the focal plane of $L_3$, thereby ensuring that the target $DS$ appears at optical infinity to the focus stimulator system ($L_1$, $L_2$). (c) Three-dimensional visual stimulator; $M_V$ and $M_H$, rotating mirrors; $CR$, center of rotation of eye; $CR'$, $CR''$, first and second images of $CR$. With $CR'$ and $CR''$ on the axes of rotation of $M_V$ and $M_H$, respectively, vertical and horizontal movement of the visual field is achieved without translation artifact. (From Ref. 8.)

to move the image vertically and is located at the first image location (after the first lens pair, $L_1$ and $L_2$); a second deflector mirror, $M_H$, is used to move the image horizontally and is located at the second image location (beyond the second lens pair, $L_3$ and $L_4$). This scheme is implemented in the form shown in Figure 19, from which it is easier to see the actual principle of operation.

The subject's eye is positioned in Figure 19 in front of the first lens pair $LP_1$ so that the center of rotation $CR$ of the eye is imaged on the axis of rotation of mirror $M_V$. The two lenses of $LP_1$ are identical and are separated by the sum of their focal lengths. It can be shown that such a configuration, sometimes referred to as a relay lens pair, produces an undistorted unity magnification image [8]. Mirror $M_1$ is fixed in position; mirror $M_V$ is ro-

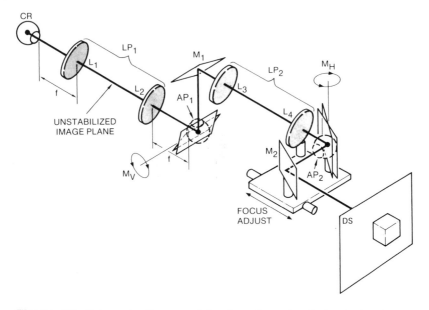

**Figure 19** Schematic diagram of the three-dimensional visual stimulator: *CR*, center of rotation of eye; $L_1$, $L_2$, $L_3$, and $L_4$, multiple-element camera lenses; *LP*, lens pair; *AP*, artificial pupil; *DS*, display screen; $M_V$, mirror that rotates the visual field vertically; $M_H$, mirror that rotates the visual field horizontally; $M_1$, fixed mirror; $L_4$, $M_H$, and mirror $M_2$ move in synchronism to adjust the optical distance to the display screen. (From Ref. 8.)

tated by a closed-loop servomotor system to produce vertical movement of the visual field.

The eye is imaged a second time by a similar lens pair $LP_2$. Mirror $M_H$ is positioned so that the eye's center of rotation in the second image falls on the axis of mirror $M_H$. Mirror $M_H$ is rotated by a second closed-loop servomotor system to produce horizontal movement of the visual field. With the axes of rotation of both mirrors conjugate to *CR*, pure horizontal and vertical movement of the visual field is achieved without either translation effects or image size changes.

The plane of the eye's pupil is conjugate to the planes labeled $AP_1$ and $AP_2$. If a stop smaller than the natural pupil is placed in either "artificial pupil" plane, it becomes the limiting aperture of the system; consequently, the effects of natural pupil changes are eliminated. Cylindrical and spherical correction lenses for each subject are placed in a trial lens holder located

in front of aperture $AP_2$. Since plane $AP_2$ is conjugate with the pupil of the eye, correction lenses placed near plane $AP_2$ have the same visual effect as if they were placed directly at the spectacle plane.

The second lens pair, $LP_2$, is positioned so that its first lens $L_3$ is located one focal distance from plane $AP_1$. Simultaneous axial movement of lens $L_4$, mirror $M_H$ (with its servomotor), and mirror $M_2$ adjusts the spherical power of the system without change in image position, size, or brightness, as described in connection with Figure 15. Spherical power, in diopters, is linearly related to the axial position of the movable carriage, which can be adjusted manually or driven by a third servomotor.*

In the perception produced by this instrument, the subject seems to be viewing the world from the position of the second image of the eye. If mirror $M_V$, mirror $M_H$, or the focus-adjust carriage is activated, the world will appear to move vertically, horizontally, or in apparent distance, respectively. If they are all static, the world will appear static.

Lenses $L_1$, $L_2$, $L_3$, and $L_4$ are high quality, multiple-element camera lenses that are stripped of all external housing and mounting elements as well as any control elements such as $f$-stop.

## B. Performance

The field of view of the final instrument is approximately 30° in diameter. The center of the field can be moved through an angle subtending ±15° vertically and ±20° horizontally at the eye. The spherical power can be changed from −4 to +11 diopters with a movement sensitivity of 2.5 mm/diopter. Each camera lens has 10 surfaces. The loss of light when viewing through the 40 coated surfaces of four camera lenses in series is equivalent approximately to a 0.3 neutral density filter.

The deflection servosystems are capable of rotating the mirrors by more than 25° (50° movement of the visual target) with a linearity of ±0.1% of the excursion. The resolution is approximately 10 seconds of arc with a response from dc to 3 dB bandwidth of 200 Hz. The delay time (0–10%) is less than 1.5 ms, and the rise time (10%–90%) is less than 2.5 ms. The total response time is approximately 6 ms.

The focus servo, a closed-loop system with position feedback, is capable of changing spherical power by more than 14 diopters with a sensitivity of

---

*With the position of lens $L_4$ adjustable, the spacing between lenses $L_3$ and $L_4$ is no longer constant, and the imaging of the eye at mirror $M_H$ is no longer distortionless, as it would be if the distance between $L_3$ and $L_4$ were equal to the sum of their focal lengths. But only small errors result. (Appendices A, B, and C of Ref. 8 analyze the magnitude of the errors inherent in the system.)

approximately 9 diopters/V. The linearity is ±0.25% of the peak-to-peak range with a repeatability of less than 0.1 diopter. The time delay to a step is 12 ms with a maximum slewing rate of 40 diopters/s.

## V. IMAGE STABILIZATION

Research aimed at understanding the fundamental spatiotemporal properties of the visual system is severely hampered by the subject's normal eye movements, which move an otherwise completely specifiable spatiotemporal pattern uncontrollably over the retina. This uncontrolled image movement can introduce severe artifacts into the resulting data. Therefore in such studies it is necessary to be able to stabilize an input image accurately on the retina. This requires an accurate eyetracker to monitor the subject's eye movements and a means for moving the input pattern to precisely compensate for these movements. Once the subject's eye movements have been compensated, arbitrary but completely controlled motions of the retinal image can be introduced by the pattern-moving device. Both goals can be achieved by combining an eyetracker with a stimulus deflector, as suggested in Figure 20, where eyetracker outputs $H$ and $V$ are conditioned by gain control settings $G_H$ and $G_V$, respectively, as described below, to exactly compensate the subject's normal eye movements. External signals

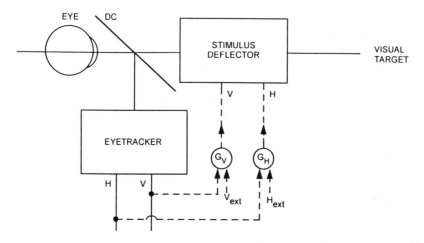

**Figure 20** Coupling the eyetracker and stimulus deflector: $G_H$ and $G_V$, gain controls applied to the horizontal and vertical outputs, respectively, of the eyetracker; $H_{ext}$ and $V_{ext}$, external signals that can control the otherwise stabilized retinal image.

to move the retinal pattern under control of the experimenter can then be applied at inputs $H_{ext}$ and $V_{ext}$.

## A. Adjusting the Gains

Precise stabilization of a retinal image requires that the compensating object pattern move as fast as the retina, in the same direction, and by the same distance. The ratio of the distance the stimulus moves to the distance the retina moves is called the "gain" of the stabilizing apparatus. Ideally the gain should be exactly 1.0, but where the eye movements are measured by one device and the stimulus is controlled by another, this desired condition can be obtained only by careful calibration.

One of the earliest methods of image stabilization did not require gain calibration. It involved attaching a tube to the subject's eyeball, with a very powerful lens (e.g., 50 diopters) at one end and the target to be viewed at the other, in the focal plane of the lens; the whole thing was held in place by suction. Thus both the sensing of eye movements and the compensating motion of the stimulus were performed by the same mechanical device. The gain was automatically unity; no adjustment was necessary or possible.

Of course this was a very difficult, dangerous, and sometimes painful procedure, and it is no longer in use. In the method of stabilization illustrated in Figure 20, gain adjustment is sometimes a troublesome task, which must be done anew for each new subject. But upon considering the alternative, every experimenter is glad to go through it.

Other methods of moving the stimulus can be used in place of the optical deflector indicated in Figure 20. If it is displayed on the face of a cathoderay tube (CRT), the stimulus can be moved around by applying the eyetracker signals to the deflection electrodes of the CRT. Early stabilization experiments with the Generation-III tracker were carried out in this way, before the optical stimulus deflector was developed. More recently most experimenters find it simpler to use a separate stabilizer, as in Figure 20. And of course, if the stimulus is not displayed on a CRT, the optical deflector is essential. But in all cases, the gain of the system must be calibrated.

This could be done by providing the experimenter with a stabilized view of the subject's retina. Then some feature of the stimulus could be aligned with a retinal landmark (such as a blood vessel), and the gain adjusted until the pair never moved apart. But this would involve an elaborate and expensive viewing system (see Appendix 4 for the design of such an instrument), and it would violate the principle of letting the subject and the experimenter be the same person whenever possible, which has motivated many of the eyetracker improvements described in the preceding sections.

The procedure for gain calibration described here permits the subject to adjust his own gain settings. It is a modification of a method used by Riggs and Cornsweet, based on afterimages. If a subject views a stabilized bright bar on a gray background and the bar is suddenly turned off, at first he will see a dark bar on the same background, because the subject's sensitivity has been decreased where the bright bar was. This effect can be obtained by good voluntary fixation, even without a stabilizing device, but if the stabilization is less than perfect, the dark bar, or afterimage, will be somewhat fuzzier than the bright one.

If the bright bar is not turned off, the subject generally can detect both the stimulus and its afterimage. The afterimage will appear as a fuzzy shadow around the edges of the bright bar, as if the dark bar were located behind the bright one. The subject's task is now to make slow eye movements, at right angles to the long direction of the bar, and watch what happens to the afterimage. If the gain is set perfectly at 1.0, the fuzzy shadow will remain equally apparent on both sides of the bright bar, no matter where the subject is looking. But if the gain is too high or too low, the shadow will creep out from behind the bright bar as the subject looks to the right and the left. If the shadow seems to move too far, the gain is too low; if it doesn't move far enough, the gain is too high.

To calibrate both horizontal and vertical gains without interruption, a target consisting of a cross can be used instead of a bar. Unless both gains are already close to unity, it is helpful to alternate horizontal and vertical eye movements, zeroing in on both settings with increasing precision. Complicated as it sounds, this procedure is readily mastered by most subjects. Because it invokes the vernier abilities of the visual system, it is also extremely sensitive.

A fixed gain cannot be built into the eyetracker design because the optimum setting varies from subject to subject. Larger eyes generally have larger radii of curvature of the cornea and lens, which makes the Purkinje images farther apart for any given rotation. In laboratories with many subjects, the stabilizer control box is likely to be plastered with many little stickers, giving the $H$ and $V$ gain compensation settings for each person.

## B. Selective Stabilization

With the method of stabilization described above it is possible to accurately compensate for the effects of a subject's normal eye movements and therefore to have complete control of image movement on the retina. It is also a useful tool for the study of image disappearance, which occurs with completely stabilized images. Another useful tool involves partial, or selective, stabilization.

For instance, if only the horizontal servo mirror is activated, then only the subject's horizontal eye movements will be compensated. Therefore, vertical elements everywhere in the image will continue to be stabilized on the retina and will tend to disappear, though horizontal elements will not be stabilized and so will tend to remain visible. But it is also possible to compose a scene in which only some elements are stabilized while others are not. Note that the unstabilized image plane of Figure 19, located halfway between lenses $L_1$ and $L_2$, is conjugate with the subject's retina and proximal to the deflection mirrors $M_V$ and $M_H$. Therefore any pattern placed in that plane will be in focus on the retina and will be viewed normally (i.e., will be unstabilized). One useful experimental paradigm is to place a window, or aperture, in that plane and to view distal (stabilized) targets as though through the window. In that case, the unstabilized window will remain visible but the stabilized target within the window will tend to disappear. What will the final perception be?

Consider, for instance, the arrangement of Figure 21a composed of a green stripe on a red background, which is viewed through the (unstabilized) vertical window. If the stabilizer is turned on, the green stripe will be stabilized on the retina and will disappear (as suggested by the dashed lines defining the green stripe). As might be expected, the resulting perception will be of a uniform red within the window area. But suppose that instead of stripe, a red–green edge is positioned in the window, as suggested in Figure 21b. Now when the stabilizer is turned on and the edge between the red and green sections disappears, we might expect that once again the area within the window will be of uniform color. But what color(s)? The transition is from a dark region to red at the left and from a dark area to green

(a)                    (b)

**Figure 21** Target patterns for selectively stabilized image experiments: (a) a stabilized green stripe on a red background within an unstabilized window frame and (b) a stabilized red–green edge within an unstabilized window frame.

at the right, with no perceptual discontinuity to account for the different information arriving from the two edges. What can we expect to see in this unnatural, induced-conflict situation? The visual system resolves this conflict in different ways for different subjects. In one form of resolution the window area is filled in with a color gradient that extends from reddish on the left to greenish on the right and passes through the normally "forbidden" color reddish-green (i.e., a color never seen before by experienced subjects, which they tend to name reddish-green) [10].

Imposed visual conflict of this type is a powerful tool for decoding the luminance and chrominance strategies used by the perceptual system. Reference 11 reports other results of this type of study.

Another powerful tool involves the use of binocular conflict. Consider, for instance, the pattern of Figure 21a being viewed through a binocular stimulus deflector system, and assume that window pattern and stripe alike are fused by the visual system into single percepts. In that case, and with the stabilizers in each eye inactivated, if the stripe in one eye is translated laterally within the window, then, as expected, the stripe will appear to move in depth as a result of the change in binocular disparity. But suppose now that the stabilizer is turned on, say, in the left eye, so that the stripe would disappear in that eye if viewed monocularly. What would the perception be in this selectively stabilized binocular situation in which the stripe disappears in one eye but is seen normally in the other eye?

Current knowledge of the visual system did not permit us to predict the result, which is actually as follows. If the stripe has a luminance component (e.g., a black stripe on a white background), motion in depth is perceived just as though the image did not disappear perceptually in the left eye. However, if there is no luminance component (e.g., an equiluminant green stripe on a red background), lateral motion is perceived but *no* motion in depth. It is as though luminance, but not chrominance, information reaches the midline stereo mechanism in the brain even with monocular disappearance due to stabilization. Reference 12 reports on other binocular conflict situations of this sort.

## VI.  SCOTOMA SIMULATOR

In Section V we described different ways in which an image can be selectively stabilized on a subject's retina. Another type of selective stabilization occurs when the subject's view of a stimulus pattern (or of a normal scene) is blocked by an obscuring spot that is stabilized on the retina while the remainder of the pattern is viewed normally. With this arrangement, in other words, the subject views a scene that moves normally on the retina except for the obscured region, which is locked in place on the retina.

One reason for the importance of this stabilized obscuration technique is that it mimics a form of retinal pathology known as a scotoma. Even the normal eye has such a region of no response located at the optic disk, the so-called blind spot. The blind spot is not perceived as a hole in the visual field but instead appears to be filled in with whatever texture or pattern surrounds it. Scotomas resulting from retinal disease also fill in in this way, so that special techniques are required to identify and map them. The ability to simulate scotomas of arbitrary shape, size, and location provides a powerful method for studying both the effects of real scotomas and the nature of the normal "filling in" process of the visual system.

The normal healthy retina is far from homogeneous in its properties; in particular, the spatial and chromatic aspects of visual responses vary dramatically with eccentricity (distance from the center of the visual field). To study these variations, it would be useful to be able to block off all but precise, selected regions of the retina, with no interference from eye movements, and this is precisely what the scotoma simulator can also provide. The ability to produce artificial scotomas of any desired size, shape, or chromatic characteristics thus has important applications in both basic and clinical studies. The design of such a device is described in this section. Essentially it is based on a relatively simple alteration of the stimulus deflector device of Section IV.

Most of the material of this section is from Reference 13.

## A. Scotoma Systems

In Section IV we described a device that provides rapid two-dimensional control over the retinal position of an arbitrary stimulus pattern; the object imaged on the retina may be a CRT, a transparency, or a real-world scene. This device, called a visual stimulus deflector, is shown schematically in Figure 22. Either a distant object or (with the aid of auxiliary lens $L_5$) a near one is imaged in planes $I_1$ and $I_2$, both of which are conjugate to the retina. The imaging optics consist of two high quality relay lens pairs, $L_1$, $L_2$ and $L_3$, $L_4$; the lenses of each pair are separated by twice their focal length.

A modification of the stimulus deflector device that will produce an artificial scotoma is shown in Figure 23. Here the stimulus pattern is a transparency $T(x,y)$ located in the image plane nearest the subject. The scotoma is an opaque spot on a transparent plate $O(x,y)$ located in the stabilized image plane (beyond $L_5$). When the eyetracker and deflector mirrors are turned on, the spot is stabilized (with respect to the retina), but the stimulus transparency is not. The stabilized scotoma pattern, which may be self-luminous, a transparency, or a reflection target, is, in effect, imaged on

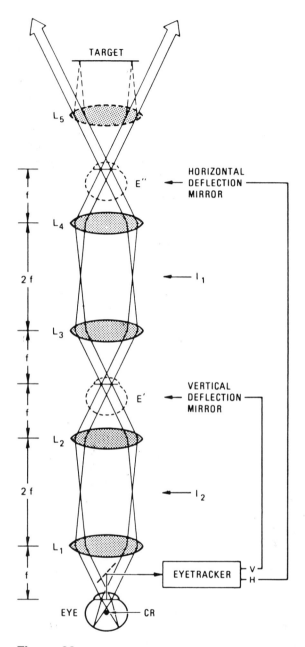

**Figure 22** Two-dimensional image stabilizing system described in Section IV. Here the target remains stationary on the retina; stabilization is provided by two servo-controlled mirrors rotated by vertical and horizontal signals from the eyetracker. These mirrors are located so that their axes are nominally conjugate with the eye's center of rotation $CR$ in the images $E'$ and $E''$ formed by lens pairs $L_1$, $L_2$ and $L_3$, $L_4$, respectively. Planes $I_1$ and $I_2$ are conjugate to the subject's retina. (From Ref. 13.)

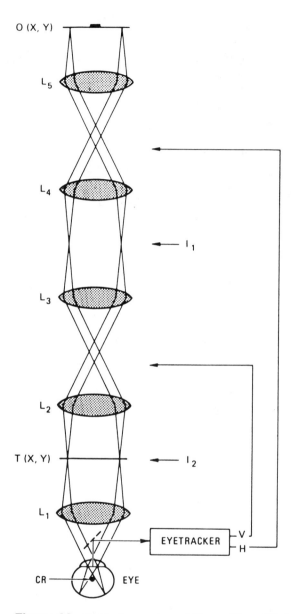

**Figure 23** Deflection system of Figure 22 modified to produce a simple type of artificial scotoma. An opaque spot on a transparent plate $O_{(x,y)}$ is located in the stabilized plane and illuminated from the rear. The stimulus pattern is a transparency $T_{(x,y)}$ located in the unstabilized plane $I_2$. (From Ref. 13.)

the unstabilized transparency. Thus, the subject views the stimulus pattern normally except that there is no illumination of the area corresponding to the image of the opaque spot, and this black shadow is locked in place on the retina. (Alternatively, the illumination and the black spot could be provided by a CRT screen, which would provide more flexibility in changing the size, shape, and location of the scotoma; these parameters could then be varied with time during an experiment.)

This seems to be the simplest system that can provide a two-dimensional stabilized obscuration of arbitrary size and shape. However, it has two disadvantages, which may or may not be serious depending on the application. First, the luminance level within the scotoma region cannot be varied; it must always be zero, to block completely the corresponding region of the stimulus. Second, the stimulus pattern must be a transparency; it cannot be a CRT or a real-world scene. (Potentially, the stimulus pattern could also be made to vary with time by using, for example, a transparent liquid crystal display device.)

In principle, the disadvantages of the preceding system (Fig. 23) are overcome by the scheme illustrated in Figure 24, which consists of two deflector optical systems (containing four servo-controlled mirrors) arranged in tandem. The eyetracker signals $(x,y)$ sent to the first deflector system are of opposite polarity from those sent to the second $(-x, -y)$, so that the second system precisely undoes the effects of the first. Thus the stimulus pattern $T(x,y)$, which in this case can be a real-world scene or a CRT screen located at the entrance to this elaborate optical system, is ultimately unaffected by the motions of the deflector mirrors. The obscuration $O(x,y)$ is located in the same stabilized plane (which is now at the halfway point of the optical system as shown in Fig. 24); therefore, its image is locked on the retina, as before, while the stimulus pattern moves normally in response to eye movements. Since the stimulus pattern is illuminated by light that has not yet passed through the obscuration plane, the luminance level within the scotoma can now be controlled (e.g., the obscuring spot could have a diffuse white surface and be illuminated from the side).

In principle, the scheme of Figure 24 is ideal, but its practical disadvantages are severe. First, the number of optical elements is doubled, significantly increasing the cost and problems of fabrication and alignment. Second, the design requires that the two horizontal axis mirrors have exactly equal and opposite deflections at all times, and similarly for the two vertical axis mirrors. It would be a difficult feat of electromechanical design and construction to achieve this condition so perfectly that no residual jitter of the unstabilized stimulus pattern could be detected by the subject.

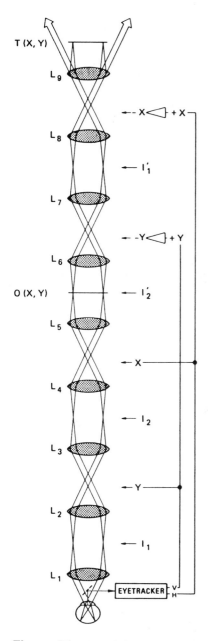

**Figure 24** Two deflection systems of the type shown in Figure 22 arranged in tandem, both driven by appropriate eyetracker signals so that one system cancels the effects of the other. The scotoma plate $O(x,y)$ is located in the stabilized plane $I_2'$. The target $T(x,y)$ need not be a transparency but can be self-luminous (including natural scenes). Disadvantages are discussed in the text. (From Ref. 13.)

65

## B.   Final Design

Figure 25 shows the most satisfactory design to date based on the considerations discussed above. Like the scheme of Figure 24, it permits the stimulus pattern to be a CRT screen or a real-world scene, and it permits the luminance level inside the scotoma to be varied, but it does not have the major

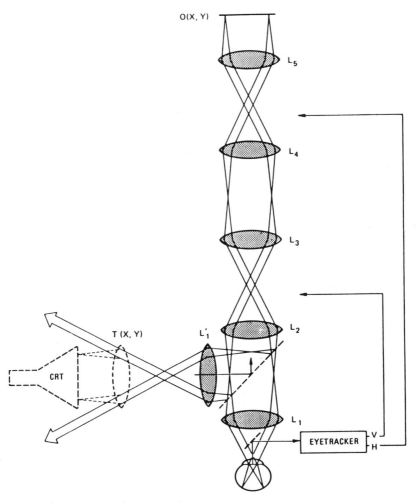

**Figure 25**   Final design in which all the features of Figure 24 are obtained with a single *(x,y)* deflection system, eliminating synchronization problems. (From Ref. 13.)

disadvantages of the preceding design. These virtues are obtained by folding the optical system of Figure 24 at the stabilization plane, thereby collapsing the two deflector systems into one.

A plane mirror is placed in the stabilization plane, and the obscuring spot (which may be self-luminous) is located at the surface of the mirror. The stimulus pattern is introduced into the optical system by way of a beam splitter, which must precede the first servo-driven mirror but otherwise can be located wherever there is room for it. (In Fig. 25, the beam splitter is shown between $L_1$ and $L_2$.) This beam splitter creates an unavoidable transmittance loss, which can be at least partly compensated by one or two methods depending on the application. First, if the stimulus pattern is self-luminous (such as a CRT), it can be chosen to be suitably bright. Second, the transmittance loss can be held to 50% in any case by using polarized light. If the beam splitter is actually a polarizing (McNeille) cube, the light passing through the stimulus deflector will be polarized with its electric vector normal to the plane of the diagram. If we mount an appropriately oriented quarter-wave plate in front of the mirror in the stabilized plane, it will rotate the orientation of the electric vector by 90°, so that on the return pass it is transmitted to the subject's eye with negligible loss. (If the stimulus pattern is provided by a CRT, this refinement would also avoid the unwanted illumination of the CRT screen by the return beam.)

The most important advantage of this system over that of Figure 24 is that it does not require the precise synchronization of two independent sets of servo-controlled mirrors to avoid artificial jitter of the (unstabilized) stimulus pattern. Since the same mirror that produces the horizontal motion also compensates for it and the same mirror that produces the vertical motion also compensates for it, the synchronization is inherently perfect. Thus, for example, even when the servo-controlled mirrors are oscillated so rapidly that the edge of the obscuring spot is simply a steady blur, no artifactual motion or blur of the stimulus pattern can be detected — although the pattern has, of course, been through the same oscillating mirrors twice, the second pass exactly canceling the motion caused by the first.

## ACKNOWLEDGMENTS

This report would be incomplete without acknowledging the involvement of four other individuals.

*Tom Cornsweet* was a professor at the University of California at Berkeley when he ran across the theoretical analysis of visual accommodation report [3]. He became so intrigued with the opportunity to study this visual system that he gave up his tenured position at UCB to come to SRI, where

he and the author teamed up in this effort. It was an effective partnership because we complemented each other. For example, Tom knew a great deal about human vision and was an inveterate lab tinkerer, whereas I had no background in vision and hate lab stuff — it is so much easier to draw pictures and write equations without having to get caught up with the real world of second- and third-order effects, which can ruin everything (although I took many trips with Tom to pick up the daily load of dry ice needed to cool the electron beam multipliers of those days, before the advent of solid state photodetectors). Tom and I worked together on the two basic instruments — the eyetracker and the optometer. In 1970 he published his highly acclaimed book, *Visual Perception*, which is still widely used as a teaching text, and in 1971 he left SRI for other entrepreneurial and academic pursuits. He is currently Professor Emeritus of the Department of Cognitive Sciences at UC Irvine.

*Carroll Steele* became involved with this instrumentation just as Tom was leaving. He saw the eyetracker through its Generation II, III, IV, and V forms, the merging of the optometer with the eyetracker to make what we refer to as a three-dimensional eyetracker, the refinement of the three-dimensional focus stimulator, and the development of all the other accessories. He was the general factotum behind the building of all the systems constructed for other laboratories, as well as the primary point of contact for maintenance of these systems. This meant that he also spent untold hours on the telephone with users: anyone who had an SRI eyetracker knew Carroll, perhaps better than either wished, and more than likely carried Carroll's phone number with him at all times. Carroll left the program and SRI upon his retirement in July 1988, but he stays in touch with SRI's licensee, Fourward Technologies.

*Lloyd Alterton* became involved with the program starting with the Generation-III tracker and was forever on call with each new redesign. His extensive paper-and-pencil ray tracing feats, ingenious mechanical designs (especially of the tricky mounts involved in the two-dimensional servo mirrors and the three-dimensional motor-driven base of the Generation-IV and V instruments), and management of the mechanical production and assembly of all the instruments were a major contribution to all the eyetracker instruments and accessories. To him, therefore, also goes a great deal of credit for the success of this program.

*My Van Nguyen* faced the task of setting up a complex electronic "production" system within what is basically a research facility. As the electronics technician for the program, he did this with characteristic energy and ingenuity, starting with the Generation-III tracker. In this capacity he was an important contributor also to the success of the program.

## APPENDIX 1. OPTOMETER*

The function of an optometer is to measure and track the accommodation distance of the eye in real time. This section describes the design of the SRI optometer. It was a further major task to merge the eyetracker with the optometer to be able to measure in real time and continuously the location in three-dimensional space on which the eye is fixated. How these instruments were merged to form what we refer to as a three-dimensional instrument is described in Appendix 2.

## Optometer Principles

Figure A-1 is an optical diagram of an eye viewing a point source through a small aperture. In Figure A-1a, the refractive power of the cornea and lens of the eye are such that the point is sharply imaged on the retina. In this case, if an aperture were moved from position $A$ to position $B$, different bundles of rays from the source would strike the retina, but the illuminated retinal spot would be stationary. In Figure A-1b, the refractive power of the eye is too small, and the retinal spot moves from position $A'$ to $B'$ in response to aperture movement from $A$ to $B$. Conversely, in Figure A-1c, the refractive power of the eye is too great, and the retinal spot moves from $A'$ to $B'$ (i.e., in the opposite direction) in response to aperture movement from $A$ to $B$. The object plane conjugate to the retina can be found by changing the distance of the source, according to the polarity of the image movement, until the retinal image is stationary. The optometer performs this function automatically and continuously.

Figure A-2 illustrates the basic optometer configuration. Instead of a mechanical aperture positioned close to the eye, an optical projection system achieves the same effect. Two adjacent, near-IR light sources, $S_2$ and $S_3$, which have a narrow spectral band centered at 0.93 $\mu$m wavelength, are located in the focal plane of lens $L_1$. An image of the light sources is formed in the plane of the pupil of the eye, which is at the focal plane of lens $L_2$. The light sources flicker on and off alternately at a rate of 400 Hz. Thus, light enters the eye first through one small area of pupil (the image of the first light source) and then through an adjacent area of the pupil (the image of the second source). This is equivalent to two alternating aperture positions.

Stop $ST_2$, which is illuminated alternately by sources $S_2$ and $S_3$, appears to the eye at a virtual distance

---

*The material of this Appendix comes primarily from Reference 6, although Reference 14 represents a more original source.

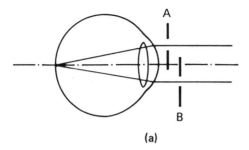

(a)

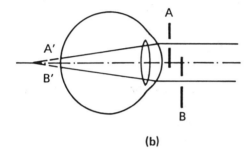

(b)

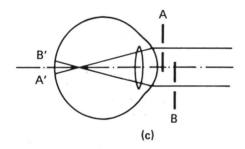

(c)

**Figure A-1** Imaging a point target at infinity through a small aperture that alternates between two positions, *A* and *B*. The intercepted-ray position at the retina will be stationary or will move with or opposite to the aperture, respectively, according to whether the eye is focused for infinity (a), beyond infinity (b), or closer than infinity (c). (From Ref. 6.)

$$L = \frac{f_2}{1 - d/f_2} \tag{A-1}$$

where $L$, $d$, and $f_2$ (the focal length of lens $L_2$) are in meters. To focus stop $ST_2$ on the retina requires an accommodation power

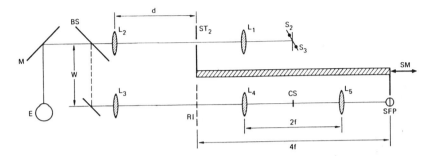

**Figure A-2** Basic optometer arrangement: $S_2$ and $S_3$, IREDs; $ST_2$, stop that is imaged on the retina; $M$, dichroic mirror; $BS$, beam splitter; $CS$, corneal stop; $SFP$, split-field photocell. $ST_2$ and $SFP$ are linked mechanically to slide $SM$. The number of diopters of accommodation required by the eye to focus on $ST_2$ is linearly related to the distance $d$ between $ST_2$ and $L_2$. When $ST_2$ is in focus on the retina, the retinal image is also reimaged at plane $RI$, which is relayed by fixed lenses $L_4$ and $L_5$ to the plane of $SFP$. For simplicity, $L_3$ is drawn opposite $L_2$, although the entire output path should be shifted to the left by the distance $W$. (From Ref. 6.)

$$D_E = \frac{1}{L} = \frac{1}{f_2}\left(1 - \frac{d}{f_2}\right) \qquad \text{(A-2)}$$

where $D_E$ is in diopters. We use the convention that the refractive power of the eye is stated relative to its power when accommodated for infinity (e.g., when $d = f_2$, $D_E = 0$ diopter). As the eye changes its refractive power, stop $ST_2$ is maintained in focus on the retina by adjusting $d$, whose position is a direct measure of the instantaneous refractive power of the eye. Note from Eq. (A-2) that $D_E$, measured in diopters, is linearly related to the distance $d$.

Stop $ST_2$ is moved along the optical axis in response to movement of the image of stop $ST_2$ on the retina. This movement is detected by reimaging the retinal image onto a split-field photocell $SFP$ and sensing lateral movement of the image in synchronism with the alternation of light sources $S_2$ and $S_3$. If stop $ST_2$ is in focus on the retina, the image will be stationary. If the image is out of focus, it will appear to move either in phase or out of phase with the alternation of the light source, as illustrated in Figure A-1.

The image formed at the photocell derives from light reflected from the retina, which passes back out through the pupil of the eye. This light is reflected by dichroic mirror $M$ and then by beam splitter $BS$. If $ST_2$ is in focus on the retina, lens $L_3$, which is identical to lens $L_2$, forms an image of

the retinal image in a plane that is conjugate with stop $ST_2$ (i.e., at plane
$RI$, which is at a distance $d$ from lens $L_3$). For clarity, lens $L_3$ is drawn
adjacent to lens $L_2$, as though the dashed portion $W$ of the output path
were of zero length; actually, $L_3$ is located at the same optical distance
from the eye as is $L_2$. Split-field photocell $SFP$ could be located in plane $RI$
except that it is necessary first to block the corneal reflection, which is
much brighter than the reflected retinal image. Thus, the image in plane $RI$
is relayed by a pair of fixed lenses $L_4$ and $L_5$. With $L_4$ and $L_5$ separated by a
distance equal to twice their focal length, the retinal image formed in plane
$RI$ is relayed a distance equal to four focal lengths, as shown in Figure A-2,
in which plane $SFP$ is located. An image of the plane of the pupil is ob-
tained in the focal plane of lens $L_4$, which is conjugate also to the plane of
the light sources $S_2$ and $S_3$. A small corneal stop $(CS)$ placed in this plane
blocks the small but very bright corneal reflection of sources $S_2$ and $S_3$.

Stop $ST_2$ and the $SFP$ are mechanically linked. Thus, when stop $ST_2$ is in
focus on the retina, the retinal image will be conjugate with, and therefore
stationary on, the split-field cell. If $ST_2$ is out of focus, movement of the
image on the retina in one phase or the other will drive the slide $SM$ in the
appropriate direction until the error signal is zero and the image is station-
ary on the retina, and therefore on the photocell. If the servosystem has a
faster response than the accommodation system of the eye, the instanta-
neous position of the slide (i.e., distance $d$) will provide an accurate mea-
sure of the instantaneous refractive power of the eye.

## Optometer Range

From Eq. (A-2), we see that $D_E = 1/f_2$ when $d = 0$. Thus, the maximum
measurable diopters is equal to the focal length (in diopters) of lens $L_2$. To
measure an accommodation level up to $+20$ diopters, for instance, lens $L_2$
would require a focal length of 0.05 m, or 50 mm. The problem with a lens
having such a short focal length is that it must be brought very close to
the eye, leaving very little room for other optical elements that might be
needed.

A way to increase this distance and the diopter range at the same time is
to use an image of stop $ST_2$ instead of the stop itself. The problem with a
real stop, of course, is that it cannot pass through the lens. That is, we
cannot achieve negative values of the distance parameter $d$. But an image
can pass through the lens, and in that way the power of the instrument can be
increased beyond the power of lens $L_2$. [Equation (A-2) holds exactly even
for negative values of $d$.] This fact is important in understanding how the
eyetracker and optometer are merged, which is the subject of Appendix 2.

## APPENDIX 2. THREE-DIMENSIONAL EYETRACKER*

The major task in building a composite, three-dimensional instrument was to combine an optometer instrument of the form shown in Figure A-2 with the eyetrackers shown in Figures 7 and 11. To help the reader appreciate how the merging was achieved, we must note a few of the basic features of a refracting telescope (sometimes known also as a relay lens pair).

The simplest telescope consists of a pair of positive lenses separated by a distance equal to the sum of their focal lengths. In that case, it is easy to show that the object and image distances, $p$ and $q$, measured from each lens (Fig. A-3), have the following linear relationship:

$$q = f_2 \left(1 + \frac{f_2}{f_1}\right) - \left(\frac{f_2}{f_1}\right)^2 p \qquad \text{(A-3)}$$

where $f_1$ and $f_2$ are the focal lengths of the two lenses. As a result, both the axial magnification $\Delta q/\Delta p$ and the lateral magnification $(M = f_2/f_1)$ are constant, independent of distance $p$. It is therefore possible with this configuration to achieve imaging without axial or lateral distortion (at least to a first-order approximation); compare this case with single-lens imaging, in which axial and lateral magnification both vary with the object-to-lens distance.

Of specific interest to this discussion is that the object and image distances are linearly related, even for $f_2 \neq f_1$. In fact, just as Eq. (A-2) is true for an object on the far side of the lens (negative values of $d$), so too it

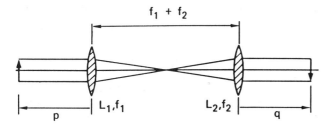

**Figure A-3** Telescope configuration. With two lenses separated by the sum of their focal lengths, the object and image distances $p$ and $q$ are linearly related, and lateral magnification is independent of $p$. (From Ref. 6.)

---

*The material of this Appendix comes primarily from Reference 6.

is readily shown that Eq. (A-3) is true for an object (or an image of an object) that falls between the two lenses of Figure A-3 and even beyond the right-hand lens (i.e., negative values of $p$). Thus, a telescopic relay in the optometer path does not alter the linear relation between eye diopters and the movement of stop $ST_2$.

In Figures 7 and 11, lenses $L_7$ and $L_8$ together form a unity magnification image of the Purkinje reflections at mirror $M_{11}$, which is the focal plane of lens $L_9$. Looked at another way, lens $L_7$ is a focal distance from the pupil plane of the eye and plays the role of lens $L_2$ in Figure A-2, while lenses $L_8$ and $L_9$, which are separated by the sum of their focal lengths, together form a (nonunity ratio) telescope system. By merging the optometer with the eyetracker on the distal side of lens $L_9$ as viewed from the eye, we benefit significantly from the first Purkinje image stabilization provided by mirror $M_{10}$, while maintaining the linear relation of Eq. (A-2) between eye diopters and servo motion. We can also obtain a large diopter range even though lens $L_7$ is of relatively long focal length. The main disadvantage of this scheme is that lenses $L_7$, $L_8$, and $L_9$ are now common to the input and output paths of the optometer. Any reflection of optometer input light that enters the optometer output path from these lens surfaces can cause serious artifact signals because the total light reflected from the fundus of the eye is extremely small. Elimination of these reflections therefore requires special care, as noted below.

A schematic of the composite instrument is shown in Figure A-4. The two instruments are merged via beam splitter $BS_4$, which is mounted between lens $L_9$ and beam splitter $BS_1$ (see Fig. 7 or 11). Although $BS_4$ reflects the optometer light at right angles to the plane of the paper of Figure 7 or 11, $BS_4$ is shown in Figure A-4 as transmitting, rather than reflecting, so that the optometer and relevant eyetracker optics can be drawn in a single path.

## Optometer Input Path

Light sources $S_2$ and $S_3$ are imaged by lens pairs $L_{20}$ and $L_{21}$ onto a right-angle mirror $M_{20}$, which causes two half-disks of light to appear side by side (lower inset, Fig. A-4). The two half-disks of light are energized out of phase. An image of this flickering light pattern, which is in the focal plane of lens $L_{22}$, is formed on iris diaphragm $IR_2$ located in the focal plane of lens $L_{23}$ and also in the focal plane of lens $L_{24}$. (Lenses $L_{23}$ and $L_{24}$, which are identical and are separated by twice their focal length, thus form a unity ratio relay lens.) Another image of the light sources $S_2$ and $S_3$ is thus formed on mirror $M_{11}$, which is conjugate to the pupil plane of the eye. The diameter of the light source pattern at the eye pupil plane is adjustable by means of iris $IR_2$ (see inset, Fig. A-4).

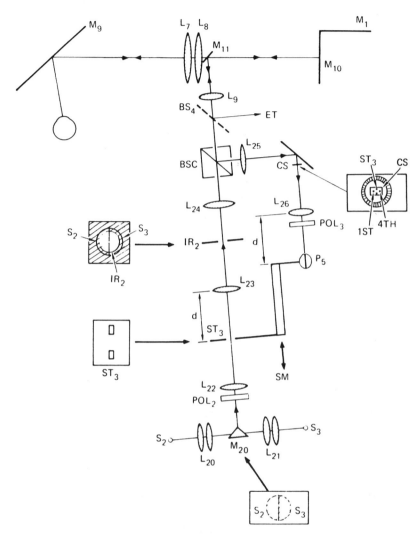

**Figure A-4** Merging the two instruments. The instruments are merged by means of beam splitter $BS_4$: $ET$, remainder of the eyetracker system; $BSC$, polarizing beam splitter cube; $S_2$ and $S_3$, IREDs; $M_{20}$, 90° mirror that merges the images of $S_2$ and $S_3$; $ST_3$, stop that is imaged on the retina; $IR_2$, adjustable iris conjugate with the eye pupil plane; $P_5$, split-field photocell on which the retinal image falls; $CS$, corneal stop, $POL_2$ and $POL_3$, polarizers that reinforce the input and output polarization directions of $BSC$; $ST_3$ and $P_5$ are linked mechanically to slide $SM$. (From Ref. 6.)

Stop $ST_3$ and lens $L_7$ together are functionally equivalent to stop $ST_2$ and lens $L_2$ in Figure A-2, except that they are separated by two relay lens pairs $(L_8, L_9)$ and $(L_{23}, L_{24})$ in series. (Relay lens pairs in series have the same linearity properties as a single lens pair.) With stop $ST_3$ positioned so that its image is in the focal plane of $L_9$, light from $ST_3$ reaching lens pair $L_7$ and $L_8$ is collimated, and another image of $ST_3$ is formed halfway between $L_7$ and the eye, a distance $f_7/2$ from the eye (which represents 9 diopters of refractive power). As $ST_3$ moves farther from (or closer to) $L_{23}$, the final image moves farther from (or closer to) the eye: that is, to a position of less (or more) dioptric power.

Stop $ST_3$ is a narrow slit with its center blocked (see the inset on the left of Fig. A-4). The center is blocked because very bright, on-axis input light would otherwise be reflected directly back by mirror $M_{11}$ (after reflection from $M_{11}$ to $M_{10}$ and then back toward $L_8$) and could cause a serious artifact in the optometer output signal.

## Optometer Output Path

Lenses $L_{25}$ and $L_{26}$ are conjugate with lenses $L_{24}$ and $L_{23}$, respectively. A corneal stop $CS$ is located in a plane conjugate with iris $IR_2$. If stop $ST_3$ is in focus on the retina, an image of the retinal image is formed at a distance $d$ from lens $L_{26}$. The split-field cell $P_5$ is placed in this plane, as shown in Figure A-4. If $ST_3$ is out of focus on the retina, its image on the retina moves in synchronism with $S_2$ and $S_3$. This side-by-side motion is detected by $P_5$, and the resulting signal drives the slide containing $ST_3$ until the retinal image is again stationary.

Potentially large artifact signals can be generated in the optometer output by specular reflections of optometer input light from lenses $L_7$, $L_8$, $L_9$, and the cornea, which are common to the input and output paths of the optometer. This potentially serious artifact is eliminated by polarizing the optometer input light with a polarizing beam splitter cube $BSC$. Any specularly reflected light from lenses $L_7$, $L_8$, $L_9$, and the cornea has the same polarization as the input light and, therefore, will not be reflected into the optometer output path but will pass directly back through the $BSC$.

Polarizers $POL_2$ and $POL_3$, shown in the optometer input and output paths in Figure A-4, are not logically necessary, although they are important for proper functioning. Polarizer $POL_2$ blocks the input light that would normally be reflected by $BSC$, thus substantially reducing the magnitude of light that may be rereflected from the external surface of $BSC$ and that could reenter the output path. Furthermore, because $BSC$ is not a perfect polarizer, a certain amount of light is also scattered at its diagonal interface. $POL_3$ significantly reduces the amount of scattered light that enters the output.

## Optical Isolation Between the Two Instruments

Eyetracker light is blocked from the optometer by a sufficiently large corneal stop $CS$ in the optometer output path. The inset on the right of Figure A-4 shows the Purkinje reflection from the optometer, labeled $ST_3$, and from the eyetracker, labeled 1st and 4th. The $BSC$ prevents most of the optometer light that is reflected from the cornea from reentering the output path of the optometer. However, this reflected light is so bright that it is still necessary to use a corneal stop $CS$ large enough to block the corneal image of $ST_3$. By enlarging the stop (inset, Fig. A-4), we also block light from the first and fourth images from the eyetracker. The stabilizing action of the eyetracker keeps the corneal reflection blocked by the stop $CS$ even under conditions of eye rotation and/or translation.

## Electronic Isolation of the Instruments

Most of the eyetracker light is eliminated from the optometer by the enlarged corneal stop, as noted above. In the eyetracker, the effects of a bright corneal image of the optometer input falling on top of a weak fourth Purkinje image (in certain directions of gaze) are eliminated by a high pass electrical filter, which creates a single-sideband system for the 4 kHz eyetracker signal. This filter eliminates any 400 Hz optometer signals from the eyetracker channels. A combination of low pass and bandpass filters removes from the optometer signal any residual 4 kHz eyetracker signals.

The two-dimensional eyetracker and optometer merged in this fashion yields a three-dimensional eye-tracking instrument that performs well along all three axes. In effect, because the two instruments are well shielded from each other, the performance of each is essentially unaffected by the presence of the other.

## APPENDIX 3. ERI LASER PHOTOCOAGULATOR*

Although the instrument described here was not developed at SRI, we need to familiarize the reader with the principles of the photocoagulator before describing how it can be improved by image stabilization (Appendix 4).

Laser photocoagulation is a recognized technique of modern ophthalmological surgery. With this method, coagulation "burn" lesions are created at the fundus by means of the focused energy of a laser beam. Such coagulators are generally built in the style of a binocular slit-lamp apparatus with facility added for a steerable laser input. To align the laser to the desired

---

*The material of this Appendix is taken primarily from Reference 15.

fundus location, means are provided for illuminating the fundus (to make it visible to the operator) and for energizing the laser beam at low power. When the operator is satisfied with the alignment, he or she energizes the full power of the beam, generally by means of a foot switch. Separate controls are available to preset the intensity and duration of each flash.

In this method, a contact lens with a flat front face is placed on the subject's eye. The lens, which is large and bulky, is continually manipulated by the ophthalmologist, in an attempt to stabilize the eye mechanically and to redirect light scattered from the front surface of the lens so that it will not enter the viewing system during the procedure.

This contact lens limits the usefulness of the current photocoagulation technique. The astigmatic distortion caused by the contact lens varies with different angles of incidence of the beam, which causes the shape of the burn area, hence the local energy density at the retina, to vary with retinal location. In addition, the operator must continually manipulate the contact lens, which requires, in effect, three hands: one hand to adjust the aiming of the laser, another to adjust the focus of the laser spot on the retina, and the "third" to manipulate the contact lens, all simultaneously. Finally, the lens creates undesirable light reflections, as noted above.

Seeking to avoid these limitations, in the mid-1970s the Eye Research Institute (ERI) of Boston designed a photocoagulator that does not require a contact lens. The ERI device provides a continuous binocular view of the fundus and offers the ability to focus a laser beam onto the retina and adjust its position while viewing the fundus. No attachments are made to the patient's eye. The ERI system is shown in Figure A-5.

### Input Illumination

Light from a fiber-optic bundle (top of Fig. A-5) is focused by a condensing lens onto diaphragm $D$, which is imaged by lens $L_5$ onto a 45° sloping mirror $M_1$, which reflects the downward-directed input light into the eye. Lens $L_1$, in turn, forms an image of $M_1$ in the pupil plane of the eye, and the image is adjusted to have a diameter of approximately 3 mm. Lens $L_1$ is an aspheric, plano–convex lens, specially designed for high quality imaging between the plane of the mirror $M_1$ and the pupil plane of the eye; this requirement is explained below. The input light provides a broad illumination of the fundus.

### Binocular Viewing System

Light reflected from the fundus that passes back out through the pupil of the eye is focused by lens $L_1$ in plane $R_1$, which is conjugate with the retina. Each path of the binocular viewing system is composed of a set of lenses

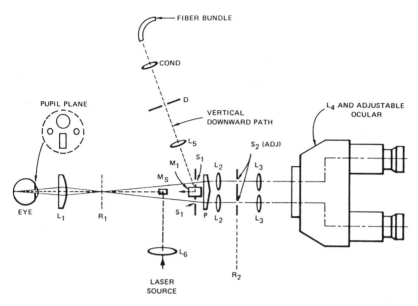

**Figure A-5** ERI laser coagulator system. (From Ref. 15.)

$L_2$, $L_3$, $L_4$, and an adjustable ocular. The two paths are converged by prism $P$, located just beyond the mirror $M_1$. Just in front of the prism are a pair of stops, $S_1$, which are located in the same plane as the mirror $M_1$ and therefore are also focused in the pupil plane of the eye. These stops define the limiting aperture for each binocular path; the image of each stop in the pupil plane is approximately 1 mm in diameter. That is, only light passing back through these 1 mm portions of the pupil is available in the retinal images thus formed. Any input light reflected from the corneal surface cannot enter the output viewing path as long as the image of diaphragm $D$ does not intersect the viewing apertures in the plane of the eye pupil. The special design of lens $L_1$ maximizes the isolation between the input and output light paths and thereby minimizes the very bright reflected corneal light from the output paths. The only element common to the input and output paths is the lens $L_1$ itself, which is specially coated to reduce reflections.

An image of the fundus is formed between lenses $L_2$ and $L_3$ in each viewing path, and in that plane is located an adjustable iris $S_2$, which defines the field of view.

## Input Laser Source

The input laser light must be focused on the retina and must be adjustable in position. The beam is brought into the eye via mirror $M_s$, whose orientation is manually adjustable to properly position the beam on the retina. Mirror $M_s$ is positioned axially to be in focus nominally at the nodal point of the eye; this leads to minimum variation in the shape of the beam on the retina as the laser is swept to different locations. The laser beam itself is focused at plane $R_1$, which is conjugate with the retina. To compensate for the axial variation in the position of $R_1$ with the refractive condition of the patient, beam focus is adjusted by changing the axial position of lens $L_6$. This adjustment is made while viewing the beam through the binocular viewing system.

In sum, the viewing apertures, the input light aperture, and the image of mirror $M_s$ are configured in the pupil plane as shown in the inset in Figure A-5. The input light passes through an area about 3 mm in diameter in the upper region of the pupil. The binocular viewing system works through two lateral apertures approximately 1 mm in diameter. The laser beam is introduced through a mirror system confined to a small region of the lower pupil. These images occupy an area of the pupil on the order of 5 mm in diameter, and the patient's pupil must therefore be dilated for all procedures involving this instrument.

## APPENDIX 4. FUNDUS ILLUMINATION AND MONITORING INSTRUMENT (FIMI)*

Eye movement poses a limitation on current photocoagulator techniques. Since the laser flash generally induces an involuntary eye movement within 150–200 ms, laser flashes of short duration (less than about 150 ms) are typically used. This minimizes the smearing effect caused by sudden eye movements during the flash, as well as smear from normal eye movements, drifts, and tremors. However, this constraint to short exposures limits the clinical potential of the coagulation procedure. It has been shown that longer, low intensity burns (0.5–2.5 s) can be more effective and produce fewer complications than short, high intensity burns.

In addition, short exposure does *not* eliminate the effects of eye movements that occur just as the operator presses the actuate button (i.e., between the time the operator is satisfied with the position of the beam on the fundus and the time he actuates the beam). Coagulation close to the center

---

*The material of this Appendix is taken primarily from Reference 15.

of vision is therefore usually avoided, because sudden eye movements could bring the beam onto the fovea and cause serious visual damage.

Occluding or constricting a small blood vessel requires great accuracy and stability in aiming the laser beam. With current techniques, it often takes many flashes to hit a small target area, whereas only a few flashes (or a single flash) might suffice if the beam were stabilized on the retina regardless of the patient's eye movements. The extra flashes required with current techniques cause unnecessary scarring of the retina.

It is therefore desirable to stabilize the point of intersection of the laser beam on the retina. Currently, some attempts are made to minimize the amount of eye movement by the use of anesthesia (potentially dangerous) or a recumbent patient position (inconvenient). Greater accuracy and convenience could be achieved, however, if the laser beam could be controlled in real time by the patient's eye movement. The laser beam, once positioned at the desired retinal location, would then remain stabilized at that spot independent of eye movement.

To achieve this goal, the author in the late 1970s proposed coupling a DPI eyetracker and an ERI photocoagulator to form a stabilized laser-coagulator system. A primary advantage of the ERI coagulator for this purpose is that it does not require that a contact lens be placed on the patient's eye, which would seriously interfere with operation of the eyetracker. The resulting instrument, described in this section, has turned out to be useful for more than just photocoagulation and has become known as a general fundus illumination and monitoring instrument, or FIMI.*

The goal of a stabilized coagulator is to have the laser beam track the patient's eye movements, thus stabilizing the position of the beam at any preselected position on the patient's retina. Because the eye can move with high velocity (up to 100 deg/s for movements on the order of one degree, and up to 1000 deg/s for large movements), good stabilization requires that the stabilization system have high frequency response.

The desired stabilization could be achieved if it were possible to rotate the deflector mirror $M_s$ directly from the eyetracker output signals. However, it would be difficult to incorporate the necessary drive mechanisms into such a tiny space. An equivalent solution is to place a steerable mirror in a plane conjugate with $M_s$, which would have the same effect as rotating $M_s$ itself.

---

*Although significant interest has been shown in this device for stabilized photocoagulation, it has not yet been applied clinically, primarily because of the current cost of the eyetracker relative to the cost of the basic photocoagulator apparatus—in addition to the extra training that is required for operating this more complex, combined instrument.

## Relay Lens Pair

An ideal method for achieving the necessary imaging of mirror $M_s$ would use a unity ratio relay lens pair — that is, a pair of lenses of equal focal length separated by the sum of their focal lengths (see Section IV and Appendix 2 for some discussion of relay lens pairs). An important feature of such a relay lens pair is that every ray from every object point will preserve the same angular relationship (except for a reversal of polarity) at the corresponding image point. For instance, a ray from object point $A$ in Figure A-6 that is parallel to the optic axis passes through the corresponding image point $A'$, also parallel to the axis. The same is true for an input ray at any angle $\alpha$ with the optic axis; the ray will pass through the image point with the same angular relationship. This is not the case, however, with a single lens. For instance, the input ray parallel to the axis shown in Figure A-6b passes obliquely through the image point.

Another important property of a unity ratio relay lens pair is that if the object moves an arbitrary axial distance $\Delta$, the image plane will move by precisely the same amount. As a result, the distance between input and output planes remains constant (equal to $4f$) regardless of the location of

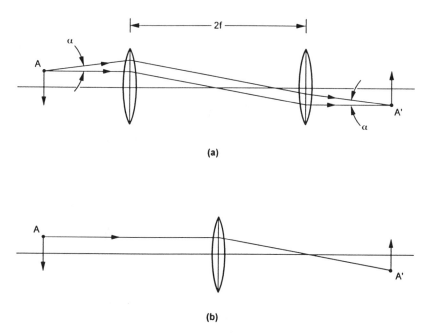

(a)

(b)

**Figure A-6**   Single lens and lens-pair imaging. (From Ref. 15.)

the input plane. As illustrated in Figure A-7, the constant angle property noted above is unaffected by such movements of the object and image planes with respect to the lenses. In other words, the object does not have to be precisely located a focal length from the first lens for the constant angle property to hold.

It can be seen, then, that if a two-axis steerable mirror is imaged by a pair of lenses (of focal length $f$) separated by a distance $2f$, and if the mirror is located a distance $4f$ from deflector mirror $M_s$, the laser beam can be steered horizontally and vertically exactly as if mirror $M_s$ itself were deflecting the beam.

## Single-Axis Mirrors in Series

It is difficult to achieve high frequency response from a gimbaled, two-axis mirror system that must move through large deflection angles. For this reason, it is often simpler to use two, single-axis mirrors in series, each with high frequency response, even though this requires imaging the eye twice, as was done in Section IV. As shown in Figure A-8, a mirror that rotates about a horizontal axis is placed at one image location, and a mirror

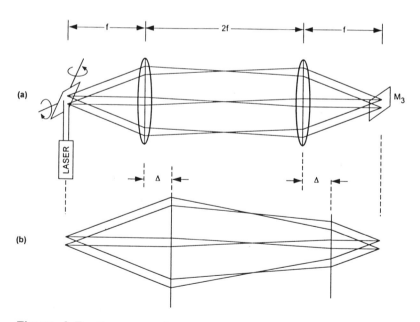

**Figure A-7** Constant angle property preserved with a relay lens pair. (From Ref. 15.)

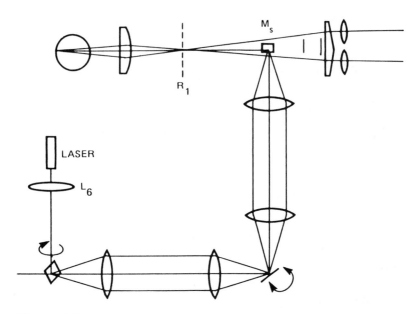

**Figure A-8**   Two single-axis mirrors used in series for high frequency response. (From Ref. 15.)

that rotates about a vertical axis is placed at the second image location (the order is unimportant).

Focusing lens $L_6$ serves the same (focusing) role in the configuration of Figure A-8 as it did in Figure A-5. It converges the laser beam and is adjusted in axial position to focus the beam on the retinal image plane $R_1$. The axial position is adjusted to compensate for any spherical refractive error of the patient's eye.

## Merging the Eyetracker, Stabilizer, and Coagulator

Figure A-9 shows schematically the various components and connections of the stabilized coagulator system. A dichroic mirror *DC*, which transmits visible light but reflects infrared light, is located between the patient and the coagulator. The eyetracker is placed on the patient side of the dichroic mirror, as shown. The dichroic mirror transmits the visible light of the illumination and laser beam, but reflects the infrared light from the eye-tracker into the patient's eye. The infrared light reflected from the Purkinje images, in turn, is reflected from the mirror back into the detector circuits of the eyetracker.

The coagulator—or FIMI, as it was eventually called—has two input

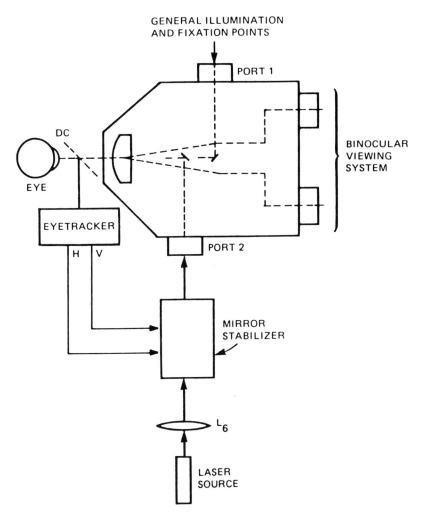

**Figure A-9** Schematic diagram of the stabilized coagulator system. (From Ref. 15.)

ports and two output, or viewing ports, as illustrated in Figure A-9. General illumination, from the fiber optic bundle in Figure A-5, enters through a path labeled Port 1 in Figure A-9. The laser beam enters through the path labeled Port 2. In the stabilized system, a two-axis stabilizer of the sort discussed in connection with Figure A-8 is interposed between the laser source and Port 2. The servo-controlled horizontal and vertical mirrors of

the stabilizer are controlled from the horizontal and vertical outputs of the eyetracker. As discussed in Section V, for accurate stabilization these output signals must be individually calibrated for each patient.

When the system is properly calibrated, any input pattern of light (e.g., the laser beam) will be stabilized on the fundus. As viewed from the (binocular) output ports, the fundus would be seen in normal (i.e., unstabilized) view, but the input light pattern would remain fixed in position on the retina regardless of eye movements. That is, the pattern (spot) will move in precise synchronism with the retina and will have the appearance of being attached to it. The position of the light pattern can be altered by changing the dc position of the deflection mirrors. The general background light from Port 1 can be energized simultaneously to aid the operator in aligning the laser spot to the desired position.

### Stabilized Input and Output

Thus far we have discussed stabilization of the input pattern (e.g., a laser beam). However, with a second, independent stabilizer, it is possible also to stabilize the retinal pattern as seen from the viewing system. In that case, the operator is provided with a stabilized image of the retina as well as a stabilized laser spot on the retina.

Stabilization of the retinal image provides dramatic improvement in the ease of setting servo gains in order to freeze (stabilize) the input laser spot at any given retinal position. In addition, it provides an opportunity to use measuring instruments in the viewed retinal path (e.g., to measure light levels at a given point on the retina with a fiber optic detector — as suggested in Appendix 5 for the case of laser Doppler blood flow measurement in the retina) without the serious effects of retinal image motion due to normal eye movements.

### APPENDIX 5.   STABILIZED LASER DOPPLER BLOOD FLOW MEASUREMENT

This material, abstracted from a paper by Mendel et al. [16], relates to the study of blood flow in the retina. It is therefore entirely different from the many vision-related areas of research and clinical application for which the eyetracker is currently being used.

> The measurement of ocular blood flow is essential to improve our understanding of several diseases afflicting the eye, such as diabetic and hypertensive retinopathy, arterial and venous occlusions, and glaucoma. For example, in chronic, open-angle glaucoma the mechanism of damage to the optic nerve head is controversial; one hypothesis that awaits fur-

ther examination with an improved method of blood flow measurement holds that the nerve tissue is damaged by insufficient blood flow due to a deficiency in the tissue's ability to regulate its own blood supply in response to increased intraocular pressure. Ocular blood flow is also of basic physiologic interest because of the unique nature of the vascular system of the eye, which responds to a stimulus of flickering light, and is under local and possibly central nervous control.

. . .

Laser Doppler velocimetry (LDV) has the ability to provide a fast, direct, and quantitative measurement of absolute blood velocity. This technique . . . is based on the method of light beating spectroscopy. In a retinal blood vessel illuminated by a low power laser beam, light is scattered from both moving red blood cells and from the surrounding, stationary walls of the blood vessel. The light from the moving blood cells is Doppler-shifted in frequency according to the velocity of the cells. The interference of the shifted light scattered from the red cells mixing with the unshifted light scattered from the vessel wall causes beating at their difference frequencies. This beating can be recorded with a photodetector. . . . The maximum blood velocity, corresponding to flow at the vessel centerline, is determined by establishing the cutoff frequency, below which the power spectrum of the photocurrent has significant power due to beat frequencies.

Though the application of laser Doppler velocimetry to the measurement of ocular blood flow has been a highly productive tool for basic and clinical studies, eye movement artifacts are a continuing difficulty when performing LDV measurements in humans. As the beam location intermittently deviates from the vessel centerline, the measured blood velocity declines. One solution is to employ rejection criteria in an attempt to identity and discard data obtained while the laser beam is located off the vessel centerline. A more direct approach is to stabilize the measurement against eye movements.

. . .

We recently introduced a new approach to performing stabilized laser Doppler velocimetry based on a . . . dual Purkinje image eyetracker providing control signals for the compensation of both horizontal and vertical eye movements with high angular resolution and speed of response. Two-dimensional tracking will be particularly advantageous for future laser Doppler flowmetry measurements of tissue blood flow in

optic nerve head, where regions of neural tissue are small and in close proximity to large blood vessels. In [Ref. 16] we present the design and initial performance of our dual Purkinje eyetracker-based stabilized LDV system.

The laser delivery optical pathway of our instrument is similar in overall design to that of a device previously developed for performing retinal photocoagulation under stabilized conditions [15,17]. However, to eliminate eye movement artifacts in LDV required the development of a stabilized detection pathway (as suggested in Appendix 4. The paper shows the great improvement in laser Doppler blood flow measurement obtained by stabilizing the laser beam with an accurate eyetracker.)

## APPENDIX 6. PATENTS

The following U.S. patents held by SRI are related to the various instruments discussed in this chapter.

Patent 3,353,027, Aiming device, J. C. Bliss and H. D. Crane, November 1967.

Patent 3,394,347, Optical pattern recognition device using non-linear photocell, H. D. Crane, July 1968.

Patent 3,536,383, Automatic optometer for measuring the refractive power of the eye, T. N. Cornsweet and H. D. Crane, October 1970.

Patent 3,712,716, Eye tracker, T. N. Cornsweet and H. D. Crane, January 1973.

Patent 3,724,932, Eye tracker and method, T. N. Cornsweet and H. D. Crane, April 1973.

Patent 3,804,496, Two-dimensional eye tracker and method for tracking an eye, H. D. Crane and T. N. Cornsweet, April 1974.

Patent 4,264,152, Visual stimulus deflector, H. D. Crane, April 1981.

Patent 4,287,410, Double Purkinje eye tracker, H. D. Crane and C. M. Steele, September 1981.

Patent 4,373,787, Accurate three-dimensional eyetracker, H. D. Crane and C. M. Steele, February 1983.

Patent 4,443,075, Stabilized visual system, H. D. Crane, April 1984.

Patent 4,544,246, System for producing selective stabilization of a portion of the retinal image, H. D. Crane and D. H. Kelly, October 1985.

## REFERENCES

1. J. C. Bliss and H. D. Crane, Optical detector for objects within an adjustable range, *J. Opt. Soc. Am. 54*:1261–1266 (1964).
2. J. C. Bliss and H. D. Crane, Relative motion and nonlinear photocells in

optical image processing, *Optical and Electro-Optical Information Processing*, MIT Press, Cambridge, MA, 1985, pp. 615–638.

3. H. D. Crane, A theoretical analysis of the visual accommodation system in humans, NASA Contract NAS 2-2760, SRI Project 5454, NASA Ames Research Center, 1966.

4. T. N. Cornsweet and H. D. Crane, Accurate two-dimensional eyetracker using first and fourth Purkinje images, *J. Opt. Soc. Am.* *63*(8): 921–928 (1973).

5. T. N. Cornsweet and H. D. Crane, Double-Purkinje-image eye tracker, NASA Contract NAS2-3517, SRI Project 6009, Quarterly Report 3, 1967.

6. H. D. Crane and C. M. Steele, Accurate three-dimensional eyetracker, *Appl. Opt.* *17*:691–705 (1978).

7. H. D. Crane and C. M. Steele, Generation-V dual-Purkinje-image eyetracker, *Appl. Opt.* *24*:527–537 (1985).

8. H. D. Crane and M. Clarke, Three-dimensional visual stimulus deflector, *Appl. Opt.* *17*:706–714 (1978).

9. H. D. Crane and T. N. Cornsweet, Ocular focus stimulator, *J. Opt. Soc. Am.* *60*:577 (1970).

10. H. D. Crane and T. P. Piantanida, On seeing reddish green and yellowish blue, *Science 221*:1078–1080 (1983).

11. T. P. Piantanida and H. D. Crane, Selectively stabilized images, presented at Oculomotor Symposium (OMS-80), California Institute of Technology, Pasadena, 1980.

12. T. P. Piantanida and H. D. Crane, "Stereopsis" without binocular perception or retinal disparity, presented at Topical Meeting on Recent Advances in Vision, Optical Society of America, Sarasota, FL, 1980.

13. H. D. Crane and D. H. Kelly, Accurate simulation of visual scotomas in normal subjects, *Appl. Opt.* *22*:1802–1806 (1983).

14. T. N. Cornsweet and H. D. Crane, Servo-controlled infrared optometer, *J. Opt. Soc. Am.* *60*:548–554 (1970).

15. H. D. Crane, Stabilized laser coagulator, NASA Contract NAS 2-9934, SRI Project 7451, NASA Ames Research Center, 1979.

16. M. J. Mendel, V. V. Toi, C. E. Riva, and B. L. Petrig, Eye-tracking laser Doppler velocimeter stabilized in two dimensions, *J. Opt. Soc. Am. A10*: 7 (1993).

17. G. T. Timberlake and H. D. Crane, Eyetracker-stabilized laser photocoagulation, *Invest. Ophthalmol. Vis. Sci.* (suppl.) *26*:38 (1985).

# Introduction to Chapter 3

Most stabilized-image studies in the United States derive from the work of either L. A. Riggs or D. H. Fender (a student of R. W. Ditchburn in the U.K.). My long-time friendship with Derek Fender has been a source of much pleasure, but my scientific heritage is more directly connected to Riggs by the influence of his students, particularly Tom Cornsweet and Ulker Tulunay-Keesey. There was no formal collaboration, but even Riggs eventually served as a subject in one of my experiments. I had been interested in stabilized-image experiments ever since graduate school (when I wrote to ask Riggs about some data), but I had no opportunity to participate in the field until I moved to SRI in 1966.

There I was located next door to the lab where Cornsweet and Crane were developing eyetrackers and other visual instruments, as described in the preceding chapter. Whenever Tom and Hew had a model that more or less worked, I would get a chance to try it out. Long before they had one that could really make a retinal image steady enough to disappear, certain non-SRI colleagues were calling me "lucky Don" with ill-concealed envy. Eventually, the eyetracker's performance was good enough to induce me and other investigators to risk putting the cost of one into our grant applications. From then on, Hew had a real production line to run, supplying demands from all over the world. (Once it worked, Tom moved on to other interests.)

So my stabilized-image work is partly the result of an unlikely series of

coincidences, and especially of the right people coming along at the right time. (But isn't that true of many successful projects?) In any case, I believe the work described in the following chapter is some of the best I have done.

I have tried to make Chapter 3 completely self-contained. However, Chapters 3, 4, and 5 are all closely related, and the latter two offer more recent viewpoints on some of the material in Sections V and VI of this chapter. Chapter 4, in particular, provides the best available theoretical model of the spatiotemporal data presented here. Chapter 5 then introduces the tricky question of temporal phase-shift. Some readers may wish to make a quick pass through all three chapters and then skip around, but the present order has been chosen for the benefit of those who wish to savor each on its own merits.

All the data in this chapter were taken with a conventional sine-wave grating, the stimulus pattern that has been so popular in the last two or three decades. Although this rectilinear homogeneous pattern yields only limited precision in measuring the imaging properties of the two-dimensional visual field (which is strongly inhomogeneous and more or less circularly symmetric), let the reader be reassured. This problem is addressed in Chapter 7, which introduces circular, frequency-modulated patterns (and in Chapter 8, where computer modeling is applied to the entire retinocortical system).

# 3

# Eye Movements and Contrast Sensitivity

## D. H. Kelly

*SRI International, Menlo Park, California*

The normal, healthy eye is in constant motion, even when the subject is not following a moving object or looking from place to place. He may be holding his gaze as steady as possible, but very small eye movements can still be detected by a sufficiently precise instrument. Early measurements of these small eye movements were obtained by several investigators, including Ditchburn [1] at the University of Reading in England, Riggs [2] at Brown University, and Yarbus [3] in Russia. Their belief in the importance of such data can be inferred from the difficult (and sometimes hazardous) techniques involved in these pioneering experiments: all three groups used a mechanical device rigidly attached to the subject's eye by a suction cup or a large, tight-fitting contact lens. A useful entrée into the early literature on this topic is Ditchburn's book [1]. More recent studies have had the benefit of noncontact methods of measuring eye movements, as described in the preceding chapter.

Any eye movement will of course move the image of a stationary stimulus across the retina, but this effect can be counteracted (particularly for small motions) by a feedback system that moves the stimulus accordingly. The result is called a "stabilized retinal image." The subject's perception of such an image tends to fade and may vanish altogether, depending on other properties of the stimulus [2,4]. This "disappearance of stabilized images" was a very exciting discovery in the early studies of small eye movements. It implied that every retinal image must move or change in some way if it is

to be visible. Perhaps this phenomenon was startling because most (optical and electronic) imaging systems don't normally behave that way. On the other hand, it can be regarded as just another example of the irritability of living tissue, which usually responds only when its environment changes.

The involuntary eye movements that occur during fixation consist mostly of slow drifting motions, interrupted by sudden jumps, or "microsaccades" [1]. One hypothesis is that drifts facilitate vision, while saccades serve to maintain the line of sight at or near the fixation point. The drifts are evidently *sufficient* to maintain normal vision, as discussed below, but not all visual perceptions require drift motions. For example, a bright, contrasty spatial pattern that is flashed too briefly to be affected by any eye movement nevertheless can be seen.

There are many studies of eye movements per se, but this chapter is confined to the role of small eye movements in perception, and particularly in the perception of that ubiquitous stimulus, the sine-wave grating. In engineering parlance, we will be considering the steady state, which is appropriate for a continuous drifting motion at constant velocity. (Transient analysis would be more appropriate for studying the effects of saccades, but these phenomena are potentially much more complex. For example, if an idealized saccade carries the fixation point instantly from one bright bar of the grating to another, there is effectively no change in the fixated stimulus.)

## I.  EYE MOVEMENTS AS ARTIFACTS

The nature of spatial vision depends on the temporal behavior of the visual process; both properties must be studied together. That dictum can be justified at various levels of the visual system, as discussed in the following chapter. Here it applies at the earliest stage, where eye movements provide a universal form of spatiotemporal interaction even before the proximal stimulus impinges on the receptor cells of the retina.

A simple example of this type of spatiotemporal interaction is obtained by considering the retinal image of a (fairly coarse) sine-wave grating being scanned across the retina by a drift motion of velocity $V$ (deg/s). The spatial frequency of this stimulus $f_S$, expressed in cycles per degree (c/deg) of visual angle, is of course unaffected by the motion. At any fixed point on the retina, however, the input to a local receptor cell will be sinusoidally modulated in time, at the temporal frequency $f_T$ (Hz, or cycles/s), where $f_T = V f_S$. The output of that cell will therefore depend as much on the scanning velocity as it does on the spatial pattern [5].

Natural eye movements may thus be regarded as an uncontrolled *artifact* in any experiment that is critically dependent on the spatial properties of

the stimulus. Aside from patterns presented as very short flashes, that radical doctrine applies to most of the psychophysics of spatial vision developed over the past century.

Fortunately, the same considerations suggest a two-part approach to the control of these artifacts. First, develop a suitable technique for stabilizing the retinal image, to eliminate the effects of natural eye movements. Then, control the motion of the retinal image by moving the distal stimulus as desired, thus providing *surrogate eye movements*. This procedure should mitigate the problems of natural eye movements as uncontrolled artifacts, but it raises another interesting question: Can we devise artificial eye movements that create the same perceptual results as the natural ones? For sine-wave gratings, at least, it turns out that this can be done quite precisely.

## II.  THE DISAPPEARANCE OF SINE-WAVE GRATINGS

What is the most effective technique for stabilizing the retinal image? That depends on the kind of experiment to which stabilization is applied and the criterion that is adopted for effectiveness. Cornsweet and others [2,4] have held that the perception of a perfectly stabilized image always disappears, but that postulate applies only to constant stimuli. (A pattern flashed for a few microseconds is equally visible with or without stabilization, because natural eye movements are too slow to affect such a stimulus.) Within these constraints, the Cornsweet postulate implies that the most effective image stabilizer is the one that makes a constant stimulus least visible, and that is the criterion we will adopt.

For the sine-wave gratings of interest here, "visibility" is usually measured in terms of the contrast threshold: the greater the contrast at which the sine-wave stimulus remains invisible, the more effective the stabilization. However, sine-wave thresholds are also sensitive to the luminance and size of the target, psychophysical technique, individual differences, and so on. To control for these effects as much as possible, we can compare stabilized and unstabilized thresholds, keeping all other conditions the same, and calculating the threshold elevation ratio as our final criterion [6].

Figure 1 shows four sets of such data collected in different laboratories, representing four different stabilization techniques [7]. The independent variable is the spatial frequency of the grating, as usual. In the uniform log scales used here, threshold elevation is shown by the linear distance between each pair of curves (contrast increasing *downward*). The "unstabilized" control curve in each case was obtained with natural eye movements, but it turns out that artificial ones can play the same role, as discussed below.

One should not make too much of the interlaboratory comparisons in

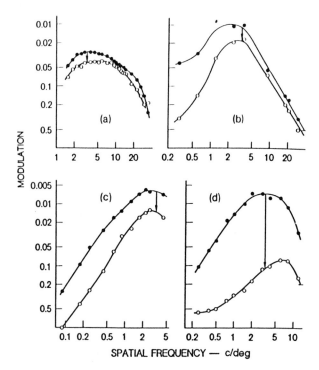

**Figure 1** Sine-wave contrast sensitivity measurements, showing the threshold elevations produced by four different techniques for the stabilization of retinal images available in 1979: open circles, stabilized stimulus patterns; solid circles, unstabilized controls. (From Ref 7.)

Figure 1. These data represent the state of the art in 1979, and some of the techniques have been improved. However, the data are included for three reasons. First, they show that the threshold elevation criterion is very sensitive; it readily distinguishes the results of different techniques at different spatial frequencies. Second, although the stabilized contrast threshold is very high at some frequencies, in no case was it unmeasurable. All the stabilized patterns were visible at 100% contrast. Thus if Cornsweet's postulate is correct, all the stabilization methods were perturbed by artifacts such as those listed above (perhaps different ones in different laboratories).

Third, the noncontact technique of Figure 1d, as used in our laboratory, compares very favorably with the others, at all spatial frequencies. Its superiority in terms of contrast threshold elevation has not been contravened in the ensuing years, supporting our belief that the experiments described be-

low are representative of the best that can be done at the present state of the art of retinal image stabilization.

## III. SYNTHETIC EYE MOVEMENT EFFECTS

After the image had been stabilized, the next step in controlling retinal inputs was to find suitable motions of the distal stimulus pattern that mimic the effects of natural eye movements. (For obvious reasons, one cannot control the physical motion of the eyeball itself; it was only the retinal effects of this motion that we attempted to synthesize.)

We started from the hypothesis that pattern vision is mediated by natural drift motions, as mentioned above. A steady state approximation to these drifts can be obtained by moving a sine-wave grating across the visual field at constant velocity, in treadmill fashion (the extent and location of the pattern remaining constant). We tested the suitability of this steady state condition by measuring contrast thresholds and comparing them to the corresponding unstabilized thresholds [5,6], attempting to answer two important questions. First, is there a steady state velocity at which the contrast sensitivity function matches the function obtained with natural eye movements? And if so, how does that velocity compare to the natural drift velocities?

In 1978 Murphy [8] raised the question of whether there is any fundamental difference between visual signals obtained by motion of the distal stimulus and those obtained by eye movements, which might evoke proprioceptive feedback from the oculomotor system. (If that were the case, the first two questions would be moot.) In his experiments, however, Murphy found no such difference. Our controlled-velocity data served to confirm his result under stabilized conditions and to extend it to natural drift motions.

The solid circles in Figure 2 represent conventional, unstabilized contrast thresholds, while the dashed and solid lines show comparable data for the same subject with controlled stimulus velocities. Each of these velocities differed by more than an order of magnitude from its neighbors. At 0.15 deg/s (solid line), there was a very good match (closer than usually obtained between two successive measurements of the same contrast sensitivity function). The bandwidth of the natural sensitivity was slightly broader than the single-velocity curve, suggesting that the unstabilized thresholds represent a considerable range of drift velocities; say, from 0.1 to 0.2 deg/s. The measured velocities for this subject's natural drift motions fell well within that range [5,6].

Because the sensitivity changes slowly with velocity, the choice of a surrogate velocity for simulating normal, unstabilized vision need not be

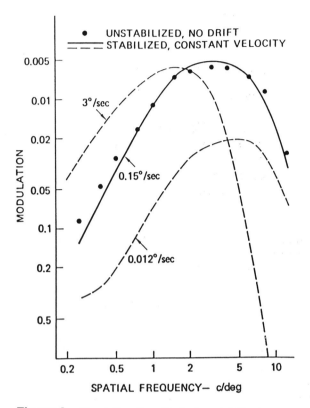

**Figure 2** Simulating the effect of unstabilized eye movements on contrast sensitivity. A smooth curve was obtained at three constant velocities of the (stabilized) retinal image. Points show the normal, unstabilized contrast sensitivity of the same subject, fixating stationary gratings. (From Ref. 6.)

very precise. The individual differences in contrast sensitivity functions among normal subjects are greater than the shift obtained by doubling the velocity in this region.

Results like these sounded the death knell for unstabilized experiments in spatial vision, at least in our laboratory. After 1979, all our experiments were done by stabilizing eye movement effects and superimposing controlled motions of the distal stimulus, on the general principle that it is better to control any significant experimental variable than to leave it uncontrolled. Retinal image motion is thus provided by the experimenter, not by the subject. Data obtained in this way are much cleaner than unstabilized data, even where the compensation for eye movements is less than perfect.

If the image stabilizer merely reduces the perceptual effects of natural eye movements by an order of magnitude or so (as in Fig. 1d), these effects should be completely swamped by the synthetic motion input, particularly if the latter is near threshold.

Thus synthetic eye movements may turn out to be even more important in the history of retinal image stabilization than the disappearance of stabilized-image percepts (although we will return to the latter at the end of this chapter). In any case, important results continue to emerge from applications of the synthetic motion technique; some of these are illustrated below.

## IV. SPATIOTEMPORAL CONTRAST SENSITIVITY

The notion that sine-wave thresholds could be used to study spatiotemporal interaction was formally proposed by the author [9] in 1962 and first implemented by Robson [10] four years later (although it was implicit in the earlier work of Schade [11]). By providing a spatiotemporal stimulus of the form,

$$F(x,t) = L(1 + m \sin 2\pi f_S x \sin 2\pi f_T t),$$

the early, unstabilized experiments of Robson and others attempted to manipulate the spatial frequency $f_S$ and the temporal frequency $f_T$ as independent variables, while measuring the threshold value of the generalized contrast $m$ at a fixed luminance $L$, seeking to determine what if any interactions occur between the spatial and temporal responses to this stimulus as they traverse the visual pathways.

Strictly speaking, that could not be done in the presence of the fixational eye movements described above (Sec. I), because they produce an uncontrolled, preretinal modulation of the stimulus, which unavoidably affects the measurements. The early results [10] showed a strong spatiotemporal interaction, but that could have been either a scanning effect or a neural property, or both.

Until these experiments were carried out, it was often assumed that *neither* effect occurred: that is, the spatial and temporal responses of the visual process were thought to be independent of each other. But that would imply that the shape of the spatial contrast sensitivity function was independent of the temporal waveform of the stimulus, and similarly, that the shape of the temporal contrast sensitivity function was independent of the spatial pattern of the stimulus. That was not the case, but meanwhile, experiments of many other kinds had failed to reveal the presence of spatiotemporal interaction merely because they were designed with the tacit assumption that there wasn't any.

When spatiotemporal sine-wave thresholds were measured under stabi-

lized-image conditions, and plotted as a function of both spatial and temporal frequencies, the sensitivity *surface* shown in Figure 3 was obtained [6]. Although temporal frequency is one of the independent variables in this plot, sine-wave flicker was *not* used to generate the stimuli. Instead, all the data were obtained with sine-wave patterns moving across the visual field at constant velocity

$$F(x,t) = L[1 + m \sin 2\pi f_S(x - Vt)]$$

in accord with the steady state approach described above. Temporal frequencies for this stimulus are readily calculated from the relation $f_T = V f_S$ (discussed in Sec. I).

That procedure guarantees that every point in the retina is stimulated by the same temporal waveform, whereas a flickering sine-wave pattern is a standing wave that provides no temporal change at its nodes and twice the traveling-wave amplitude at its antinodes. Over most of the spatiotemporal frequency domain, the standing- and traveling-wave thresholds differ by the factor of 2 that would be expected, but in stabilized-image experiments, the assumptions involved in that calculation can just as well be avoided by using moving stimuli and interpolating the results.

Another advantage of the constant velocity procedure is that in log–log

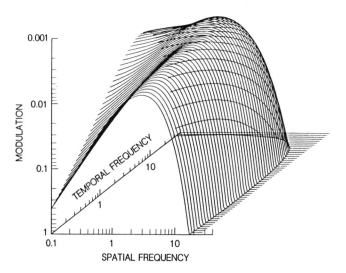

**Figure 3** Spatiotemporal, contrast sensitivity surface with smooth interpolation. Each individual curve represents the spatial–frequency response at a fixed temporal frequency. Neighboring curves are separated by increments of 0.05 log temporal frequency. (From Ref. 6.)

coordinates, the spatial frequency function has *the same shape* at any fixed velocity; only the height and frequency of the sensitivity peak decreases with increasing velocity. These curves are all fitted by the same (bandpass-type) interpolation function [6], illustrated in Figure 4, indicating that even when natural eye movements are replaced by artificial ones, retinal velocity remains a critical parameter in the visual system. Figure 4a shows experimental thresholds at 0.15 deg/s (as in Fig. 2), and at a much higher velocity, 11 deg/s. Figure 4b shows the effect of a wide range of velocities, covering about three orders of magnitude.

To represent constant temporal frequencies (as in Fig. 3), these sensitivity curves must be rotated 45° (in log-frequency space) and interpolated. (When this is done, the shapes of the resulting profiles are no longer constant; they represent strong spatiotemporal interaction.) As a final check on this procedure, additional data were taken at a few selected temporal frequencies (with moving stimuli as usual). Some of these data are compared with the (rotated) interpolation predictions in Figure 5. It can be seen that the fits are as good as those in Figure 4a.

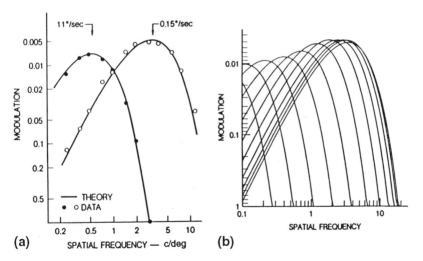

(a)    (b)

**Figure 4** Constant velocity (i.e., diagonal) profiles across the sensitivity surface of Figure 3 all have the same shape in log–log coordinates. This is the interpolation function used to construct the surface from individual data points. (a) Graph that shows how well this function fits the data at two greatly differing velocities. (b) The interpolated peak frequencies and sensitivities at velocities of 0.125, 0.25, 0.5, 1, 2, 4, 8, 16, 32, 64, and 128 deg/s. (From Ref. 6.)

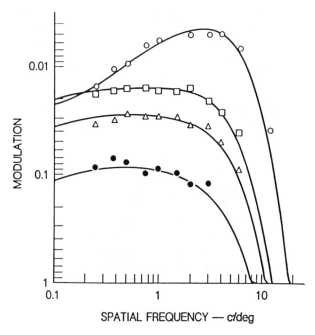

**Figure 5**  Selected curves from Figure 3, with measured contrast sensitivity points, at constant temporal frequencies of 2 Hz (open circles), 13.5 Hz (squares), 17 Hz (triangles), and 23 Hz (solid circles). (From Ref. 6.)

The threshold surface in Figure 3 is the most complete description we have of spatiotemporal interaction in the visual system [6]. (Its shape has been compared to "a loaf of bread bent in the middle.") For some purposes, this shape can be better appreciated in the form of a contour map of the surface, as shown in Figure 6. Here it can be seen that the surface is almost bilaterally symmetric about a diagonal line that represents a constant velocity somewhere between 1 and 2 deg/s.

That is the region of maximum spatiotemporal interaction, where the shape of the spatial contrast sensitivity function changes most rapidly with a change of temporal frequency, and vice versa. At very low and very high temporal frequencies, on the other hand, the spatial contrast sensitivity function changes shape more slowly. And the temporal function changes shape more slowly at very low and very high spatial frequencies. These properties are significant for the model described in the next section. (According to Cornsweet's postulate, the spatial function should go to zero at zero temporal frequency, but not on the log scales used here.)

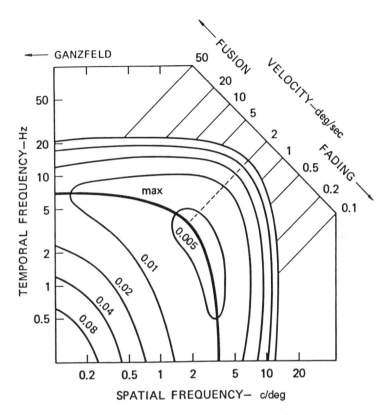

**Figure 6**  Contour map of the spatiotemporal sensitivity shown in Figure 3. The log velocity scale is compressed by a factor of 0.707 because of the 45° rotation; thus a larger velocity range is required to cover any given frequency range. The heavy line ("max") represents the locus of peak sensitivity at any constant velocity. The entire surface has approximate bilateral symmetry about the dashed diagonal line, $V = 2$ deg/s. (From Ref. 6.)

## V.  MODELING CONTRAST SENSITIVITY SURFACES

Why does the spatiotemporal threshold surface have its characteristic shape? A good answer to that question would comprise a plausible theoretical model that might suggest important hypotheses about some of the mechanisms of spatiotemporal interaction in the visual system.

Many years before there were any stabilized measurements of the threshold surface, some theorists made the necessary assumptions to transform contrast sensitivity data for stationary gratings (like the unstabilized curves in Fig. 1) into spatial line-spread functions. (Patel [12] seems to have been

the first to try this.) There was no problem of spatiotemporal interaction because the temporal aspects of these experiments were simply ignored. Bilateral symmetry was usually introduced (e.g., by means of the Fourier cosine transform), and the (Mexican-hat-shaped) results were somewhat reminiscent of the receptive field profiles that electrophysiologists were obtaining from the mammalian retina. Kelly [13] reviewed the early transform work in 1977.

That antagonistic, center-surround structure suggested to Burbeck and Kelly [14] that the seemingly complicated, spatiotemporal contrast sensitivity data of Figure 3 or 6 could be modeled as the difference of two other spatiotemporal surfaces, much simpler in form. They postulated that both underlying components were approximately low pass and precisely separable (although the surface depicted in Figs. 3 and 6 is obviously neither). By assuming that one component had greater bandwidths (in space and time) than the other, they could attribute the decrease of sensitivity in the low frequency corner of the measured surface to the antagonistic effect of the narrow-band mechanism on the wide-band one. (These mechanisms were later christened "E" for "excitatory" and "I" for "inhibitory.")

The postulate of separability was essential to make the Burbeck–Kelly model manageable. It meant that the (normalized) product of two contrast sensitivity curves, one spatial and one temporal, could specify the entire $E$ surface, and two more, the $I$ surface. In mathematical terms, they postulated that

$$E - I = e_S(f_S)e_T(f_T) - i_S(f_S)i_T(f_T).$$

The next step was to derive the "$e$" and "$i$" functions. In view of their bandwidth assumptions, Burbeck and Kelly inferred that the second term of this equation can be neglected when either the spatial or the temporal frequency is high enough [14]. (This effect can be seen at the "back" of Fig. 3, where the last four or five $e_S$ curves all have the same shape in log coordinates.) In these high frequency regions, the shape of $e_S$ at a fixed value of $f_T$ and the shape of $e_T$ at a fixed value of $f_S$ can be read directly off the measured sensitivity surface. These two curves together determine the theoretical $E$ surface. Knowing that surface, and the $E - I$ surface (the data), one could readily calculate an $I$ surface that would fit perfectly, but it might not be separable.

To make a critical test of their separability postulates (and to enhance the elegance of their model), Burbeck and Kelly [14] instead derived $i_S$ only at 1 Hz, and $i_T$ only at 0.5 c/deg. From these two low frequency curves, they calculated a separable $I$ surface. Contour maps of the two (separable) excitatory and inhibitory surfaces are shown in Figure 7. The calculated difference surface ($E - I$) was remarkably similar to the contrast sensitiv-

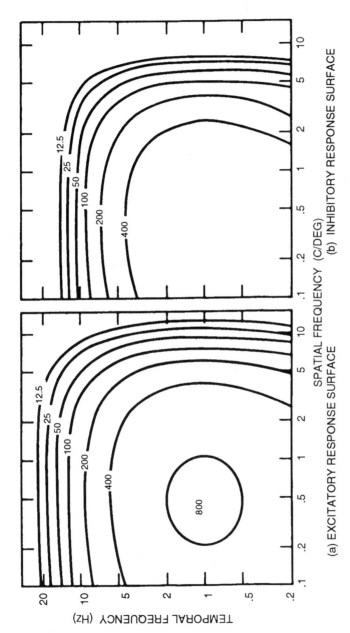

**Figure 7** Contour maps of the theoretical, center ("excitatory") and surround ("inhibitory") surfaces derived by Burbeck and Kelly from the contrast sensitivities shown in Figures 3 and 6. Unlike those data, both these surfaces possess spatiotemporal separability; but when the smaller surface is subtracted from the larger, a good approximation to Figure 6 results. (From Ref. 14.)

ity map of Figure 6, including its symmetry about a constant velocity of 1 or 2 deg/s. Finally, the Burbeck–Kelly model was used to predict other spatiotemporal data (not collected when the original surface was modeled); the fits were comparable to those in Figures 4a and 5.

Because of the way they were derived, both the $e$ and the $i$ functions deviate slightly from an ideal low pass shape. As can be seen in Figure 7, they are not perfectly flat at low frequencies. However, this has no significant consequence: perfect low pass, separable functions could readily be constructed that would predict the data equally well. What is significant is the success of the separability postulates. Separable mechanisms are usually simpler than inseparable ones, which suggests that this approach does reveal some physiological components that underlie the spatiotemporal contrast sensitivity.

The sizes (and other properties) of retinal receptive fields vary greatly over the large area of the stimulus that was used to obtain these data, so Burbeck and Kelly prudently did not claim to be modeling any particular type of receptive field [14]. Indeed, their terms "excitatory" and "inhibitory," were chosen mainly to avoid the connotations of "center" and "surround." Nevertheless, developments described in the next section and elsewhere in this book tend to confirm that this type of spatiotemporal interaction is a common property of parvocellular receptive fields in primates.

## VI. CHROMATIC CONTRAST SENSITIVITY

Up to this point, we have considered spatiotemporal interaction as if it were independent of the wavelength composition of the stimulus, but that is not the case. Here we take the first step toward characterizing the three-way spatiotemporal–chromatic interactions that begin in the retina.

This work had to await the development of a cathode-ray tube (CRT) that could display high quality chromatic patterns. (All the preceding data were obtained with a homochromatic display.) Because the early visual process is organized for the detection of chromatic as well as luminance contrast, it seemed appropriate to study chromatic contrast sensitivity by methods similar to those described in Section IV. The stimuli were sinusoidal, isoluminant red–green gratings, moving across the retina at constant velocity. The blue channel of the CRT was turned off, and the luminances of the red and green channels were matched by flicker photometry (for the given subject) [15].

There were relevant studies by earlier investigators (as there had been for the luminance–contrast results). Spatial contrast sensitivity had been measured with red–green gratings in some studies [16,17], and temporal

chromatic contrast sensitivity had been measured in others [18–20], but stabilized fixation control had not been applied to either, singly or in combination [21] until the experiments described here [15]. The chromatic sensitivity surface obtained with stabilized, drifting gratings is shown in Figure 8.

Chromatic contrast sensitivity has been defined in various ways. The definition used here conforms as closely as possible to the usual definition of achromatic contrast, given the properties of the color CRT. Because the luminance of the green phosphor was almost twice that of the red, the two were brought into approximate isoluminance by viewing the CRT through a sharp-cutting orange filter (Wratten 16). The isoluminant condition was "fine-tuned" for the given subject by electronically adjusting the green con-

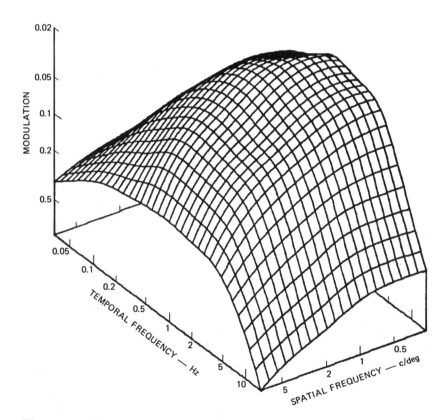

**Figure 8**   Chromatic contrast sensitivity surface measured with red–green, isoluminant, drifting sinuoidal gratings. Data were obtained at one-octave intervals of spatial and temporal frequency, and smoothed by a cubic–spline interpolation algorithm. The mesh has a spacing of four lines per octave. (From Ref. 15.)

trast to a level slightly below the red. That adjustment also had to be varied with the temporal frequency of the stimulus. Under these conditions, the chromatic contrast was taken as equal to the measured luminance contrast of the red phosphor [15].

For technical reasons, the homochromatic stimuli of Figure 3 could not be drifted at temporal frequencies below 0.5 Hz, while the newer, chromatic display was extended to much lower temporal frequencies. First we compare the two surfaces over the region they have in common.

The most important property of the chromatic sensitivity data in Figure 8 is that they are predicted by the same $E$ and $I$ functions used by Burbeck and Kelly to fit the luminance sensitivity data [14], although the shape of the surface in Figure 8 is very different from that in Figure 3. For the region above 0.5 Hz, the chromatic surface is low pass, in both spatial and temporal frequency, while the luminance surface is bandpass; neither is separable. Those results are in accord with theoretical properties of the R/G-opponent receptive fields of the central retina, as modeled by Ingling and his collaborators [22,23]. A receptive field model of this type provides a simple way of thinking about the relation between the two surfaces.

Suppose we assume, for the moment, that the $E$ function represents the response of the center of an R/G-opponent receptive field, and the $I$ function represents the response of its surround, as a homochromatic grating drifts past at a constant velocity. At low spatial and temporal frequencies, the center and surround responses will be out of phase (regardless of whether long- or middle-wave receptor cells are responding), because of the antagonism of their respective pathways. This center–surround opposition produces the low frequency decrease in the $E - I$ function.

Next, let this homochromatic grating be made up of the (in-phase) sum of red and green gratings, so that its hue is yellow. (The spatiotemporal contrast sensitivity is very insensitive to hue or wavelength changes, as long as the stimulus is homochromatic.) Finally, let us reverse the phase of either the red or the green component of this stimulus, to obtain an (isoluminant) red–green grating. Now if the receptive field center is more sensitive to one of these components, and the surround is more sensitive to the other, the relative phase of their responses will also be reversed: both center and surround responses will increase and decrease together, because the red component increases as the green component decreases, and vice versa. In effect, the chromatic grating has converted the center–surround antagonism into synergism.

That kind of thinking suggested that it might be possible to predict the chromatic contrast sensitivity by an $E + I$ function, modeling the phase reversal just described by this change of sign [15]. The contour map in

Figure 9 shows how well it works. Points in this figure represent the same data shown in Figure 8, at contours separated by a contrast factor of 2.0. Solid lines represent the function $(E + I)/30$ at similar intervals. (The scale factor of 30 was required by the spectral overlap of the long- and middle-wave cone pigments, and also the overlap of the red and green phosphors in our display, both of which tend to dilute chromatic contrast relative to

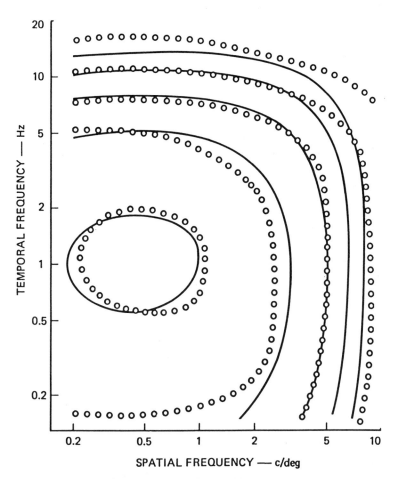

**Figure 9** Comparison of theoretical and experimental contour maps of chromatic contrast sensitivity. Circles represent the smoothed data of Figure 8, over the range covered by the Burbeck–Kelly model. Curves represent the theoretical prediction that results from adding (instead of subtracting) the two components of that model, scaled as described in the text. (From Ref. 15.)

luminance contrast.) In view of all the types and sizes of retinal receptive field within the stimulus area of these experiments, the fit of the (reversed) Burbeck–Kelly model to the chromatic surface is quite remarkable at temporal frequencies above 0.5 Hz (although there is some deterioration at the highest spatial frequencies in Fig. 9).

The idea that a single type of receptive field can respond to either chromatic or luminance contrast, depending on the stimulus, is now called "multiplexing" [24]. It is a radical departure from traditional opponent-color theories (where the chromatic signal is generated by subtraction, not addition). Nevertheless, there is increasing evidence, discussed in Chapter 4, that this is the way visual inputs are encoded.

## VII.  DISAPPEARANCE OF CHROMATIC GRATINGS

As Figure 8 indicates, the chromatic sensitivity also decreases steadily at very low temporal frequencies, below 0.5 Hz. This behavior can be seen more clearly in Figure 10, which is a cross section of the chromatic surface at a constant spatial frequency of 1.0 c/deg (where the temporal frequency is numerically equal to the drift velocity) [15].

Contrast thresholds are more difficult to measure at these very low drift rates, but the data of Figure 10 have been extended to less than half the

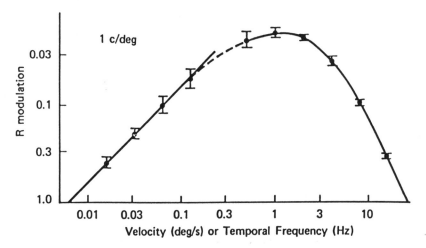

**Figure 10**   Chromatic contrast sensitivity for 1-c/deg, isoluminant, red–green gratings as a function of retinal velocity (or temporal frequency) in log–log coordinates. This curve represents a profile across the sensitivity surface shown in Figure 8. The theoretical straight line for low velocities has a slope of 1. (From Ref. 15.)

lowest temporal frequency shown in Figure 8. A straight line was fitted to these very low frequency data and extrapolated to its intercept at our maximum chromatic contrast. From Figure 10, we infer that even at the greatest contrast we could display, this chromatic grating of 1 c/deg would disappear at a velocity of 0.008 deg/s. That is the most direct evidence we have for the validity of Cornsweet's postulate, and it also suggests a mechanism for these disappearance effects.

The slope of the best-fitting straight line in Figure 10 is exactly 1.0, over a velocity range of more than 20 : 1; when the velocity drops by half, the sensitivity is cut in half. That is the behavior of a perfect temporal differentiator. Other tests showed that in this region, the sensitivity is proportional *only* to the temporal frequency; it is independent of the velocity, spatial frequency, and orientation of the grating that combined to produce this temporal frequency [15]. Those results suggest a simple, distal mechanism, probably located in the retina.

In the earlier measurements (Fig. 1d), stabilized luminance gratings did not disappear completely, even at zero drift velocity. However, the data of Figures 8–10 were taken with entirely new equipment, including an improved stabilizer. Does the disappearance indicated in Figure 10 represent a fundamental difference between the luminance and chromatic responses, or is it just the result of improved apparatus? We replicated the zero-velocity measurements of Figure 1d by shifting the relative phase of the red and green components in our color display to obtain homochromatic (yellow) luminance gratings. We also measured the zero-drift contrast sensitivity with our standard (red–green) chromatic gratings. The results are shown in Figure 11, where open symbols show the zero-drift condition and solid symbols the unstabilized (control) condition, for both the homochromatic and the red–green gratings [25].

With the stabilizer turned off, both contrast sensitivity curves are very similar to those obtained in other unstabilized experiments. The luminance contrast sensitivity in Figure 11a has a bandpass form, increasing rapidly at low spatial frequencies, while the chromatic contrast sensitivity in Figure 11b starts to fall off even where the luminance contrast sensitivity is still rising. The threshold elevation effect for luminance contrast in Figure 11a is about 50% greater than that in Figure 1d, perhaps because of the improved apparatus, but that is still not enough to make these luminance gratings disappear at maximum contrast. However, the stabilized chromatic gratings in Figure 11b do disappear, as would be expected from the results of Figure 10.

The maximum chromatic contrast we can generate is well below the stabilized threshold, not merely at 1 c/deg, but over the entire spatial frequency range. (The highest spatial frequency is just barely detectable at

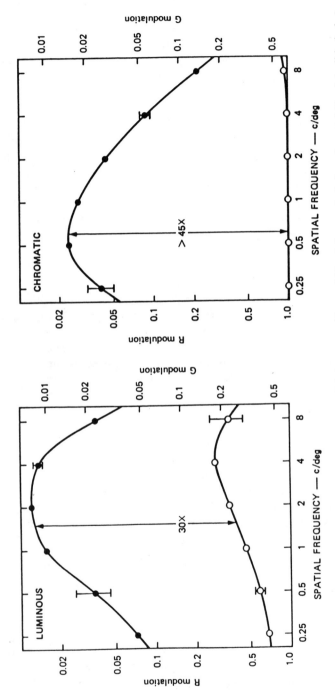

**Figure 11** Contrast sensitivity as a function of spatial frequency for stabilized (open circles) and unstabilized (solid circles) sinusoidal gratings with no object motion, plotted in log–log coordinates. On the left, red and green stimulus components are superimposed in the same phase, producing a homochromatic yellow grating. On the right, the same components are superimposed out of phase, producing an isoluminant, red–green grating with chromatic contrast only. (From Ref. 25.)

maximum contrast.) Stabilized, stationary chromatic gratings do indeed disappear, at contrasts where luminance gratings are readily visible. What causes the great difference between the chromatic and achromatic stimuli in the zero-drift (stabilized) sensitivities shown in Figure 11?

Chromatic responses are less sensitive than achromatic ones in many situations. (Recall that the achromatic Burbeck–Kelly model had to be attenuated by a factor of 30 to fit the chromatic sensitivities.) Although center–surround antagonism reduces achromatic responses relative to chromatic ones, that effect is counteracted by the overlap between the spectral sensitivities of the cone pigments, which dominates at high spatial and temporal frequencies. The unstabilized data in Figure 11 provide an example of this: achromatic sensitivity is greater than chromatic sensitivity at all spatial frequencies greater than 1 c/deg. The same effect is observed when chromatic and achromatic sensitivities are measured as functions of temporal frequency [19].

It is the temporal frequency aspect of this behavior that explains why luminance gratings are more difficult to stabilize than chromatic ones. As discussed in the preceding chapter, our stabilizer has a finite bandwidth, which means that its compensation for eye movements deteriorates as the temporal frequency increases. But since the chromatic response is already attenuated by an order of magnitude relative to the achromatic one at high temporal frequencies, the stabilization doesn't have to be as precise to make chromatic gratings disappear. If Cornsweet's postulate holds, the difference between the two stabilized curves in Figure 11 would be eliminated by perfect stabilization.

## REFERENCES

1. R. W. Ditchburn, *Eye-Movements and Visual Perception*, Clarendon Press, Oxford, 1973.
2. L. A. Riggs et al., Disappearance of steadily fixated test objects, *J. Opt. Soc. Am. 43*:495–501 (1953).
3. A. L. Yarbus, *Eye-Movements and Vision*, Plenum Press, New York, 1967.
4. R. W. Ditchburn and B. L. Ginsborg, Vision with a stabilized retinal image, *Nature 170*:36–37 (1952).
5. D. H. Kelly, Visual processing of moving stimuli, *J. Opt. Soc. Am. A2*:216–225 (1985).
6. D. H. Kelly, Motion and vision. II. Stabilized spatio-temporal threshold surface, *J. Opt. Soc. Am. 69*:1340–1349 (1979).
7. D. H. Kelly, Motion and vision. I. Stabilized images of stationary gratings, *J. Opt. Soc. Am. 69*:1266–1274 (1979).
8. B. J. Murphy, Pattern threshold for moving and stationary grating during smooth eye movements, *Vision Res. 18*:521–530 (1978).

9.   D. H. Kelly, New stimuli in vision, in *Abbilden und Sehen*. International Commission for Optics, Munich, 1962.

10.  J. G. Robson, Spatial and temporal contrast-sensitivity functions of the visual system, *J. Opt. Soc. Am. 56*:1141–1142 (1966).

11.  O. H. Schade, Electro-optical characteristics of television systems. I. Characteristics of vision and visual systems, *RCA Rev. 9*:5–37 (1948).

12.  A. S. Patel, Spatial resolution by the human visual system. The effect of mean retinal illuminance, *J. Opt. Soc. Am. 56*:689–694 (1966).

13.  D. H. Kelly, Visual contrast sensitivity, *Opt. Acta 24*:107–129 (1977).

14.  C. A. Burbeck and D. H. Kelly, Spatio-temporal characteristics of visual mechanisms:Excitatory–inhibitory model, *J. Opt. Soc. Am. 70*:1121–1126 (1980).

15.  D. H. Kelly, Spatiotemporal variation of chromatic and achromatic contrast thresholds, *J. Opt. Soc. Am. 73*:742–750 (1983).

16.  E. M. Granger and J. C. Heurtley, Visual chromaticity–modulation transfer function, *J. Opt. Soc. Am. 63*:1173–1174 (1973).

17.  K. T. Mullen, The contrast sensitivity of human colour vision to red–green and blue–yellow gratings, *J. Physiol. (London) 359*:381–400 (1985).

18.  H. DeLange, Research into the dynamic nature of the human fovea–cortex systems with intermittent and modulated light. II. Phase shift in brightness and delay in color perception, *J. Opt. Soc. Am. 48*:784–789 (1958).

19.  D. H. Kelly, Luminous and chromatic flickering patterns have opposite effects, *Science 188*:371–372 (1975).

20.  G. J. C. Van Der Horst, Chromatic flicker, *J. Opt. Soc. Am. 59*:1213–1217 (1969).

21.  G. J. C. Van Der Horst and M. A. Bouman, Spatiotemporal chromaticity discrimination, *J. Opt. Soc. Am. 59*:1482–1488 (1969).

22.  E. Martinez-Uriegas and D. H. Kelly, Chromatic and achromatic parvo channels, *Invest. Ophthalmol. Vision Sci.* (suppl.) *30*:128 (1989).

23.  C. R. Ingling, Jr. and E. Martinez-Uriegas, The spatiotemporal properties of the r-g X-cell channel, *Vision Res. 25*:33–38 (1985).

24.  E. Martinez-Uriegas, Zone theory, multiplexing model and psychophysical data, in *Human Vision, Visual Processing and Digital Display*, Proceedings of SPIE Meeting, San Jose, 1992.

25.  D. H. Kelly, Disappearance of stabilized chromatic gratings, *Science 214*:1257–1258 (1981).

# Introduction to Chapter 4

I first got to know Eugenio (Gene) Martinez in the early 1980s, although my friendship with his mentor, Carl Ingling, goes back 10 years earlier. One day Carl waylaid me outside the exhibit hall at a meeting of the Association for Research in Vision and Ophthalmology (ARVO) because he felt Dr. Martinez-Uriegas had some things to say that I ought to hear. So this young professor from Mexico and I sat on the curb in the Florida heat while he sketched graphs and wrote equations; Gene had come prepared for our meeting. In retrospect, that curbside conversation seems of historic importance, at least for me.

The subject was three-way spatiotemporal–chromatic interaction, a very important aspect of human vision on which my work and that of Martinez and Ingling had been converging for several years. Our discussion that day was the beginning of a fruitful scientific relationship. Gene is a skillful mathematical modeler, as you will see in this chapter, whereas I am mostly an experimentalist. And because he had approached the subject from the viewpoint of color vision, whereas I had pursued mainly spatiotemporal interactions in one way or another ever since the early 1960s, we complemented each other's notions almost perfectly.

Eventually, I persuaded Dr. Martinez-Uriegas to join me in California, where he and I collaborated until my retirement from SRI. It has been a pleasure to work with him (although he did most of the work). May you enjoy reading about his conquest of this area as much as I did watching him achieve it.

The heart of the multiplexing model, at least as it has influenced me, is in Section V of this chapter. Perhaps the most startling thing I contemplated that day on the curb at ARVO is now his Eq. (5). But at present Gene has a much simpler and more elegant way of leading up to it. And his work has so many ramifications in various subfields of visual science that I urge you to read this chapter straight through. You will be amply rewarded.

In that sense, this is the most comprehensive chapter in the book, influencing as it does our understanding of spatial vision, temporal vision, color vision, and how they are all inextricably entwined in the physiology of the visual process.

# 4

# Chromatic–Achromatic Multiplexing in Human Color Vision

**Eugenio Martinez-Uriegas**

*SRI International, Menlo Park, California*

## I. INTRODUCTION

In many elementary textbooks of science, color is defined as a physical property of matter. Although that notion is misleading, it does have some truth in it because color is a visual percept that depends to a high degree on the spectral absorption characteristics of the surface being viewed, provided the conditions of illumination are not very unusual. Color tells us something about the nature of objects. More precisely, color is one of the many representations of the environment constructed by the brain processes that comprise the visual system. However, most of the visual information about objects is conveyed by the perception of spatial properties that are relatively independent of color, in particular shape and texture. But the perception of color, coupled to spatial perception, is useful to decode additional information in parallel. For example, in our everyday visual experience, we identify certain shapes and surface textures (viewed in the appropriate context) as specific types of food; simultaneously, we estimate the qualities of such edible objects to a large extent on the basis of their color—whether fruits and vegetables are fresh, green, ripe, or spoiled, whether breads are appropriately baked, whether meats are rare, medium, or well cooked, and whether colorant substances are dissolved in water. If we think of all the synthetic and realistic images profusely generated by current technology, the variety of examples showing the importance of color is practically end-

less. Therefore, it is of great interest to understand the visual processing of chromatic information and to elucidate the neural machinery involved in this task. One of the fundamental concepts of this endeavor is the distinction between chromatic and achromatic phenomena. As we discuss below, such a distinction is straightforward in physical terms, but it does not directly imply a clear distinction in terms of human perception, and that ambiguity has motivated many ongoing research efforts to arrive at psychophysical and neurophysiological distinctions between chromatic and achromatic phenomena.

## II. DISTINCTION BETWEEN CHROMATIC AND ACHROMATIC PHENOMENA

Through accurate measurement, we can discriminate *physically* between a light changing in intensity, while its spectral energy distribution maintains the same shape, and a light whose spectral energy distribution changes shape significantly in space or time or both. Thus, the first light changes intensity by the same proportion at every wavelength—an achromatic change—while the intensity changes in the second light vary with wavelength, thereby defining an overall chromatic change. On the subjective level, we perceive differences between chromatic and achromatic changes to the extent that we can *visually* discriminate spatiotemporal changes in hue from spatiotemporal changes in luminance. The general question of how to relate these subjective discriminations between chromatic and achromatic variations to the objective (physical) distinctions is one of the basic problems at the core of visual science. The fundamental problem arises from three general observations:

1. Physical energy of light is not related in a simple and direct way to its visually perceived intensity. For example, when we view equal-energy samples of light from different regions of the visible spectrum under identical displaying conditions, the perceived intensities can be extremely different. The converse also holds; lights of very different energy content can be perceived as equally intense.
2. The physical spectral content of light is not directly related to visually perceived color. For example, many spectrally different lights (i.e., objectively different) appear to be visually identical. Lights with this property are called metamers.
3. Spatial and temporal variations in spectral content and/or intensity of light produce variations in visually perceived chromatic and achromatic properties that are not simple extrapolations into space and time of the perceptions experienced under homogeneous steady state light.

The history of visual psychophysics and the derived disciplines of photometry and colorimetry shows the large variety of approaches that have been used, and issues that have been raised, concerning these problems [1–3]. With the development of electrophysiology in this century, many predictions made by psychophysics (e.g., the trichromacy of human color vision) have been linked to data on visual cells, but the proposed links with respect to chromatic and achromatic visual processes are not yet clearly consistent beyond photoabsorption, and the interactions of photoreceptor signals at all levels of visual processing are still under very active study and discussion.

This chapter reviews a fundamental inconsistency between a postulate of the psychophysical opponent-color theory of vision — *the postreceptor chromatic-achromatic independence* — and psychophysical and neurophysiological evidence about postreceptor processing.

## III. CHANNEL INDEPENDENCE IN ZONE THEORY

The independence of chromatic and achromatic subsystems is a central issue because it is essential to zone theory and psychophysical opponent-color models [4–8]. According to those models, *postreceptor* processing is separated into *parallel* channels for chromatic (color-opponent) and achromatic (color-nonopponent) signals, as shown in Figure 1, adapted from the latest version of Guth's model. The outputs of these channels are sent to later stages, where the measured visual behavior presumably arises. These stages encompass such basic color percepts as hue, saturation, and brightness, which are modeled as appropriate combinations (interactions) between hitherto independent chromatic and achromatic signals. This chapter emphasizes the more general view that the assumption of chromatic and achromatic independence is valid only to explain experimental data measured under idealized, steady state spatiotemporal conditions. For data measured under more realistic conditions, human visual processes at the front end of the visual system are better explained as processes having a dual chromatic–achromatic nature, which manifests as a type of spatiotemporal multiplexing and is analyzed in the following sections.

In traditional opponent-color theory, the definition of independent chromatic and achromatic channels is based only on *spectral* criteria: one luminance or broad-band channel (labeled $A$ in Fig. 1) characterized by a certain *additive* combination of different cone spectral sensitivity functions, and two color-opponent channels characterized by two different *subtractive* combinations. The weights assigned to the cone sensitivities (labeled $a$–$g$ in Fig. 1) are different for different models, but some of the operational criteria commonly adopted to set the weights are as follows: the spectral

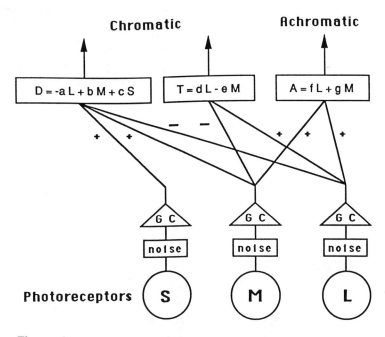

**Figure 1** Initial stages of an opponent-color model. After short-, medium-, and long-wave length-sensitive (S, M, L) cone photoabsorption, the process branches into independent chromatic and achromatic channels. Coefficients $a$–$g$ are model parameters; GC is gain control. (Adapted from Ref. 8.)

sensitivity of the luminance channel should match the spectral sensitivity function as measured by heterochromatic flicker photometry or by the minimally distinct border technique, and the wavelengths corresponding to perceptually unique hues should be sensitivity cross-points (zero net output) of the red–green and yellow–blue chromatic channels (respectively labeled $T$ and $D$, for tritanopic and deuteranopic, in Guth's scheme). Leaving aside variations from subject to subject, these criteria are met only under very restricted, specialized conditions of spatial and temporal stimulus — for example, the "aperture colors" restriction, which means that the measurements supporting the model are limited to small, homogeneous light patches. In general, these models cannot formally address visual phenomena when the stimulus varies along space or time, because wavelength is the only stimulus variable explicitly represented. Nonetheless, opponent-color models successfully explain important psychophysical data, represent a much-needed synthesis of the one-time rival theories of Young–Helmholtz and Hering, and have been useful guides in the design of numerous research efforts.

The emphasis here is on psychophysical and neurophysiological evidence indicating that chromatic and achromatic visual processes appear to be independent only under extreme spatiotemporal conditions but are really intertwined across substantial regions of their spatiotemporal dynamic range. As we discuss below, first principles applied to receptive field characteristics indicate that early visual neurons are not selectively sensitive to chromatic signals. After a case for this emphasis has been made, it can be concluded that models of color vision as well as models of spatiotemporal vision must incorporate chromatic–achromatic multiplexing at a fundamental level.

## IV. COLOR SUMMATION AND COLOR OPPONENCY: SIMPLE SENSOR FUNDAMENTALS

Despite our demonstrated ability to discriminate chromatic from achromatic changes in the visual scene, neurophysiological evidence indicates that chromatic and achromatic visual processes are not independent in the early stages; rather, they appear to be intertwined across substantial regions of their spatiotemporal dynamic range. Receptive field characteristics indicate that visual neurons at stages before the visual cortex are not selectively sensitive to chromatic signals [9–11].

There are two important physiological facts of primate vision that cannot be overemphasized: (a) photoreceptors with different photopigments are interspersed in a single layer of the retina, and (b) signals from these photoreceptors do not have private lines to higher stages of processing (i.e., signals interact at least within small neighborhoods). The first fact implies that different photopigments must be at separate retinal locations; even contiguous receptors never overlap. The second underlies the powerful concept of the receptive field of a neuron, where excitatory and inhibitory interactions have been used to infer functional roles for visual neurons.

Mostly from the influence of opponent-color theory of visual psychophysics, it has been thought for about 50 years that achromatic selectivity is a property of visual cells, which effectively *add* signals from different cone types, and chromatic selectivity is a property of cells that effectively *subtract* signals from different cone types (long-, medium-, and short-wavelength-sensitive: L, M, S) [2]. When this dictum is applied to primate precortical visual processes without spatial qualifications, however, it becomes misleading, because it hides fundamental assumptions: either different types of cone must be all in the same place, which is not the case in retinas with a single layer of photoreceptors, or else the light being used as stimulus must be uniform and homogeneous over the area covered by all the cones involved, a relatively common condition in the lab but obviously

not the case of realistic visual stimulation at the fovea, where the finest details in brightness and color changes are resolved. The essentials of such a conventional concept of additive and opponent combination of cone signals are analyzed below for a pair of simplified sensors.

In Figure 2, the (positive) signals of two cones of different type, L and M, are combined in two ways: by addition and by subtraction. According to the conventional concept, the additive sensor is an *achromatic* mechanism, while the subtractive sensor is a color-opponent or *chromatic* mechanism. The middle part of Figure 2 shows the profiles of two conventional stimuli made from red and green sinusoidal patterns of the same contrast. On the left, the sine profiles are superimposed in spatial phase to produce a pattern of alternating bright-yellow and dim-yellow stripes such that the difference in the modulation of L and M outputs is the same at every point (i.e., a simplified achromatic pattern). On the right, the two sinusoids are spatially superimposed in counterphase to produce a chromatic pattern of alternate red and green stirpes with amplitudes such that the sum of the modulation of L and M cone outputs would be constant at every point (a

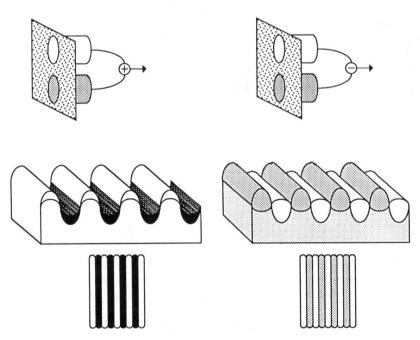

**Figure 2**   Top: simple sensors that add (left) or subtract (right) outputs from two different types of visual photoreceptor. Middle: two types of stimulus pattern, an achromatic light pattern (left) and a chromatic light pattern (right). Bottom: the corresponding icons used in Figures 3, 4, 15, and 16.

simplified isoluminous pattern). At the bottom are the icons that will be used in some of the remaining figures to represent those patterns. The conventional concept of additivity and opponency implies that the additive sensor should be selective with respect to achromatic stimuli; that is, it should respond only to the pattern on the left but should not respond to the pattern on the right, and vice versa—that the opponent sensor should respond only to the pattern on the right. Figure 3 shows that contrary to this convention, neither sensor is actually selective to chromatic or achromatic stimuli; instead, both sensors respond well to stimuli of both types, thereby reflecting an intrinsic duality, a type of multiplexing. Figure 3 also illustrates how both sensors respond well to chromatic or achromatic patterns at any orientation *except for vertical patterns*, as discussed below. The simulated response in every case is computed by convolving the input pattern with two unitary Gaussian functions of space centered at different positions $(x,y)$ and multiplied each by the corresponding spectral sensitivity $L(\lambda)$ or $M(\lambda)$ (e.g., Smith and Pokorny's cone sensitivity functions in Ref. 2); the cone responses are added or subtracted according to the specified wiring.

To understand how the chromatic–achromatic multiplexing of additive and subtractive mechanisms is affected by spatial frequency and orientation, it is useful to analyze the amplitude modulation of the response of the simple sensors defined above when chromatic and achromatic patterns of different spatial frequencies are presented at different angles. A summary of the results follows.

## A.  Spatial Frequency

Figure 4 illustrates how additive and subtractive sensors have complementary behavior with respect to spatial frequency and chromatic or achromatic predominance. The surfaces separately represent the amplitude modulation of the sensors to chromatic and achromatic patterns. Note that a subtractive sensor generates a stronger modulation to chromatic patterns at low spatial frequencies or to achromatic patterns at high spatial frequencies of stimulation. The additive sensor has the opposite behavior: high gain for achromatic patterns of low spatial frequency or to chromatic patterns of high spatial frequency. Nonetheless, there is a wide range of spatial frequencies for which both chromatic and achromatic patterns generate significant modulation in both wiring schemes.

## B.  Orientation

Going back to Figure 3, it is clear that when the stimulus pattern is perpendicular to the sensor orientation (horizontal in the upper panel of Fig. 3) or when it is oriented along almost any diagonal (middle panel), both types of

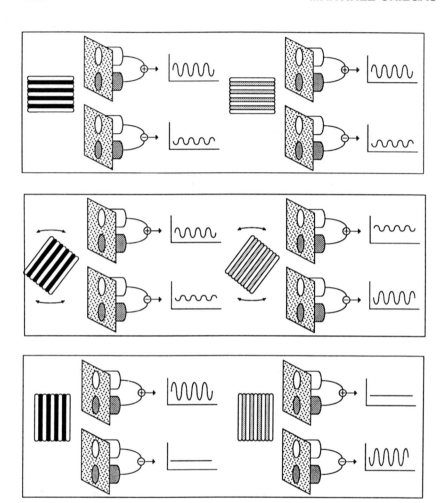

**Figure 3**  Responses of additive and opponent sensors to chromatic and achromatic patterns. Upper panel: patterns presented horizontally; both sensors respond to chromatic as well as achromatic patterns. Middle panel: patterns presented at an oblique orientation; again, both sensors respond to both types of pattern. Lower panel: the opponent sensor does *not* respond to achromatic patterns and the additive sensor does *not* respond to chromatic patterns, but this occurs only when the patterns are oriented vertically, along the sensor's orientation.

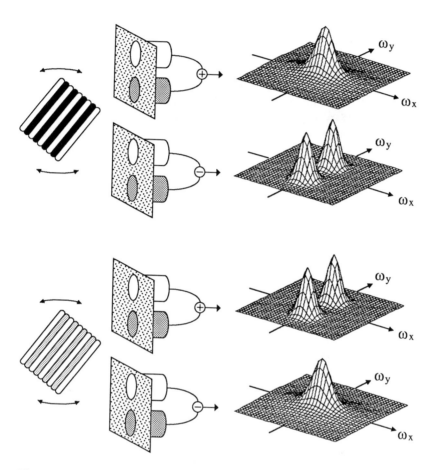

**Figure 4** Amplitude modulation surfaces. Upper half: both types of sensor are presented with achromatic patterns at all orientations and spatial frequencies. Lower half: the patterns are chromatic. All four surfaces are normalized to their maxima. Vertical stimuli of varying spatial frequency correspond to points along the $\omega_x$ axis.

sensor are chromatic-achromatic ambiguous. Only when the stimulus pattern is vertical, *oriented* along the two receptors as shown in the bottom panel of Figure 3, does the additive sensor respond with specifically achromatic signals and the subtractive sensor with specifically chromatic signals, *just as the conventional concept dictates*.

Two of the amplitude modulation surfaces of Figure 4 show the corre-

sponding range of orientations around the vertical (i.e., stimuli represented close to the frequency axis $\omega_x$), where the amplitude of modulation is practically zero (the flat regions between the two peaks in the second surface for the opponent sensor under achromatic patterns and in the third surface for the additive sensor under chromatic patterns), while the modulation is significant in the same region in the other two surfaces. Therefore, the additive sensor is selective for achromatic stimuli oriented around the vertical within a certain range, just as the opponent sensor is selective for chromatic stimuli oriented around the vertical. However, both sensors do respond with significant (but not greater) gain to stimuli at many other orientations, whether chromatic, achromatic, or a mixture. Therefore, if there is a process determining that the most relevant response of an oriented sensor is the one produced by stimuli aligned with the sensor's orientation (i.e., an orientation selectivity mechanism), such a response is also selective to either achromatic or chromatic changes depending on the sign of the wiring.

In summary, any periodic or nonperiodic stimulus made of straight bar-like regions *oriented* along the direction of the two-receptor sensor produces a specific response without any chromatic–achromatic ambiguity; at any other orientation, however, neither sensor gives a specific response; instead, there is a mixture of information about the chromatic, achromatic, spatial frequency, and orientation characteristics of the stimulus.

Therefore, the conventional concept of chromatic and achromatic specificity of subtractive and additive multispectral sensors is appropriate if the sensors are selective to orientation. Subtractive multispectral sensors with circularly symmetric receptive fields, like those characteristic of parvo neurons in precortical vision, lack orientation selectivity, and their signals are therefore chromatic–achromatic ambiguous. Only at cortical stages, where orientation selectivity is established, is it feasible to attain chromatic and achromatic specificity within the parvocellular pathways.

What about precortical magnocellular cells? How does the multiplexing model explain that they are practically color-blind (i.e., specifically achromatic, even though their receptive fields are circularly symmetric)? Magnocellular units show hardly any chromatic–achromatic multiplexing mostly because neither their center nor surround mechanisms are strongly selective for L or M cone input; therefore, differentiation of spectral sensitivity, an essential condition for multiplexing, is practically absent [12]. Nonetheless, there are reports of some magno cells with unbalanced spectral sensitivities between center and surround mechanisms, with resulting chromatic–achromatic multiplexing, which, in addition, is of a nonlinear type because of the nonlinearities typical of magnocellular units [13].

## V. MODEL OF SPATIOTEMPORAL CHROMATIC– ACHROMATIC MULTIPLEXING

The seminal ideas of multiplexing were presented by a student of Robert Boynton, Carl Ingling, Jr., together with Bruce Drum, one of his students, in 1973; and also by Russell and Karen De Valois in 1975. Since the late 1970s when he was a student of Ingling, the present author has developed the current model of multiplexing and has used it as a tool to describe the interactions of spectral and spatiotemporal opponency that take place in the various classes of neurons within the parvocellular system. It has become clear that the model's main thrust is the concept that chromatic processing is not independent from achromatic processing immediately after photoabsorption, but only after a yet unknown number of spatiotemporal channels have been formed at more central stages of visual processing. An updated summary of the model applied to the main subtypes of color-opponent parvocellular units is presented below.

The sensitivities of parvo cells found in primate lateral geniculate nuclei (LGN) can be represented as the subtraction of excitatory and inhibitory sensitivities corresponding to the center and surround of their receptive fields. The four most common subtypes include two ON-center, OFF-surround (subtypes $L_{on}$ and $M_{on}$) and two OFF-center, ON-surround (subtypes $L_{off}$ and $M_{off}$). Note that this ideal, schematic representation can be extended, without loss of the model's implications, to any variety of L/M opponency given by various strategies of combining the cone types that subserve center and/or surround [14,15]. For the simple type of opponency, Table 1 lists the adopted nomenclature.

Three points are worth emphasizing about the functions being used to model these LGN cell sensitivities. First, the assumption of spectral separa-

**Table 1** Model Sensitivities of Excitatory and Inhibitory Mechanisms Acting on Parvocellular Color-Opponent Cells of Four Subtypes[a]

| Cell sensitivity | Excitatory sensitivity | Inhibitory sensitivity |
|---|---|---|
| $L_{on}(\lambda, x, y, t)$ | $L(\lambda)\, N(x, y, t)$ | $M(\lambda)\, W(x, y, t)$ |
| $M_{on}(\lambda, x, y, t)$ | $M(\lambda)\, N(x, y, t)$ | $L(\lambda)\, W(x, y, t)$ |
| $L_{off}(\lambda, x, y, t)$ | $M(\lambda)\, W(x, y, t)$ | $L(\lambda)\, N(x, y, t)$ |
| $M_{off}(\lambda, x, y, t)$ | $L(\lambda)\, W(x, y, t)$ | $M(\lambda)\, N(x, y, t)$ |

[a]$L$ and $M$ are the spectral sensitivities of the long-wavelength- and middle-wavelength-sensitive cones, respectively; $N$ and $W$ are "narrow" and "wide" spatiotemporal sensitivity functions that fulfill the conditions stated in the text.

bility: the sensitivity of any excitatory or inhibitory mechanism is expressed as the *product* of a spectral function and a spatiotemporal function because the spectral properties are due only to the cone photopigment, while the spatiotemporal properties are due only to the neural wiring subsequent to photoabsorption. Second, although the spectral functions are defined precisely, by adopting Smith and Pokorny's $L(\lambda)$ and $M(\lambda)$ cone sensitivity functions [2], the model is flexible enough to incorporate any combination of cone sensitivities for the excitatory and inhibitory mechanisms; for example, a simulation presented below (Sec. VI) shows that the model appropriately represents cells whose centers are fed by a single cone signal while their surrounds are fed by a random combination of different cone signals. Third, the two types of spatiotemporal function—*narrow*, $N(x,y,t)$, and *wide*, $W(x,y,t)$—are not defined with the same precision as the spectral functions, but are required to have the following three properties:

1. $N$ and $W$ are positive spacetime functions, have circular symmetry in space, and are monophasic in time.
2. $N$ is nonzero in a smaller domain than $W$, in both space and time. The names "narrow" and "wide" arise from this condition.
3. The spatiotemporal integrals of $N$ and $W$ over the entire domain have the same value. This condition implies that $N$-$W$ and $W$-$N$ represent zero–mean operators.

These conditions capture the essential spatiotemporal characteristics of parvo cells observed in retina and LGN. All the algebraic functions that have been hitherto proposed to model the spatiotemporal properties of these visual cells, and all the proposed types of center–surround temporal delays, are compatible with these conditions, but there is no general consensus about their specific forms (as there is about the three cone spectral sensitivity functions). The present model can fulfill its purpose while remaining flexible enough to be valid for any functions $N$ and $W$ that meet the requirements above.

From Table 1, the sensitivity functions for the four schematic subtypes of parvocellular color-opponent geniculate units are:

$$L_{on} = LN - MW \qquad (1)$$

$$M_{on} = MN - LW \qquad (2)$$

$$L_{off} = MW - LN \qquad (3)$$

$$M_{off} = LW - MN \qquad (4)$$

where the function arguments have been left out for clarity. Now, all these cells are shown to be chromatic–achromatic ambiguous through the following *multiplexing identity* [16,17]:

$$L_{on} = LN - MW = \frac{1}{2}\{(L + M)(N - W)$$
$$+ (L - M)(N + W)\} \tag{5}$$

because inside the braces the first of the two composite terms adds L and M cone outputs (i.e., achromatic), while the second term subtracts those outputs (i.e., chromatic). Equivalent expressions result for the other three cell types. Thus, none of these units can unambiguously encode stimulus changes either in chromaticity alone or in luminosity alone. This result holds as well for any other cell with pooled spectral functions for center and/or surround, as long as spectral functions and spatiotemporal functions are different for center and surround mechanisms. Moreover, the result is valid for the few *magno* cells for which it is relevant (i.e., those that appear to have sufficient spectral difference between their center and surround mechanisms) [18,19].

Therefore, within this scheme, the parvo signals from LGN cells represented by Eqs. (1)–(4) are ambiguous with respect to chromatic or achromatic specificity. The schematic picture is that LGN outputs are predominantly of two types: *achromatic magno* signals and *chromatic–achromatic parvo* signals (with the possible exceptions of apparently small populations of color-opponent magno cells [18], achromatic parvo cells without color opponency [20], and very few nonambiguous color-opponent parvo units (Hubel and Wiesel's type II) [21]. Magno achromatic signals have high resolution in the temporal domain while parvo multiplexed signals have medium to high spatial resolution [22].

Following the reports that color-opponent, chromatic characteristics are well represented in cortical regions [23–27], and in view of the implausibility of these processes deriving only from the extremely scarce type II units of LGN (a hypothesis recently revived [28]), the decoding of the ambiguous color-opponent parvo signals into separate chromatic and achromatic responses appears to be essential. The solution to this problem that was first proposed in 1985 (and apparently the only one) states *that the four types of signal given by Eqs. (1)–(4) must interact by pairs at some cortical level* [29–32]:

$$L_{on} + M_{on} = (L + M)(N - W) \tag{6}$$
$$L_{off} + M_{off} = (L + M)(W - N) \tag{7}$$
$$L_{on} + M_{off} = (L - M)(N + W) \tag{8}$$
$$L_{off} + M_{on} = (M - L)(N + W) \tag{9}$$

The first two interactions decode achromatic signals, because the resulting sensitivity is proportional to $L + M$, and the last two decode chromatic signals, because the resulting sensitivity is proportional to $L - M$. Therefore, Eqs. (6)–(9) represent an ideal procedure for separating the two types

of information. Following similar reasoning, D'Zmura and Lennie applied Eqs. (8) and (9) to a physiological implementation of their color space [33]. Since the ON and OFF pathways seem to be independent up to the striate cortex [34], Eqs. (6)–(9) also predict that certain interactions between ON and OFF cortical pathways are necessary for decoding chromatic parvo signals and different combinations are necessary for decoding achromatic signals.

Separating the chromatic from the achromatic component by adding the outputs of cells of the types given in Table 1 requires that the intervening cells *all have the same L*, *M*, *N*, and *W* sensitivity functions. This requirement is easily justified for the spectral functions $L$ and $M$, but it is an idealization for the spatiotemporal functions $N$ and $W$ which, for different cells, are different at least in corresponding to different positions because cones do not overlap each other. Thus, the additional condition of orientation selectivity becomes necessary.

## VI. SIMULATION OF CHROMATIC AND ACHROMATIC SPECIFICITY OF CORTICAL CELLS

The role of orientation explained in Section III for simplified two-cone sensors is readily extended to simulate the general properties of cortical cells. However, the results of the simulation discussed below are difficult to compare with the experimental data on primate visual cells because the electrophysiological results even from the same cortical region and sublayer are still being interpreted in diverging and sometimes controversial terms, partly as a result of the diversity of testing techniques used and the variety of operational definitions of chromatic versus achromatic conditions of stimulation. There seems to be little doubt about criteria to establish orientation selectivity in cortical neurons [35–37], but when the characterization is to be made in terms of chromatic or achromatic specificity, a broad spectrum of criteria emerges [11,12].

### A. Three Stages of the Simulation

The simulated wiring of arrays of cortical receptive fields involves three processing stages, which are characterized by major differences in anatomical and physiological properties; these stages are photoreceptor mosaic, postreceptor retina plus lateral geniculate nucleus, and visual cortex. The present examples are further simplified by restricting the characterization of these stages to a few receptive field properties and to a few of the possible parameters. The three processing stages included in the following simulation are defined next.

### 1. First Stage: Receptor Lattice with L and M Cones

In this simulation, L and M cone types are distributed on two-dimensional crystalline triangular lattice, as illustrated in Figure 5. Rods and the third type of cone (S) are excluded for simplicity. The relative number of L to M cones in the lattice can be arbitrarily fixed; then one can obtain as many different spatial distributions as wanted just by random variation of the location of L and M cones, or other pseudorandom distributions [38].

The spectral parameter of primary importance is the ratio of numbers of cones $N_L/N_M$, herein called the *spectral ratio*. The value 1.65 is used here as standard reference. It corresponds to the standard photopic luminosity function of the International Commission on Illumination (CIE), namely $V(\lambda)$, where $\lambda$ is the wavelength of light. We adopt the conventional assumption that a standard luminance channel $V$ adds L and M cone outputs

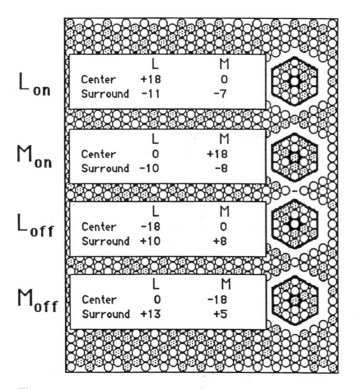

**Figure 5** Four subtypes of parvocellular receptive field. L cones are open circles; M cones are dark circles. The single cone in the center contributes the same as all 18 cones in the surround. Insets show the L and M cone inputs to center and surround. Cone type and polarity of the center characterize each subtype.

and use Smith and Pokorny's cone sensitivity functions $L(\lambda)$ and $M(\lambda)$ normalized at their maxima. That is, except for this normalization factor, $V(\lambda) = 1.65\ L(\lambda) + M(\lambda)$ is the overall spectral sensitivity of a system having a receptor lattice with the standard spectral ratio.

The emphasis of this section is on the behavior of the spectral ratio in massive collections of simulated neurons of LGN and visual cortex. Computing the relative L to M cone input, the spectral ratio can be determined for a whole cone lattice, a subregion of the lattice, a whole receptive field, or a subregion of a receptive field. The spectral ratios of lattices with only L and only M cones presumably represent deuteranope and protanope conditions of abnormal color vision and are the asymptotes of a range. In the same scale as the standard value, 1.65, normals have spectral ratios from 1.51 to 2.47 in the fovea [39,40], although others conclude that the range encompassing normals is smaller [41,42].

## 2.   Second Stage: Circularly Symmetric Receptive Fields

The postreceptor processing performed by the midget system at the retina and its retinotopic mapping at the LGN in four parvocellular layers remains to be modeled in appropriate detail. The second stage in this simulation follows a conventional description of LGN parvo cells in terms of the inputs feeding their receptive fields: parvo cells ultimately combine signals from different types of cone in a local center–surround fashion.

The wiring of four subtypes of parvocellular receptive field is defined by the type of cone signal that feeds the receptive field center (as a first step, it is assumed that only one type of cone feeds the center [15]) and by the polarity, ON or OFF, of the center's response to stimulation; they are denominated $L_{on}$, $M_{on}$, $L_{off}$, and $M_{off}$. Surrounds respond with the opposite polarity and may include cones of both types. Figure 5 shows examples of the four basic subtypes on a pseudorandom cone lattice.

According to current electrophysiological characterizations of parvocellular LGN units in primates [12,37], there are six basic types of parvocellular receptive field. Two of them have S cone input, and for simplicity these were not included in the present simulation. As explained before, the other four types of parvocellular unit ($L_{on}$, $M_{on}$, $L_{off}$, and $M_{off}$) cannot encode information in a purely chromatic or purely achromatic way; they are better described as spatiotemporally multiplexed chromatic–achromatic signals. The decoding rules require the addition of signals from L-center and M-center units. For achromatic decoding, the units must be of the same polarity (all ON-center or all OFF-center), while for chromatic decoding the polarity must be different and must be locked to the center type ($L_{on}$ plus $M_{off}$ or $M_{on}$ plus $L_{off}$). Figure 6 illustrates the application of chromatic and achromatic decoding rules in the present simulation; for clarity the

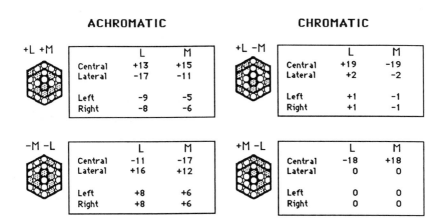

**Figure 6** Illustration of the achromatic and chromatic demultiplexing rules. For clarity, only two contiguous and overlapping receptive fields are combined. On the left, the two are either on the ON (top) or the OFF (bottom) type, while on the right the rule requires one ON and one OFF. In combining the receptive fields, it is critical to account for the effects of cones that feed both surrounds, as well as the effects of cones that feed the center of one receptive field and the surround of the other. Insets show the resulting L and M cone input for the central (the six-cone-long and one-cone-wide central stripe) and lateral (flanking regions altogether) regions and separately for left and right flanking regions. The demultiplexed pairs are typical examples drawn from a cone lattice with standard spectral ratio of 1.65.

interaction of only two contiguous LGN receptive fields is computed for these examples. For each field, the center has the same spatial weight as the surround (18 units). When receptive fields are added, it is necessary to compute appropriately the weights of receptors that happen to feed the surrounds of both fields and the weights of receptors that happen to feed the center of one field and the surround of the other.

## 3.  Third Stage: Cortical Receptive Fields

The wiring of cortical receptive fields is simulated on the basis of two properties, chromatic–achromatic decoding (demultiplexing) as illustrated in Figure 6 and orientation selectivity. The decoding rules require that the cells whose signals are added to decode chromatic and achromatic information have the same spatial and temporal sensitivity functions. The temporal aspect of this condition can be reasonably assumed to hold for cells like those illustrated in Figure 6, because similar and contiguous cells probably have similar time courses of response; furthermore, data and models indicating differences in temporal phase between different cone mechanisms could be incorporated in the simulation, but further refinement and addi-

tional complexity would be required [43,44]. The spatial similarity between cells also could be assumed to be true, except for one fact: even if the spatial sensitivity profiles of contiguous cells are identical, the spatial functions are still different because the receptive fields are spatially shifted. However, all the projections of those spatial functions on an axis that is perpendicular to the direction of shift could be identical. Therefore, the addition of signals from units along a straight line complies with the spatial condition in the dimension orthogonal to such a line; furthermore, the decoding is consistent with the known cortical property of orientation selectivity.

## B.  Results

The results reported here are based on the following steps of the simulation:

1.  Build a cone lattice with a specified spectral ratio.
2.  Build as many circular receptive fields as possible within the lattice and with specific dimensions of center and surround.
3.  Compute the spectral ratio of each receptive field and separate spectral ratios for center and surround.
4.  Using circular receptive fields and the rules for decoding chromatic and achromatic information, build as many elongated receptive fields as possible within the lattice and with specific dimensions and orientation.
5.  Compute the spectral ratio of each receptive field and separate spectral ratios for the central band, lateral bands, bandpass component, and low pass component.

The examples presented here correspond to the finest receptive fields with orientation selectivity (single-cone width in the central region) that can be generated by the simulation. Figure 7 shows examples of these fields. The first stage of processing is represented by the cone lattice with pseudo-random distribution of L and M cones. Because of this distribution, the spectral ratio (i.e., the cone–input balance) of individual receptive fields from the second stage varies widely, in agreement with results from other simulations and electrophysiological measurements [12,45]. Restricted to single-cone centers, the wiring for the second stage (retina plus LGN) produces receptive fields with either $L(\lambda)$ or $M(\lambda)$ spectral sensitivity in the center and a variably weighted linear combination of both in the surround. Figure 8 shows the typical variability of the spectral ratio of the surround. When the center is type L and the spectral ratio is very low, or when the center is type M and the ratio is very high, the greatest extent of spectral opponency between center and surround is indicated; a lower degree of opponency results for surrounds with a more balanced number of L and M

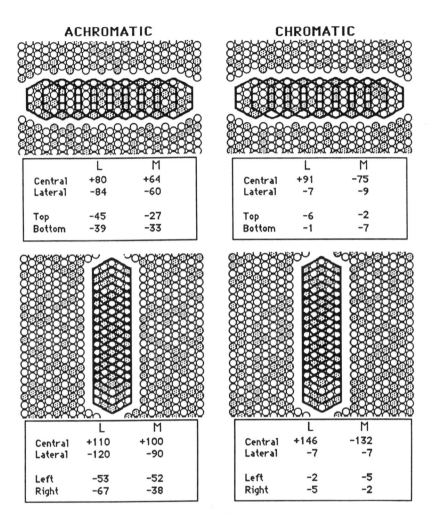

**Figure 7** Simulated receptive fields from the third stage of processing (cortex). Signals originate from a triangular cone lattice with standard spectral ratio; cones around the sampled area have been removed for clarity. Overlapping hexagons represent the LGN receptive fields that combine into each cortical receptive field following the rules for achromatic (left) and chromatic (right) demultiplexing, as illustrated in Figure 6 but pooling together more LGN fields. In this example, horizontal fields (top) comprise 9 LGN fields each, while vertical fields (bottom) comprise 15 LGN fields each. The insets show raw spectral results for each region within the elongated receptive field.

**Figure 8**   Subsample of 100 second-stage receptive fields showing typical variability of L/M cone input (spectral ratio) to the surround of single-cone-center fields. The cone lattice has a standard spectral ratio (dotted line).

cones. This is in agreement with the different degrees of spectral opponency between center and surround documented in the reports cited above. On the ordinate in Figure 8 are the spectral ratios of 100 from a run of 2700 surrounds; many other runs show similar results. All the fields are wired from a cone lattice with standard spectral ratio shown as a horizontal dotted line.

It is reasonable to think that at least several hundred receptive fields are involved in any simple step of visual processing, and it is important to characterize each step in terms of spatial, temporal, and spectral properties. The latter are the central concern of this chapter. The simplest hypothesis is that the spectral sensitivity of such a step is given by the combined contribution of all the receptive fields involved. Figure 9 shows the average spectral ratio (on the ordinate) taken for increasing number of surrounds (in the abscissa), up to 2700; the average is off from the lattice's spectral ratio by as much as 15% when computed for less than 1000 surrounds.

The following results are about the effect of the chromatic–achromatic decoding on the spectral ratio. The question is, When a number of circular

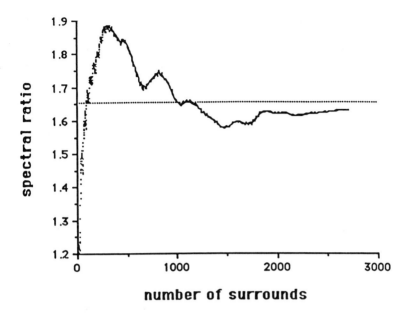

**Figure 9**    Average spectral ratio (L/M cone input) of surrounds of circular fields. The average (ordinate) is taken over increasing number of surrounds (abscissa). Note variability from the standard spectral ratio (dotted line) of the lattice.

receptive fields are wired together into a cortical receptive field according to the decoding rules, and this wiring is executed in a massively parallel fashion, what is the behavior of the spectral ratio across the population of cortical receptive fields for both chromatic and achromatic decoding?

To answer this question we apply an implication of the decoding rules. It has been shown that a circular receptive field of the second stage can be represented by the sum of two components, an achromatic spatiotemporal bandpass filter and a chromatic spatiotemporal low pass filter [16]. The wiring implied by the decoding rules is aimed at the systematic cancellation of either one of those components in all the fields that are wired together into a third-stage field. As expected, the results of the simulation show that this cancellation indeed occurs, although it is not perfect because of the randomness introduced by the L and M cone positions in the lattice. Thus, the spectral ratio of massive numbers of receptive fields indicates the extent to which the decoding works, because positive values of that ratio indicate achromatic processing while negative ones indicate spectral opponency (i.e., chromatic processing).

The plots in Figure 10 show that both central and lateral regions of cortical fields wired under the achromatic rule have positive spectral ratios. Note that the variability of the ratio is greater for the central region than for the lateral region, because the former is defined as a single-cone stripe while the latter encompasses two two-cone stripes. In general, the ratio in the central region is not the same as that in the lateral region, which implies a residual spectral opponency between those regions which corresponds to the low pass component of each cortical field. To quantify the relative weight of that component, the simulation computed the gain of the band-pass component of each cortical field and compared it with the gain of the

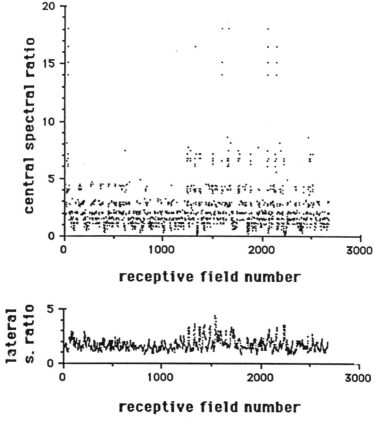

**Figure 10** Spectral ratios for central (top) and lateral (bottom) regions of 2700 demultiplexed achromatic receptive fields. Note that the range of variability is larger for the central region, because of its smaller sampling area.

low pass component of the same field. Figure 11 shows the ratio of those gains, defined as the dominance of the achromatic bandpass component over the chromatic low pass component. Therefore, the residual capacity of chromatic processing in receptive fields wired to decode achromatic information is very small. Keep in mind that the simulation computes spectral ratios along the orientation of the receptive field.

Simulation of the chromatic decoding yields the following results. The central region is always spectrally opponent as shown by Figure 12a, where all the spectral ratios are negative; the lateral region is not, however. Figure 12b shows that the lateral spectral ratio is positive for 90% of the receptive fields. Although this ratio is positive, the net inputs of both L and M types to the lateral region are always negative and significantly smaller (about 0.1) than the corresponding inputs to the central region. The result is shown in Figure 13a: in more than 95% of these cortical fields, both the low pass component and the bandpass component are driven by spectrally opponent cone inputs of the same polarity; that is, both components encode chromatic information. Figure 13b shows the accumulative averages of data in

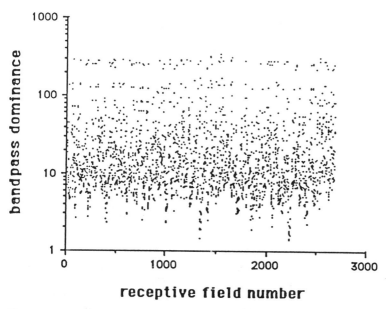

**Figure 11**    In the log scale on the ordinate, note the extreme dominance (ratio of gains) of the bandpass component over the low pass component in a typical run of 2700 achromatic demultiplexed receptive fields.

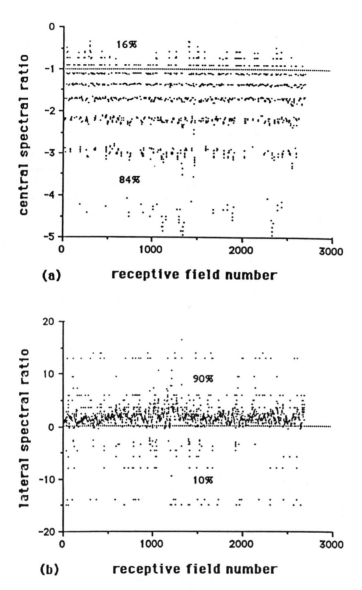

**Figure 12** Spectral ratios of the central (a) and lateral (b) regions of 2700 chromatic demultiplexed receptive fields. Note that 84% of the central regions have a negative spectral ratio smaller than $-1$. The positive ratios in (b) for 90% of the fields result from L and M total inputs being both negative. See the fields on the right-hand side of Figure 7.

Figure 13a. The ratio of such averages (Fig. 13c) shows that the low pass component weights about 50% more than the bandpass component.

All the examples presented here were run from a lattice with the standard spectral ratio (1.65). Recall that for decoded achromatic processes as illustrated in Figure 10, it is reasonable to expect variability in the average L and M cone contributions up to 15%, depending on the number of receptive fields involved. If the lattice's spectral ratio is changed, these variations shift in the same direction. For decoded chromatic processes, an interesting result follows directly from the decoding rules and the low pass, bandpass analysis. It turns out that the low pass component of all the decoded cortical fields, without exception, combines L and M input in a spectrally opponent fashion with a spectral ratio of $-1$. Figure 14a shows the spectral ratios for both bandpass and low pass components in a typical run for chromatic decoding. Moreover, this result is independent of the lattice's spectral ratio (i.e., of the relative number of L and M cones), as long as both types of cone are encompassed by the cortical receptive field. Figure 14b shows the average spectral ratios from the data in Figure 14a. Note that the bandpass component has an average spectral ratio that is larger (in absolute value) than both the invariant ratio $(-1)$ from the low pass component and the lattice's spectral ratio (the standard 1.65 in all the runs shown here).

## VII.  MULTIPLEXING AND CURRENT SPATIAL MODELS

Achromatic specificity (at a given orientation) is obtained by wiring together outputs of contiguous color-opponent LGN parvo cells, all of which must be of the same polarity (either ON-center or OFF-center) and all with receptive fields along the same straight line on the retina. Although from retina to cortex there are intermediate stages of center–surround opponency, the general result turns out to be equivalent to the two-cone additive sensor of Section III because outputs of L-center and M-center units, being of the same polarity, are effectively added at the cortical cell, the surrounds being practically canceled by the centers along the central elongated region.

Chromatic specificity (at a given orientation) is also obtained by wiring together outputs of contiguous color-opponent LGN parvo cells having receptive fields along the same line; but the demultiplexing rule requires that the cell subtype (L- or M-center) be locked to the cell polarity (ON or OFF). Thus, all cells being combined are either from the set comprising subtypes $L_{on}$ and $M_{off}$ or from the set comprising subtypes $M_{on}$ and $L_{off}$. The general result is equivalent to the two-cone opponent sensor of Section III because outputs from L-center and M-center units, being of opposite

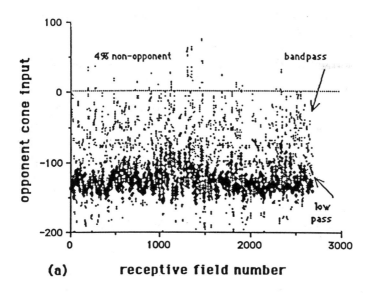

**(a)**            **receptive field number**

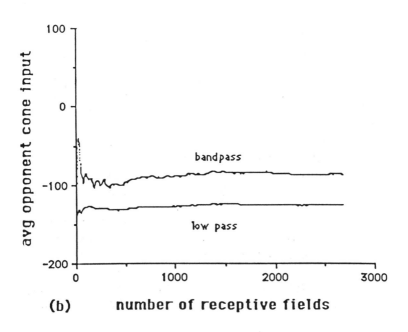

**(b)**      **number of receptive fields**

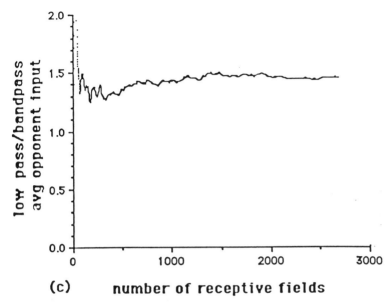

(c)      number of receptive fields

**Figure 13**   (a) Plot showing 96% of 2700 chromatic demultiplexed fields with opponent cone input in both bandpass (small dots) and low pass (large dots) components. (b) Accumulative averages of the data (a), taken over the number of fields given in the abscissa. (c) Ratio of the averages plotted in (b) showing that the average low pass component weights about 60% more than the average bandpass component for samples of chromatic demultiplexed fields with more than 100 elements.

polarity, are effectively subtracted at the cortical cell and the surrounds are practically canceled out.

Another important aspect of the simulated cortical receptive fields is the convergence, on the same cortical cell, of *contiguous* rows of LGN receptive fields: in the case of achromatic decoding, rows of ON units may alternate with rows of OFF units; in the case of chromatic decoding, rows of opposite spectral polarity may be wired together (in one or more cortical stages) to generate a variety of spatial frequency and orientation tuning characteristics. Moreover, the condition of orientation, especially in the case of chromatic specificity, where some evidence indicates lower resolution of orientation tuning [11,25,37], can easily be applied at larger spatial scales by wiring together several rows of LGN outputs under the *same* demultiplexing rule. The consequent loss of spatial resolution is traduced into larger areas of uniform spectral opponency in the case of chromatic

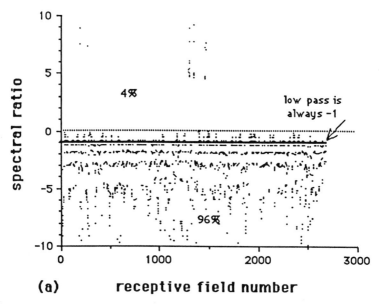

**(a)          receptive field number**

**Figure 14**    (a) For chromatic demultiplexed fields, the spectral ratio of the low pass component is invariant at −1, while it varies widely for the bandpass component, which nonetheless has a negative spectral ratio in most cases (96% of the fields). (b) Accumulative averages of the spectral ratio data in (a), taken over the number of fields indicated in the abscissa.

decoding and into wider rows with the same achromatic polarity in the case of achromatic decoding.

Figure 15 shows surfaces representing the spatial profile and the gain (in the spatial frequency domain) under stimulation with chromatic and achromatic patterns of a cortical neuron wired from a collection of alternate ON and OFF rows of LGN parvocellular inputs; each ON row is of the achromatic type illustrated in Figure 7 and each OFF row is the corresponding achromatic wiring with only OFF-center outputs. The unit's spatial profile can be adjusted to approximate any spatial model that conjointly represents orientation and excitatory and inhibitory bands by adjusting the weight of each LGN input of the cortical unit, thereby representing some kind of synaptic efficiency. The example is an approximation of a Gabor profile in one axis and a Gaussian profile in the other axis. Other profiles are equally well approximated [46–49]. It should not be surprising that just about any spatial profile can be reasonably well approximated because after all, each LGN input can be represented by any of a variety of

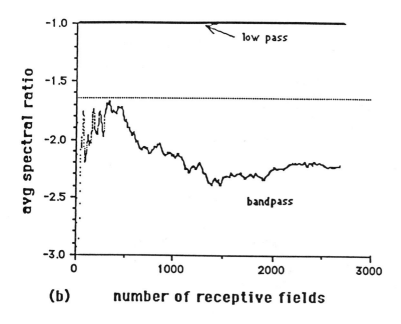

(b)     number of receptive fields

center–surround spatial models and then individually weighted by at least one synaptic weight [37]. Also, the receptive field may be the result of several cortical stages, where different subregions are assembled before being integrated in a single higher level neuron.

Independently of the particular spatial profile adopted, the general result is that neurons wired according to the first demultiplexing rule are selective for achromatic patterns *oriented* along the cell's orientation [axis because they have the highest gain under those conditions and are practically unresponsive to isoluminant chromatic patterns of the same orientation. Outside a certain range of vertical orientations, these hypothetical cortical cells respond to both chromatic and achromatic patterns, but note that the response to chromatic patterns always has much lower gain because there is no locking of polarity (ON or OFF) with cell subtype (L or M) (see also Fig. 11). Current models for possible mechanisms of orientation selectivity have in common the relationship between spatial frequency and orientation [37,47,49–51].

Figure 16 shows surfaces representing the spatial profile and the gain (in the spatial frequency domain) under stimulation with chromatic and achromatic patterns of a cortical neuron wired according to the demultiplexing rule for chromatic specificity (i.e., LGN signals $L_{on}$ and $M_{off}$ are

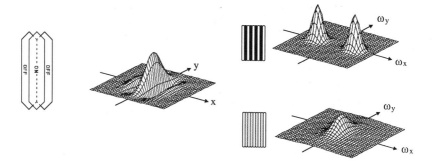

**Figure 15**   Example of using achromatic demultiplexed cortical fields to fit specific spatial profiles. Each of the rows on the left is a demultiplexed achromatic receptive field of the type illustrated in Figure 7; the one in the center obeys the "all-ON rule" and the lateral ones obey the "all-OFF rule." They are built with appropriate weights for each LGN input signal in order to fit a Gabor profile in the $x$-axis direction and a Gaussian profile in the $y$-axis direction. On the right are the modulation response surfaces for achromatic (top) and chromatic (bottom) stimulus patterns.

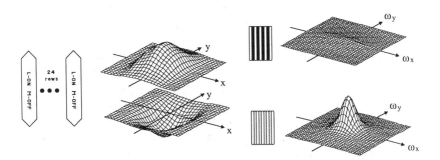

**Figure 16**   Example of using chromatic demultiplexed cortical fields to fit specific spatial profiles. Each of the 24 rows on the left is a demultiplexed chromatic receptive field of the type illustrated in Figure 7. All these rows obey the $L_{on}$ and $M_{off}$ chromatic rule. They are built with appropriate weights for each LGN signal in order to fit Gaussian profiles in both directions. For clarity, the resulting profile is separated in its positive and negative lobes. Although the two lobes are practically in register, they do not have points in common other than zero values. On the right are the modulation response surfaces for achromatic (top) and chromatic (bottom) stimulus patterns.

wired together from 27 consecutive rows just like the row illustrated in Fig. 7). Cell outputs are Gaussian weighted along every row in this example. For clarity, separate surfaces are shown for the positive and negative lobes that result after surround cancellation, but the points of one surface are not on the other; the upper surface encompasses the maxima, which correspond to the $L_{on}$ center locations, and the lower surface, of opposite sign, encompasses the minima, which correspond to $M_{off}$ center locations. The surfaces on the right-hand side represent the gain in the spatial frequency domain under chromatic and achromatic input. Note that orientation selectivity is poor because there is an arbitrary decrease in resolution (24 rows wired together with the same chromatic rule) without a corresponding increase in the length of the rows. Hypothetical cortical cells like this one respond to both chromatic and achromatic stimuli, but the response gain to achromatic stimuli is orders of magnitude smaller than to chromatic stimuli because there is no consistent pattern of polarity. More elaborate cortical cells built by adding several chromatic receptive fields like the wide one illustrated in Figure 16 but alternating in spectral polarity (i.e., combining $M_{on}$ and $L_{off}$ outputs) would represent receptive fields of alternate L-M and M-L bands, like those of the early reports of double-opponent cells [52–54]. Other spatial arrays of double opponency can be represented easily by arranging the corresponding regions of different spectral polarity and adjusting the weight of each LGN input to the cortical unit.

To summarize so far, it is difficult to compare the simulation results to the observed complexity in striate cortex [11,37,55], especially with respect to the chromatic decoding, which merely starts at $V_1$. It is apparent that selective chromatic processing, to the extent of selectivity given by the decoding rules simulated here, may be attained in several processing steps beyond the first cortical stages with results equivalent to the single decoding step of the simulation. One prediction of this theory that could perhaps be relevant to guide physiological studies in the search for chromatic processes is the implication of the decoding rules for the ON and OFF parvocellular subtypes. For achromatic decoding, the ON and OFF pathways should remain segregated along oriented receptive field regions of the same polarity, while chromatic decoding, even if wired in several more stages than those simulated here, requires the combination of ON and OFF signals through a system that keeps type and polarity mutually locked.

## VIII. RELATIONSHIPS WITH PSYCHOPHYSICS

From the beginning, the model of multiplexing has been rooted in both electrophysiology and psychophysics [9,10,16,17,31,32]. Although the simulation of the preceding section is exclusively in terms of properties of

receptive fields, the results from a variety of psychophysical studies can be explained with the multiplexing model just described. With conventional opponent-color models, many psychophysical data are explained by hypothetical interactions between chromatic and achromatic channels. These interactions must take place at stages beyond the stage where the channels are independent, because of the independence postulate in these models. Even though some of these classic explanations are adequate, the multiplexing model opens two fundamentally different alternatives: (a) explanation of psychophysical data in terms of properties of a postreceptor stage, where chromatic and achromatic data are multiplexed; and (b) explanation of psychophysical data in terms of properties of stages at higher levels, where chromatic and achromatic data have been demultiplexed through separate processes, thereby becoming independent. The second alternative is different from conventional chromatic–achromatic independence in that many of the properties of independent demultiplexed subsystems arise from properties of the prior multiplexed stage, which is not possible in current opponent models, where chromatic and achromatic subsystems have in common only the photoabsorption stage. Sections VIII. A–VIII. D summarize psychophysical data that can be understood in terms of these alternatives as implied by the model of multiplexing.

## A.  Chromatic–Temporal Interactions

Threshold mechanisms tapped by Stile's two-color paradigm display different spectral sensitivity curves when they are probed with brief stimuli of different duration [56,57]. The multiplexing model explains these differences in terms of the different weights that spatiotemporal sensitivity functions $N$ and $W$ have on cone signals $L$ and $M$ for different durations. In contrast, a conventional explanation needs first to assume the independence of chromatic and achromatic channels and then to explain these observations in terms of interactions between these two channels. In physiological terms the latter explanation would link these threshold functions with cortical levels of processing, while the multiplexing model would link them with retinal and LGN stages.

## B.  Chromatic and Achromatic Spatiotemporal Threshold Surfaces

A group of related studies on chromatic and achromatic thresholds [58–61] are explained by the multiplexing model. Some of these studies did not include temporal variations as Kelly's did; therefore they practically represent a spatial subset of the broader spatiotemporal ranges measured by

Kelly. In the chromatic domain, however, Mullen [60] extended her measurements from the red–green dimension into the yellow–blue dimension, while Kelly did not. The central concern of these studies was to measure detection thresholds for chromatic and achromatic sinusoidal gratings. When the spatiotemporal thresholds for achromatic stimulation were compared to those for equiluminous, chromatic stimulation, Kelly found that the same pair of spatiotemporal transfer functions ($E$, $I$) could fit both sets of data. The sum ($E + I$) fitted the chromatic spatiotemporal threshold surface, while the difference ($E - I$) fitted the achromatic surface. Since it seems unlikely that the same spatiotemporal functions $E$ and $I$ would characterize unrelated, independent chromatic and achromatic threshold surfaces, the authors of these studies reasoned, in accordance with the multiplexing model, that the *same* mechanism was responsible for both surfaces (see chapter 3). A similar analysis led Rohaly and Buchsbaum [61] to infer that a common spatiochromatic mechanism was involved in both chromatic and achromatic thresholds for gratings varying in spatial frequency, as measured by Mullen, consistent with Kelly's analysis.

An important question emerges from these studies: How can the spatiotemporal threshold surface be expressed as a difference of two transfer functions ($E - I$) when the stimulus modulation is achromatic, and also as the sum of the *same* two transfer functions ($E + I$) when the stimulus modulation is chromatic? Specifically, what is the mechanism that shows both these manifestations? These questions can be answered by proposing a *parallel* between the spatiotemporal functions $N$ and $W$ of the neurophysiological multiplexing model and the transfer functions $E$ and $I$ inferred from the psychophysical data. From Eq. (5) we have:

$$LE - MI = \tfrac{1}{2}\{(L + M)(E - I) + (L - M)(E + I)\} \qquad (10)$$

where $L$ and $M$ are the same cone spectral sensitivity functions as before, and the spatiotemporal transfer functions $E$ and $I$ are those *empirically* derived by Kelly, which are similar in the spatial domain to those obtained by Mullen and modeled by Rohaly and Buchsbaum. The current interpretation in terms of the multiplexing model is that the spectral dependence (functions $L$ and $M$) is exclusively due to the L and M cone photopigments, while the spatiotemporal dependence ($E$, $I$) is due to the neural wiring of the pathways through which the photoreceptor signals must pass before they are combined. Hence the spatiotemporal transfer functions $E$ and $I$ do *not* depend on the spectral cone absorption efficiency, and the model's separability assumption holds. The left-hand side of Eq. (10) represents a common mechanism (which nonetheless could comprise *several* spatiotemporal subchannels), and the right-hand side shows how it can be expressed

in terms of two components that correspond to the achromatic and chromatic spatiotemporal threshold surfaces measured in the studies cited above.

The experimental surfaces follow the shape of the profiles predicted by multiplexing, a spatiotemporal bandpass characteristic for the achromatic component $(E - I)$ and a low pass characteristic for the chromatic component $(E + I)$; therefore, an explanation derived from the model, consistent with the threshold data, is that under achromatic spatiotemporal modulation of the stimulus, the mechanisms represented by the second of the two terms in brackets in Eq. (10) do not contribute to the output modulation, while under isoluminant chromatic spatiotemporal modulation of the stimulus, the mechanisms represented by the first term do not contribute to the output modulation. Although these mechanisms combine chromatic and achromatic components, it can be quantitatively demonstrated that only one of them effectively contributes to the response, because the conditions of stimulation in these studies are either isoluminant chromatic or isochromatic luminous, thereby rendering one of the components inactive.

An alternative explanation involving central processing, still in terms of the multiplexing model, is that the chromatic and achromatic surfaces arise from *decoded* mechanisms given by Eqs. (6)–(9), which retain the essential spatiotemporal properties (conferred by their common postreceptoral origin) given by Eq. (5) but display such new characteristics as orientation selectivity and double color opponency. However, this alternative explanation is weakened by the fact that the data of those studies are detection thresholds, which probably reflect the activity of front-end (i.e., more peripheral) mechanisms in a well-engineered system.

## C. Luminous Efficiency and Unique Yellow Location

In the simulation of Section VI we started by setting the spectral ratio of the cone lattice equivalent to the photopic luminous efficiency function obtained by heterochromatic flicker photometry (most probably mediated by the magno system); that is how the standard value 1.65 was defined. Several psychophysical studies have considered this working hypothesis [39–42]. Interindividual variations in the spectral ratio of the cone lattice would then account for related variations in the luminous efficiency function of those individuals. At the same time, there is evidence that unique yellow is relatively stable among individuals with normal color vision but with significantly different luminous efficiency functions [40]. Thus, we could conceivably link the relative stability of unique yellow with the resulting invariance of the spectral ratio (at $-1$) for the low pass component of decoded chromatic receptive fields as shown in Section VII (see Fig. 14a).

It is simple to demonstrate that this invariant keeps its value for lattices with different spectral ratios as long as they are not too close to the asymptotes for dichromats. The difference in sign and absolute value between the −1 invariant and the standard spectral ratio of 1.65 is also in the right direction, toward a value that implies more relative weight of M cone signals in the chromatic decoding than the weight they have in the achromatic parvo decoding and in the lattice as a whole.

## D. Multiplexing Applied to Chromatic Boundaries: Stereopsis

Many studies that measure some visual response in terms of the relative intensity of two colored lights in bipartite fields or any two-color spatial pattern can now be analyzed under a different approach. Through the multiplexing model, we can define *boundaries* for intensity ratios of any pair of colored lights, such that *every* achromatic demultiplexed subsystem (i.e., those that effectively add different cone outputs) will fail to render as equal any pair of lights of different chromaticity, whenever those lights are presented with an intensity ratio beyond such boundaries.

The derivation of boundary values is useful to explain psychophysical tasks that fail or are practically disabled at luminance ratios of 1, standard isoluminance, *even when the largest possible differences in chrominance between figure and background are introduced* [55,62,63]. This means that the strongest signals from chromatic-specific subsystems (subsystems that, after demultiplexing, effectively subtract signals from different cone types) are *not* sufficient. Thus, for the tasks to be preformed, at least one and probably several achromatic subsystems must signal that the achromatic step between contiguous regions of the image is sufficiently different. We do not know enough about the number and nature of the achromatic subsystems involved for each task. However, it is reasonable to assume that any achromatic visual subsystem will combine signals at least from L and M cones through a large number of neural units. It is further assumed here that all the unknown spatiotemporal factors introduced by postreceptor processing of cone signals would have the net effect of changing the relative cone-specific contributions to the spectral sensitivity of the given achromatic subsystem. These simplifying assumptions are justifiable for the purpose of defining *boundary* values for the possible spectral sensitivity curves of all achromatic subsystems of that type.

We have already used conventional luminance in the simulation (Sec. VII). Standard luminance [CIE's photopic luminous efficiency function $V(\lambda)$] was explained as a combination of $L(\lambda)$ and $M(\lambda)$ cone sensitivity functions. With Smith and Pokorny functions $L(\lambda)$ and $M(\lambda)$ [2] normalized to 1, we can write:

$$[V(\lambda)]_{std} = 1.65\,L(\lambda) + M(\lambda) \tag{11}$$

Real observers show great variability in their luminosity functions (measured by a conventional technique, e.g., heterochromatic flicker photometry), presumably as a result of differences in the relative number of L and M cones [39]. Recent estimates of the cone-type variability in observers with normal color vision place the weighting constant between 1.51 and 2.47 for foveal vision [41,42]. Then,

$$V(\lambda) = k\,L(\lambda) + M(\lambda) \tag{12}$$

where values of $k$ outside the normal range (1.51, 2.47) could indicate an abnormally low (or high) number of one or the other type of cone, and the extremes ($k = 0$, $k = \infty$) represent dichromats missing completely the L-type or the M-type photopigment. In the simulation of Section VII, $k$ was related to the spectral ratio of the cone lattice. In a similar fashion, the spectral sensitivity of any achromatic demultiplexed subsystem $i$ (comprising any number of demultiplexed receptive fields) can be written as follows:

$$V_i(\lambda) = p_i\,L(\lambda) + q_i\,M(\lambda), \qquad 0 < p_i, q_i < 1, \text{ and } p_i + q_i = 1 \tag{13}$$

where unknown constants $p_i$ and $q_i$ (positive, normalized, and complementary) account for all the unknown factors that change the balance of cone-specific contributions to the $i$th achromatic subsystem. Negative values of $p_i$ and $q_i$ are excluded because chromatic signals are assumed to be *insufficient*; then, even if they intervene, their effect could be at most, the partial cancellation of signals from either the L or the M cones conveyed by demultiplexed achromatic pathways, but never effectively reversing the sign. Therefore, we can establish a general criterion for equiluminance: two lights of different wavelength are indistinguishable by the $i$th demultiplexed achromatic channel (i.e., they are equiluminous for that channel) if

$$I_a\,[p_i\,L(a) + q_i\,M(b)] = I_b\,[p_i\,L(b) + q_i\,M(b)] \tag{14}$$

where $I_a$ and $I_b$ are the radiances of lights with wavelengths $a$ and $b$. Thus, the radiance ratio

$$\frac{I_a}{I_b} = \frac{p_i\,L(b) + q_i\,M(b)}{p_i\,L(a) + q_i\,M(b)} \tag{15}$$

reaches *boundary values* for $\{p_i = 1, q_i = 0\}$ and $\{p_i = 0, q_i = 1\}$ given by

$$\frac{I_a}{I_b} = \left\{ \frac{L(b)}{L(a)}, \frac{M(b)}{M(a)} \right\} \tag{16}$$

The basic idea behind this notion is that no two lights having a radiance ratio outside the range defined by their corresponding boundary values can be encoded as equiluminous by any achromatic subsystem of the type defined above; that is, those lights are explicitly different for every demultiplexed achromatic subsystem. Therefore, *that information is available to every higher level process requiring achromatic contrast.*

For example, top and bottom curves in Figure 17 show the predicted (radiance ratio) boundaries for all possible light pairs given by a light of wavelength $a = 700$ nm and another of wavelength $b$ ($b =$ any wavelength between 400 and 700 nm, given in the abscissa). The curve plotted between the boundary curves is the standard luminosity function $V(\lambda)$ normalized at the comparison wavelength (700 nm); that is, it represents how many times brighter (in standard luminance) is a light of wavelength $b$ in the abscissa than a light of 700 nm of the same radiance. Figure 18 is equivalent to Figure 17, except that the ordinate is not logarithmic and is expressed as luminance ratio instead of radiance ratio (i.e., radiance units are transformed to standard luminance; hence, equal luminance ratios plot as a horizontal line of unitary height). This conversion is made because standard luminance is somewhat related to perceived intensity, while radiance is far from any visual correlate.

To better understand this and the other graphs, let us examine the mean-

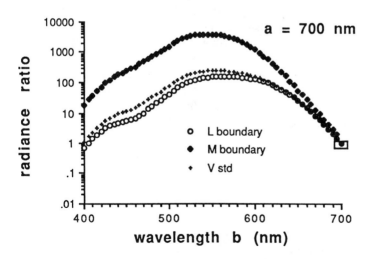

**Figure 17** Predicted L and M boundaries, given as a radiance ratio in the ordinate, for all possible pairs of lights such that one light has fixed wavelength $a = 700$ nm (red), and the other has a wavelength $b$ given by the abscissa. The standard luminance function ($V_{std}$) always plots between the two boundary curves.

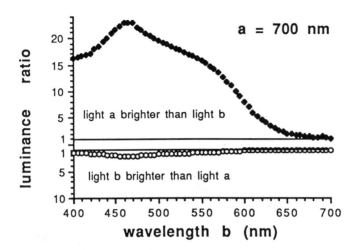

**Figure 18**   The same data as in Figure 17 except that the ordinate is not logarithmic and the values are expressed as *luminance* ratios instead of radiance ratios between lights *a* and *b*. Standard luminance values, the units used here, plot as horizontal lines at the value 1.

ing of the peak value in Figure 18: for the pair of lights of 700 nm (deep red, the comparison light for all the points of this graph) and 465 nm (blue, in the abscissa), the upper plot shows that the red light must be at least 22 times "brighter" (in luminance units) than the blue light for the ratio to be beyond the predicted boundary; the lower plot (note positive units with the scale increasing downward) shows that the blue light needs to be at least 2.3 times "brighter" than the red light for the ratio to be beyond the predicted boundary at the other end. Because of the experimental data discussed below, it is important to note that the boundaries are not symmetric across wavelength. Figures 19 and 20 illustrate similar calculations for a yellow-green comparison light (*a* = 560 nm), and Figures 21 and 22 for a blue comparison light (*a* = 460 nm).

Figure 23 summarizes the theoretical boundaries (in luminance ratio units) for all possible wavelength pairs between 400 and 700 nm. Figures 18, 20, and 22 are vertical slices of Figure 23. Note also that the bottom surface has the same shape as the top surface but inverted (just because of the inverted scale) and rotated 90°. The reason is that every wavelength plays the role of comparison light twice.

Psychophysical data that fit the model of boundaries derived from multiplexing are found in Lu and Fender's study on stereopsis [64]. These investigators effectively measured the boundary values (in luminance ratio units)

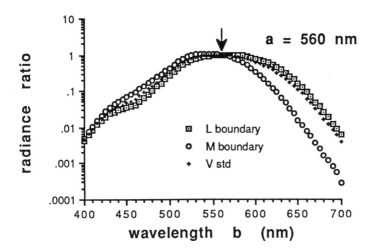

**Figure 19**  Predicted L and M boundaries, given as a radiance ratio in the ordinate, for all possible pairs of lights such that one light has a fixed wavelength $a = 560$ nm (yellow-green) and the other has a wavelength $b$ given by the abscissa. The standard luminance function ($V_{std}$) always plots between the two boundary curves.

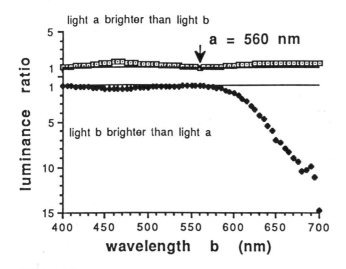

**Figure 20**  The same data as in Figure 19 except that the ordinate is not logarithmic and the values are expressed as *luminance* ratios instead of radiance ratios between lights $a$ and $b$. Standard luminance values, the units used here, plot as horizontal lines at the value 1.

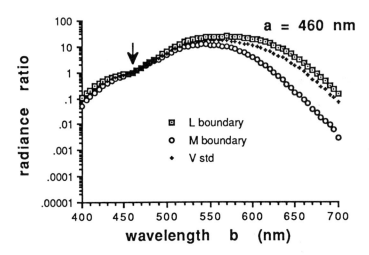

**Figure 21**   Predicted L and M boundaries, given as a radiance ratio in the ordinate, for all possible pairs of lights such that one light has a fixed wavelength $a = 460$ nm (blue), and the other has a wavelength $b$ given by the abscissa. The standard luminance function ($V_{std}$) always plots between the two boundary curves.

defined by the perception of depth in a two-color stereogram of the Julesz type. When the two colors had the same luminance, depth was not perceived, independently of which colors were used. For depth to be perceived, the luminance ratio of any given color pair had to be different from unity. Furthermore, Lu and Fender found an asymmetry: depending on what color was brighter in any given pair, the luminance ratio required for stereopsis was different. Those two experimental values correspond to the boundary values because stimuli with ratios beyond those limits elicited the perception of depth, and any stimuli with ratios between those two boundaries did not elicit the perception of depth. Their summary plots (Figs. 4 and 5 in Ref. 64) are reproduced together as Figure 24, to be compared with Figure 23 derived from the model. Lu and Fender labeled the vertical axis "contrast ratio," but the text of their paper clearly shows that the quantities plotted are actually luminance ratios. Theoretical and empirical boundary surfaces have a striking similarity, even though Lu and Fender's data are for a higher level function (stereopsis) and their plots consist of a relatively small number of points spanning a limited wavelength range (justified by the technical difficulties of the experiment), and considering that they used linear interpolation between data points relatively far from each other to build the surface.

The demultiplexing model prediction of these data should be compared

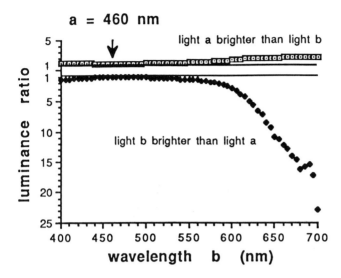

**Figure 22** The same data as in Figure 21 except that the ordinate is not logarithmic and the values are expressed as *luminance* ratios instead of radiance ratios between lights *a* and *b*. Standard luminance values, the units used here, plot as horizontal lines at the value 1.

to the brilliant explanation reported by Phil Russell [65]. He hypothesized that the effect of the achromatic component from a parvo color-opponent cell must dominate over the chromatic component of the same cell for its signal to be significant for stereopsis under Lu–Fender conditions. Calculations based on his reasoning give results similar to those of Figure 23. The difference in the two explanations is that one (Russell's) would link stereopsis (in the Lu–Fender conditions) with stages of parvo processes that have *not* been demultiplexed, whereas the other (boundaries) would link it to a mechanism where achromatic demultiplexed processes with *all possible spectral ratios*, like those found in the third stage of the simulation, are necessary for stereopsis. It is well known that binocular neurons are not found at precortical levels where multiplexed processes prevail; but it is also clear that some of the parvocellular pathways are not demultiplexed even at higher cortical levels and could be involved in stereopsis; therefore, both explanations remain viable.

Although the predicted boundaries were calculated for spectral lights, they can be readily extended to color boundaries displayed with nonspectral primaries (e.g., color CRT phosphors) by adopting the principle of univariance [3]. Also, a common assumption of a front-end nonlinearity at photo-

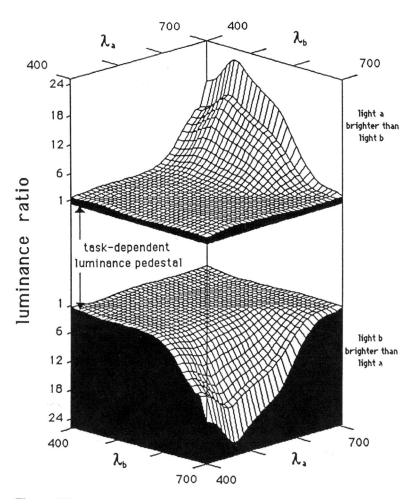

**Figure 23** Predicted boundaries given as luminance ratios in the ordinate, for a pair of lights *a* and *b* with wavelengths $\lambda_a$ and $\lambda_b$. Figures 18, 20, and 22 are vertical slices of this three-dimensional plot. When the visual stimulus is defined by color edges with luminance ratios between the two boundary surfaces, the corresponding visual task will be seriously or totally disabled, according to the model. Different visual tasks will have a different luminance pedestal that should be added between the surfaces; its value is the minimum luminance ratio required to perform the task when the two wavelengths are identical.

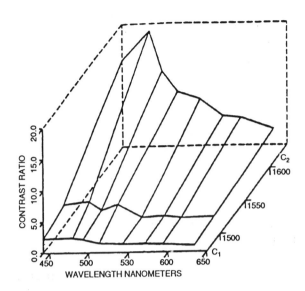

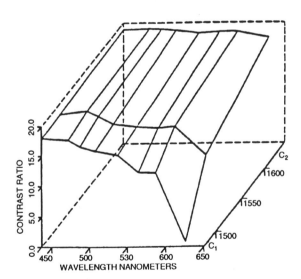

**Figure 24**  Surfaces interpolated from the luminance ratios required for stereopsis. Although Lu and Fender [64] labeled the ordinate as "contrast ratio," it is clear from their paper that it is in luminance ratio units. Upper surface, $C_2$ brighter than $C_1$; lower surface, $C_1$ brighter than $C_2$. These empirical surfaces have a striking similarity to the predicted surfaces of Figure 23. (From Ref. 64.)

receptor sites would not change the essence of the predictions; however, nonlinearities *after* multiplexing (e.g., half-wave rectification at cortical stages and probability summation of signals) would convey additional implications.

## E. Minimum Grating Measurements

Following the studies of minimum flicker match and minimum border match [2], this author has studied the minimum grating match. In analogy to the criteria of minimum flicker and minimum border, the minimum grating criterion is a perceptual match of two lights of different spectral content; however, the lights are presented as two sinusoidal gratings of the same spatial frequency and different color, and the two gratings are interlaced in spatial counterphase. The task of the subject is to minimize the perceived pattern by adjusting the contrast of one of the gratings. The principle guiding this experiment is the same principle used for a minimum flicker match or a minimum border match, where the eye is used as a zeroing instrument. Instead of a flickering light or a two-color border, the observer has to minimize the perceived pattern.

It was found that minimum grating matches are linear with respect to contrast. Figure 25 shows that increasing values of the fixed contrast re-

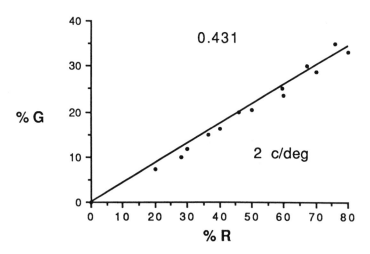

**Figure 25** Minimum grating matches (in percent red and green contrast) of subject SS. The matches behave linearly for contrast values within a wide range. The slope of the best-fitting straight line was defined as the minimum grating match for that spatial frequency.

quire proportionally larger values of the variable contrast for the match. The average luminance of the stimulus was kept constant at 65 cd/m². The contrast range was tested from 20% to 80% for red and from 10% to 40% for green. Half the points were measured with the red contrast fixed, and the other half with the green contrast fixed. All the points fell along the same line. The slope of the line best fitting the data was defined as the relative efficiency of the red light with respect to the green light. The red light was 43% as efficient as the green light for this subject, because she needed more than twice the red contrast to match a given amount of green contrast in the minimum grating paradigm. By removing the grating patterns and alternating the same two lights in a temporal sinusoidal fashion at 15 Hz, conventional flicker matches were measured in the same contrast range. Figure 26 shows the data for the same subject. Minimum grating matches at 2 c/deg and flicker matches are nearly the same, but the small difference in slope is significant because error bars are practically the size of the points. Next, higher spatial frequencies were evaluated. It is worthwhile to mention at this point the controls for the three sources of error detected in pilot tests: eye movements, chromatic adaptation, and chromatic aberration. Involuntary eye movements were controlled by stabilizing

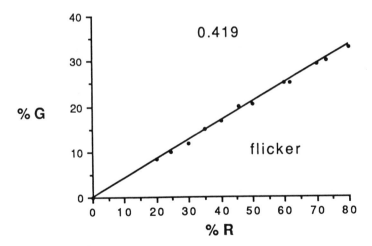

**Figure 26**   Minimum flicker matches (in percent red and green contrast) of subject SS. The matches were made between the same lights used in the minimum grating match but presented in a homogeneous field and sinusoidally alternated at 15 Hz. The slope of the best-fitting straight line was defined as the subject's flicker match.

the retinal image with an eyetracker and stabilizer as described elsewhere [66]. Chromatic adaptation was controlled by introducing a slow drift in the already stabilized gratings. The drift had to be slow enough to preserve the perception of pattern but fast enough to avoid differential chromatic adaptation to the red and green bars of the gratings. For every spatial frequency tested, the gratings were drifted at a speed such that the temporal frequency introduced was 0.4 Hz in all cases. Axial chromatic aberration was corrected with a Bedford & Wyszecki achromatizing lens at the exit pupil. Lateral chromatic aberration was corrected by optimizing the lateral position of the eye with respect to the exit pupil of the system while looking at red–green, square-wave gratings, flickered in counterphase. When the eye position is not optimal, lateral aberration produces thin yellow lines at the red–green borders of the square-wave grating. Counterphase flicker of these gratings is minimized by adjusting the contrast of one of the gratings, but the thin yellow lines produce a residual glimmering that disappears only when the lateral position of the eye is optimal and lateral chromatic aberration is corrected.

Figure 27 shows the complete data for one of three subjects. Increasingly more green contrast is required to match the red contrast for higher spatial frequencies in the range of 2–12 c/deg, as indicated by the slopes of the lines. The small horizontal and vertical bars in the bottom right graph correspond to two standard deviations for those points. The bars for all the other points are smaller and omitted for clarity.

The three sets in Figure 28 summarize the data for all three subjects. The vertical axis corresponds to the slopes of the contrast matching data. A value of 0.5 on this axis means that the red contrast is half as efficient as the green contrast for the mechanism driving the perceptual match. Spatial frequency is on the horizontal axis. The first point on the left of each set corresponds to the slope obtained from flicker matches. Therefore, when spatial frequency is increased, the minimum grating match becomes more "red-sensitive" than a standard flicker match of the same lights. A similar shift of spectral sensitivity with increased spatial frequency can be found in a report of Mullen [60]. Figure 29 shows her data: small arrows indicate the maxima or minima, which are the relevant points in the context of Mullen's study, and it is clear that they correspond to lower percent of red light (in the horizontal axis) for increasing spatial frequency. Moreover, the spectral sensitivity curve obtained with minimum border matches is more red-sensitive than the standard CIE luminosity function, which is closely fitted by flicker matches. It suggests that in judging the sharpness of the border, visual mechanisms with higher red-sensitivity than mechanisms for flicker play a significant role. Figure 30, from a classical study, shows such a difference [67]. Figure 31, from another report [68], compares

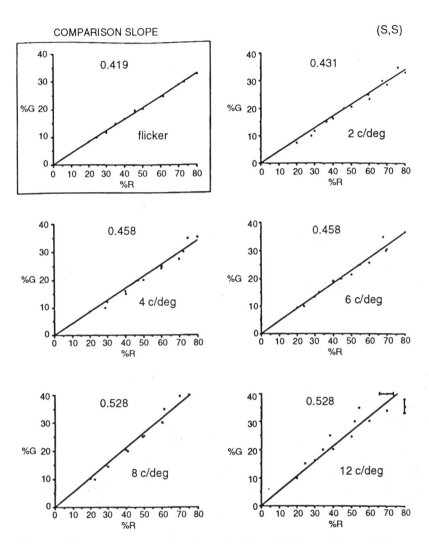

**Figure 27** Complete matching data of subject SS. The top left graph is a reproduction of Figure 26, the flicker match used for comparison. The other graphs show the data for increasing spatial frequencies 2, 4, 8, and 12 c/deg. The small bars in the graph at the bottom right represent the maximum errors of all data and correspond to 2 standard deviations for those points.

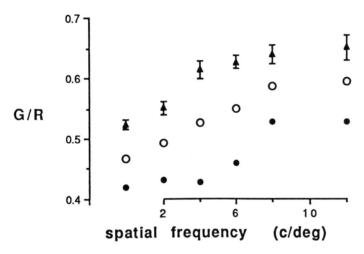

**Figure 28**   Summary of minimum flicker matches (points on the left) and minimum grating matches from three subjects. Ordinate values represent slopes from plots of raw experimental data like those shown in Figure 27.

relative achromatic contrast measured by flicker matches and by minimum border matches (MBM), showing sensitivity shifts in the same direction. It must be pointed out, however, that in the studies corresponding to Figures 30 and 31 the data are averages from different subjects.

These results may be interpreted by the following reasoning: the detection and discrimination of pattern is dominated by achromatic mechanisms, which are tuned at different spatial frequencies and with different spectral sensitivities. At low spatial frequencies the achromatic mechanisms involved in pattern detection have a spectral sensitivity that closely resembles the spectral sensitivity of the mechanisms involved in flicker matches, but at higher spatial frequencies, the mechanisms involved are more "red-sensitive" or less "green-sensitive," or both.

How can we interpret the shift toward more red-sensitivity in mechanisms tuned to higher spatial frequencies? We have no conclusive answers yet, however, an explanation in terms of the multiplexing model is illustrated in Figure 32. On the theoretical curve are the three sets of experimental slope values (ordinate) of Figure 28. On the abscissa are the values for $k$, which is a hypothetical spatial ratio predicted from multiplexing [see the spatiotemporal terms $p$ and $q$ in Eq. (15) with $k = p/q$] according to the formula:

$$\frac{R}{G} = \frac{k\,L_g + M_g}{k\,L_r + M_r} \tag{17}$$

where $L_{r\ or\ g}$ and $M_{r\ or\ g}$ are the quanta of red or green light absorbed by L and M cones. Current studies are evaluating several possible interpretations for the spatial ratio $k$.

## F. Chromatic and Achromatic Afterimages

Don Kelly and this author have worked together measuring afterimages for the past few years [69]. In our experimental setup, the subject perceives a nonbleaching negative afterimage after the eye has been conditioned for several seconds by a retina-stabilized grating: either an isoluminant red/green conditioning grating, which produced a green/red (spatially reversed) afterimage, or an achromatic conditioning grating (bright yellow–dim yellow), which produced an achromatic afterimage also spatially reversed. At a designated time after conditioning, during the appearance of the afterim-

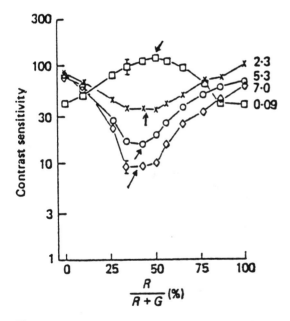

**Figure 29**  Contrast sensitivity as a function of red/green luminance ratio at four spatial frequencies (c/deg). Small arrows, added at the extremum of each curve to show the relevant points in the present context, indicate lower percent values of red light (on the abscissa) for increasing spatial frequencies. (Data from Ref. 60.)

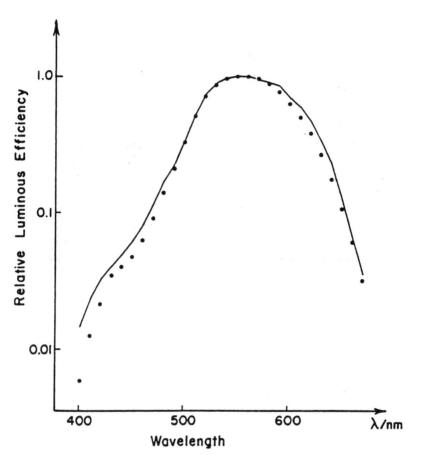

**Figure 30**   Minimum border matches (line) are more red-sensitive than minimum flicker matches (solid circles). (Data from Ref. 67.)

age, we presented a flashed grating of the same spatial frequency and measured its threshold. The flashed grating could be isoluminant red–green or achromatic, and it could be in phase or in counterphase with the afterimage. The stabilized stimulus was foveally presented, subtended 4 degrees of visual angle, and its average luminance was maintained constant for every condition at 65 cd/m$^2$.

The results for one of the three subjects are shown in Figure 33; results for the other subjects are practically identical. On the vertical axis are the values of threshold contrast of the flashed gratings. The horizontal axis is merely a classification in three groups; the group on the right represents

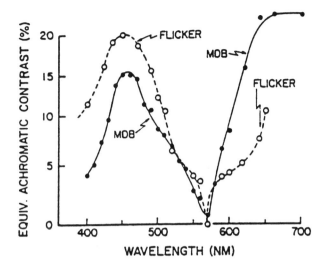

**Figure 31** Equivalent achromatic contrasts determined by two methods. Minimum border matches are represented with solid symbols. Minimum flicker matches with a standard of 580 nm are represented by open symbols. The difference is in the same direction as the difference between minimum grating matches and flicker matches (note the region beyond 580 nm), although different subjects participated in the compared methods; MDB, minimally distinct border. (Data from Ref. 68: Figure 16.9.)

the thresholds for chromatic and achromatic flashed gratings on a uniform background, without any afterimages. The group on the left represents the thresholds of the flashed gratings presented on top of an achromatic afterimage; and the group in the middle represents the thresholds of the flashed gratings presented on top of an isoluminant red–green afterimage. A major asymmetry is readily evident: both types of afterimage have a strong effect on the threshold of the isoluminant red–green flashed grating; in comparison, the threshold of the achromatic flash is virtually unaltered by either type of afterimage. Also, these results are independent of spatial phase. The importance of such a large effect rests on the implications of the physical differences between the two types of flashed grating. It is reasonable to think that the threshold of the red–green isoluminant grating is driven by color-opponent processes, probably subserved by the parvocellular subsystem, while the threshold of the achromatic grating flash is driven by a broad-band process, probably subserved by the magnocellular subsystem (a parallel observation in another lab assumed that *bleaching* afterimages were conveyed by the parvocellular system [70]). Therefore,

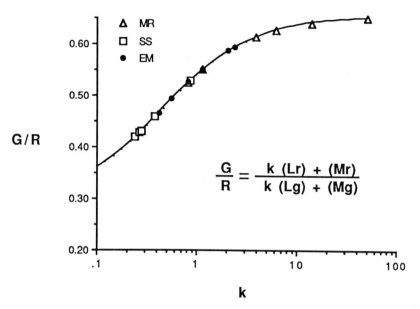

**G/R**

$$\frac{G}{R} = \frac{k\,(Lr)\,+\,(Mr)}{k\,(Lg)\,+\,(Mg)}$$

**Figure 32** Relationship between the multiplexing model and minimum grating data. On the abscissa are the values of $k$ from the formula given as an inset. The meaning of $k$ is related to the spatial ratio $p/q$, with $p$ and $q$ from Eq. (15). On the theoretical curve are the three sets of data from minimum grating matches by three subjects.

the data suggest that both chromatic and achromatic afterimages are predominantly subserved by parvocellular processes. However, we wanted to be sure that these results were not a peculiar outcome from a certain set of experimental conditions. So we set out to measure the contrast of both types of afterimages in order to analyze their behavior under spatial and temporal variations.

Three techniques to measure the contrast of afterimages were tested; the most accurate and reproducible one was a cancellation technique. The conditioning grating and the afterimages were produced in the same way as before, but instead of a flashed grating we presented a steady, canceling grating on top of the afterimage. This canceling grating was always of the same type and spatial frequency as the conditioning grating and was always presented in spatial counterphase with the afterimage. We measured the contrast of the canceling grating that was required to cancel out the perceived afterimage. We varied the contrast (10–90%), duration (1–12 s), and spatial frequency (0.25–4.0 c/deg) of the conditioning grating, and the time

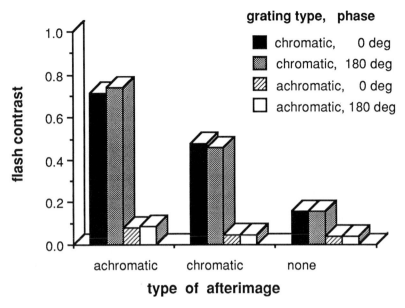

**Figure 33**   Effect of afterimages on the threshold of chromatic and achromatic flashed gratings. The ordinate represents the threshold in percent contrast. On the abscissa there are the three sets of conditions. Left: the flash is presented on an achromatic afterimage; middle: the flash is presented on a chromatic isoluminant afterimage; right: the flash is presented in the absence of afterimages. Within each set, the flash is presented in spatial phase or counterphase with the afterimage, as indicated.

between its offset and the presentation of the canceling grating. Again, three subjects produced similar data.

Figure 34 shows the data for one of the low spatial frequencies. Higher conditioning contrast yields proportionately higher afterimage contrast for both chromatic and achromatic afterimages. The slope of the best-fitting straight line is the ratio of afterimage contrast to the contrast of the conditioning grating. That slope is defined as the relative afterimage contrast in upcoming figures.

Figure 35 summarizes how the relative afterimage contrast varies with spatial frequency. It has a low pass profile with cutoff frequency of about 4 c/deg. We also varied the time of conditioning to obtain the time course of buildup of the afterimage, and then we varied the time between the onset of the afterimage and the presentation of the canceling grating, to obtain

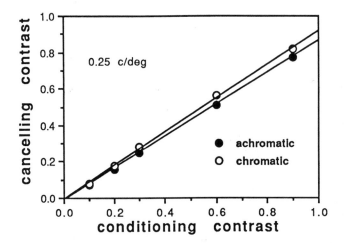

**Figure 34**   Measurement of the strength of chromatic and achromatic afterimages of 0.25 c/deg with the cancellation technique. Afterimage contrast increases linearly with conditioning contrast.

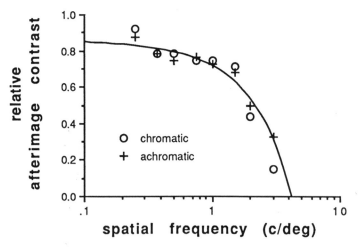

**Figure 35**   Summary of data on the variation of relative afterimage contrast with respect to spatial frequency.

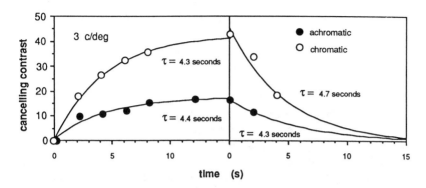

**Figure 36**  Buildup and decay of chromatic and achromatic afterimages. In all cases the curves fit exponential functions (increasing or decreasing, accordingly) with the indicated time constants $\tau$. Similar data was obtained for lower spatial frequencies.

the time course of decay. Figure 36 is a typical buildup and decay curve: it corresponds to one of the high spatial frequencies tested, but all the lower frequencies had similar time courses of buildup and decay. They were all well fitted by exponential functions with time constants between 4 and 8 seconds.

In summary, afterimage contrast is linearly related to conditioning contrast in the range of 10 to 80%. Chromatic and achromatic afterimages have similar low pass spatial frequency characteristics, cutting off at about 4 c/deg. Both types of afterimage build up and decay exponentially, with time constants between 4 and 8 seconds.

The linearity of afterimage contrast and the spatial and temporal properties of afterimages support the main finding of these experiments: that the threshold of an achromatic grating flash is virtually undisturbed by either chromatic or achromatic afterimages, which nonetheless strongly modify the threshold of an isoluminant chromatic grating flash. All the similarities between chromatic and achromatic afterimages suggest a common underlying mechanism. Their clearly selective interaction with the isoluminant chromatic grating, not with the achromatic one, dismiss the feasibility of an achromatic transient system and point to a sustained multiplexed system as the common mechanism conveying both chromatic and achromatic information.

## IX.  GENERALIZATION OF MULTIPLEXING

The essence of multiplexing can be generalized in several ways. First, multiplexing is a representation valid for $n$ dimensions. A mathematical theorem

presented and demonstrated in the Appendix supports this abstract level of generalization. Second, and perhaps more practical, multiplexing can be generalized as a theory of the excitation–inhibition duality, so pervasive in all biological sensory systems. Whatever the sensory modality, the initial processes take as physical input some form of energy distributed in space and time. The top box of Figure 37 represents a distribution **Q** of any form of energy, as a function with arguments in three physical dimensions: an energy variable ($\phi$) (wavelength of light, air pressure in sound waves, mechanical force, chemical concentration, etc.), three-dimensional space (x,y,z), and time (t). Whatever the relevant information is for a given sensory modality, it must be extracted from the spatiotemporal distribution of energy. The first processing stage is transduction: such specialized sensors as photoreceptors, auditory hair cells, Meissner's cells for touch, papilla cells for taste, and olfactory rods respond with neuroelectric signals to specific forms of energy. The following stages involve specialized wiring strategies of various types depending on the neural pathway, but everything

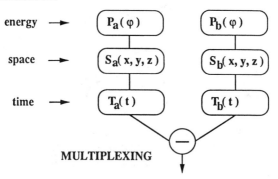

**Figure 37** Multiplexing in any sensory modality. The appropriate stimulus is given by a space (x,y,z) − time (t) energy signal **Q**. This signal is sampled by two sensors *a* and *b* of a given sensory system. The sensors are characterized by three separable sensitivity functions, one that depends on an energy variable $\varphi$, one that depends on 3D space (x,y,z) and one more that depends on time (t).

indicates that excitatory–inhibitory interactions are commonplace after transduction in every sensory pathway; therefore, it is attractive to propose that *spatiotemporal multiplexing follows transduction in all sensory modalities*. This is not really new. There have been landmark studies, especially in vision, where inhibition has been understood as a differential sampling operator: either *spatial*, for edge detection, *temporal*, for flicker and movement detection, or *spectral*, for color processing. What is new in this model is that the dimensions of sampling do not have to be independently encoded; a single mechanism samples *simultaneously* several dimensions in a spatiotemporal multiplexed fashion, which is described with precision by the multiplexing theorem.

Another level of generalization emerges from the fact that multiplexing is a representation valid for any number of dimensions, as demonstrated in the Appendix. In Figure 38, which is an extension of Figure 37, the box on the top represents an arbitrary signal as a function in **n** dimensions. The multiplexing theorem says that this signal can be multiplexed by an opponent system sampling it in **m** dimensions, with sampling functions $A$ and $B$ for each dimension. Decoding is also generalized. Suppose we want to de-

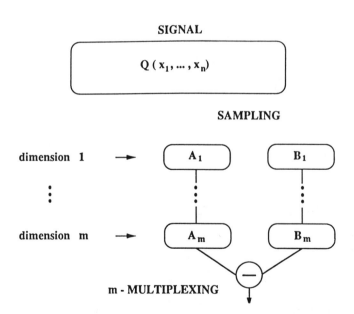

**Figure 38** Generalization of multiplexing. A signal **Q** defined in $n$ dimensions is sampled by two functions $A$ and $B$ in each of $m$ (not necessarily equal to $n$) dimensions.

code the dimension labeled *i*. Then, a conjugated sampling system is required, as illustrated in Figure 39, where the sampling functions labeled *i* are interchanged. The addition of outputs from the two systems decodes an integrative signal in the selected dimension (like the achromatic signal in vision), and the subtraction decodes a comparative signal (like the color signal in vision). The first one is an *i*-correlated signal, while the second one is an *i*-decorrelated signal. These ideas are set forth rigorously in the Appendix.

## X. APPLICATION OF MULTIPLEXING TO COMPRESSION OF DIGITAL COLOR IMAGES

The conventional representation of digital color images consists of three arrays of numbers RGB corresponding to the three primaries of color CRTs. In principle, these arrays are in *spatial register*; thus, for each pixel

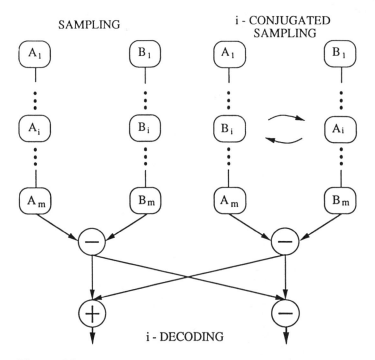

**Figure 39** Diagram illustrating the generalization of decoding of a multiplexed signal. The *i*-conjugated process is built by interchanging the *i*th sampling functions *A* and *B*. Then, the complete results of original and conjugated sampling processes are separately added and subtracted to obtain *i*-correlated and *i*-decorrelated signals.

(picture element) there are three numbers independently available for digital processing and display. In contrast, human color vision involves a retina with a *single layer* of photoreceptors comprising cones of three types interspersed in that layer. Different cones are at different retinal locations, and this is one of the foundations of the multiplexing model; to a practical mind, it suggests that digital color images are overrepresented, with three times as many numbers than are strictly necessary.

The idea becomes important because of the size of digital color images. Realistic color requires at least 24 bits per pixel (8 bits for each primary), which will soon become standard in personal computers as more and more realistic imagery is being used. So, an image of, say, $512 \times 512$ pixels requires 6.3 million bits; a satellite image of $5000 \times 5000$ pixels requires 600 million bits. Thus, efficient compression of digital color imagery is a centerpiece in the development of any commercial application requiring massive storage and/or fast transmission of digital images in color.

The current standard for still-image compression is a baseline system specified by the Joint Photographic Experts Group (JPEG). This system is essentially single band, or monochrome [71]. Thus, for color (or more general multispectral) images, the JPEG standard basically encodes each component independently, and indeed, some applications simply compress R, G, and B or any other spectral image components separately. This is seldom optimal, however, because in most cases there is significant correlation in the information contained by different spectral bands of the same image. In the case of color images intended for human viewing, JPEG recommends that the original RGB image components be decorrelated by linear transformation into the $YIQ$ (or $YC_1C_2$) planes of an opponent-color space, because most of the visual information, about 93%, is allocated to the $Y$ plane by the transformation; therefore, the $I$ and $Q$ planes can be spatially subsampled to reduce drastically their size without significant perceptual losses. After such initial compression, generally referred to as *front-end compression*, JPEG performs an independent spatial frequency compression of the $Y$ and the subsampled $I$ and $Q$ components to reach further overall compression. For the latter compression, the three planes are divided into blocks of $8 \times 8$ pixels and a discrete cosine transform (DCT) is computed for each block. Next the coefficients of the transformed blocks are weighted in accordance with the number of bits allocated by a quantization matrix for each spatial frequency; two independent quantization matrices are used, one for the $Y$ plane and another for both $I$ and $Q$ planes. Finally, run-length (Huffman) encoding is applied to the quantized coefficients [72]. See the top diagram in Figure 40.

It is important to emphasize two characteristics of the currently standard technique for compression of color images for human visualization: (a) it

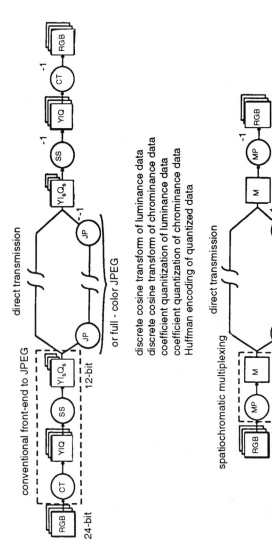

**Figure 40** Top: a conventional color space transformation (CT) and subsampling (SS) precedes the application of standard image compression JPEG (JP). Bottom: the multiplexing procedure (MP) is a simpler front-end to JPEG and requires a simpler, single-plane implementation of JPEG or any other conventional gray-level compressor.

obtains front-end compression by subsampling the chromatic planes $I,Q$ resulting from a color space transformation; and (b) it performs DCT and quantization computations *independently* for achromatic ($Y$) and chromatic (subsampled $I$ and $Q$) planes. The evident parallel between this technique and the zone theory's postulate of independent processes for chromatic and achromatic encoding is not a coincidence. The $YIQ$ color space transformation is a technical inheritance from the development of color TV, which applied existing opponent-color models.

As the model of multiplexing brings into question the independence postulate, it also suggests an alternative process to compress digital color images. Suppose that the input consists of three 8-bit-per-pixel planes, R, G, and B. The main steps of this process are as follows:

1. It does a much simpler front-end computation than a $YIQ$ transformation. It builds a single 8-bit-per-pixel plan *à la retina*: that is, in some pixels the numbers come from the R plane, in others they come from the G plane, and in some others they come from the B plane; but there is only one number per pixel, and the same total number of pixels as in one of the original planes. This is a spatiochromatic multiplexed plane (M) of the same size as the original image but with one-third the numbers.
2. Depending on the needs of specific applications, the M plane is stored and/or transmitted as it is, or it is further compressed by any conventional *single-plane* compression algorithm (e.g., single-plane JPEG as illustrated in the lower diagram of Fig. 40).
3. After storage and/or transmission (and conventional decoding of M if a single-plane compression was used for additional compression), the plane M is decoded into R, G, and B planes, according to the demultiplexing rules of the model [Eqs. (6)–(9), appropriately restructured for RGB images].

At the vision labs of SRI we have processed many realistic images of very different content with top-of-the-line commercial JPEG software and with our multiplexed procedure; the results indicate three principal advantages of the compression technology derived from multiplexing:

1. Immediate 3 : 1 compression without any computation. When decoding has been performed without any further compression, the perceived spatial resolution and color rendition of the decoded images is almost indistinguishable from the originals.
2. Compatibility with several single-plane compression processes designed for black and white (gray-level) images, when additional compression is required.

3.  Tradeoff between visually perceived quality and compression ratio (up to 100 : 1) similar to that obtained with commercial versions of full-color JPEG. The new multiplexed technology, however, saves whatever additional complexity is required by those conventional means to store, process, and transmit the chromatic data (e.g, whatever processing is required to deal with the $I$ and $Q$ planes), including the front-end computation required to transform RGB to $YIQ$, which involves nine digital multipliers and is not a simple matter as it is in analog systems like current color TV.

One of the many possible applications being tested at SRI is the conversion of digital still cameras currently designed to produce gray-level digital images into cameras that deliver full-color digital images. For example, the output of a digital camera designed to render 8-bit black and white images can be easily transformed to deliver 24-bit, full-color images of the same dimensions. This is true for the whole range of digital cameras, from low cost models with low resolution (say, 380 × 250 pixels) up to high resolution cameras with 5000 × 5000 pixels. With the multiplexing technology, the electronics and memory that handle the output from charge-coupled devices (CCDs) within a current black and white digital camera remain the same; only the CCD itself needs to be modified with available technology into a single-plane, color-coded CCD, but that does not change its output bandwidth. An additional advantage is that this application is compatible with standard single-plane JPEG compression; thus, current black and white digital camera systems using single-plane JPEG would maintain their advantages for efficient storage and transmission, but the feature of full-color rendition would be added.

## XI.  SUMMARY

Multidimensional multiplexing is a model based on first principles; it has a mathematically demonstrated validity as a formal abstraction. In contradistinction with a more common style of modeling in vision research, it is not an *operational* model that requires validation by data obtained under null-hypothesis paradigms. Rather, it is a model that provides explanations for apparently unrelated data, indicates conditions and outcome of phenomena yet to be measured, and suggests practical applications.

This chapter shows how the multiplexing model reveals inconsistencies between the psychophysical assumption of independent achromatic and chromatic processes following photoabsorption and the neurophysiological data on precortical processes; it also makes explicit some spatiotemporal restrictions on the conventional dictum of neural wiring for color-opponent

and color nonopponent interactions and reveals the relationship of chromatic and achromatic decoding with orientation selectivity and current models of spatial vision. Although it does not offer a clear solution to ongoing controversies in the interpretation of electrophysiological data on chromatic and achromatic processes, it does provide new insight into a broad range of psychophysical data from spatiotemporal threshold surfaces to stereopsis of chromatic stereograms. The model, originally conceived for two and three dimensions, has been formally generalized for any number of dimensions, opening its range of applicability to other sensory processes and even nonbiological systems. The model also provides a new tool for compression and decompression of digital color images with practical advantages over existing technology.

## APPENDIX

The following theorem was discovered and proved by the author to support the generalization of opponent multiplexing. A search for known equivalent forms has not been successful so far, indicating the possibility that the theorem is original.

### Theorem

Let $Q_a$ and $Q_b$ be two real-valued vector functions having the same range $R$ (the set of real numbers) and the same domain:

$$Q_a, Q_b : D_1 \times D_2 \times \cdots \times D_n \to R \qquad \text{(A-1)}$$

where each $D_i$, for all $i = 1, \ldots, n$, is a subset of any one of $R^1$, $R^2$, $\ldots, R^m$. If there are functions $A_i, B_i : D_i \to R$, for all $i = 1, \ldots, n$, such that $Q_a$ and $Q_b$ are separable into the products:

$$Q_a = A_1 A_2 \cdots A_n \qquad \text{and} \qquad Q_b = B_1 B_2 \cdots B_n \qquad \text{(A-2)}$$

Then, the addition or subtraction of $Q_a$ and $Q_b$ is equal to the average of products of *certain* additions and subtractions of functions $A_i$, $B_i$:

$$Q_a \pm Q_b = \frac{1}{2^{n-1}} \sum_{k=1}^{2^{n-1}} \prod_{i=1}^{n}{}_k (A_i \Delta B_i) \qquad \text{(A-3)}$$

where the operation $\Delta$ is defined by the following rules:

1. For each $i$, $\Delta$ is either the operation of addition $(+)$ or subtraction $(-)$.
2. For each $k$, the distribution of the $n$ signs resulting from $\Delta$ must be different.
3. For each $k$, the product of the $n$ signs given by $\Delta$ must be a positive

sign for the sum $\mathbf{Q_a} + \mathbf{Q_b}$ and a negative sign for the difference $\mathbf{Q_a} - \mathbf{Q_b}$.

## Demonstration

The theorem is proved here for the difference. The proof for the sum follows the same reasoning. The proof is obtained by mathematical induction:

Let the functions $\mathbf{Q_a}$ and $\mathbf{Q_b}$ be such that conditions (A-1) and (A-2) of the theorem are satisfied.

1. For $n = 1$ the theorem is trivial:

$$\mathbf{Q_a} - \mathbf{Q_b} = A_1 - B_1 \tag{A-4}$$

For $n = 2$:

$$\mathbf{Q_a} - \mathbf{Q_b} = \tfrac{1}{2}\left\{(A_1 + B_1)(A_2 - B_2) + (A_1 - B_1)(A_2 + B_2)\right\}$$
$$= \tfrac{1}{2}(2A_1 A_2 - 2B_1 B_2) = A_1 A_2 - B_1 B_2 = \mathbf{Q_a} - \mathbf{Q_b} \tag{A-5}$$

Expression (A-5) will be used below; it is not a necessary step in the mathematical induction formalism.

2. Given that the theorem is true for $n = 1$, and assuming now that it is true for $n$, it is proven for $n + 1$:

$$\mathbf{Q_a} - \mathbf{Q_b} + (A_1 A_2 \cdots A_n A_{n+1}) - (B_1 B_2 \cdots B_n B_{n+1}) \tag{A-6}$$

define the functions $\mathbf{A}$ and $\mathbf{B}$ as:

$$\mathbf{A} = A_1 A_2 \cdots A_n \quad \text{and} \quad \mathbf{B} = B_1 B_2 \cdots B_n \tag{A-7}$$

then,

$$\mathbf{Q_a} - \mathbf{Q_b} = \mathbf{A}A_{n+1} - \mathbf{B}B_{n+1} = \tfrac{1}{2}\left\{(\mathbf{A} + \mathbf{B})(A_{n+1} - B_{n+1})\right.$$
$$\left. + (\mathbf{A} - \mathbf{B})(A_{n+1} + B_{n+1})\right\} \tag{A-8}$$

where expression (A-5) was applied to obtain (A-8). Now, we are assuming the theorem valid for $n$; thus we apply it separately to each of the terms $(\mathbf{A} + \mathbf{B})$, which are of order $n$, and substitute the result in Eq. (A-8):

$$\mathbf{Q_a} - \mathbf{Q_b} = \frac{1}{2}\left[\frac{1}{2^{n-1}}\sum_{k=1}^{2^{n-1}}\prod_{i=1}^{n}{}_k\,(\mathbf{A_i}\,\Delta\,\mathbf{B_i})\right](\mathbf{A}_{n+1} - \mathbf{B}_{n+1})$$
$$+ \frac{1}{2}\left[\frac{1}{2^{n-1}}\sum_{k=1}^{2^{n-1}}\prod_{i=1}^{n}{}_k\,(\mathbf{A_i}\,\Delta\,\mathbf{B_i})\right]^{*}(\mathbf{A}_{n+1} + \mathbf{B}_{n+1}) \tag{A-9}$$

It is necessary to realize that the two terms in brackets define two disjoint sets of sign distributions, in accord with the rules for operation $\Delta$. That is, the first term in brackets is the expression for $\mathbf{A} + \mathbf{B}$; then, by rule 3 following Eq. (A-3), each of its sign distributions must produce a positive sign, whereas the second term in brackets, marked with an asterisk to distinguish it from the first one, is the expression for $\mathbf{A} - \mathbf{B}$; so, each of its sign distributions must produce a negative sign. It follows that all the sign distributions in the first term are different from those in the second one, thereby forming disjoint sets with the same number of elements. When the two different factors with subindex $(n + 1)$ are introduced into the brackets there are three consequences: (a) the number of terms in each product increases from $n$ to $n + 1$; (b) the two sets of sign distributions keep the characteristic of being disjoint (i.e., all the sign distributions are different); and (c) all the resulting distributions in both terms are now such that multiplying the signs within each distribution always results in a negative sign; therefore:

$$\mathbf{Q_a} - \mathbf{Q_b} = \left[ \frac{1}{2^n} \sum_{k=1}^{2^{n-1}} \prod_{i=1}^{n+1}{}_k (\mathbf{A_i} \, \Delta \, \mathbf{B_i}) \right]$$

$$+ \left[ \frac{1}{2^n} \sum_{k=1}^{2^{n-1}} \prod_{i=1}^{n+1}{}_k (\mathbf{A_i} \, \Delta \, \mathbf{B_i}) \right]^* \qquad (A\text{-}10)$$

where the asterisk on the second term indicates again that all its sign distributions are different from those in the first term. The two terms have the same number of products; that is, the total number of products $\Pi$ being added is $(2^{n-1}) + (2^{n-1}) = 2^n = 2^{n+1-1}$; then:

$$\mathbf{Q_a} - \mathbf{Q_b} = \frac{1}{2^{n+1-1}} \sum_{k=1}^{2^{n+1-1}} \prod_{i=1}^{n+1}{}_k (\mathbf{A_i} \, \Delta \, \mathbf{B_i}) \qquad (A\text{-}11)$$

which is the expression of the theorem for $n + 1$. That completes the proof.

## Example

The conclusion of the theorem given by expression (A-3) and the rules for operation $\Delta$ are clarified by writing the terms for $n = 3$:
For the sum:

$$\mathbf{Q_a} + \mathbf{Q_b} = (A_1 A_2 A_3) + (B_1 B_2 B_3)$$
$$= \frac{1}{4} \{ (A_1 + B_1)(A_2 + B_2)(A_3 + B_3)$$

$$+ (A_1 + B_1)(A_2 - B_2)(A_3 - B_3)$$
$$+ (A_1 - B_1)(A_2 - B_2)(A_3 + B_3)$$
$$+ (A_1 - B_1)(A_2 + B_2)(A_3 - B_3)\} \qquad \text{(A-12)}$$

In accordance with the rules, the four distributions of signs within each product are different and each would give a positive sign if its signs were multiplied:

$$(+ + +), \ (+ - -), \ (- - +), \ (- + -)$$

For the difference:

$$\mathbf{Q_a} - \mathbf{Q_b} = (A_1 A_2 A_3) - (B_1 B_2 B_3)$$
$$= \tfrac{1}{4} \ \{(A_1 - B_1)(A_2 - B_2)(A_3 - B_3)$$
$$+ (A_1 - B_1)(A_2 + B_2)(A_3 + B_3)$$
$$+ (A_1 + B_1)(A_2 + B_2)(A_3 - B_3)$$
$$+ (A_1 + B_1)(A_2 - B_2)(A_3 + B_3)\} \qquad \text{(A-13)}$$

according to the rules, each of the four products has a different sign distribution that produces a negative sign:

$$(- - -), \ (- + +), \ (+ + -), \ (+ - +)$$

## Lemma

To separate $(\mathbf{Q_a} - \mathbf{Q_b})$ into its $i$th integrator (an expression proportional to the addition of functions $A_i + B_i$) and its $i$th comparator (an expression proportional to the subtraction of functions $A_i - B_i$), we perform the following operations.

Define the function $\mathbf{X}$ in terms of the functiuons $\mathbf{Q}$ given in Eq. (A-2).

$$\mathbf{X} = \mathbf{Q_a} - \mathbf{Q_b}$$
$$= (A_1 A_2 \cdots A_i \cdots A_n) - (B_1 B_2 \cdots B_i \cdots B_n) \qquad \text{(A-14)}$$

Define the $i$-conjugated function $^c\mathbf{X_i}$ of $\mathbf{X}$, by interchanging the $i$th functions in the $\mathbf{Q}$s, as follows:

$$^c\mathbf{X_i} = (A_1 A_2 \cdots B_i \cdots A_n) - (B_1 B_2 \cdots A_i \cdots B_n)$$
$$\text{for all } i = 1, \ldots, n \qquad \text{(A-15)}$$

then, whenever $A_i$ and $B_i$ are not zero,

$$\mathbf{X} + {}^c\mathbf{X_i} = (A_i + B_i)\left(\frac{\mathbf{Q_a}}{A_i} - \frac{\mathbf{Q_b}}{B_i}\right) \qquad \text{for all } i = 1, \ldots, n \qquad \text{(A-16)}$$

is the $i$th integrator of $\mathbf{X}$, and

$$\mathbf{X} - {}^{c}\mathbf{X_i} = (A_i - B_i)\left(\frac{\mathbf{Q_a}}{A_i} + \frac{\mathbf{Q_b}}{B_i}\right) \quad \text{for all } i = 1, \ldots, n \quad \text{(A-17)}$$

is the *i*th comparator of **X**.

### Demonstration

From definitions (A-14) and (A-15), and whenever $A_i$ and $B_i$ are not zero, for all $i = 1, \ldots, n$, we can write

$$\mathbf{X} = A_i\left(\frac{\mathbf{Q_a}}{A_i}\right) - B_i\left(\frac{\mathbf{Q_b}}{B_i}\right) \quad \text{(A-18)}$$

and

$${}^{c}\mathbf{X_i} = B_i\left(\frac{\mathbf{Q_a}}{A_i}\right) - A_i\left(\frac{\mathbf{Q_b}}{B_i}\right) \quad \text{(A-19)}$$

Adding and subtracting Eqs. (A-18) and (A-19) results in expressions (A-16) and (A-17), respectively.

## ACKNOWLEDGMENTS

Special thanks to Don Kelly for his encouragement and words of wisdom. Thanks to John D. Peters for the excellent programming work for the simulations, and for his original contributions, together with those of Hew Crane, to the development of the color image compression technology. Without their strong practical sense, the technology would not have reached the actual level of applicability. Portions of the material in this chapter were presented in meetings of the Association for Research in Vision and Ophthalmology, the Optical Society of America, and the Society of Photo-optical Instrumentation Engineers during the last seven years. The material in the Appendix was developed during the author's tenure at the Universidad Nacional Autónoma de México (UNAM).

## REFERENCES

1.  T. N. Cornsweet, *Visual Perception*, Academic Press, New York, 1970.
2.  R. M. Boynton, *Color Vision*, Holt Rinehart & Winston, New York, 1979.
3.  G. Wyszecki and W. S. Stiles, *Color Science: Concepts and Methods, Quantitative Data and Formulae*, Wiley, New York, 1982.
4.  L. M. Hurvich and D. Jameson, Some quantitative aspects of an opponent-colors theory. II. Brightness, saturation and hue in normal and dichromatic vision, *J. Opt. Soc. Am. 45*:602–616 (1955).

5. P. L. Walraven, On the mechanisms of colour vision. Doctoral dissertation, Institute for Perception RVO-TN, Soesterberg, Netherlands, 1962.

6. C. R. Ingling, Jr., and B. H. Tsou, Orthogonal combination of the three visual channels, *Vision Res. 17*: 1075–1082 (1977).

7. S. L. Guth, R. W. Massof, and T. Benzschawel, Vector model for normal and dichromatic color vision, *J. Opt. Soc. Am. 70*:197–212 (1980).

8. S. L. Guth, Model for color vision and light adaptation, *J. Opt. Soc. Am. A8*:976–993 (1991).

9. R. L. De Valois and K. K. De Valois, Neural coding of color, *Handbook of Perception* (E. C. Carterette and M. P. Friedman, eds.), Academic Press, New York, 1975.

10. C. R. Ingling, Jr., and B. A. Drum, Retinal receptive fields: Correlations between psychophysics and electrophysiology, *Vision Res. 13*:1151–1163 (1973).

11. P. Lennie, J. Krauskopf, and G. Sclar, Chromatic mechanisms in striate cortex of macaque, *J. Neurosci. 10*(2):649–669 (1990).

12. P. Lennie and M. D'Zmura, Mechanisms of color vision, *CRC Crit. Rev. Neurobiol. 3*:333–400 (1988).

13. J. Kremers, B. B. Lee, and P. K. Kaiser, Sensitivity of macaque retinal ganglion cells and human observers to combined luminance and chromatic temporal modulation, *J. Opt. Soc. Am. A 9*:1477–1485 (1992).

14. A. M. Derrington, J. Krauskopf, and P. Lennie, Chromatic mechanisms in lateral geniculate nucleus of macaque, *J. Physiol. (London) 357*:241–265 (1984).

15. P. Lennie, P. W. Haake, and D. R. Williams, Chromatic opponency through random connections to cones, *Invest. Ophthalmol. Vision Sci.* (suppl.) *30*(3): 322 (1989).

16. C. R. Ingling, Jr., and E. Martinez-Uriegas, The spatiotemporal properties of the r-g X-cell channel, *Vision Res. 25*:33–38 (1985).

17. E. Martinez-Uriegas, Spatial, temporal and spectral model of the X-channel in human vision, Ph.D. dissertation, Ohio State University, University Microfilms, Ann Arbor, MI, 1982.

18. E. Kaplan, B. B. Lee, and R. Shapley, New views of primate retinal function, *Progress in Retinal Research* (N. Osborne and G. Chader, eds.), Pergamon Press, Oxford, 1990.

19. R. Shapley and E. Kaplan, Responses of magnocellular LGN neurons and M retinal ganglion cells to drifting heterochromatic gratings. *Invest. Ophthalmol. Vision Sci.* (suppl.) *30*(3):322 (1989).

20. E. Kaplan and R. Shapley, X and Y cells in the lateral geniculate nucleus of macaque monkeys, *J. Physiol. 330*:125–143 (1982).

21. P. Gouras and E. Zrenner, Color coding in primate retina, *Vision Res. 21*: 1591–1598 (1981).

22. P. H. Schiller, N. K. Logothetis, and E. R. Charles, Role of the color-opponent and broad-band channels in vision, *Visual Neurosci. 5*:321–346 (1990).

23. M. S. Livingstone and D. H. Hubel, Anatomy and physiology of a color system in the primate visual cortex, *J. Neurosci. 4*:309–356 (1984).

24. S. Shipp and S. M. Zeki, Segregation of pathways leading from area V2 to areas V4 and V5 of macaque visual cortex, *Nature 314*:322 (1985).
25. S. M. Zeki, The distribution of wavelength and orientation selective cells in different areas of monkey visual cortex, *Proc. R. Soc. Lond. [Biol.] 217*:449–470 (1983).
26. S. M. Zeki, Colour coding in the cerebral cortex: The reaction of cells in monkey cortex to wavelengths and colours, *Neuroscience 9*:741–765 (1983).
27. S. M. Zeki, Colour coding in the cerebral cortex: The responses of wavelength-selective and colour-coded cells in monkey visual cortex to changes in wavelength composition, *Neuroscience 9*:767–781 (1983).
28. D. Hubel and M. Livingstone, Color puzzles, *Cold Spring Harbor Symp. Quant. Biol. 55*:643–649 (1990).
29. E. Martinez-Uriegas, A solution to the color–luminance ambiguity in the spatiotemporal signal of primate X-cells, *Invest. Ophthalmol. Vision Sci. (suppl.) 26*(3):183 (1985).
30. E. Martinez-Uriegas, Algebraic analysis of parvocellular color-opponent on–off interactions, presented at the Optical Society of America Annual Meeting, 1988, paper 64.
31. E. Martinez-Uriegas, Spatiotemporal multiplexing of chromatic and achromatic information in human vision, *SPIE Proc. Ser. 1249*:178–199 (1990).
32. E. Martinez-Uriegas, Simulation of parvocellular demultiplexing, *SPIE Proc. Ser. 1453*:300–313 (1991).
33. M. D'Zmura and P. Lennie, Mechanisms of color constancy, *J. Opt. Soc. Am. A 3*:1662–1672 (1986).
34. P. H. Schiller, J. H. Sandell, and J. H. R. Maunsell, Functions of the ON and OFF channels of the visual system, *Nature 322*:824–825 (1986).
35. F. W. Campbell and L. Maffei, Electrophysiological evidence for the existence of orientation and size detectors in the human visual system, *J. Physiol. 207*: 635–652 (1970).
36. R. L. De Valois, D. G. Albretch, and L. G. Thorell, Spatial frequency selectivity of cells in macaque visual cortex, *Vision Res. 22*:545–559 (1982).
37. R. L. De Valois and K. K. De Valois, *Spatial Vision*, Oxford University Press, New York, 1988.
38. A. J. Ahumada, Jr., and A. Poirson, Cone sampling array models, *J. Opt. Soc. Am. A 4*:1493–1502 (1987).
39. W. A. H. Rushton, and H. D. Baker, Red–green sensitivity in normal vision, *Vision Res. 4*:75–85 (1964).
40. C. R. Ingling, Jr., E. Martinez-Uriegas, and S. S. Grigsby, Test for a correlation between $V\lambda$ and the $+y$ opponent-channel sensitivity, *Color Res. Appl. 15*:285–290 (1990).
41. C. M. Cicerone, and J. L. Nerger, The relative numbers of long-wavelength-sensitive to middle-wavelength-sensitive cones in the human fovea centralis, *Vision Res. 29*:115–128 (1989).
42. C. M. Cicerone, Individual variability in the configuration of the cone mosaic in human retina, *Invest. Opthalmol. Vision Sci. (suppl.) 31*(4):494 (1990).
43. W. H. Swanson, J. Pokorny, and V. C. Smith, Effects of temporal frequency

on phase-dependent sensitivity to heterochromatic flicker, *J. Opt. Soc. Am. A 4*:2266–2273 (1987).

44. W. H. Swanson, J. Pokorny, and V. C. Smith, Effects of chromatic adaptation on phase-dependent sensitivity to heterochromatic flicker, *J. Opt. Soc. Am. A 5*:1976–1982 (1988).

45. F. M. de Monasterio, and S. J. Schein, Spectral bandwidths of color-opponent cells of geniculocortical pathway of macaque monkey, *J. Neurophysiol. 47*: 214–224 (1982).

46. D. Marr, *Vision*, W. H. Freeman, San Francisco, 1982.

47. J. G. Daugman, Uncertainty relation for resolution in space, spatial frequency, and orientation optimized by two-dimensional visual cortical filters, *J. Opt. Soc. Am. A 2*:1160–1169 (1985).

48. R. A. Young, The Gaussian derivative model for spatial vision. I. Retinal mechanisms, *Spatial Vision 2*:273–293 (1987).

49. D. D. Stork and H. R. Wilson, Do Gabor functions provide appropriate descriptions of visual cortical receptive fields? *J. Opt. Soc. Am. A 7*:1362–1373 (1990).

50. A. B. Watson and A. J. Ahumada, Jr., A hexagonal orthogonal-oriented pyramid as a model of image representation in visual cortex, *IEEE Trans. Biomed. Eng. BE-36*:97–106 (1989).

51. H. R. Wilson, D. Levi, L. Maffei, J. Rovamo, and R. De Valois, The perception of form: Retina to striate cortex, *Visual Perception: The Neurophysiological Foundations*, (L. Spillman and S. S. Werner, ed.), Academic Press, New York, 1990.

52. C. R. Michael, Color vision mechanisms in monkey striate cortex: Dual-opponent cells with concentric receptive fields, *J. Neurophys. 41*:572–588 (1978).

53. C. R. Michael, Color vision mechanisms in monkey striate cortex: Simple cells with dual opponent-color receptive fields, *J. Neurophys. 41*:1233–1249 (1978).

54. C. R. Michael, Color-sensitive complex cells in monkey striate cortex, *J. Neurophys. 41*:1250–1266 (1978).

55. M. S. Livingstone and D. H. Hubel, Connections between layer 4b and thick cytochrome oxidase stripes of area 18 in the squirrel monkey, *J. Neurosci. 7*: 3371–3377 (1987).

56. C. R. Ingling, Jr., and E. Martinez-Uriegas, Stiles's $\pi^5$ mechanism: Failure to show univariance is caused by opponent channel input, *J. Opt. Soc. Am. 71*: 1134–1137 (1981).

57. M. A. Finkelstein and D. C. Hood, Detection and discrimination of small brief lights: Variable tuning of opponent channels, *Vision Res. 24*:175–181 (1984).

58. D. H. Kelly, Motion and vision. II. Stabilized spatio-temporal threshold surface, *J. Opt. Soc. Am. 69*:1340–1349 (1979).

59. D. H. Kelly, Spatiotemporal variation of chromatic and achromatic contrast thresholds, *J. Opt. Soc. Am. 73*:742–750 (1983).

60. K. T. Mullen, The contrast sensitivity of human colour vision to red–green and blue–yellow gratings, *J. Physiol. 359*:381–400 (1985).

61. A. M. Rohaly and G. Buchsbaum, Inference of global spatio-chromatic mech-

anisms from contrast sensitivity functions, *J. Opt. Soc. Am. A* 5:572–576 (1988).

62. P. Cavanagh, J. Boeglin, and O. V. Favreau, Perception of motion in equiluminous kinematograms, *Perception, 14*:151–162 (1985).

63. R. L. Gregory, Vision with equiluminant colour contrast. 1. A projection technique and observations, *Perception 6*:113–119 (1977).

64. C. Lu, and D. H. Fender, The interaction of color and luminance in stereoscopic vision. *Invest. Opthalmol. Vision Sci. 11*:482–490 (1972).

65. P. W. Russell, Chromatic input to stereopsis, *Vision Res. 19*:831–834 (1979).

66. H. D. Crane and C. M. Steele, Generation-V dual-Purkinje-image eyetracker, *Appl. Opt. 24*:527–537 (1985).

67. G. Wagner and R. M. Boynton, Comparison of four methods of heterochromatic photometry, *J. Opt. Soc. Am. 62*:1508–1515 (1972).

68. R. M. Boyton, Ten years of research with the minimally distinct border, *Visual Psychophysics and Physiology*, (J. C. Armington, J. Krauskopf, and B. R. Wooten, eds.), Academic Press, New York, 1978.

69. D. H. Kelly and E. Martinez-Uriegas, Measurements of chromatic and achromatic afterimages, *J. Opt. Soc. Am. A 10*:29–37 (1993).

70. C. R. Ingling, Jr., and S. Grigsby, Perceptual correlates of magnocellular and parvocellular channels: Seeing depth and form in afterimages, *Vision Res. 30*: 823–828 (1990).

71. J. L. Mitchell and W. B. Pennebaker, Evolving JPEG color data compression standards, *Standards for Electronic Imaging Systems* (M. Nier and M. E. Courtot, eds.), SPIE Optical Engineering Press, Bellingham, WA, 1991.

72. M. Rabbani, and P. W. Jones, Digital image compression techniques, *Tutorial Texts in Optical Engineering*, SPIE Optical Engineering Press, Bellingham, WA, 1991.

# Introduction to Chapter 5

Ever since the 1950s, when there were the only two people in the world doing sine-wave flicker experiments — Hendrik DeLange, at Philips Eindhoven, and D. H. Kelly at UCLA — I have had a somewhat proprietary interest in temporal vision studies with sinusoidal stimuli. After a society meeting in Washington a few years later, I was attending a dinner party for *visioniks* hosted by C. R. Cavonius, who had a very nice apartment across the river in Alexandria. I don't know what criteria Carl used to pick his guests, but he must have had some interest in all of us.

Seated on my right was a very pleasant fellow I had never met, although his name sounded vaguely familiar. I didn't realize he was the author of a manuscript on visual evoked potentials that I had recently reviewed; I had been rather harsh with that study for using periodic flashes instead of sine waves. As our conversation grew more heated, I suddenly stopped and asked his name again. "Good heavens," I said, "you're *that* Carroll White!" Carroll's eyes grew wide as the whole table turned to look at us. "And you," he blurted, "My God, you're Sine-Wave Kelly!"

Today, of course, temporal sine waves are not such a curiosity. A whole new generation of talented young visual scientists are pursuing far more subtle and esoteric experiments and theories than anything DeLange or I attempted.

Dr. William H. Swanson is one of the best and brightest of this generation. Since he is not my contemporary, I don't know Bill as well as some of

my other authors, but I know his work. He has a strong background in mathematics, which is essential to the studies reviewed here. An alumnus of the well-known Smith–Pokorny lab at Chicago, he struck out on his own seven years ago and has continued to be very prolific ever since. I am delighted to have him give you an overview of some very important current work.

The question of phase-shift is not very significant for most spatial-vision experiments because, if the spatial response function is symmetric, there is no phase-shift. But for temporal vision, there is a totally different constraint. The law of causality for passive systems implies that no element of the response may precede the stimulus, which requires that there must be a non-negative phase lag everywhere.

Active feedback complicates the situation somewhat, but several important studies of phase-shift in flicker responses have been prompted by such engineering constraints. After reviewing earlier studies, Dr. Swanson describes the most recent work in this area, which makes use of chromatic responses to get a handle on the elusive parameter of temporal phase.

# 5

# Time, Color, and Phase

## William H. Swanson

*Retina Foundation of the Southwest and University of Texas
Southwestern Medical Center, Dallas, Texas*

## I. INTRODUCTION

The interaction of time and color can be striking. If two quite different colors (such as red and green) are alternated slowly, the change in apparent color is dramatic. Alternatively, if the two colors are alternated rapidly, a single intermediate color appears to be flickering. If in addition the ratio of luminances of the two colored lights is varied, the apparent flicker can be minimized. Typically, flicker is at a minimum for only a very narrow range of luminance ratios. This phenomenon was first exploited as a photometric method a century ago [1] with a technique that has become known as *heterochromatic flicker photometry* (HFP) [2].

Under appropriate conditions, the spectral sensitivity function obtained with HFP is quite similar to the spectral sensitivity function for detection of a fixed high temporal frequency [3], and essentially the same spectral sensitivity function can be obtained by measuring increment thresholds for brief pulses of monochromatic test lights superimposed on a white adapting field [4] or by measuring the minimal distinct border between adjacent colored regions [5].

The fact that several different psychophysical methods yield similar spectral sensitivities has frequently been interpreted in terms of two independent psychophysical systems: a luminance system, which responds to high temporal frequencies and has nonopponent spectral sensitivity, and a chro-

matic system, which is less sensitive to high temporal frequencies and has chromatically opponent spectral sensitivity [6]. Within the framework of this theoretical construct, purely chromatic modulation is often defined as exchange between isoluminant colors, for which the response of the luminance system has been nulled by flicker photometry.

There are a number of ways of defining luminance and chromatic systems. The June 1993 of the *Journal of the Optical Society of America A* recently focused on a number of complexities in defining luminance. The introduction to the issue [7] discusses the development of the concept of luminance and emphasizes that luminance thresholds of different types may be mediated by different retinocortical pathways. The theoretical construct of an independent luminance system that mediates all thresholds for luminance modulation is therefore overly simplistic.

As discussed in Chapter 4 of this volume, a chromatically opponent retinocortical pathway can carry mixed luminance and chromatic information, which may be decoded into chromatic and luminance components in the cortex. This mechanism may mediate detection of luminance modulation for most combinations of spatial and temporal frequencies, with the exception of the "high velocity corner" of the spatiotemporal domain (i.e., the combination of low spatial frequencies and high temporal frequencies [8]. Since heterochromatic flicker photometry is usually performed with uniform fields and relatively high temporal frequencies, it may null the responses of the mechanism mediating detection in this "high velocity corner" of the spatiotemporal surface, but not responses of the mechanism(s) mediating detection for lower temporal frequencies and/or higher spatial frequencies.

This chapter reviews a range of studies on sensitivity to temporal modulation of chromaticity and discusses them in terms of psychophysical mechanisms analogous to the parvocellular (PC) and magnocellular (MC) retinocortical pathways (the properties of the cells in PC and MC pathways are discussed in Chapter 4, and in Section VIII of this chapter). It does not aim to be a comprehensive review, and for simplicity the focus is on thresholds mediated only by inputs from the long-wavelength-sensitive (L) and middle-wavelength-sensitive (M) cones. While there is a significant body of research on temporal sensitivity mediated by short-wavelength-sensitive (S) cones, it is outside the scope of this chapter.

The chapter begins with a discussion of sensitivity to chromatic flicker, followed by a discussion of conditions under which equiluminant stimuli produce residual brightness flicker, hence do not necessarily measure chromatic sensitivity. The residual brightness flicker is analyzed in terms of response of the MC mechanism due to phase shifts between inputs of the L and M cones. This leads to a discussion of models for the PC and MC

mechanisms in terms of L and M cone responses. Then an example is given, expanding the model of the PC mechanism presented in Chapters 3 and 4 by incorporating information about the L and M cone modulations. Following this, an analysis is presented which shows that under some conditions MC cells may have phase shifts greater than 90°. This can make it difficult to distinguish PC and MC mechanisms, since a large phase shift in one mechanism may make it behave like the other mechanism. Physiological data from cells in the PC and MC pathways are discussed, to provide guidelines concerning the sizes of phase shifts reasonable for models of the psychophysical PC and MC mechanisms. Finally, the insights gained from the analysis of chromatic flicker are extended to a wider range of stimuli by use of chromatic impulse responses.

## II. SENSITIVITY TO CHROMATIC FLICKER

The terms *luminance modulation* and *chromatic modulation* are often used to distinguish stimuli of two types: those for which luminance changes while chromaticity remains constant, and those for which chromaticity changes while luminance remains constant. However, there are (at least) three problems with this terminology. First, there may be an implicit assumption that thresholds for the two types of modulation are mediated by separate chromatic and luminance channels. Second, it is not clear under which conditions luminance can be considered to truly remain constant during chromatic modulation. Lights equated in luminance at one mean luminance may not be equal in luminance at a second mean luminance. Similarly, lights equated in luminance at one temporal frequency may not be equal in luminance at a second temporal frequency. Third, under some conditions (discussed in Sec. III), the percept elicited by chromatic modulation is that of a change in brightness but not in chromaticity.

To avoid these problems, an alternate terminology will be employed in this chapter. Instead of "luminance modulation," the term *homochromatic modulation* will be used to refer to modulation of radiance with no change in chromaticity. Instead of "chromatic modulation," the term *heterochromatic modulation* will be used to refer to modulation of chromaticity, using exchange of lights equated in luminance by flicker photometry.

Temporal modulation sensitivity functions for homochromatic and heterochromatic flicker from a recent study [9] are shown in Figure 1. As discussed in the first section of the Appendix, these data are consistent with earlier reports [10–14]. At all mean luminances, modulation sensitivity for homochromatic flicker is relatively independent of mean luminance at low temporal frequencies and highly dependent on mean luminance at high temporal frequencies. Therefore, as mean luminance increases there is an

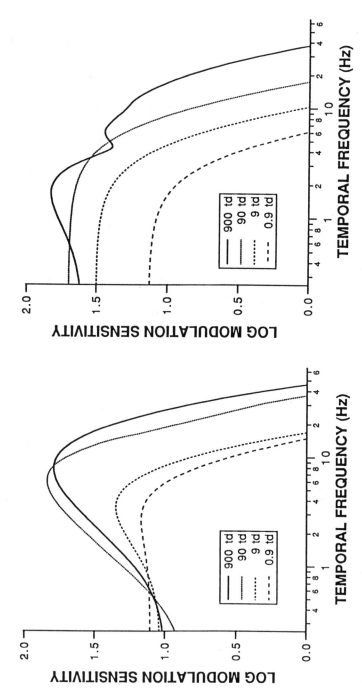

**Figure 1** Modulation sensitivity functions for homochromatic (left) and heterochromatic (right) flicker with a 2° field metameric to approximately 600 nm. Mean luminances are indicated in the legend. The functions were derived from equations and parameters given by Swanson et al. [9].

increase in bandpass characteristics and a shift in peak sensitivity to higher temporal frequencies. For heterochromatic flicker, modulation sensitivity is dependent on mean luminance at all temporal frequencies up to about 100 troland (td) and above 100 td sensitivity increases primarily at high temporal frequencies. These effects of mean luminance are more complex than those seen for homochromatic flicker, and the temporal tuning function at 900 td has an odd shape.

When these temporal tuning curves for homochromatic and heterochromatic flicker are plotted in terms of amplitude sensitivity, as in Figure 2, the effects of mean luminance are highlighted in a different way. For both types of flicker, amplitude thresholds for high temporal frequencies are independent of mean luminance. This phenomenon, which is known as *high frequency linearity*, does not obtain at all mean luminances. High frequency amplitude sensitivity for homochromatic flicker is somewhat higher than 1 td than near 10 td, presumably because of transition from detection by rods to detections by cones. For heterochromatic flicker a different pattern obtains: high frequency amplitude sensitivity is constant for 1-100 td, then increases near 1000 td.

## III. RESIDUAL BRIGHTNESS RESPONSES TO HETEROCHROMATIC FLICKER

It has been known for most of this century that as temporal frequency of equiluminant flicker is increased, the apparent alternation of color ceases before apparent brightness flicker ceases [3,15,16]. It has also been noted that under some conditions, as modulation of heterochromatic flicker is decreased, the observer may report that once the apparent alternation of color has ceased, there is a residual apparent brightness flicker [11,17].

Wisowaty [18] argued that this residual flicker was due to subtle stimulus artifacts. When the same wavelength was used in each of the two optical channels in his apparatus, it was not possible to eliminate all flicker by matching the luminances of the two channels, indicating the existence of a stimulus artifact such as inhomogeneity of the test field. However, Kaiser et al. [19] used an integrating sphere to combine their two channels, and at the beginning of each experimental session they verified that there was no stimulus artifact by using the same wavelength in each channel. For heterochromatic flicker they found residual flicker at luminances of 46-146 td, so there must have been some source of residual flicker other than stimulus artifact.

Swanson et al. [9] provided evidence that the residual brightness response could be due to the MC mechanism responding to heterochromatic modulation. They used red and green light-emitting diodes (LEDs) for the pri-

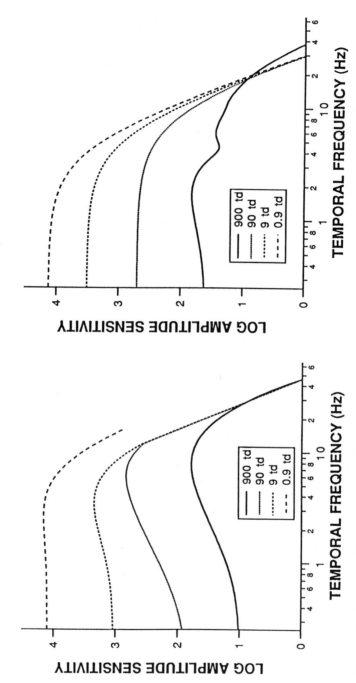

**Figure 2**  Functions for homochromatic (left) and heterochromatic (right) flicker, replotted from Figure 1 in terms of amplitude sensitivity.

maries, so it was not possible to use the same wavelength in each channel to test for artifacts, and instead they tested dichromats. A dichromatic retina responds as if both LEDs had identical spectra and differed only in luminance. Using 8 Hz counterphase flicker at 100% modulation, for which the response of the MC mechanism is maximum, both protanopes and deuteranopes were able to completely cancel the percept of flicker by making photometric matches. This ruled out any stimulus artifact that could generate a response in the MC mechanism. Swanson et al. [9] analyzed their data with impulse responses and obtained a bimodal impulse response for heterochromatic modulation at 900 td (see Sec. IX). The first peak of the bimodal impulse response was identical in timing to the impulse response obtained from the 900 td data for homochromatic modulation.

At low photopic adaptation levels the residual brightness flicker may be due to rod–cone interactions [20,21]. However, a number of studies reported residual brightness flicker at mean luminances of 100–3500 td [13,16,22–26]. For these conditions, rod responses are saturated, and the residual brightness flicker could not be due to rod–cone interactions.

## IV.  PHASE SHIFTS BETWEEN CONE INPUTS

The residual brightness flicker present for heterochromatic modulation can often be eliminated by shifting the relative phase of the two primaries by a few degrees away from perfect counterphase [13,16,22,23]. A more direct method of determining the effects of stimulus phase is to measure modulation threshold as a function of the relative phase of red and green primaries [24–26]. At mean luminances of 100 td and higher, sensitivity is sometimes minimum at phases other than 0° or 180°, as illustrated at 6 Hz in Figure 3. At a given temporal frequency, the data are symmetrical about a *phase axis* (the phase of least sensitivity). This indicates that stimuli at all phases are detected by a single mechanism, except perhaps near the phase axis (where sensitivity is minimum and another mechanism may mediate detection).

The existence of a phase axis other than 0° or 180° is evidence of a phase shifts between the L and M cone inputs to the mechanism mediating detection. Since many of the stimulus conditions for which this occurs are "high velocity" stimuli (uniform fields at high temporal frequencies), there probably are phase shifts in the MC mechanism. Such phase shifts would allow the MC mechanism to respond to heterochromatic flicker at high mean luminances. The breakdown of high frequency linearity for heterochromatic flicker above 100 td could therefore be due to phase shifts that

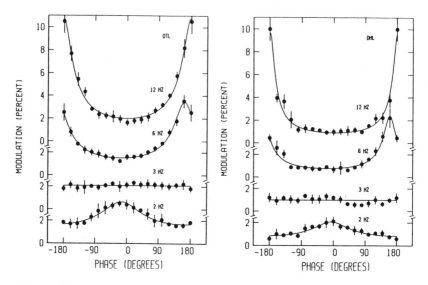

**Figure 3**  Modulation threshold as a function of stimulus phase, for stimuli produced by red and green lights equated in luminance, with a 2° field having a mean luminance of 100 td. Note that at 6 Hz thresholds are higher at 160° than at 180°. [Reprinted with permission from D. T. Lindsey, J. Pokorny, and V. C. Smith, *Journal of the Optical Society of America A 3*:921–927 (1986).]

allow the MC mechanism to mediate detection at high, but not low, mean luminances.

The phase axis can vary with temporal frequency, as illustrated in Figure 4. For these data, the phase axis increases from near 0° at 1 Hz to cross 180° at 16–20 Hz, then remains slightly greater than 180° at higher frequencies. The unusual heterochromatic modulation sensitivity function at 900 td may therefore be the envelope of two different functions: a function reflecting the temporal tuning of the PC mechanism and a function reflecting the temporal-frequency-dependent effects of phase shifts in the MC mechanism.

The phase axis can be dramatically affected by mean chromaticity. Figure 5 shows phase axes for frequencies from 6 to 20 Hz, for a 350 td test field superimposed on eight different adapting fields. The solid symbols show phase axes on a 600 nm adapting field, and the open symbols show phase axes on a 500 nm adapting field. As mean luminance of the adapting field was increased from 100 td to 3000 td, the phase axes at 6–16 Hz decreased dramatically for the 600 nm adapting field and increased dramatically for the 500 nm adapting field. Since mean luminance and chromatic-

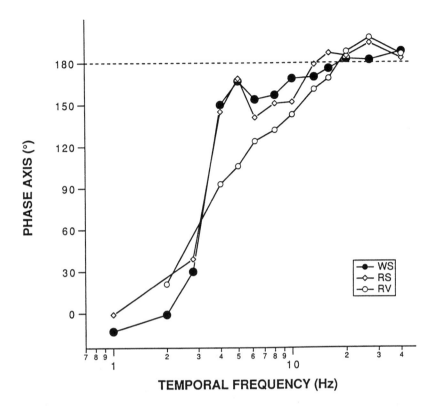

**TEMPORAL FREQUENCY (Hz)**

**Figure 4**   Phase axis as a function of temporal frequency of three observers, plotted from a table in Swanson et al. [25]. Data are for a 2°, 900 td field metameric to approximately 600 nm.

ity can have profound effects on the phase axis, the response of the MC mechanism to heterochromatic flicker may be highly dependent on stimulus conditions.

In recent years a wide range of studies have used equiluminant modulation to attempt to measure responses of the PC mechanism. However, the existence of substantial phase shifts in the MC mechanism, which vary with temporal frequency, mean luminance, and mean chromaticity, greatly complicates analysis of data gathered with equiluminant modulation. When using equiluminant flicker, control experiments are needed for each stimulus configuration to determine whether some thresholds are mediated by the MC mechanism rather than by the PC mechanism.

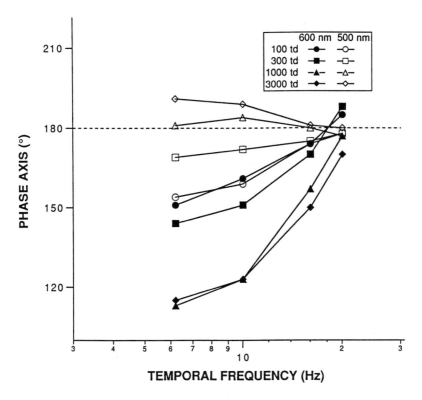

**Figure 5** Phase axis as a function of temporal frequency, for a 2° 350 td test field superimposed on 8° 500 and 600 nm adapting fields with mean luminances from 100 td to 3000 td. Data for observer NW from Swanson et al. [26].

## V.  MODELING PC AND MC MECHANISMS IN TERMS OF CONE RESPONSES

A range of types of psychophysical data make simple sums and differences of L and M cone responses both appealing and useful as first approximations for the MC and PC mechanisms. The spectral sensitivity of the MC mechanism, determined with flicker photometry, can be fit well with a linear sum of L and M cone responses [27]. The spectral sensitivity of the PC mechanism, determined with spectral increment thresholds for long-duration pulses on a coextensive white adapting field, can be fit well by a difference of L and M cone responses [28].

Data analysis in terms of these models can be simplified by plotting the data in a space based on cone responses to the stimuli. One approach is to

use a *cone excitation space*, which characterizes the cone quantal catches for the different stimuli. Three axes are defined: a homochromatic axis, for which the ratios of quantal catches in all three cones are held constant, and two heterochromatic axes, for which luminance (defined as a weighted sum of the L and M cone responses) is held constant; all three axes intersect at a single white point [29–31]. One heterochromatic axis is a tritan axis, for which quantal catch of the S cones varies while quantal catches of the L and M cones remain constant. The other heterochromatic axis is a red–green axis, for which the quantal catch of the S cones remains constant while the quantal catches of the L and M cones vary inversely (the quantal catch of one cone is decreased while that of the other is increased, so that the weighted sum is constant).

In cone excitation space the adapting field is a specific locus, and stimuli are defined as vectors beginning at this locus. Thresholds mediated only by the L and M cones are measured for a range of vectors originating at a common point and lying in a plane parallel to the plane defined by the homochromatic and red–green heterochromatic axes. If thresholds are mediated by the PC mechanism, they are expected to fall on a straight line parallel to the heterochromatic red–green axis, while if they are mediated by the MC mechanism they are expected to fall on a straight line parallel to the homochromatic axis. However, if the ratio of weights of the L and M cone inputs for the MC mechanism is different from the ratio used to construct the space, the straight lines predicted for the two mechanisms will no longer be parallel to the cardinal axes. This difference is likely to occur, since chromatic adaptation can dramatically affect the flicker photometric match, and presumably the ratio of L and M cone inputs to the MC mechanism [32,33].

Another approach is to use a *cone modulation space*, which focuses on changes in cone excitation produced by the stimulus [34–36]. In this space, each axis gives the change in cone quantal catch divided by the mean quantal catch for the adapting field, yielding $\Delta L/M$, $\Delta M/M$, and $\Delta S/S$. The adapting field cannot be specified in the space, since it is always the origin and stimuli are always vectors beginning at the origin.

When data are plotted in the $\Delta L/M$ versus $\Delta M/M$ plane in cone modulation space, thresholds mediated by the PC mechanism are expected to fall on a straight line of positive slope, and thresholds mediated by the MC mechanism are expected to fall on a straight line of negative slope. The slopes of these lines are used to derive the ratio of weights for the L and M cone inputs to the mechanisms. A number of experiments have shown that thresholds can often be fit well in this way (Fig. 6: left and middle panels). However, Stromeyer et al. [37] found that straight lines did not give good fits for thresholds gathered on intense red adapting fields (Fig. 6: right

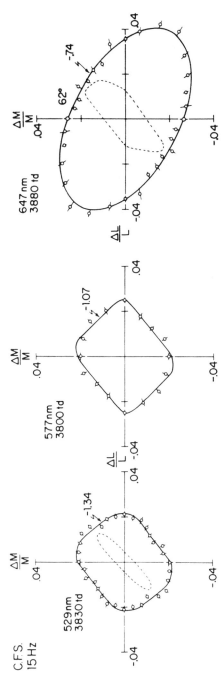

**Figure 6**  Detection contours in cone modulation space for 15 Hz flicker on green (left), yellow (middle), and red (right) adapting fields of approximately 3800 td. Note that for the green and yellow adapting fields the data are fit well with lines of positive slope and negative slope, while for the red adapting field the data are fit by an ellipse. The ellipse is computed assuming a 62° phase shift between L and M cone inputs to the MC mechanism. [Reprinted from *Vision Research*, *27*, C. F. Stromeyer III, G. R. Cole, and R. E. Kronauer, "Chromatic suppression of cone inputs to the luminance flicker mechanism," 1113–1137 Copyright (1986), with permission from Pergamon Press Ltd., Headington Hill Hall, Oxford, U.K.]

panel). They fit the data with an ellipse derived by assuming that there was a phase shift between the L and M cone inputs to the MC mechanism and estimated that the phase shift was approximately 40°–80°.

## VI. EXAMPLE: INCORPORATION OF CONE RESPONSES INTO A MODEL FOR THE PC MECHANISM

A model for the PC mechanism was discussed in Chapter 3 (Sec. V and VI). Two spatiotemporal filters, referred to as $E$ (the "excitatory" component) and $I$ (the "inhibitory" component), were used to describe the spatiotemporal surfaces for both homochromatic and heterochromatic modulation. The difference between the two $(E - I)$ yielded a homochromatic spatiotemporal surface and the sum $(E + I)$ yielded a heterochromatic spatiotemporal surface. It was assumed that $E$ and $I$ had different spectral sensitivities and that for heterochromatic stimuli the modulations for $E$ and $I$ were of opposite sign (causing a change from $E - I$ to $E + I$). Studies of macaques with selective visual pathway lesions (discussed below, in Sec. VIII) support the basic idea of the model that a single spatially and chromatically opponent mechanism can mediate normal thresholds for both homochromatic and heterochromatic stimuli over a range of spatial and temporal frequencies.

The following analysis shows that incorporation of cone responses into this model alters its predictions. Kelly [38] used the values for $E$ and $I$ that had been derived by Burbeck and Kelly [39] by analyzing a homochromatic spatiotemporal surface. He found that $(E + I)/30$ gave a reasonable description for the heterochromatic spatiotemporal surface. The factor $1/30$ was attributed to the decrease in cone modulation for heterochromatic stimuli as opposed to homochromatic stimuli.

For the PC mechanism to respond to heterochromatic stimuli, the ratio of weights for the L and M cone inputs must be different for $E$ and for $I$. The largest possible difference is found if only one cone type provides input to $E$, and only the other cone type provides input to $I$. The current analysis assumes these conditions to be the case. For Kelly's stimuli (metameric to 608 and 570 nm) and for his average equiluminant setting $[R/(R + G) = 0.39]$, the Smith and Pokorny [27] cone fundamentals yield an L cone modulation of 0.33 and an M cone modulation of $-0.17$. These modulations are indeed of opposite sign, justifying the use of $E + I$ for heterochromatic stimuli.

The L and M cone modulations for Kelly's stimuli are not equal, indicating that it is not appropriate to scale the sum $E + I$ by a constant factor. Instead, $E$ and $I$ should be scaled by separate factors, based on the cone

types providing input to $E$ and $I$. In addition, both L and M cone modulations are considerably greater than 1/30, indicating that decreased cone modulation alone is not enough to account for the scaling factor needed to make $E + I$ compatible with the heterochromatic data. To quantify these effects, responses were computed for two versions of the model, with L cone input to $E$ and M cone input to $I$ ($0.33E + 0.17I$) or M cone input to $E$ and L cone input to $I$ ($0.17E + 0.33I$).

Predictions for heterochromatic flicker generated by both versions of the model were similar when both spatial and temporal frequencies were low and were 7.5 times greater than the predictions for $(E + I)/30$. This suggests that some additional factor besides decreased cone modulation reduced sensitivity to heterochromatic flicker. This could be due to cortical processing of demultiplexed signals, as discussed in Chapter 4.

To compare predictions of these two versions of the model with Kelly's predictions, predictions for both versions were divided by 7.5, so that all three sets of predictions were equal at the corner of the spatiotemporal domain for which both spatial and temporal frequencies are low. When spatial frequency was fixed at 0.25 c/deg and temporal frequency was increased, sensitivity for the version of the model with L cone input to $E$ became higher than Kelly's predictions (by as much as 0.12 log unit at 20 Hz), and sensitivity for the version of the model with M cone input to $E$ became lower than Kelly's predictions (by as much as 0.17 log unit at 20 Hz). When temporal frequency was fixed at 0.5 Hz and spatial frequency was increased, sensitivity for the version of the model with L cone input to $E$ became higher than Kelly's predictions (by as much as 0.09 long unit at 8 c/deg), and sensitivity for the version of the model with M cone input to $E$ became lower than Kelly's predictions (by as much as 0.12 log unit at 8 c/deg).

Kelly's predictions gave good fits to his data, except at spatial frequencies above 5 c/deg and temporal frequencies above 12 Hz, where measured sensitivity was higher than predicted. Therefore the version of the model with L cone input to $E$ provides better fits to the data than Kelly's predictions, and the version of the model with M cone input to $E$ provides worse fits.

An additional consideration is the effect of phase shifts between L and M cone inputs to $E$ and $I$. Burbeck and Kelly, in deriving the spatial and temporal properties of $E$ and $I$, assumed that there were no phase differences. To determine the effects of phase shifts, for the model with L cone input to $E$ the temporal properties for $I$ were rederived from Burbeck and Kelly's data, assuming phase shifts for $I$ produced by latencies of 3, 5, and 8 ms. For latencies of 3 and 5 ms, temporal sensitivities derived for $I$ were within 0.08 log unit of Burbeck and Kelly's estimates, at all temporal

frequencies. For an 8 ms latency, temporal sensitivities derived for $I$ were within 0.1 log unit of Burbeck and Kelly's estimates up to 8 Hz, then increased by as much as 0.23 log unit at 20 Hz. However, predictions for chromatic thresholds were minimally affected by the phase shifts.

## VII.  MODELING PHASE SHIFTS IN THE PC AND MC MECHANISMS

The phase shift for a mechanism is the phase difference between the L and M cone inputs to the mechanism. The phase shift cannot be determined directly from the phase axis, since a single phase shift can yield a variety of phase axes, depending on the choice of primaries and on the weights assigned to the L and M cone inputs. In the most extreme cases, if the two primaries were identical or if the weight assigned to one of the cone inputs was zero, the phase axis would be 180° for all phase shifts.

Derivations of equations for computing the effects of phase shifts on linear combinations of L and M cone responses have been given by several authors [37,40,41]. Rather than repeating these derivations, we describe key results obtained by applying these equations to specific data sets. For convenience, all phase axes and phase shifts are expressed as values in the range −180° to 180°, and both phase axes and phase shifts are discussed in terms of their absolute values.

For the MC mechanism, a phase shift of $\rho°$ will yield a phase axis between 180° − $\rho°$ and 180°, with the precise value depending on the primaries and the ratio of weights assigned to the L and M cone inputs. Therefore, for a given set of primaries it is possible to set a lower bound on the absolute value of the phase shifts in the MC mechanism that are consistent with a specific measured phase axis. This is done by computing the smallest possible absolute value for the phase shift that could yield the measured phase axis for those primaries, across all possible weights of the L and M cone inputs.

Figure 7 shows the phase shifts of smallest absolute value derived in this way for the MC mechanism, based on phase axes reported in three different studies [23–25]. Since these are lower limits for most L and M cone weights, the actual phase shifts required for the MC mechanism would be even further from 0°. For each study and frequency, the phase axis with the smallest absolute value across observers was used, since this requires the largest phase shift. If the phase axis changed sign across observers, the positive and negative phase axes of smallest absolute values were used. In most cases the absolute value of the minimum phase shift was at least 20°, and in some cases it was greater than 90°.

As mentioned in Section IV, at some frequencies the sign of the phase

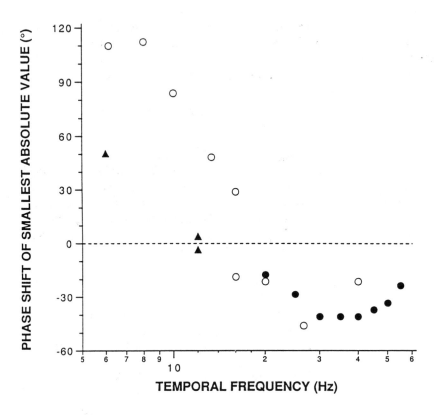

**Figure 7** Phase shifts for the MC mechanism computed from phase axes from three published studies: (●) Cushman and Levinson [23], (▲) Lindsey et al. [24], (○) and Swanson et al. [25]. For each study, phase axis, and temporal frequency, the symbol shows phase shift with the smallest absolute value that could generate the phase axis, over all combinations of weights on the L and M cone inputs to the MC mechanism.

axis can be changed by varying the state of chromatic adaptation. Figure 8 shows the phase shifts with the smallest possible absolute values derived for the MC mechanism from data gathered under two different conditions for which increase in adapting luminance changed the sign of the physical phase shift [26]. It is clear that chromatic adaptation can dramatically affect the phase shifts.

For the PC mechanism, with a 0° phase shift the L and M cone signals are 180° out of phase, since they are of opposite sign. Therefore a 0° phase

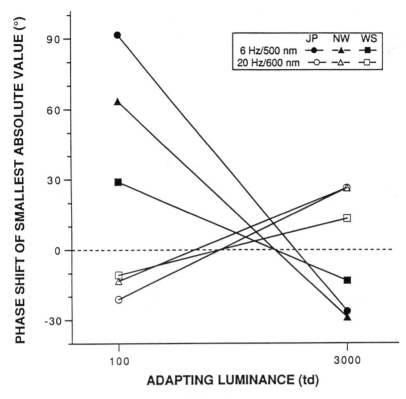

**Figure 8** Phase shifts for the MC mechanism as a function of the luminance of the adapting field, for two different stimulus conditions. As in Figure 7, these are the phase shifts with the smallest possible absolute values. These phase shifts are derived from phase axes reported by Swanson et al. [26] for 6 Hz flicker on a 500 nm adapting field (solid symbols) and for 20 Hz flicker on a 600 nm adapting field (open symbols). Circles, triangles, and squares are derived from data for three different observers.

shift could yield phase axes of any value between 0° and 180°, depending on the choice of primaries and the ratio of weights for the L and M cone inputs. If the weight for one of the cone inputs was zero, the phase axis would be 180°, while if the weights were balanced for the primaries used, the phase axis would be 0°. For other weights, the phase axis would be between 0° and 180°. In general, a phase shift of $\rho°$ in the PC mechanism will yield a phase axis between $\rho°$ and 180°. This means that for a given set of primaries it is possible to set an upper bound on the absolute value of

the phase shifts in the PC mechanism consistent with a given phase axis. Two studies [24,25] that measured physical phase shifts at frequencies below 3 Hz (where the PC mechanism presumably mediates detection) found phase axes ranging from −15° to 21°. Given the primaries used in these studies, this constrains the physiological phase shifts at these frequencies to have absolute values less than 8° [40].

The existence of substantial physiological phase shifts in the MC mechanism makes it difficult to distinguish between the MC mechanism with a phase shift greater than 90° and the PC mechanism with a phase shift of less than 90°. As Figure 7 shows, phase axes near 6 Hz require phase shifts in the MC mechanism with absolute values greater than 90°. At this point in the analysis, physiological data can be useful for deciding allowable sizes for phase shifts for the psychophysical PC and MC mechanisms.

## VIII. PHYSIOLOGICAL CORRELATES OF PSYCHOPHYSICAL PC AND MC MECHANISMS

Single-unit recordings from macaque retinal ganglion cells and thalamic cells have shown that there are two primary pathways from retina through the dorsal lateral geniculate nucleus (dLGN) to the primary visual cortex. These pathways provide physiological correlates to the psychophysical PC and MC mechanisms and suggest guidelines for phase shifts posited in the mechanisms.

One retinocortical pathway is comprised of sustained cells with chromatically opponent receptive fields; these are the midget retinal ganglion cells and the thalamic cells in the parvocellular layers of the dLGN to which they project. The second retinocortical pathway is comprised of transient cells with little or no chromatic opponency; these are the parasol retinal ganglion cells and the thalamic cells in the magnocellular layers of the dLGN to which they project. These pathways and the cells in them are often labeled "P-" (for *p*arvocellular) and "M-" (for *m*agnocellular) [42]. However, when combined with the L and M notation for cones, the P and M prefixes for retinocortical pathways become awkward. Recently the notation used in this chapter (i.e., "PC" for *p*arvocellular and "MC" for *m*agnocellular pathways) has been introduced to avoid the potential confusion between M cones and the M pathway [41].

Studies of psychophysical sensitivities of macaques with PC and MC pathway lesions indicate that the PC pathway is required for normal chromatic discrimination and that both PC and MC pathways have similar peak contrast sensitivities for homochromatic modulation [43,44]. The locations of these peak sensitivities are in different spatiotemporal regions, as shown in Figure 9. In general, the MC pathway is responsive to higher temporal

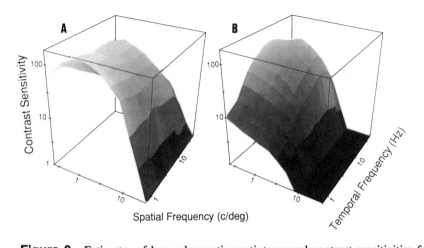

**Figure 9** Estimates of homochromatic spatiotemporal contrast sensitivities for the isolated PC pathway (left) and the isolated MC pathway (right), based on behavioral data from macaques with lesions to one or the other of the two pathways. Note that PC pathway sensitivity is equal to or greater than MC pathway sensitivity for almost all combinations of spatial and temporal frequencies, with the MC pathway having superior sensitivity only for the combination of low spatial and high temporal frequencies ("high velocities"). [Reprinted with permission from W. H. Merigan, in A. Valberg and B. B. Lee, eds., *From Pigments to Perception* (Plenum Press: New York & London, 1991) pp. 117–125.]

frequencies and lower spatial frequencies ("higher velocities") than the PC pathway, although there is broad overlap in their sensitivities. This provides support for the analysis of Ingling and Martinez-Uriegas [45], who suggested that a red–green opponent mechanism like the PC pathway could mediate normal heterochromatic and homochromatic thresholds over a wide range of spatial and temporal frequencies. It also provides support for the conclusion of Kelly and Burbeck [8] that thresholds in the high velocity corner of the spatiotemporal domain and thresholds in other spatiotemporal regions may be mediated by different mechanisms.

There are several important discrepancies between psychophysical data from macaques with MC and PC pathway lesions and single-unit data from cells in macaque MC and PC pathways. The behavioral spatial resolution limit for homochromatic patterns is higher for the PC pathway than for the MC pathway, and peak behavioral homochromatic contrast sensitivities are similar for both pathways. Single-unit studies, however, have found similar homochromatic spatial resolution limits for MC and PC cells [46], as well as much higher peak homochromatic contrast sensitivity for

MC than for PC cells [47]. These discrepancies between behavioral data and single-unit data suggest that the relative weight of the PC pathway response to homochromatic modulation is enhanced compared with the MC pathway response. This apparent affect may exist because there are about eight times as many PC cells as MC cells, and psychophysical thresholds reflect some sort of pooling of responses across cells at the cortical level [42].

Since psychophysical data from macaque monkeys with lesions in either the MC or PC pathway suggest that these pathways have similar peak sensitivities for homochromatic flicker and that for high velocity stimuli the MC pathway is the more sensitive, it seems likely that the MC pathway mediates heterochromatic flicker photometry, which is conducted at high velocities (uniform fields at high temporal frequencies). Indeed, it has been shown that responses of MC cells, but not of PC cells, can be nulled by heterochromatic flicker photometry [48] and that only MC cells have flicker photometric and minimal distinct border spectral sensitivities similar to those of human observers [49].

The PC retinocortical pathway may provide the substrate for the psychophysical PC mechanism, and the MC retinocortical pathway may provide the substrate for the psychophysical MC mechanism. The discrepancies between results of behavioral and single-unit studies of macaques make it difficult to use single-unit data to compare thresholds mediated by the different pathways, but single-unit data can be useful for studying the ways L and M cone responses are combined in the two pathways. Derrington et al. [50] measured responses of PC and MC thalamic cells to modulation from white in different directions in cone excitation space. They characterized cells with a *null plane*, defined by two orthogonal axes to the direction of best response. There was generally no response to modulation in the null plane, indicating that cone signals were combined linearly. Therefore responses of MC and PC cells, like the psychophysical MC and PC mechanisms, can be modeled in terms of linear combinations of L and M cone signals.

Derrington et al. found that the *elevation* of the null plane (its angle of inclination to the isoluminant plane) for red–green opponent PC cells was usually less than 90°, indicating that while chromatically opponent, these cells also responded to homochromatic modulation. They also found that elevations of the null planes for MC cells were greater than 0°, indicating that while these cells were quite sensitive to homochromatic modulation, they also responded to isoluminant modulation. However, since it is well established that psychophysical isoluminance is affected by mean chromaticity at the luminance used by Derrington [32,51–53], it is possible that Derrington's "equiluminant" plane was not psychophysically equiluminant.

For PC cells, Derrington et al. found small changes in elevations of the null plane with temporal frequency, suggesting small phase shifts (discussed below). They did not find systematic changes in the elevations of the MC cells with temporal frequency; given the profound effects of chromatic adaptation on phase shifts (see Fig. 8), this does not mean that effects of temporal frequency on elevation of the null plane would not have been found at other adapting chromaticities.

Recently, Smith et al. [41] measured phase-dependent sensitivity for both MC and PC cells with essentially the same apparatus and stimuli used by Swanson et al. [25] and obtained data quite similar to the psychophysical data of Swanson et al. [25]. Smith et al. had both phase and amplitude spectra available and were therefore able to analyze their data in terms of the weights of the L and M cone inputs. For PC cells, the required phase shifts were 1–2°/Hz, consistent with a latency of 3–8 ms. For the MC cells the phase shifts were larger, with a more complex relation between phase shift and temporal frequency than is provided by a fixed latency.

While it seems reasonable that for uniform fields MC cells may mediate detection of homochromatic flicker and PC cells may mediate detection of heterochromatic flicker [54], at high temporal frequencies there are significant differences between psychophysical and single-unit data. With uniform fields, at low and intermediate temporal frequencies there is good agreement between psychophysical MC mechanism data and physiological MC cell data for homochromatic modulation, and between psychophysical PC mechanism data and physiological PC cell data for heterochromatic modulation. At high temporal frequencies, however, thresholds for both PC and MC cells exceed psychophysical thresholds. Similarly, the pattern electroretinogram for 17 Hz red–green heterochromatic flicker is robust, while the cortical visual evoked potential is minimal [55]. There may be low pass temporal filters, central to the retinal ganglion cells, which limit sensitivity at high temporal frequencies [54]. In addition, the MC pathway may be nonlinear at high retinal illuminances [56].

Consideration of the effects of physiological phase shifts in PC cells may be useful for comparing single-unit data gathered by researchers using quite different experimental paradigms. Analysis of the effects of phase shifts can resolve an apparent contradiction between results of single-unit studies of PC cells of two different types [40]. Two studies found that spectral increment threshold data for PC cells changed from spectrally opponent at low temporal frequencies to nonopponent at high temporal frequencies [58,59]. This result suggests that there may be large phase shifts in PC cells. However, Derrington et al. [50] found that for PC cells an increase in the temporal frequency of a uniform field caused only small increases in the angle of elevation of the null plane in cone excitation space.

This suggests that phase shifts in PC cells should be small. Analysis of these apparently contradictory results in terms of phase shifts in the PC pathway showed that both data sets were consistent with small phase shifts in the PC pathway caused by latencies of 2.5–3.7 ms [40], consistent with the 3–8 ms latencies obtained by Smith et al. [41]. Small phase shifts can eliminate spectral opponency in increment threshold data, while relatively large phase shifts would be required to cause significant changes in the angle of elevation of the null plane in cone excitation space.

## IX. ON BEYOND FLICKER: HETEROCHROMATIC IMPULSE RESPONSES

While flicker sensitivity data are amenable to mathematical analysis, they must be related to data for temporal stimuli of other types if they are to provide information useful for a range of applications. Linear systems theory has frequently been used to make such extensions by assuming that the time-varying signal is processed by a linear filter, characterized by an *impulse response*, and that thresholds for any temporal stimulus can be predicted by convolving the stimulus with the impulse response [60,61]. The measured temporal tuning function provides the amplitude spectrum for this filter, but since the phase spectra cannot be directly measured a variety of impulse responses could fit the same data set. The most common procedure is to assume a specific mathematical form for the impulse response and adjust parameters to produce an amplitude spectrum that gives a good fit to the flicker data.

An alternate method for deriving an impulse response is to assume a large class of functions, rather than a specific model; this can be done with the minimal phase assumption [9,62,63]. By assuming that the impulse response is a minimum phase filter, the phase spectra can be derived from the amplitude spectra. The minimum phase impulse response has the smallest number of oscillations and the fastest time to peak of all impulse responses sharing the same amplitude spectrum and differing only in phase spectra. While there are theoretical reasons for assuming that the visual system is not strictly a minimum phase system [64], if the minimum phase assumption provides good fits to a range of data then it can be a useful method for characterizing temporal sensitivity without the constraints of a specific mathematical form for the impulse responses.

Lee et al. [65] directly measured impulse responses for macaque retinal ganglion cells and compared them with the predictions of minimum phase impulse responses. They found that PC pathway cells behaved as minimum phase filters with a delay before response onset and MC cells approximated this behavior but had some nonlinearities, which were significant primarily

under suprathreshold conditions. Their results suggest that minimum phase filters could give good approximations for homochromatic and heterochromatic impulse responses derived from threshold data.

Swanson et al. [9] derived minimum phase impulse responses from their temporal tuning functions for homochromatic and heterochromatic flicker. To characterize their results and to allow comparison with other studies, they fit the minimum phase impulse responses using combinations of five-stage linear filters. They found that these impulse responses (Fig. 10), along with a peak detector model, gave good predictions for pulse modulation thresholds for homochromatic and heterochromatic pulses, over a 2 log unit range of mean luminances and a 16-fold range of field diameters. As described in the second section of the Appendix, their chromatic impulse responses are similar to those derived by other researchers.

For 2° fields, Swanson et al. obtained biphasic impulse responses for homochromatic modulation at mean luminances of 9–900 td and fit them with a difference of two filters (offset by a latency difference). The 900 td heterochromatic impulse response had two peaks, and the first peak was fit by adding the positive portion of the corresponding homochromatic impulse response to a heterochromatic impulse response (Fig. 10, right). This apparently reflects phase shifts in the MC mechanism that allow it to respond to heterochromatic flicker at high temporal frequencies.

Reaction times for stimuli presented with hue substitution resemble saturation discrimination functions [66,67], as do reaction time versus wavelength functions for increment thresholds on a coextensive white background [68]. This indicates that detection is mediated by the PC mechanism. Ueno and Swanson [69] showed that as increasing amounts of edge were introduced between background and test, the reaction time versus wavelength functions for increment thresholds changed systematically from wavelength-dependent to wavelength-independent, indicating a transition from responses mediated by the PC mechanism to responses mediated by the MC mechanism. Reaction time histograms for such stimuli yield distributions consistent with detection by sustained and transient mechanisms for the wavelength-dependent and wavelength-independent data, respectively [70]. Ueno and Swanson modeled their reaction time data using the homochromatic and heterochromatic impulse responses (and the wavelength-dependent sensitivity scaling for the heterochromatic impulse response) which Smith et al. [71] generated from increment threshold data gathered under similar stimulus conditions (see second section of the Appendix). Ueno and Swanson found that it was necessary to assume a 40–50 ms delay between onsets of the heterochromatic and homochromatic impulse responses. In addition, they had to assume that cumulants of the two impulse responses were pooled prior to operation of a peak detector.

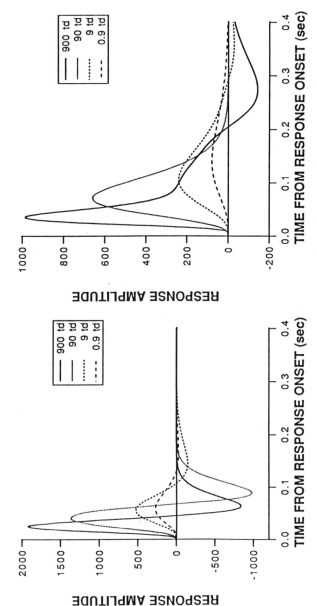

**Figure 10** Minimum phase homochromatic (left) and heterochromatic (right) impulse responses corresponding to the flicker functions shown in Figure 1. Note the unusual impulse response for heterochromatic modulation at 900 td: the first peak is fit with a scaled version of the homochromatic impulse response. The functions were derived from equations and parameters given by Swanson et al. [9].

## X.  SUMMARY

Flicker sensitivity data gathered with uniform fields yield different temporal tuning functions for homochromatic and heterochromatic flicker. While these data have often been interpreted in terms of responses of two independent mechanisms, one responding only to homochromatic flicker and the other responding only to heterochromatic flicker, it may be more appropriate to interpret the data in terms of PC and MC mechanisms, each of which is capable under some circumstances of responding to both homochromatic and heterochromatic flicker. The MC mechanism can be modeled with a sum of L and M cone responses, and the PC mechanism can be modeled with a difference. For both mechanisms the models must include temporal-frequency-dependent phase shifts between responses of the L and M cones. Measured phase axes are affected by mean luminance and mean chromaticity, and under some circumstances phase shifts in the MC mechanism must be as large as 90°.

Macaque PC and MC retinocortical pathways provide parallels to the psychophysical PC and MC mechanisms. Behavioral studies of macaques with lesions in either PC or MC pathways indicate that only the PC pathway mediates normal thresholds for heterochromatic modulation and that the PC pathway can mediate normal thresholds for homochromatic modulation over a range of spatial and temporal frequencies. These studies also indicate that only the MC pathway mediates normal thresholds for homochromatic modulation at a combination of low spatial and high temporal frequencies (the "high velocity corner"). Responses of red/green opponent PC cells are described well by a difference of L and M cone responses, with a phase shift produced by a 3–8 ms center–surround latency. For MC cells the phase shifts were related in a more complicated way to temporal frequency.

Use of impulse responses allows these results to be applied to other types of data. Heterochromatic impulse responses are monophasic up to about 100 td, but at higher mean luminances, phase shifts in the MC mechanism produce an odd heterochromatic impulse response, which shows significant contributions from both PC and MC mechanisms. The heterochromatic impulse responses are consistent with pulse modulation thresholds and reaction time data.

The existence of phase shifts in the PC and MC mechanisms means that under appropriate stimulus conditions, each mechanism may mediate both homochromatic and heterochromatic thresholds. This may make it difficult to determine which mechanism mediates detection for a particular task. Since phase shifts in the MC mechanism can vary considerably with temporal frequency, mean luminance, and chromatic adaptation, the interpreta-

tion of data gathered with equiluminant flicker calls for the determination of the absolute value of phase shifts in the MC mechanism for each stimulus configuration used. One of the simplest ways of isolating responses of the PC and MC mechanisms may be with heterochromatic and homochromatic flicker of uniform fields at mean luminances below 100 td.

## ACKNOWLEDGMENTS

Supported by grant EY07716 from the National Eye Institute. Steven Nusinowitz made helpful comments, which improved the clarity of the manuscript.

## APPENDIX

The main text emphasizes data gathered by the author in collaboration with Joel Pokorny and Vivianne C. Smith at the University of Chicago. To demonstrate that these data are not unique to the specific stimulus conditions used, we now review the relevant literature and show that the key features of data from other studies are represented in the data discussed in the main text. First we discuss temporal tuning curves for heterochromatic flicker; then we turn to heterochromatic impulse responses. Details about the spatial properties of the stimuli used in these studies are given in Table A-1.

## Temporal Sensitivity to Heterochromatic Flicker

During the first half of this century, studies of sensitivity to heterochromatic flicker were limited to measurements of the highest frequency that could be seen for equiluminant flicker, referred to as the *critical color fusion frequency*. These results are summarized in two studies, which appeared in 1957 and 1958 [72,73]: critical color fusion frequency increases systematically with separation in chromaticity of the two primaries, and for a fixed chromatic separation increases with mean luminance in a manner quite similar to the critical fusion frequency for homochromatic modulation.

In the late 1950s, DeLange [10] and Kelly [74] revolutionized the study of temporal sensitivity by measuring contrast threshold as a function of frequency for fixed mean luminances. DeLange obtained temporal tuning functions that were bandpass for homochromatic modulation and low pass for red–green heterochromatic modulation. Kelly [74] gathered homochromatic flicker data with a large blurred field, in contrast to the small field with sharp edges used by DeLange, and obtained evidence of profound

**Table A-1**  Spatial Stimulus Conditions for Studies of Chromatic Temporal Sensitivity Cited in Chapter 5

| Study | Size and mean retinal illuminance of test field: surround or adapting fields |
|---|---|
| Burr and Morrone (1993) [79] | 1 c/deg grating, 147 td; equiluminant surround |
| DeLange (1958) [10,16] | 2°, 2.9 and 285 td; 60° equiluminant surround |
| Kelly and van Norren (1977) [13] | 1.8°, 860 td; no surround |
| Regan and Tyler (1971) [12] | 2°, 1.3 and 25 td; no surround vs. 10° equiluminant surround |
| Smith, Bowen, and Pokorny (1984) [71] | 1.2°, 15 td; 4° surround |
| Swanson, Ueno, Pokorny, and Smith (1987) [9] | 0.5°–8°, 0.9–900 td; no surround |
| Uchikawa and Ikeda (1986) [78] | 0.5°, 100 td; dark surround |
| Van der Horst (1969) [11] | 5.3° × 2.8°, 0.5–220 td; 7° × 9° elliptic equiluminant surround |
| Varner, Jameson, and Hurvich (1984) [14] | 2°, 480 td; no surround vs. 100 td; 368 td 8° adapting fields |
| Wisowaty (1981) [18] | 1°, 70 td; 5° surround at several intensities |

effects of spatiotemporal interaction. A decade later, Van der Horst [11] measured temporal tuning functions for red–green heterochromatic modulation at a range of mean luminances and found that they were low pass for mean luminances of 0.5–220 td, with the corner frequency increasing with mean luminance. Van der Horst also noted that peak sensitivity (at 0.5–1 Hz) increased with mean luminance from 0.5 td to 48 td, then remained unchanged from 48 td to 220 td.

Regan and Tyler [12] measured temporal sensitivity for wavelength modulation, rather than equiluminant exchange of two primaries, and also obtained temporal tuning functions that were low pass for heterochromatic modulation and bandpass for homochromatic modulation. Their novel stimuli raise the question of what the appropriate metric is for heterochromatic modulation. DeLange used red/green equiluminant exchange to produce a flickering field, which he superimposed on a steady field of the same mean chromaticity. He varied modulation by changing the relative intensities of the flickering and steady fields (keeping mean luminance constant) and defined chromatic modulation in terms of the ratio of intensities of the flickering and steady fields. This approach has been termed an "equivalent modulation" metric. Van der Horst used equiluminant exchange of red and green phosphors on a television screen, varying modulation depths in a fixed ratio to maintain equiluminance at all contrasts. His stimuli were therefore comparable to DeLange's, but he defined modulation in terms of distance in CIE coordinates rather than in terms of physical contrast. Regan and Tyler defined modulation depth in terms of change in wavelength, a metric tied to physical properties of the stimulus but quite different from those of either DeLange or Van der Horst. The three metrics are not linear transforms of each other, so it is difficult to make precise comparisons of the shapes of the heterochromatic temporal tuning functions from these three studies.

Kelly and Van Norren [13] provided data and a theoretical framework supporting the use of DeLange's equivalent modulation metric for heterochromatic sensitivity, and subsequent studies of heterochromatic temporal tuning functions have used this metric [9,14,18]. Kelly and Van Norren suggested that the response of the mechanism mediating detection is the instantaneous value of the difference between the input signals from the two primaries, determined by the cone quantal catches for the primaries. Therefore the modulation of the instantaneous difference signal will be a constant times the stimulus modulation depth, and the shape of the heterochromatic temporal tuning function (plotted in terms of stimulus modulation depth) will be the same as the shape of the temporal tuning function of the mechanism mediating detection, scaled vertically by a constant which depends on the cone quantal catches for the two primaries. Kelly and Van

Norren's data were similar to DeLange's, except that the heterochromatic temporal tuning function showed some low-frequency attentuation.

Figures 1 and 2 in the main text, for 2° fields used by Swanson et al. [9], are consistent with and illustrate the findings listed above. Consistent with the findings of Truss [72] and Walraven [73] on critical color fusion frequency versus mean luminance, when the data for heterochromatic flicker at 0.9–90 td were plotted as log amplitude sensitivity versus log frequency, they converged at high temporal frequencies, to a line with the same slope as for homochromatic flicker (Fig. 2). Consistent with the findings of De-Lange [10], Van der Horst [11], Regan and Tyler [12], Kelly and Van Norren [13], and Varner et al. [14] on the shape of the heterochromatic temporal tuning function, at mean luminances of 0.9–90 td it was low pass while at 900 td it was bandpass, and at all mean luminances heterochromatic functions were tuned to lower temporal frequencies than homochromatic functions (Fig. 1). Consistent with the findings of Van der Horst [11] on effects of mean luminance on the peak sensitivity of the heterochromatic temporal tuning function, peak sensitivity increased with mean luminance from 0.9 td to 90 td, then remained constant from 90 td to 900 td. Figures 1 and 2 therefore summarize nearly a century of research on sensitivity to chromatic flicker.

## Heterochromatic Impulse Responses

A second approach to studying chromatic temporal processing also began in the first half of this century, using perceived simultaneity judgments. This approach, reviewed by Breton [75], measures latencies of responses to suprathreshold stimuli. Perceived simultaneity methods have shown that latency is wavelength dependent if stimuli are presented with hue substitution: latency versus wavelength functions resemble saturation discrimination functions, being longest at 570 nm and becoming progressively shorter toward the spectral extremes [75–77]. Reaction time experiments using chromatic stimuli have obtained similar results [66,67]. Bowen [77], who made both onset and offset latency measurements, used the difference as a measure of visual response duration for homochromatic increments and equiluminant pulses. Response durations for equiluminant pulses were considerably longer than for homochromatic increments, suggesting that the heterochromatic impulse response has a longer integration time than the homochromatic impulse response.

The first study to quantify the heterochromatic impulse response was that of Smith et al. [71], who measured threshold duration functions for equiluminant modulation from white, over a range of wavelengths. They found that a single impulse response fit all the data, using magnitude scal-

ing factors that corresponded with classical purity discrimination data. They also measured threshold duration functions for spectral increments on a white background and for white-on-white (a homochromatic pulse). They fit the white-on-white data with a homochromatic impulse response and found that the spectral increment data could be fit well by vector summation of the heterochromatic and homochromatic impulse responses. The use of a uniform field and an appropriately low mean luminance make it likely that the heterochromatic and homochromatic thresholds were mediated by PC and MC mechanisms, respectively.

Another method for deriving the impulse response is to measure sensitivity for two consecutive pulses as a function of pulse separation, and fit the data with a model for the impulse response [60]. Uchikawa and Ikeda [76] measured probability of detection for equiluminant modulation as a function of pulse onset asynchrony and derived chromatic impulse responses for modulation from white in several color directions. Burr and Morrone [79] used red–green hue substitution with the two-pulse summation technique, measuring detection thresholds for both positive and negative stimuli. They found that the impulse response derived by fitting their two-pulse data with an exponentially damped frequency-modulated sinusoid gave a good fit to flicker data gathered with the same stimuli.

The studies discussed above are in agreement that temporal processing involves longer integration times and a longer time to peak for heterochromatic stimuli than for homochromatic stimuli. In addition, there is good quantitative agreement concerning chromatic impulse responses. Smith et al. used monophasic five-stage filters having corner frequencies of 5 and 12.6 Hz for the heterochromatic and homochromatic impulse responses, respectively. These values are quite similar to the 6 and 10.8 Hz corner frequencies Swanson et al. [9] obtained with a similar field size and mean luminance (2° field at 9 td). Uchikawa and Ikeda derived a five-stage filter with a 5 Hz corner frequency for pulses from white towards red or green, identical to the heterochromatic impulse response of Smith et al. and similar to the 9 td heterochromatic impulse response of Swanson et al. Burr and Morrone derived homochromatic and heterochromatic impulse responses and found them to be quite similar to Swanson et al.'s 90 td, 2° impulse response.

In addition to the impulse response, it is necessary to have a detection model. Smith et al. and Swanson et al. used a peak detector, while Uchikawa and Ikeda as well as Burr and Morrone used a temporal probability summation model. It has been shown that these different models can lead to different estimates for the homochromatic impulse response [80]. However, all four studies obtained comparable results for heterochromatic impulse responses. In addition, Burr and Morrone found that their hetero-

chromatic impulse response was identical to the corresponding minimum phase impulse response and that their homochromatic impulse response was only slightly different from the corresponding minimum phase impulse response. Kremers et al. [81] compared responses to heterochromatic and homochromatic modulation of compound periodic waveforms for macaque PC and MC retinal ganglion cells and for human observers. They found that a peak detector model fit both types of data, with similar results for either a peak-trough detector or a central detector summing spikes within truncated Gaussian windows of varying duration.

While there are a range of methods for studying temporal integration of chromatic signals, and a variety of ways for deriving chromatic impulse responses, the heterochromatic impulse responses in Figure 10 are highly representative of results obtained in other laboratories.

## REFERENCES

1. O. N. Rood, On a photometric method which is independent of color, *Am. J. Sci. 46*:173–176 (1893).
2. H. E. Ives, Studies in the photometry of lights of different colours. I. Spectral luminosity curves obtained by the quality of brightness photometer and the flicker photometer under similar conditions, *Phil. Mag. 24*:149–188 (1912).
3. H. E. Ives, Studies in the photometry of lights of different colours. II. Spectral luminosity curves by the method of critical frequency, *Phil Mag. 24*:352–370 (1912).
4. P. E. King-Smith and D. Carden, Luminance and opponent color contributions to visual detection and adaptation and to temporal spatial integration, *J. Opt. Soc. Am. 66*:709 (1976).
5. G. Wagner and R. M. Boynton, Comparison of four methods of heterochromatic photometry, *J. Opt. Soc. Am. 62*:1508–1515 (1972).
6. R. M. Boynton, *Human Color Vision*, Holt, Rinehart & Winston, New York, 1979.
7. P. Lennie, J. Pokorny, and V. C. Smith, What is luminance? *J. Opt. Soc. Am. A10*: 1283–1293 (1993).
8. D. H. Kelly and C. A. Burbeck, Further evidence for a broadband, isotropic mechanism sensitive to high-velocity stimuli, *Vision Res. 27*(9):1527–1537 (1987).
9. W. H. Swanson, T. Ueno, V. C. Smith, and J. Pokorny, Temporal modulation sensitivity and pulse detection thresholds for chromatic and luminance perturbations, *J. Opt. Soc. Am. A 4*:1992–2005 (1987).
10. H. DeLange, Research into the dynamic nature of the human fovea–cortex systems with intermittent and modulated light. I. Attentuation characteristics with white and colored light, *J. Opt. Soc. Am. 48*:777–784 (1958).
11. G. J. C. Van der Horst, Chromatic flicker, *J. Opt. Soc. Am. 59*:1213–1217 (1969).

12. D. Regan, and C. W. Tyler, Some dynamic features of colour vision, *Vision Res. 11*:1307–1324. (1971).

13. D. H. Kelly and D. van Norren, Two-band model of heterochromatic flicker, *J. Opt. Soc. Am. 67*:1081–1091 (1977).

14. D. Varner, D. Jameson, and L. M. Hurvich, Temporal sensitivities related to color theory, *J. Opt. Soc. Am. A 1*:474–481 (1984).

15. F. L. Tufts, Spectrophotometry of normal and color-blind eyes, *Phys. Rev. I 25*:433–452 (1907).

16. H. DeLange, Research into the dynamic nature of the human fovea–cortex systems with intermittent and modulated light. II. Phase shift in brightness and delay in color perception, *J. Opt. Soc. Am 48*:784–789 (1958).

17. F. D. Varner, T. P. Piantanida, and H. D. Baker, Spatio-temporal Rayleigh matches, *Vision Res. 17*:181–191 (1977).

18. J. J. Wisowaty, Estimates of the temporal response characteristics of chromatic pathways, *J. Opt. Soc. Am 71*:970–977 (1981).

19. P. K. Kaiser, M. Ayama, and R. L. P. Vimal, Flicker photometry: Residual minimum flicker, *J. Opt. Soc. Am. A 3*:1989–1993 (1986).

20. M. W. von Grunau, Lateral interactions and rod intrusion in color flicker, *Vision Res. 17*:911–916 (1977).

21. T. J. T. P. Van den Berg and H. Spekreijse, Interaction between rod and cone signals studied with temporal sine wave stimulation, *J. Opt. Soc. Am. 65*: 1210–1217 (1977).

22. A. Eisner and D. I. A. MacLeod, Flicker photometric study of chromatic adaptation: Selective suppression of cone inputs by colored backgrounds, *J. Opt. Soc. Am. 71*:705–718 (1981).

23. W. B. Cushman and J. Z. Levinson, Phase shift in red and green counterphase flicker at high temporal frequencies, *J. Opt. Soc. Am. 73*:1557–1561 (1983).

24. D. T. Lindsey, J. Pokorny, and V. C. Smith, Phase-dependent sensitivity to heterochromatic flicker, *J. Opt. Soc. Am. A 3*:921–927 (1986).

25. W. H. Swanson, J. Pokorny, and V. C. Smith, Effects of temporal frequency on phase-dependent sensitivity to heterochromatic flicker, *J. Opt. Soc. Am. A 4*:2266–2273 (1987).

26. W. H. Swanson, J. Pokorny, and V. C. Smith, Effects of chromatic adaptation on phase-dependent sensitivity to heterochromatic flicker, *J. Opt. Soc. Am. A 5*:1976–1982 (1988).

27. V. C. Smith and J. Pokorny, Spectral sensitivity of the foveal cone photopigments between 400 and 500 nm, *Vision Res. 15*:161–171 (1975).

28. J. E. Thornton and E. N. J. Pugh, Red/green color opponency at detection threshold, *Science 219*:191–193 (1983).

29. D. I. A. MacLeod and R. M. Boynton, Chromaticity diagram showing cone excitation by stimuli of equal luminance, *J. Opt. Soc. Am. 69*:1183–1185 (1979).

30. J. Krauskopf, D. R. Williams, and D. W. Heeley, Cardinal directions of color space, *Vision Res. 22*:1123–1131 (1982).

31. R. M. Boynton, A system of photometry and colorimetry based on cone excitations, *Color Res. Appl. 11*:244–252 (1986).

32. J. Pokorny, Q. Jin, and V. C. Smith, Spectral luminosity functions, scalar linearity and chromatic adaptation, *J. Opt. Soc. Am. A10*:1304–1313 (1993).

33. W. H. Swanson, Chromatic adaptation alters spectral sensitivity at high temporal frequencies, *J. Opt. Soc. Am. A10*:1294–1303 (1993).

34. C. Noorlander, M. J. G. Heuts, and J. J. Koenderink, Sensitivity to spatiotemporal combined luminance and chromaticity contrast, *J. Opt. Soc. Am. 62*:111–117 (1981).

35. C. F. Stromeyer, R. E. Kronauer, and G. R. Cole, Adaptive mechanisms controlling sensitivity to red-green chromatic flashes, *Color Vision: Physiology and Psychophysics* (J. D. Mollon and L. T. Sharpe, eds.), Academic Press, New York, 1983, pp. 313–330.

36. G. R. Cole, T. Hine, and W. McIlhagga, Detection mechanisms in L-, M- and S-cone contrast space, *J. Opt. Soc. Am. A 10*:38–51 (1993).

37. C. F. I. Stromeyer, G. R. Cole, and R. E. Kronauer, Chromatic suppression of cone inputs to the luminance flicker mechanism, *Vision Res. 27*:1113–1137 (1987).

38. D. H. Kelly, Spatiotemporal variation of chromatic and achromatic contrast thresholds, *J. Opt. Soc. Am. 73*:742–750 (1983).

39. C. A. Burbeck and D. H. Kelly, Spatiotemporal characteristics of visual mechanisms: Excitatory inhibitory model, *J. Opt. Soc. Am. 70*:1121–1126 (1980).

40. W. H. Swanson, Effects of phase shifts between cone inputs on responses of chromatically opponent cells, *From Pigments to Perception* (A. Valberg and B. B. Lee, eds.), Plenum Press, London, 1991, pp. 447–450.

41. V. C. Smith, B. B. Lee, J. Pokorny, P. R. Martin, and A. Valberg, Responses of macaque ganglion cells to the relative phase of heterochromatic modulated lights, *J. Physiol. 458*:191–221 (1992).

42. W. H. Merigan and J. H. R. Maunsell, How parallel are the primate visual pathways? *Annu. Rev. Neurosci. 16*:369–402 (1993).

43. W. H. Merigan, P and M pathway specialization in the macaque, *From Pigments to Perception* (A. Valberg and B. B. Lee, eds.), Plenum Press, London, 1991, pp. 117–125.

44. P. H. Schiller, The color-opponent and broad-band channels of the primate visual system, *From Pigments to Perception* (A. Valberg and B. B. Lee, eds.), Plenum Press, London, 1991, pp. 127–132.

45. C. R. Ingling and E. Martinez-Uriegas, The spatiotemporal properties of the r-g cell channel, *Vision Res. 25*:333–338 (1985).

46. J. M. Crook, B. Lange-Malecki, B. B. Lee, and A. Valberg, Visual resolution of macaque retinal ganglion cells, *J. Physiol. 396*:205–224 (1988).

47. E. Kaplan and R. M. Shapley, The primate retina contains two types of ganglion cells with high and low contrast sensitivity, *Proc. Natl. Acad. Sci, U.S.A. 83*:2755–2757 (1986).

48. B. B. Lee, P. R. Martin, and A. Valberg, The physiological basis of heterochromatic flicker photometry demonstrated in the ganglion cells of the macaque retina, *J. Physiol. 404*:323–347 (1988).

49. A. Valberg, B. B. Lee, P. K. Kaiser, and J. Kremers, Responses of macaque ganglion cells to movement of chromatic borders, *J. Physiol. 458*:579–602 (1992).

50. A. M. Derrington, J. Krauskopf, and P. Lennie, Chromatic mechanisms in lateral geniculate nucleus of macaque, *J. Physiol. 357*:241–265 (1984).

51. H. E. Ives, Studies in the photometry of lights of different colours. V. The spectral luminosity curve of the average eye, *Phil. Mag. 24*:853–863 (1912).

52. H. DeVries, The luminosity curve of the eye as determined by measurements with the flicker photometer, *Physica 14*:319–341 (1948).

53. C. R. Ingling, B. H. Tsou, T. J. Gast, S. A. Burns, J. O. Emerick, and L. Riesenberg, The achromatic channel. I. The nonlinearity of minimum border and flicker matches, *Vision Res. 18*:379–390 (1978).

54. B. B. Lee, J. Pokorny, V. C. Smith, P. R. Martin, and A. Valberg, Luminance and chromatic modulation sensitivity of macaque ganglion cells and human observers, *J. Opt. Soc. Am. A 7*:2223–2236 (1990).

55. M. Bach and J. Gerling, Retinal and cortical activity in human subjects during color flicker fusion, *Vision Res. 32*:1219–1223 (1992).

56. B. B. Lee, P. R. Martin, and A. Valberg, A non-linearity summation of M- and L-cone inputs to phasic retinal ganglion cells of the macaque, *J. Neurosci. 9*:1433–1442 (1989).

57. W. H. Swanson, Heterochromatic modulation photometry in heterozygous carriers of congenital color defects, *Colour Vision Deficiencies X* (B. Drum, J. D. Moreland, and A. Serra, eds.), Documenta Ophthalmologica Proceedings Series, Vol. 54, 1991, pp. 457–471.

58. P. Gouras and E. Zrenner, Enhancement of luminance flicker by color-opponent mechanisms, *Science 205*:587–589 (1979).

59. C. C. A. M. Gielen, J. A. M. van Ginsbergen, and A. J. H. Verdrik, Recon-struction of cone-system contributions to responses of colour-opponent neu-rons in monkey lateral geniculate, *Biol. Cybernetics 44*:211–221 (1982).

60. M. Ikeda, Temporal impulse response, *Vision Res. 26*(9):1431–1442 (1986).

61. A. B. Watson, Temporal sensitivity, *Handbook of Perception and Human Performance* (K. R. Boff, L. Kaufman, and J. P. Thomas, eds.), Wiley, New York, 1986.

62. D. G. Stork and D. S. Falk, Visual temporal impulse responses from flicker sensitivities, *J. Opt. Soc. Am. A 4*:1130–1135 (1987).

63. G. Dagnalie, Temporal impulse responses from flicker sensitivities: Practical considerations, *J. Opt. Soc. Am. A 9*:659–672 (1992).

64. J. D. Victor, Temporal impulse responses from flicker sensitivities: Causality, linearity, and amplitude data do not determine phase, *J. Opt. Soc. Am. A 6*: 1302–1303 (1989).

65. B. B. Lee, J. Pokorny, V. C. Smith, J. Kremers, and A. Valberg, The tempo-ral response of macaque ganglion cells. *Invest. Opthalmol. Visual Sci. 33*: 1997–2011 (1990).

66. M. J. Nissen and J. Pokorny, Wavelength effects on simple reaction time, *Percep. Psychophysiol. 22*:457–462 (1977).

67. M. J. Nissen, J. Pokorny, and V. C. Smith, Chromatic information process-ing, *J. Exp. Psychol. 5*:406–419 (1979).

68. T. Ueno, J. Pokorny, and V. C. Smith, Reaction times to chromatic stimuli, *Vision Res. 25*:1623–1627 (1985).

69. T. Ueno and W. H. Swanson, Response pooling between chromatic and lumi-nance systems, *Vision Res. 29*:325–333 (1989).

# Introduction to Chapter 6

The reader who has gone straight through the book may be convinced at this point that none of the three dimensions of visual perception — time, space, and color — can profitably be studied alone. If there is an exception that proves this rule, it would be Dr. Piantanida's chapter, which deals with genetic control of the spectral absorbances of the retinal photopigments. Even these spectral properties undoubtedly evolved in relation to how the pigments are used and what is done with the signals they generate. For the moment, however, it is convenient to ignore those larger issues, because recent results in the molecular biology of rod and cone pigments are so exciting.

Like Chapter 1, this chapter is a review of some very important properties of human vision. But here we are dealing not with century-old fundamentals, but with yesterday's headlines. The advent of molecular biology has revolutionized most aspects of biological science, and the study of color vision is no exception.

Long before the discovery of DNA molecules, there was an important link between color vision and genetics. The finding that certain defects of color perception ran in families, showing a sex-linked inheritance pattern, caused some visual scientists to become interested in genetics, and vice versa. But like other geneticists of the time, they could only infer genotypes by studying phenotypes and plotting Mendelian inheritance trees.

Because the normal human retina was thought to contain only three

types of cone pigment, the psychophysics of color vision provided reasonably precise characterizations of the relatively few types of color-defective phenotype. An important motivation for such studies was the possibility that a suitable genetic database might help reveal the mechanisms of normal color vision. But progress was slow (sometimes because of unrealized spatial and temporal influences on color perception).

Then came the molecular biology revolution. What had only been modeled, inferred, and guessed could now be measured and catalogued on a molecular scale. With a strong background in both genetics and color vision, Tom Piantanida was ideally situated to exploit this revolution, and he did. Collaborating with Jeremy Nathans and others, he was in on the ground floor of what has become a large and thriving scientific enterprise.

A very versatile scientist (and enthusiastic race-car driver), Tom has been my valued colleague and occasional collaborator at SRI for many years. Always generous with his help and advice about color vision and other issues, he has recently become involved with virtual reality and its applications. We were not surprised when he leaped into the molecular biology ferment and soon became an expert on the subject. No one is better qualified than Dr. Piantanida to guide us through the molecular genetics of color vision. And the extensive glossary he provides should also be helpful in reading other chapters that deal with color vision.

70. T. Ueno, Sustained and transient properties of chromatic and luminance systems, *Vision Res. 32*:1055–1065 (1992).
71. V. C. Smith, R. W. Bowen, and J. Pokorny, Threshold temporal integration of chromatic stimuli, *Vision Res. 24*:653–660 (1984).
72. C. V. Truss, Chromatic flicker fusion frequency as a function of chromaticity difference, *J. Opt. Soc. Am. 47*:1130–1134 (1957).
73. P. L. Walraven, H. J. Leebeek, and M. A. Bouman, Some measurements about the fusion frequency of colors, *Opt. Acta 5*:50–54 (1958).
74. D. H. Kelly, Effects of sharp edges in a flickering field, *J. Opt. Soc. Am. 49*: 730–732 (1959).
75. M. E. Breton, Hue substitution: Wavelength latency effects, *Vision Res. 17*: 435–443 (1977).
76. F. Weingarten, Wavelength effect on visual latency, *Science 176*:692–694 (1972).
77. R. W. Bowen, Latencies for chromatic and achromatic visual mechanisms, *Vision Res. 21*:1457–1466 (1981).
78. K. Uchikawa and M. Ikeda, Temporal integration of chromatic double pulses for detection of equal-luminance wavelength changes, *J. Opt. Soc. Am. 3*: 2109 (1986).
79. D. C. Burr and M. C. Morrone, Impulse response functions for chromatic and achromatic stimuli, *J. Opt. Soc. Am. A10*:1706–1713 (1993).
80. A. B. Watson, Probability summation over time, *Vision Res. 19*:515–522 (1979).
81. J. Kremers, B. B. Lee, J. Pokorny, and V. C. Smith, Sensitivity of macaque retinal ganglion cells and human observers to compound periodic waveforms. *Vision Res. 14*:1997–2011 (1993).

# 6

# The Molecular Genetics of Human Color Vision: From Nucleotides to Nanometers

## Thomas P. Piantanida

*SRI International, Menlo Park, California*

## I. BASIC CONCEPTS

### A. Trichromatic Vision

The initial stage of color perception — disregarding preretinal absorption — is photoreception. The spectral sensitivity envelopes of the photoreceptors are the primary determinant of color vision phenotype; postreceptoral processes can modify color vision, but they cannot produce it unless the spectral information has been captured in the photoreceptors. Photoreceptor spectral sensitivity in most chordates, humans included, is determined by the protein portion of the photopigment housed in photoreceptor membranes. The amino acid sequence of the protein, *opsin*, interacts with the chromophore, *retinal*, to tune the spectral sensitivity of the resultant visual photopigment. In humans, and in some other chordates, four genes affect photoreceptor spectral sensitivity.

One gene encodes the opsin of the rod photopigment, rhodopsin. Rods cannot provide information about the spectral distribution of the photon energies falling on the retina, however, because they contain only a single photopigment. Comparison of the photon capture by at least two receptors with different spectral sensitivities is the minimal requirement for color vision; color vision is the result not of signal strengths in the receptors, but of differences in signal strengths among receptors with different spectral

sensitivities. Rods, containing only a single photopigment, can encode only the magnitude of photon capture.

Cones, being of three classes (in color-normal human observers), each with a different spectral sensitivity, can encode the colors of objects by providing differential signals to subsequent processing stages of the visual system. The differences in spectral sensitivity of the cones is determined by three color vision genes that determine the amino acid sequence of the cone opsins.

## B.  Molecular Genetics

Genes are actually segments of a tremendously long molecule of DNA — deoxyribonucleic acid. The DNA molecule (Fig. 1) is composed of nucleotides consisting of a sugar (deoxyribose), a phosphate group, and one of four bases: adenine (A), guanine (G), cytosine (C), and thymine (T). The nucleotides are polymerized into a pair of long strands that are wound together into a double helix with pairs of bases forming bridges between the twisted strands. The bases always pair in particular arrangements: C always pairs with G and A always pairs with T. Because of this specific pairing, one strand of the DNA molecule is a template for the other.

Single-stranded DNA is also a template for another macromolecule, RNA — ribonucleic acid. RNA is very similar to DNA, except that deoxyribose has been replaced by ribose, and the T base has been replaced by another called uracil (U). During transcription of DNA into RNA, the specificity of base pairing guarantees that the sequence of bases on RNA is always the complement of bases on the DNA from which it was transcribed. Thus, a single strand of DNA with the sequence:

C-G-A-G-T-T-A-A-A-G-T-C

would be transcribed into RNA with the sequence:

G-C-U-C-A-A-U-U-U-C-A-G

When a gene is transcribed, a particular kind of RNA is produced, messenger RNA (mRNA). In humans (and in many other eukaryotes), mRNA contains more information that is required to produce a complete protein or protein subunit. Before mRNA is translated into protein, part of the mRNA molecule is excised. The sequences in the gene that correspond to the excised mRNA sequences are called intervening sequences or introns, whereas the sequences that are actually translated into protein (expressed) are called exons. Thus, genes frequently consist of an alternating series of exons and introns. The genes that encode the protein portion of the human visual photopigments, for example, consist of either five exons and four

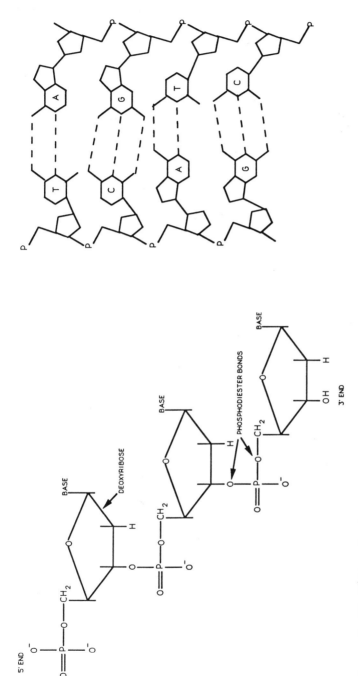

**Figure 1**  The DNA molecule, showing both strands of the deoxyribose–phosphate double helix and the four bases, adenine, cytosine, guanine, and thymine. (From Ref. 45.)

introns, or six exons and five introns, depending on the type of photopigment.

## C.  Color Vision Biochemistry

Much of what we know about the biochemistry of color vision is based on the pioneering research of George Wald [1], for which he was awarded the Nobel Prize in 1967. Wald and his coworkers documented that when a photon is absorbed by a photopigment molecule, the chromophore portion of the molecule—the vitamin A derivative retinal—changes configuration from the 11-*cis* from the all-*trans* form. This conformational change initiates a series of chemical reactions that eventually cleaves retinal from opsin.

Opsin is the component of the photopigment molecule that is encoded

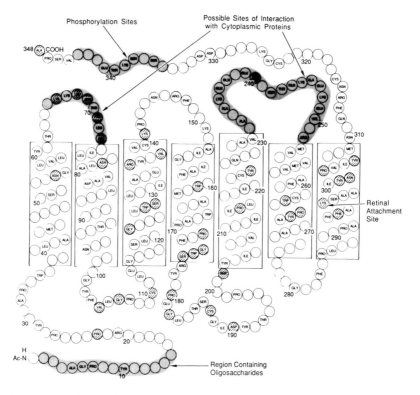

**Figure 2**   The tertiary structure of the photopigment molecules consists of seven transmembrane helices, interactive loops and side chains, and several invariant amino acids. (From Ref. 43.)

by the visual pigment genes. It is also responsible for tuning the spectral sensitivity of the photopigment molecule. Native retinal absorbs light maximally at about 380 nm, and protonated retinal absorbs maximally near 440 nm. When retinal is bound to an opsin molecule, the spectral sensitivity of the resultant molecule can be shifted, usually toward longer wavelengths, depending on the amino acid sequence of the opsin.

The visual pigments are located in the disk membranes of the receptors. The opsin portion is large enough to form a palisade of seven helices that span the disk membrane and form a pocket for 11-*cis*-retinal (Fig.2). The chains linking the helices contain important amino acid sequences that interact with other molecules within the disk and in the interdiskal space.

## II.  MOLECULAR BIOLOGY OF COLOR VISION

### A.  Rhodopsin

The amino acid sequences of the human rod and cone opsins were disclosed largely by Nathans and colleagues. Nathans and Hogness [2] compared the nucleotide sequence of human rhodopsin to that of bovine rhodopsin, which had been sequenced by Ovchinnokov et al. [3] and by Hargrave et al. [4]. These investigators reported that the human and bovine rhodopsin genes were very similar, each consisting of five exons and four introns. The similarity did not stop there, however: both molecules were found to consist of 348 amino acids, and of these, 325 were identical (Fig. 3).

### B.  The S Pigment Opsin

Nathans and coworkers [5] also analyzed the human cone opsins. The first cone opsin gene they isolated was localized to chromosome 7, which identified it as the S (short-wavelength–sensitive) pigment gene (blue), since both the M (medium-wavelength–sensitive) and L (long-wavelength–sensitive) pigment genes are X-linked. This S pigment gene was found to have the same five-exon/four-intron structure as the rhodopsin gene. Furthermore, like rhodopsin, the S pigment contains a protein containing 348 amino acids, some 40% of which are common to both proteins. Because of the strong homology between the S pigment and rhodopsin, and the results of hydrophobicity tests, which identify hydrophilic and hydrophobic regions of the molecule, suggested that the S pigment molecule (Fig. 4) has the same tertiary structure as the rhodopsin molecule. Like rhodopsin, it is assumed to consist of seven helices that span the photoreceptor disk membrane.

Nathans et al. [5] found that both the L pigment gene (red) and the M pigment gene (green) consist of six exons, rather than the five exons of the rhodopsin or S pigment genes (Fig. 5). The first exon of the L and M pigment genes was new, being shared by neither rhodopsin nor the S pig-

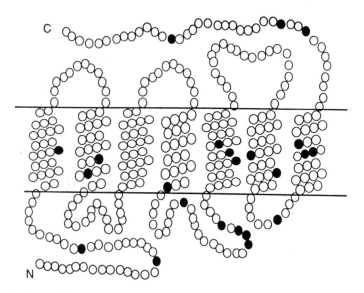

**Figure 3** The human rhodopsin molecule. Each of the 348 circles represents an amino acid; the solid circles represent amino acids that differ in human and bovine rhodopsin. (From Ref. 2.)

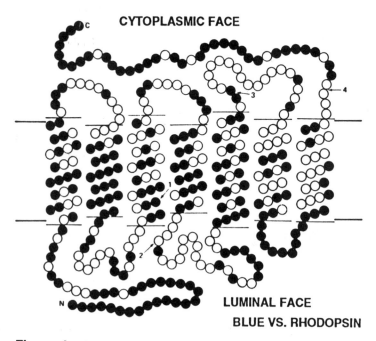

**Figure 4** Comparison of the S cone opsin with rhodopsin. The solid circles represent amino acid substitutions between these two molecules; open circles represent identical amino acids. (From Ref. 5.)

CYTOPLASMIC FACE

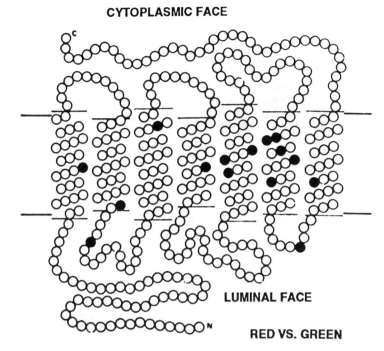

LUMINAL FACE

RED VS. GREEN

**Figure 5**   Comparison of the L and M cone opsins. The solid circles represent amino acid substitutions between these two molecules; open circles represent identical amino acids. (From Ref. 5.)

ment gene. Both the L and M pigment genes encoded an opsin that consisted of 348 amino acids, compared with the 345 amino acids of rhodopsin and S pigment. By examining DNA from dichromats, Nathans et al. [6] determined which of the amino acid sequences they had isolated belonged to the L and M pigments.

## C.   The L and M Pigment Genes

Sequence analysis by Nathans et al. [5] revealed that only 15 amino acids were substituted between the L and M pigments, suggesting the possibility of gene duplication. Nathans et al. [5] also found that among color-normal males, there was a variable ratio of L to M pigment genes (Fig. 6). The L/M ratio could be 1 : 1, 1 : 2, or 1 : 3. Subsequent researchers [7] have reported L/M ratios of as much as 1 : 5. These findings are interpreted as multiple, identical copies of the M pigment gene on the X chromosome. Sequence analysis of the color vision locus by Vollrath et al. [8] suggests that the L pigment gene and one or more copies of the M pigment gene form

**Figure 6**   The genotypes of color-normal males. The L pigment gene is shown as a solid arrow, and the M pigment gene is shown as an open arrow. (From Ref. 5.)

a tandem array on the X chromosome. The high degree of sequence homology and the arrangement of the genes on the X chromosome suggest that the M pigment gene probably arose by duplication of the L pigment gene.

High sequence homology and head-to-tail arrangement of the L and M pigment genes may also account for the variable number of M pigment genes. These factors would enhance the possibility of mispairing of L and M pigment genes during meiosis. Recombination between the mispaired X chromosomes could produce two chromosomes with unequal numbers of genes. In this way, one of the M pigment genes could be transposed to the other chromosome, producing a chromosome with one L pigment gene and two M pigment genes. The other X chromosome would be left with just a single L pigment gene. X chromosomes with more than two M pigment genes could arise by subsequent unequal intergenic recombinations (Fig. 7).

**Figure 7**   Intergenic recombination of the L (red) and M (green) pigment genes showing how a ratio of two M to one L could have arisen by crossing over between the mispaired L and M pigment genes. The L pigment gene is shown as a solid arrow, and the M pigment gene is shown as an open arrow; the tails of the arrows represent the 5′ end of the genes. Diagonal lines denote upstream and downstream sequence divergence. (From Ref. 5.)

## III. COLOR VISION POLYMORPHISM

### A. "Normal" Human Color Vision

Color vision polymorphism has been recognized for centuries, but only within the last 30 years has polymorphism of normal color vision been recognized. Among the first to suspect that there might be more than one normal color vision phenotype was Waaler [9–11]. In his early work, Waaler [9] examined the color vision of nearly 20,000 school-age children. He hypothesized that four (possibly six) alleles were responsible for color vision deficiencies. In his later studies, Waaler [10,11] used an anomaloscope with variable bichromatic primaries to examine the color vision of normal subjects. His results suggested that there were several types of "normal" color vision.

Another researcher whose studies presaged the discovery of polymorphism of normal color vision was Alpern. Alpern and Pugh [12] reported variability in the action spectrum of the L pigment of deuteranopes and color normals (Fig. 8). Alpern and Moeller [13] suggested that deuteranomalous trichromacy might occur as a result of an individual's having inherited two types of L pigment with slightly different spectral sensitivities.

### B. "Normal" Color Vision in Other Primates

Color vision polymorphism has been recognized in primates since Jacobs and Neitz [14] reported the occurrence of three middle- to long-wavelength-sensitive (M/L) photopigments in squirrel monkeys. Since squirrel monkeys have only a single locus on the X chromosome that encodes a cone photopigment, males are dichromatic. However, three forms of dichromacy have been found among male squirrel monkeys, depending on which of the three types of M/L photopigment a particular male inherits (Fig. 9). Females, whose karyotype includes two X chromosomes, have the potential for inheriting two M/L photopigments, in addition to their S pigment. In fact, many female squirrel monkeys have trichromatic color vision; in addition to the three types of dichromacy exhibited by their male conspecifics, female squirrel monkeys may have one of three forms of trichromacy.

### C. Psychophysical Evidence in Humans

Evidence of polymorphous trichromatic vision in primates spurred Neitz and Jacobs [15] to examine the color vision of humans for similar evidence. They used an anomaloscopy to examine the ranges and midpoints of Rayleigh matches made by color-normal males, and reported that the midpoints were distributed multimodally across their observers. Neitz and Jacobs [15] hypothesized that the multimodality of Rayleigh match midpoints was a

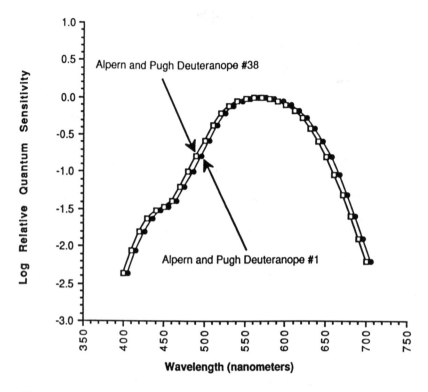

**Figure 8**   The spectral sensitivity curves of two deuteranopes, showing that more than one L cone pigment occurs in deuteranopes. (From Ref. 12.)

manifestation of more than one M or L cone photopigment among their observers (Fig. 10). Their calculations suggested that a 3 nm shift in the spectral sensitivity of the M cones in some subjects could account for their data. Neitz and Jacobs [15] also cited data from the literature that supported their hypothesis. More recent evidence from Winderickx et al. [16], cited below, suggests that polymorphism of only the L pigment gene can account for the observed variations in color matching among color-normal subjects.

Several laboratories examined the question of multimodality of Rayleigh match midpoints and the underlying genetic mechanism and concluded that there was insufficient evidence either for multimodality [17] or for polygenic inheritance [18]. Recently, however, Piantanida and Gille [19] found that the distribution of Rayleigh match midpoints depended on the choice of psychophysical method used to measure the Rayleigh matches (Fig. 11).

These results are consistent with either the Neitz and Jacobs [15] or the Winderinckx [16] model of color vision polymorphism but fail to distinguish between them.

Other evidence, however, such as the excessive width of the Smith and Pokorny [20] L cone fundamental, but not of the M cone fundamental, suggests polymorphism only of the L cone photopigment. Averaging of spectral sensitivity data across color-normal subjects would tend to broaden the spectral sensitivity envelope of polymorphic photopigments but not of monomorphic photopigments.

## D. Molecular Genetic Evidence in Humans

On the basis of the number of amino acid substitutions between the M and L pigments encoded by each exon, and the presumed spectral sensitivities of photopigments expressed by hybrid genes, Nathans et al. [5,6] hypothesized that the critical region for determining the spectral sensitivities of the M and L pigments is exon 5, where seven substitutions are encoded. Amino acid locations 277 and 285, encoded by exon 5, were implicated in the spec-

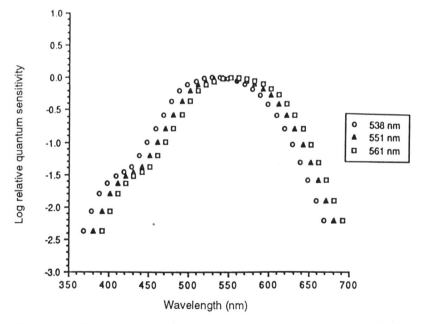

**Figure 9** The three midspectral photopigments of squirrel monkeys. Peak sensitivities for the three pigments are at 538, 551, and 561 nm. (From Ref. 14.)

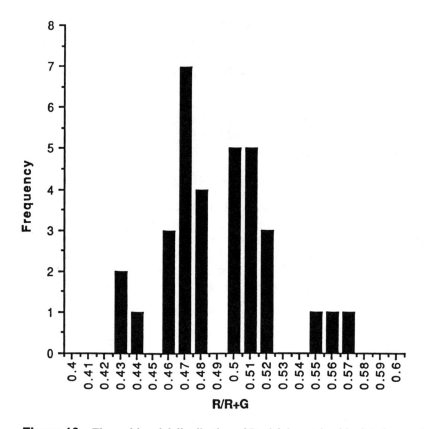

**Figure 10**   The multimodal distribution of Rayleigh match midpoints from color-normal males. (From Ref. 14.)

tral sensitivity differences of both the L and M pigments. Nathans and colleagues [5,6] further refined the amino acid positions that seemed most likely to affect spectral sensitivity. These researchers reported that in addition to amino acid positions 277 and 285, position 180, encoded by exon 3, appeared to influence photopigment spectral sensitivity significantly.

Neitz and colleagues [21] hypothesized that the 180/277/285 amino acid sequence of the L pigment is serine/tyrosine/threonine, while that of the M pigment is alanine/phenylalanine/alanine. Their molecular genetic model of human color vision posited that the approximately 30 nm shift in spectral sensitivity from the M pigment ($\approx$ 531 nm peak sensitivity) to the L pigment ($\approx$ 561 nm peak sensitivity) could be accomplished through cumulative spectral shifts caused by amino acid substitutions at amino acid posi-

tions 180, 277, and 285 nm. They reported that substituting Ala[180] for Ser[180] resulted in a 6 nm shift of spectral sensitivity toward shorter wavelengths, substituting Phe[277] for Tyr[277] shifts spectral sensitivity by 10 nm toward shorter wavelengths, and substituting Ala[285] for Thr[285] shifts sensitivity by another 15 nm in the same direction.

In a pioneering study, in which they expressed the human color vision genes in tissue culture cells and then synthesized photopigments by introducing native retinal, Merbs and Nathans [22] measured the spectral sensitivity of the resultant S, M, and L photopigments. They reported the spectral sensitivity peaks of the S and M pigments to be 426 and 530 nm, respectively. They found two forms of the L pigment, which differed in amino acid residue at position 180. The L pigment with Ala[180] had a spectral

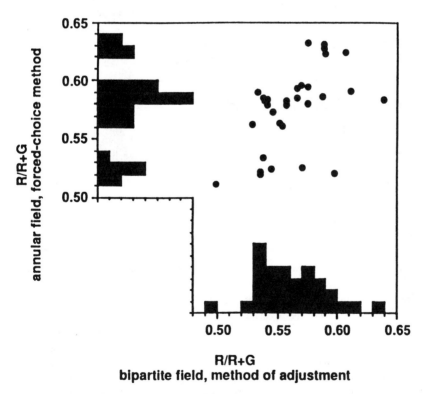

**Figure 11**   The distribution of Rayleigh match midpoints from color-normal males, measured by a spatial, bipartite, method-of-adjustment Rayleigh match procedure (*x* axis) and by a temporal, concentric, forced-choice Rayleigh match procedure (*y* axis). (From Ref. 19.)

sensitivity peak near 552 nm, and the L pigment with $Ser^{180}$ was reported to have a spectral sensitivity peak near 557 nm. Merbs and Nathans estimated the spectral sensitivity shift due to the $Ala^{180}$ to $Ser^{180}$ substitution at 4.3 nm, while Sanocki et al. [23], by different methodology, estimated the shift to be between 2.6 and 4.3 nm.

In addition to the three important amino acid locations noted above in connection with the work of Neitz et al. [21], Winderickx et al. [16] identified two other locations, encoded by exon 4, that appeared to modify the spectral sensitivity of the visual pigments. They tested 50 young Caucasian males anomaloscopically and compared their anomaloscope matches to their Southern blots and to their sequenced DNA. A correlation was found between the slope of the anomaloscope function and the amino acid residues at locations 230 and 233. Winderickx et al. [16] calculated that the substitution of $Ile^{230}$ for $Thr^{230}$ and $Ala^{233}$ for $Ser^{233}$ increased sensitivity to long-wavelength light, indicating a shift in spectral sensitivity toward longer wavelengths. They also calculated the frequencies of the L pigment variants. The data are quite similar to the multimodal distribution of Rayleigh match midpoints reported by several groups of researchers [15,19,24].

## IV.  COLOR-DEFECTIVE VISION
### A.  Red/Green Color Vision Defects

Six major forms of red/green color vision defects have been identified on the basis of the types and severity of color confusions and hue discrimination deficits associated with these conditions [25]. All six major red/green color vision defects are inherited as X-linked recessive characteristics [26]. Two classes of the X-linked recessive red/green color vision defects are recognized. One involves defective L cone sensitivity — the protan defects — and the other involves defective M cone sensitivity — the deutan defects. Within each class of defect, there is a further subdivision based on the severity of the condition.

The most severe form of protan defect, called *protanopia*, is the dichromatic form, which is characterized by extreme insensitivity to "red" light and confusion of all colors within the red-to-green part of the visible spectrum. The deutan dichromatic analogue, *deuteranopia*, is manifested by confusion of all colors within the red-to-green part of the visible spectrum, but entails no red-light-sensitivity deficit. There may be reduced sensitivity to "green" light, but this is difficult to measure accurately. Protanopia and deuteranopia affect about the same proportions of the U.S. male population: somewhere around 1% [26]. The incidence in females is much lower, of course, because the conditions are inherited as X-linked recessive. Thus,

for females to manifest protanopia, they must inherit the gene for protanopia on both their X chromosomes. The same is true for deuteranopia. The other four X-linked recessive red/green color vision defects are collectively called the anomalous trichromacies because, unlike the dichromacies (protanopia and deuteranopia), they permit trichromatic, albeit abnormal, color discriminations. Like a color-normal observer, persons with any of the anomalous trichromacies cannot match all the colors they can perceive by mixing only two primary colors; three primaries are necessary in parts of their color gamut. Two protan and two deutan types of anomalous trichromacy are recognized – the extreme and simple types [27] – although the distinctions within these types and even between these types and the dichromacies are not rigid [28].

Protanomalous trichromacy, whether of the simple or extreme type, is characterized by reduced sensitivity to red light and reduced hue discrimination. Both types are presumed to be caused by a shift of L cone photopigment spectral sensitivity curve toward shorter wavelengths.

Both types of deuteranomalous trichromacy are characterized by distinctive color confusions and undiminished sensitivity to red light. Both are attributed to displacement of the L cone photopigment spectral sensitivity curve toward longer wavelengths.

Early genetic models of the X-linked recessive color vision defects posited mutations of the color vision genes on the X chromosome as the mechanism for shifting the spectral sensitivity of the L and M cone photopigment [29,30]. Recent developments in DNA sequencing and analysis, however, have shown that the color vision defects – at least the common X-linked forms – are attributable not to point mutations of the color vision genes but, potentially, to gross intergenic and intragenic changes [5,6].

Nathans et al. [6] reported partial gene deletions and partial gene duplications in the DNA from color-defective observers. They also reported that some deuteranopes appear to be lacking the entire M pigment gene. An important clue derived from these analyses is that no deuteranopes appear to have an exon 5 that encodes the amino acid phenylalanine (Phe) at position 277 and alanine (Ala) at position 285, which would be an M-pigment-gene-specific exon 5. Some, however, show the L-pigment-gene-specific pattern of encoding tyrosine (Tyr) at position 277 and threonine (Thr) at position 285. These results suggest that in addition to the normal L pigment gene, some deuteranopes have a hybrid gene consisting of an upstream segment of the M pigment gene and a downstream segment of the L pigment gene (Fig. 12).

The importance of exon 5 is amplified by the results of Southern blot analysis in protanopes obtained by Nathans et al., who reported that only one protanope showed evidence for encoding $Tyr^{277}/Thr^{285}$, even though

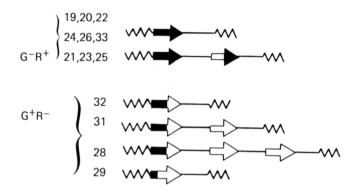

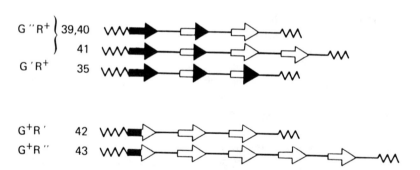

**Figure 12** The genotypes of color-defective vision. Solid arrows represent L pigment genes, open arrows M pigment genes, and half-solid arrows hybrid gene composed of some L and some M pigment sequences. (From Ref. 6.)

protanopes typically showed upstream exons derived from the L pigment gene. With the exception of this single protanope, the data suggest that protanopes inherit a hybrid gene consisting of upstream exons from the M pigment gene and downstream exons from the L pigment gene. Their Southern blot analysis also suggests that protanopes may inherit multiple copies of the M pigment gene, or they may inherit a single copy, or even no copy of this gene.

Some patterns in the Southern blot analysis indicate nonintegral ratios

of the various fragments of the L and M pigment genes, which at times hinder interpretation of results obtained from color-defective observers, inasmuch as genotypes can be inferred reliably only when the ratios approach integral values. In three of their nine deuteranopes, reliable interpretation of the Southern blots is consistent with inheritance of a hybrid 5'-M/ 3'-G gene and a normal L pigment gene. The six remaining deuteranopes showed Southern blot patterns consistent with inheritance of the L pigment gene only. Of the four protanopes whose Southern blots were reliably interpreted, all appear to have inherited a 5'-L/3'-M hybrid gene and either two, one, or no M pigment genes.

Anomalous trichromacy has been attributed to the presence of abnormal photopigments in either the L or M cones of the anomalous trichromat [29,30]. These photopigments are abnormal in that their peak spectral sensitivities are displaced somewhat from those of normal L and M cone photopigments. Reports from several laboratories [6,23] suggest that downstream regions, particularly exons 3 and 5, of the L and M pigment genes influence the spectral sensitivity of the resultant photopigment. The Southern blots of anomalous trichromats reported by Nathans et al. [6] show downstream sequence changes that could account for the observed spectral sensitivity shifts. Data from Nathans et al. [6] on the inferred genotypes of anomalous trichromats ($R^+G'$, deuteranomalous; $R^+G''$, extreme deuteranomalous, $G^+R'$, protanomalous; $G^+R''$, extreme protanomalous) are shown in Figure 12.

Evidence for 5'-M/3'-L hybrid genes, indistinguishable by this test from the gene seen in deuteranopes, is found in the Southern blot patterns of deuteranomalous and extreme deuteranomalous trichromats. Further analysis suggests that in addition to inheriting a hybrid gene, deuteranomalous trichromats inherit a single copy of the L pigment gene and a variable number of copies of the M pigment gene. Generally, protanomalous trichromats appear to lack a normal L pigment gene, much like protanopes. In fact, the genotypes of some protanopes and many protanomalous trichromats are indistinguishable, consisting of a single hybrid 5'-L/3'-M gene and multiple copies of the M pigment gene [6].

Evidence from a number of laboratories implicates hybrid genes in X-linked recessive red/green color vision defects, although there is not complete agreement as to the critical role of hybrid genes in color vision defects [6,7,16]. Gene hybridization of the type seen in color-defective observers could be the result of unequal *intragenic* recombination, similar in concept to the unequal *intergenic* recombination that is believed to account for the variable number of M pigment genes in color-normal observers. Binding of homologous regions of the X-linked color vision genes could cause mispairing of L and M pigment genes or segments of these genes. Intergenic recom-

bination (Fig. 13) of mispaired genes would result in an abnormal number of copies of one of the genes, whereas intragenic recombination of mispaired gene segments could produce either 5'-L/3'-M or 5'-M/3'-L hybrid genes.

There is, however, evidence that while hybrid genes may be implicated in color-defective vision, their presence alone does not account for the color vision phenotype. Drummond-Borg et al. [7] and Jørgensen et al. [31] reported that the frequency of hybrid color vision genes in Caucasians and Afro-Americans was higher than the incidence of color vision defects in these groups, suggesting that hybrid genes may not always cause defective color vision. Partially to examine this issue further, Deeb et al. [32] analyzed the DNA of 64 anomaloscopically tested, color-defective males and 129 color-normal males, 65 of whose color vision phenotypes were studied anomaloscopically. They also examined the location of gene fusion by polymerase chain reaction (PCR).

Deeb et al. [32] found that except for a single deutan subject who had no detectable gene rearrangement by Southern blot analysis or PCR, all the color-defective subjects they tested showed evidence of either gene hybridization or deletion. The effect of gene hybridization per se is not elucidated in this report, however, because subjects with hybrid genes who were identified as protanopes had DNA coding sequences that were indistinguishable from those of some protanomalous trichromats, ostensibly with identical hybrid genes.

Only among the deuteranopes just mentioned [32] was gene deletion evident. Surprisingly, 3 of 13 who were found to have deletion of the M

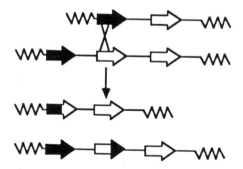

**Figure 13**  Intragenic recombination of the L (solid arrows) and M pigment (open arrows) genes; half-solid arrows are hybrid genes. The tails of the arrows represent the 5' end of the genes. Diagonal lines denote upstream and downstream sequence divergence. Crossing over within the mispaired L and M pigment genes could have produced 5'-L/3'-M and 5'-M/3'-L hybrid genes. (From Ref. 6.)

pigment gene were found to be deuteranomalous, rather than deuteranopic, suggesting the possibility of a more subtle gene rearrangement than was detectible with Southern blots and PCR.

To further complicate the picture, 4 of the 129 color-normal subjects tested by Deeb et al. [32] had hybrid genes despite having anomaloscopically normal color vision.

The finding of Deeb et al. [32] that some persons with a deletion of the M pigment gene were trichromatic, albeit deuteranomalous, implies that these deuteranomals might have more than one copy of the L pigment gene but the copies are not exact duplicates. For example, if the two copies were identical except for the nucleotides that encode amino acid position 180, it would be possible for the person who inherited these genes to produce M cone pigments that differed in spectral sensitivity by 4–6 nm. If this were the case, the person would be trichromatic, assuming that he also produced a functional S cone pigment, but with local deficits in hue discrimination and predictable color confusions.

Antedating the finding of Deeb et al. [32] by several decades, Alpern and Moeller [13] suggested that deuteranomalous trichromats might inherit two of the L cone pigments that Alpern and Pugh [12] had measured in deuteranopes by psychophysical means. Speculating further from these observations, the occurrence of protanomaly suggests polymorphism of the M cone pigment.

A related explanation for the observation of Deeb et al. [32] is that the Southern blot analyses that purportedly identify the L and M pigment genes unambiguously do not, in fact, do so. Neitz, et al. [33] tested the hypothesis proposed by Nathans et al. [6] that in deuteranomalous trichromats both the M pigment gene and the hybrid L/M gene are expressed in a single class of cones. The results of their color-matching tests on deuteranomalous trichromats indicated that no measurable amount of M cone pigment is expressed in deuteranomals. An interpretation that is consistent with the color-matching results and not refutable by Southern blot analysis is that the genes identified as M pigment genes in deuteranomalous trichromats actually encode L cone pigment.

An alternative interpretation that links those of Alpern and Moeller [13] and Neitz et al. [33] relies on the assumption that in humans, only a single copy of the M pigment gene—most likely the one immediately downstream from the L pigment gene—is expressed, despite the presence of multiple copies of this gene. If we hypothesize that in deuteranomals, the hybrid 5′-M/3′-L-pigment gene falls in the tandem array between the L and M pigment genes, then the 5′-M segment of the hybrid gene may provide a recognition site that derepresses the 5′-M/3′-L-pigment gene, causing it to be expressed, while the 3′-L segment encodes an L pigment sequence. If we

further hypothesize that the L pigment sequence in the hybrid gene differed at amino acid position 180 from that of the L pigment encoded by the L pigment gene, the deuteranomal would have two L cone pigments that differed in spectral sensitivity by a few nanometers. This scenario would provide the deuteranomal with trichromatic vision but would not require that nucleotide sequences identified by Nathans et al. [6] as M pigment sequences actually be L pigment sequences.

## B.  Yellow/Blue and Achromatic Color-Defective Vision

Much of the research into color vision polymorphism has concentrated on the X-linked color vision genes. Sensitivity measurements from several laboratories [34–38] indicate that persons with blue-cone monochromacy show no evidence of functional L or M cone pigments. At low light levels, the spectral sensitivity of blue-cone monochromats is identical to that of rhodopsin, while at higher light levels, their spectral sensitivity function resembles the sensitivity of the S cone photopigment [39]. Only quite recently have blue-cone monochromats begun to be studied by molecular geneticists.

In a study of 12 families with blue-cone monochromacy, Nathans et al. [40] identified two molecular genetic variants. Some blue-cone monochromats appeared to have deletions near the 5' end of the tandem array of L and M pigment genes, while others appeared to have a single gene (either a 5'-L/3'-M hybrid gene or a L pigment gene) that contained a point mutation.

In eight of the dozen families, Nathans et al. [40] reported deletions ranging in length from about 500 base pairs (0.5 kb) to about 54,000 base pairs (54 kb). These investigators reported three types of deletion: those involving only sequences upstream of the L pigment gene, those involving some or all of the L pigment gene, and those involving all the L pigment gene plus upstream sequences of the M pigment gene. They analyzed the location of each deletion and identified a region of DNA that appears to be critical to expression of L and M pigment genes. All the deletions, including the smallest 579-bp deletion, encompassed a region approximately 4 kb upstream of the L pigment gene. This implies that some nucleotide sequence in a region approximately 4 kb upstream of the L pigment gene is critical to the activation of both the L and M pigment genes.

Nathans et al. [40] reported that in four of the families they studied, one of the X-linked color pigment genes had been lost through recombination. In some cases, the recombination was intergenic and in others it was intragenic, but in each case, the result was a dichromatic color vision defect.

Dichromacy probably was not attributable solely to the recombination, because in each of the recombinants, the remaining single gene had a point mutation in exon 4 that encoded a single base substitution of cytosine for thymine. This T-to-C alteration caused a critical amino acid substitution at location 203, encoding arginine rather than cysteine. The importance of this substitution can be seen in the observation that a cysteine residue is conserved at this amino acid position in all the visual pigments. Functionality of the L and M cone photopigments (as well as rhodopsin and the S cone photopigments) is apparently dependent on the presence of a critical cysteine residue at amino acid location 203 (Fig. 14).

## C. Tritanopia

Tritanopia is an autosomal-dominant condition that is characterized by reduced S cone sensitivity and dichromatic color matches [41]. Since the incidence of tritanopia is much lower than any of the X-linked recessive red/green color vision defects, the condition is difficult to estimate. Estimates of the incidence of tritanopia range from 1 in 60,000 [41] to 1 in 500 [41]. By analogy with red/green dichromatic color vision, tritanopia is assumed to be caused by the functional absence of S cones.

In a recent study of five families with tritanopia, Weitz and colleagues [43] reported that sequencing of the S pigment gene on chromosome 7 revealed point mutations that presumably inactivated the S cone opsin. Two affected individuals from different families showed evidence of a point mutation in exon 1, where a guanine-to-adenine substitution resulted in replacement of glycine by arginine at amino acid location 79. Weitz et al. [43] refer to this mutation as the G79R allele. Two other affected individuals, also in two different families, reportedly showed evidence of a point mutation in exon 3 that was expressed as a substitution of proline for serine at amino acid position 214 of the S cone opsin, the S214P allele. Another individual was found to show deletion of a single nucleotide in intron 3, near the intron3/exon3 junction, which might interfere with splicing of the mRNA into a functional template for translation of the S cone opsin.

Weitz et al. [43] reported that all individuals who were homozygous for the G79R allele were tritanopic, but those who were heterozygous could have either normal or tritanopic color vision. All affected individuals with the S214P allele were heterozygotes who carry a copy of the normal allele on their other chromosome 7. However, not all heterozygotes in families with the S214P allele expressed tritanopia. The deletion near the intron3/exon3 junction, however, appears to be unrelated to tritanopia: in the family that showed the deletion, one affected individual showed no evidence of the deletion.

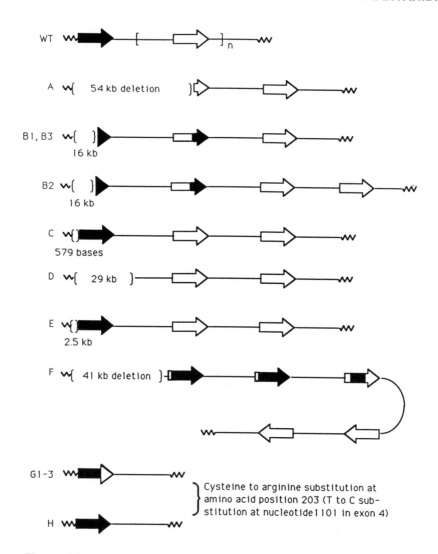

**Figure 14**   Genotypes of blue-cone monochromats. The L pigment gene is shown as a solid arrow, and the M pigment gene is shown as an open arrow. WT is the wild type, A–F are genotypes with successively larger upstream deletions, and G and H are genotypes with point mutations that eliminate a critical cysteine residue in the cone-opsin molecule. (From Ref. 39.)

In the case of individuals carrying either the G79R or S214P allele, tritanopia may result from changes in the pattern of folding in the transmembrane region of the opsin. Why some heterozygotes manifest tritanopia and others do not, however, remains a mystery.

## V. SUMMARY AND CONCLUSIONS

Human color vision depends principally on genetics. Genes on the X chromosome and on chromosomes 3 and 7 are primary determinants of color vision phenotype. The rhodopsin gene, on chromosome 3, encodes the amino acid sequence of the rod opsin; the S pigment gene on chromosome 7 encodes an opsin with the same number, but a different sequence of amino acid residues; and the two color vision genes on the X chromosome encode slightly longer opsins that are very similar to each other and quite different from rhodopsin and the S cone pigment. The opsin portion of the visual pigment molecule tunes the spectral absorption of the resultant photopigment, the chromophore retinal being common to all the human visual pigments.

Psychophysicists, electrophysiologists, microspectrophotometrists, and others have measured the absorption spectra of the human cones through a variety of means. They have come to agree that peak sensitivity of the S cone pigment is near 430 nm, that of the M cone pigment near 530 nm, and that of the L cone pigment near 560 nm. Within the last decade, molecular geneticists have begun to elucidate the nucleotide sequences of the S, M, and L pigment genes and the amino acid sequences of the opsins themselves. Several surprising findings were made. First, until molecular geneticists determined the number of M and L pigment genes contained in each X chromosome, no one would have predicted the occurrence of different ratios of M and L pigment genes within different individuals; it was always assumed that each X chromosome contained a single copy of the M pigment gene and a single copy of the L pigment gene. Findings so far indicate that the M/L ratio in color-normal individuals can range from 1 : 1 to 5 : 1.

Another surprising finding provided by the molecular geneticists was that rather than the X-linked recessive red/green color vision defects being attributable to point mutations in the photopigment genes, as had been believed, these color vision defects appear to be associated with hybrid genes. Hybrid genes are those in which part contains the nucleotide sequence of the L pigment gene and part contains the nucleotide sequence of the M pigment gene. The exact effect of hybrid genes is still to be determined, however, since not all persons with hybrid genes have defective color vision, and not all persons with ostensibly the same hybrid gene show the same color vision phenotype.

To further mystify us, molecular geneticists have found evidence for polymorphism of normal color vision, that is, more than one form of normal color vision. These molecular genetic findings explain some interesting phenomena that had been detected in psychophysical experiments, such as multimodality of color-matching results across color-normal male subjects, and differences in the width of the M and L fundamental curves.

Finally, where molecular geneticists have found point mutations in color vision genes (e.g., in blue-cone monochromacy and tritanopia), the invariable result is a nonfunctional photopigment, rather than one with a displaced spectral sensitivity.

We have gained tremendous insights into normal and defective color vision during the last decade through such techniques as Southern blots and PCR. Some of the old questions about color vision remain. For example, we still would like to know what causes simple protonomalous trichromacy. Such questions, however, have been refined to the point where we may be able to answer them in the near future on the nucleotide level.

## GLOSSARY

**Action spectrum**   To have an action (e.g., to initiate vision or photosynthesis), a pigment molecule must absorb photons. The probability of absorbing a photon that strikes the pigment molecule is dependent on the wavelength of the photon. A plot of the probability of photon capture as a function of photon wavelength is called the action spectrum of the photopigment.

**Allele**   A gene that encodes a particular characteristic can have several forms, which usually differ in nucleotide sequence. The different forms of the gene are called alleles. An example is the common ABO blood types, which has three alleles that encode red blood cell surface proteins. The allele that encodes protein *a* is called *A*, that which encodes *b* is called *B*, and that which encodes no surface protein is called *O*.

**All-*trans***   The retinal molecule has a chain of carbon atoms connected by multiple, alternating double and single bonds. It is possible for the rhodopsin molecule to rotate about each of the bonds, which means that it can occur in many conformations. In the common conformation of retinal in human visual pigments, there is a rotation about carbon atom 11, causing retinal to form a kink. When retinal has all its bonds rotated so that the molecule forms a straight line, it is said to be in the *all-trans* conformation. Upon capturing a photon, retinal changes from the kinked 11-*cis* conformation to the linear all-*trans* conformation.

**Amino acids**   These basic subunits are combined in immense diversity to

produce all the proteins of the body. The 20 common amino acids and their customary abbreviations are as follows:

| | | | |
|---|---|---|---|
| Alanine | Ala | Leucine | Leu |
| Arginine | Arg | Lysine | Lys |
| Asparagine | Asn | Methionine | Met |
| Aspartic acid | Asp | Phenylalanine | Phe |
| Cysteine | Cys | Proline | Pro |
| Glutamine | Gln | Serine | Ser |
| Glutamic acid | Glu | Threonine | Thr |
| Glycine | Gly | Tryptophan | Trp |
| Histidine | His | Tyrosine | Tyr |
| Isoleucine | Ilu | Valine | Val |

**Anomaloscope**   The definitive instrument for determining color vision phenotype. It contains of a pair of primary lights, usually red and green, that can be mixed in any proportion to match any color that falls in the spectrum between red and green (e.g., yellow). Typically, a subject will adjust the proportions of the two primaries until the mixed color matches the standard color, usually yellow, which can be changed in brightness by the subject. Factors in determining a subject's color vision phenotype include the range of mixtures of the red and green primaries the subject selects to match the yellow standard, the midpoint of the match range, and the brightness of the standard selected by the subject.

**Binding**   The double strands of DNA are linked together by hydrogen bond between the bases. When the strands are separated, however, new configurations are possible. Thus a single strand of another nucleotide (e.g., RNA, single-stranded DNA, or an artificially produced nucleotide chain) can become bound to such a separated DNA strand if the base sequences of the former is complementary to the sequence of bases on a given separated DNA strand.

**Blue-cone monochromat**   Persons having only functional rods and blue-sensitive cones. Because rods function in low illumination and cones in high, only one class of receptor is active under most conditions of illumination. A single class of photoreceptors is insufficient for providing color information about the illuminant.

**Chordate**   Organism that has a dorsal nerve cord. All vertebrates, including humans, have a dorsal nerve cord.

**Chromophore**   The part of the pigment molecule that changes conformation when it captures a photon. In humans it is 11-*cis*-retinal.

**Chromosome**   The DNA in humans and many other organisms is seg-

mented into a series of structures that are visible in the cell nucleus during
cell division. Under microscopic examination, each of these structures ap-
pears to be a linear body which, during cell division, is at first attached to
and then separates from an exact duplicate linear body. These linear bodies,
actually called *colored bodies*, ergo chromosomes, in the early literature,
are assemblies of coiled and condensed DNA. Each chromosome contains
a large number of genes and, except for the occasional anomaly, a particu-
lar gene can always be found on the same chromosome in all humans.
Humans have 46 chromosomes, consisting of 22 pairs that contain the
genes that encode most human characteristics, and a pair of sex chromo-
somes: two Xs in females and an X and a Y in males.

**Color confusion**   Color perception is principally dependent on three fac-
tors: the spectral energy distribution of the illuminant, the differential spec-
tral reflection from illuminated surfaces, and the spectral sensitivity of the
photoreceptors. If one of these factors is abnormally constrained, the result
is confusion among colors that may be discriminable under unconstrained
conditions. For example, the colors of a red car and a brown car may be
confused at night when the vehicles are illuminated only by the narrow-
band sodium lamps now commonly used. Color confusions of the sort
discussed in this chapter result from constraints on the spectral sensitivities
of the photoreceptors in persons with hereditary color vision deficiencies.
Among persons with normal color vision, colors in the range from red to
green are discriminated on the basis of the relative photon captures of the
L and M pigments. If either of the pigments is absent, or if one is abnormal
in a way that causes its spectral sensitivity to be shifted toward the other,
the person inheriting this defect will be unable to discriminate some of the
colors that are discriminable by persons with normal color vision. That is,
some colors will be confused. The types of color that are confused by a
person can be used to identify the underlying spectral sensitivity changes.

**Complement**   The bases of the nucleic acids are of two kinds. One kind
can make three hydrogen bonds with another base, and the other kind can
only make two hydrogen bonds. Two DNA bases, cytosine (C) and guanine
(G), each make three bonds, while thymine (T) and adenine (A) make two.
Because of this specificity, an A on one strand of DNA will bond only with
a T on the other strand, and a G on one strand will bond only with a C on
the other. Therefore, A is the complement of T, and G is the complement
of C; the sequence ATTACG is the complement of the sequence TAATGC.
Complementary sequences are said to bind.

**Cone fundamentals**   The hypothesized spectral sensitivity curves of the
three classes of cones in humans. The cone fundamentals were derived from

an examination of the results of psychophysical tests on a large number of color-normal humans. They represent the best estimate of the spectral sensitivities underlying normal color perception. The L cone fundamental is somewhat broader than the M cone fundamental, possibly because of averaging across color-normal humans with two distinct L cone pigments.

**Deletion**   A form of mutation that can change the amino acid sequence encoded by DNA is a deletion. If one or more bases are deleted from the DNA, the mRNA that is transcribed from the altered DNA will reflect this deletion because of complementation. When the mRNA is translated into protein, an incorrect amino acid may be inserted into the protein because the DNA encodes the sequence of amino acids in the protein. A deletion can result in an altered protein that may not exhibit the characteristics of the normal protein.

**Deoxyribonucleic acid (DNA)**   A very long molecule consisting of a pair of strands composed of sugars (deoxyribose) linked together linearly by phosphodiesterase bonds. Each sugar has a base (A, C, T, or G) attached to it, which links it to the opposite strand by complementation. The two strands twist around each other to form a double helix. DNA is the molecule that contains the genetic memory of the organism, encoding all the characteristics of that organism.

**Derepress**   Most of the time, a large proportion of an organism's genes are turned off (i.e., repressed). Repressed genes are not expressed. When conditions are right, the genes are turned on—derepressed—so that they will be expressed, and then, when conditions change, the genes are again repressed. A good example is the gene for fetal hemoglobin, which is derepressed in utero, becomes repressed shortly after birth, and stays repressed for the remainder of life. Conversely, the gene for adult hemoglobin is repressed in utero and derepressed for the remainder of life.

**Deuteranomal**   A trichromatic person whose only M cone pigment has a spectral sensitivity that is shifted toward that of the L cone pigment; such a person will not accept the color matches made by a color-normal person. Likewise, the deuteranomalous trichromat will find to be acceptable color matches that are rejected by persons with normal color vision. Because only the M cones are affected in deuteranomaly (the condition of being deuteranomalous), long-wavelength sensitivity is unaffected, and therefore, normal.

**Deuteranope**   A dichromatic person who lacks functional M cones. In the absence of contextual cues, deuteranopes perceive all colors between red and green as matching, provided the intensities of the colors are adjusted

properly. Because they have functional L cones, deuteranopes have normal long-wavelength sensitivity.

**Dichromatic**   Persons with only two cone photopigments have color vision that is two-dimensional. That is, they can match any of the colors they can experience by mixing only two suitably chosen primary colors.

**Dichromats**   Persons with only two photopigments, usually S cone and either L or M cone pigments, are dichromats.

**Duplication**   A gene is said to be duplicated when an exact copy is replicated and inserted into the genome.

**11-*cis***   The active conformation of retinal; it is characterized by a rotation about carbon 11 in the side chain, which causes a kink in the retinal molecule.

**Eukaryote**   Organism having nuclear membranes that segregate its DNA from the cytoplasm of the cell. Humans are eukaryotes. Organisms lacking nuclear membranes, termed prokaryotes, are typified by bacteria.

**Exon**   Generally, all the nucleotide sequences that constitute a gene are transcribed into RNA, but not all the RNA is translated into protein. Some parts of the RNA are excised, and the remaining segments are respliced. The respliced parts are translated into protein. The parts of a gene that encode the RNA segments that get translated into protein are called exons.

**Expressed**   A gene is said to be expressed when the phenotype reflects the information encoded in the gene. Expression involves transcription of the DNA sequences into RNA, posttranscriptional changes, and translation of the RNA into protein.

**Gene**   A gene can be thought of as a location in the DNA that encodes a characteristic or as a DNA sequence that encodes a protein or a polypeptide subunit of a protein.

**Gene fusion**   When part of one gene becomes attached to part of another, gene fusion has occurred, resulting in a hybrid gene. Gene fusion results from intragenic recombination.

**Genotype**   A description of the alleles on homologous chromosomes that encode the same characteristic is called the genotype. For example, two genotypes encode type A blood: AA, which indicates the *A* allele on both chromosomes, and AO, which indicates the *A* allele on one chromosome and the *O* allele on the other.

**Heterozygous**   A person who carries two different alleles that encode the

same characteristic is heterozygous. For example, a person with type A blood can be homozygous, having the *A* allele on both chromosomes, or heterozygous, having an *A* allele on one chromosome and an *O* allele on the other.

**Homologous** This term refers to either chromosomes or nucleotide sequences. A pair of chromosomes that consist of the same series of genes are homologues. Regions of nucleotide sequences of single-stranded DNA or RNA or of a synthesized polynucleotide molecule are said to be homologous to the nucleotide sequence of another segment of single-stranded DNA if the sequences of bases are complementary.

**Homozygous** A person who carries two identical alleles that encode the same characteristic is homozygous. For example, a person with type A blood can be homozygous, having the *A* allele on both chromosomes, or heterozygous, having an *A* allele on one chromosome and an *O* allele on the other.

**Hybrid genes** Genes that comprise nucleotide sequences derived from segments of other genes are hybrid genes. Hybrid genes are produced by intragenic recombination.

**Hydrophobicity** The degree to which an amino acid can interact with water molecules determines its hydrophobicity/hydrophilicity. Polar amino acids are more likely to interact with water molecules because water molecules are also polar. Nonpolar amino acids are more likely to interact with lipids (fats and oils) because lipids are nonpolar. Because cell membranes have a lipid core, proteins are more likely to have hydrophobic ("water-hating") amino acids in parts of the protein that traverse the interior of the membrane.

**Intron** Generally, all the nucleotide sequences that constitute a gene are transcribed into RNA, but not all the RNA is translated into protein. Some parts of the RNA are excised and the remaining segments are respliced. The respliced parts are translated into protein. The parts of a gene that encode the RNA segments that get excised are called introns because they remain in the cell nucleus.

**Karyotype** A description of an organism's chromosome complement or of its localized gene arrangement constitutes a karotype.

**Locus** The position of a gene on a chromosome is the locus of that gene.

**Meiosis** The process that results in the halving of the chromosome number by sending one member of a homologous chromosome pair to each of two

cells. The product of meiosis is a germ cell (egg or sperm) that contains the haploid number of chromosomes.

**Midpoints** The Rayleigh matches of all subjects are variable, some span just a small range of R/R + G ratios, while others span a broader range. Generally the Rayleigh match range of color-normal subjects is fairly small but still varies across subjects. To provide a metric for comparing subjects, the middle of the Rayleigh match range (i.e., the midpoint) is calculated.

**Mispairing** During meiosis, chromosome homologues align next to each other and chromosome segments are interchanged in a process called recombination. The alignment of the chromosomes is accomplished through complementation, where the bases on one chromosome bind to the complementary bases on the other. If two genes — call them A and B — that lie close together on the chromosome have very similar nucleotide sequences, as the L and M pigment genes do, then it is possible for the A gene on one chromosome to bind the B gene on the other chromosome. This mispairing can result in either altered karyotypes (if intergenic recombination occurs) or hybrid genes (if intragenic recombination occurs).

**Monomorphic** Characteristics that have only one phenotype are monomorphic, whereas those that have more than one are either dimorphic (such as gender) or polymorphic (such as eye color).

**mRNA** Messenger RNA is the molecule that is translated into protein. It is transcribed from DNA, undergoes posttranscriptional modification, is transported out of the nucleus, and is translated in the cytoplasm.

**Multimodality** The condition of showing a multimodal frequency distribution of a variable. Multimodality is visualized as a frequency distribution that contains more than two peaks, separated by troughs that approach a frequency of zero. When measured appropriately, the midpoints of Rayleigh matches are distributed multimodally across color-normal human males.

**Nucleotide** A segment of a nucleic acid molecule consisting of a base (A, C, G, or T in DNA, A, C, G, or U in RNA), a carbohydrate (ribose in RNA; deoxyribose in DNA), and a phosphate group that can link nucleotides together into long chains by phosphodiesterase bonds.

**Opsin** The protein portion of a visual pigment, consisting, in humans, of 348 base pairs in rhodopsin and the S cone pigment, and 364 base pairs in the L and M cone pigments. Opsin spans the disk membranes of rods and cones and forms a pocket for binding 11-*cis*-retinal.

**Phenotype** The manifestation of a characteristic (e.g., eye color, blood

type, color vision type) is the phenotype of that characteristic. For example, one blood group phenotype is type A, but this phenotype is the manifestation of two genotypes: AA and AO.

**Point mutation**   An alteration at a single nucleotide location is a point mutation. The alteration may be a substitution or a deletion. A substitution may result in the eventual incorporation of an incorrect amino acid into the expressed protein molecule. A deletion in an exon causes a change in the reading frame of that exon. Because the codons for incorporation of amino acids into protein consist of triplets of nucleotides, which are read sequentially, a deletion causes the triplet where the deletion occurs, and all subsequent triplets, to be misread. Because of this misreading, the resultant protein contains a series of incorrect amino acids.

**Polygenic inheritance**   Some characteristics, such as the ABO blood group, are encoded by a single gene, while others, such as eye color, are encoded by several genes whose expression jointly determines the phenotype. Eye color, for example, is determined by genes that individually encode the amount of pigment in the iris and the degree of *in utero* degeneration of the anterior layer of the iris, and probably other genes, as well.

**Polymerase chain reaction (PCR)**   A recently developed procedure used to amplify a small amount of DNA and to produce single-stranded DNA suitable for sequencing. The procedure involves the synthesis of two sequences, about 15 nucleotides long, which are complementary to a comparable number of bases on the 3′ and 5′ ends of the segment of DNA that is to be amplified/sequenced. These synthetic single-stranded molecules are called primers. To amplify the desired DNA segment, one or more copies of that segment are added to a reaction vessel along with a large number of free single nucleotides, each containing one of the four bases, copies of the 3′ and 5′ primers, and a DNA polymerase obtained from an organism that lives in a very hot environment. [DNA polymerase from humans, for example, would be denatured (destroyed) by temperatures only slightly higher than the physiological human temperature, whereas DNA polymerase from bacteria that live in thermal vents is not denatured at temperatures that cause the two strands of DNA to separate.] The reaction vessel is heated to a temperature that causes the two DNA strands to separate and then cooled to allow binding of the primers to the complementary DNA strand. The DNA polymerase causes new nucleotides to be added sequentially to the 5′ end of the 3′ primer and to the 3′ end of the 5′ primer, using the single-stranded DNA as a template. When enough time has elapsed to replicate the entire segment of single-stranded DNA, the temperature is elevated to separate the newly synthesized DNA strand from the original

single-stranded DNA segment. The temperature is then lowered enough to restart DNA replication, and each of the two single-stranded DNA segments now acts as a template for DNA synthesis. The cycle of heating and cooling is repeated multiple times, and each time it is completed, the number of DNA molecules is doubled. Single-stranded DNA for sequencing can be produced by adding a reduced amount of one of the primers to the reaction vessel. When one of the primers is exhausted, the other primer continues to replicate single-stranded DNA.

**Polymorphism**   When more than two forms of a characteristic can occur, the phenotypes are polymorphic. The ABO blood types, which have four forms (type A, type B, type O, and type AB), are an example of polymorphism.

**Protanomal**   A trichromatic person whose only L cone pigment has a spectral sensitivity that is shifted toward that of the M cone pigment; such a person will not accept the color matches made by a color-normal person. Likewise, the protanomalous trichromat will find to be acceptable color matches that are rejected by persons with normal color vision. Because the L cones are affected in protanomaly (the condition of being protanomalous), long-wavelength sensitivity is impaired.

**Protanope**   A dichromatic person who lacks functional L cones. In the absence of contextual cues, protanopes perceive all colors between red and green as matching, provided the intensities of the colors are adjusted properly. Because they have no functional L cones, protanopes have abnormally low long-wavelength sensitivity.

**Rayleigh match**   The definitive test for determining color vision phenotype. Typically, a subject will adjust the proportions of the two primary lights (usually red and green) presented on an anomaloscope until the mixed color matches the standard color light (usually yellow), which can be changed in brightness by the subject. The mixtures of the red and green primaries the subject selects to match the yellow standard is called the Rayleigh match to honor J. W. Strutt (Lord Rayleigh), who devised the procedure.

**Recombination**   A normal genetic event that takes place during meiosis, when homologous pairs of chromosomes are aligned next to each other. Segments of the homologues are exchanged, usually so that each homologue retains its full complement of genes. This reciprocal exchange (i.e., recombination) re-sorts the genes that are transmitted from parent to offspring, thereby increasing genetic diversity.

**Retinal**   This vitamin A derivative is the chromophore of all four human visual pigments. It is bound to the opsin molecule within the disk membrane

in the active 11-*cis* conformation. When retinal captures a photon, it changes conformation, triggering a cascade of photochemical reactions that results in vision.

**Ribonucleic acid (RNA)**    RNA is a very long molecule consisting of a backbone composed of sugars (ribose) linked together linearly by phosphodiesterase bonds. Each sugar has a base (A, C, U, or G) attached to it according to the sequence of bases on the strand of DNA from which it was transcribed. RNA comes in three basic varieties: messenger RNA (mRNA), which consists of the codons that direct the ordering of amino acids in the protein encoded by the DNA from which it was transcribed; transfer RNA (tRNA), which contains the anticodon that recognizes the codon on mRNA, as well as a link to a specific amino acid; and ribosomal RNA (rRNA), which forms the ribosomes that juxtapose the tRNA anticodons and the mRNA codons and link the amino acids into a chain.

**Sequence**    As a noun, "sequence" refers to the order of nucleotides on DNA or RNA or to the order of amino acids in a protein. As a verb, it refers to the process of identifying the order of nucleotides on DNA or RNA or the order of amino acids in a protein.

**Southern blots**    This is a technique for grossly identifying differences in nucleotide sequences in the same segment of DNA. These differences can be on the two homologues of the same person or on chromosomes from different people. The procedure consists of digesting a DNA sample with restriction enzymes, which are small assemblies of nucleotides that recognize a target sequence of bases on the DNA and cleave the DNA within the target sequence. The same enzyme will recognize multiple target sites on the DNA and cleave the DNA into a series of fragments of different length. Because the nucleotide sequences in exons should be different for different alleles, the same restriction enzyme may recognize different target sites in the two alleles, resulting in restriction fragments that differ in length for the two alleles. This is called *restriction fragment length polymorphism* (*RFLP*). If the fragmented DNA is subjected to a process of gel electrophoresis, which causes smaller pieces of DNA to migrate further down the gel than longer pieces, the fragments can be separated and identified as to length. If the digested DNA from two persons with different alleles is subjected to gel electrophoresis, the RFLP pattern will be different for each person because the same enzyme will have cleaved the DNA of each one at different points. The RFLP pattern can be made visible by binding radiolabeled nucleotides to the gel and then using the gel to expose a piece of film. The patterns that develop can be used to identify nucleotide sequences that are derived from particular alleles and even from particular parts of alleles.

Analysis of Southern blots can be used to determine genotype, as well as the karyotype of persons whose DNA has been digested by restriction enzymes.

**Tandem array**   The genes that encode the L and M pigments are arranged linearly on the X chromosome, with the L pigment gene upstream of the M pigment gene. This head-to-tail arrangement of the genes is called a tandem array.

**Tissue culture**   This is the process of removing cells from the body and inducing them to grow in an artificial medium. Very often these cells will fuse into a tissue in the culturing medium. It is sometimes possible to make genes express in tissue culture by incorporating them into the genome of cultured cells.

**Transcription**   The process of making an RNA molecule on a template of single-stranded DNA is called transcription. Transcription produces RNA that is a faithful complementary copy of the DNA that was transcribed.

**Translation**   The process of assembling a string of amino acids based on the nucleotide sequence of mRNA is called translation.

**Upstream**   DNA is always transcribed from the 5' end to the 3' end, and mRNA is always translated from the 5' end to the 3' end. Thus, the direction of information flow is 5' to 3', so the 3' end of the molecule is considered to be downstream. Therefore, the 5' end of nucleic acids is the upstream end.

**X-linked recessive inheritance**   Mode of inheritance that occurs when a gene on the X chromosome has multiple alleles and the wild-type allele is dominant. Thus in males, who have only a single X chromosome, inheritance of one of the mutant alleles produces an abnormal phenotype, such as protanopia or hemophilia. In females, who have two X chromosomes, however, inheritance of the wild-type allele on one X chromosome masks the effects of a mutant allele on the other X chromosome. Therefore, a heterozygous woman would not manifest the abnormal phenotype, but she would transmit the mutant allele to half of her sons and daughters. Unless a daughter also inherited a mutant allele of the same class, say protan or deutan, from her father, she would not manifest the abnormal phenotype, but she could still pass the mutant allele to half of her offspring. A son who inherited a mutant allele from his mother (the only parent from whom he can inherit an X chromosome, since his father had to have contributed the maleness-inducing Y chromosome) will manifest the abnormal condition and will pass the mutant allele to all his daughters. The predominant

familial pattern seen in X-linked recessive inheritance is an affected grandfather whose daughters are unaffected but whose grandsons have his condition.

5′ Nucleic acids have a backbone of sugars linked together by phosphodiester bonds. The orientation of the sugars in the nucleic acids is always the same, with the 5′ carbon oriented in one direction and the 3′ carbon oriented in the opposite direction. The 5′ end of nucleic acids is the end to which the 5′ carbons of its constituent sugars are oriented.

## ACKNOWLEDGMENTS

The author acknowledges the many landmark contributions made to the field of color vision molecular genetics by Dr. Jeremy Nathans. It was a privilege and an honor to have collaborated with Dr. Nathans in elucidating the underlying molecular genetic causes of human color vision deficiencies. The author also thanks Drs. Maureen Neitz, Jay Neitz, Gerald Jacobs, Del Lindsey, Davida Teller, Matt Alpern, Vivianne Smith, Joel Pokorny, Margaret Lutze, Samir Deeb, Arno Motulsky, John Mollon, Meredith Appelbury, Paul Hargrave, Roger Klingaman, Eberhart Zrenner, Al Nagy, Janice Nerger, Michael Crognale, and Elizabeth Sanocki for informative discussions on the major issue in color vision genetics. The author especially thanks Dr. Sanocki for allowing him to use her data prior to publication.

## REFERENCES

1. G. Wald, Molecular basis of visual excitation, *Science 162*:230–239 (1968).
2. J. Nathans and D. S. Hogness, Isolation and nucleotide sequence of the gene encoding human rhodopsin, *Proc. Nat. Acad. Sci., U.S.A. 81*:4851–4855 (1984).
3. Y. A. Ovchinnikov, N. G. Abduaev, M. Y. Feigina, I. D. Artomonov, A. S. Zolotarev, A. I. Moroshnikov, V. I. Martinow, M. B. Kostina, A. G. Kudelin, and A. S. Bogachuk, The complete amino acid sequence of visual rhodopsin, *Biorg. Khim. 8*:1424–1427 (1982).
4. P. A. Hargrave, J. H. McDowell, D. R. Curtis, J. K. Wang, E. Jusczak, S.-L. Fong, J. K. M. Rao, and P. Argos, The structure of bovine rhodopsin, *Biophys. Struct. Mech. 9*:235–244 (1982).
5. J. Nathans, D. Thomas, and D. S. Hogness, Molecular genetics of human color vision: The genes encoding the blue, green, and red pigments, *Science 232*:193–202 (1986).
6. J. Nathans, T. P. Piantanida, R. L. Eddy, and T. B. Shows, Molecular genetics of inherited variation in human color vision, *Science 232*:203–232 (1986).
7. M. Drummond-Borg, S. S. Deeb, and A. G. Motulsky, Molecular patterns of

X-linked color vision genes among 134 Seattle males of European origin, *Proc. Natl. Acad. Sci., U.S.A. 86*:983–996 (1989).

8.  D. Vollrath, J. Nathans, and R. W. Davis, Tandem array of human visual pigment genes at Xq28, *Science 240*:1669–1672 (1988).

9.  G. H. M. Waaler, Über die Erblichkeitsverhältnisse der verscheidenen Arten von angeborener Rotgrünblindheit, *Z. Indukt. Abst. Vererb. 45*:279–333 (1927).

10. G. H. M. Waaler, The heredity of normal and defective colour vision, *Avhandlinger Utgitt Av Det Norske Videnskaps-Akademi I Oslo I. Mat-Naturv. Klasse* Ny Serie, No. 9 (1967).

11. G. H. M. Waaler, Genetics and physiology of colour vision, *Acta Ophthalmol. Suppl. 122* (1973).

12. M. Alpern and E. N. Pugh, Jr., Variation in the action spectrum of erythrolabe among deuteranopes, *J. Physiol. 266*:613–646 (1977).

13. M. Alpern and J. Moeller, The red and green cone visual pigments of deuteranomalous trichromacy, *J. Physiol. 266*:647–675 (1977).

14. G. H. Jacobs and J. Neitz, Inheritance of color vision in a New World monkey (*Saimiri sciureus*), *Proc. Natl. Acad. Sci., U.S.A. 84*:2545–2549 (1987).

15. J. Neitz and G. H. Jacobs, Polymorphism of cone pigments among color normals: Evidence from color matching, *Colour Vision Deficiencies*, Vol. 9 (B. Drum and G. Verriest, eds.), Kluwer Academic Publishers, Dordrecht, the Netherlands, 1989.

16. J. Winderickx, D. T. Lindsey, E. Sanocki, S. S. Deeb, D. Y. Teller, and A. G. Motulsky, A Ser/Ala polymorphism in the red photopigment underlies variation in colour matching among colour normal individuals, *Nature 356*: 461–433 (1992).

17. G. Jordan and J D. Mollon, Two kinds of men? *Invest. Ophthalmol. Vision Sci. (suppl.) 29*:164 (1988).

18. M. Lutze, N. J. Cox, V. C. Smith, and J. Pokorny, Genetic studies of variation in Rayleigh and photometric matches in normal trichromats, *Vision Res. 30*:149–162 (1990).

19. T. P. Piantanida and J. L. Gille, Methodology-specific Rayleigh-match distributions, *Vision Res. 32*:2375–2377 (1992).

20. V. C. Smith, and J. Pokorny, Spectral sensitivity of the foveal cone pigments between 400 and 500 nm, *Vision Res. 15*:161–171 (1975).

21. M. Neitz, J. Neitz, and G. H. Jacobs, Spectral tuning of pigments underlying red–green color vision, *Science 252*:971–974 (1991).

22. S. L. Merbs and J. Nathans, Absorption spectra of human cone pigments, *Nature 356*:433–435 (1992).

23. E. Sanocki, D. T. Lindsey, J. Winderickx, D. Y. Teller, S. S. Deeb, and A. G. Motulsky, Serine/alanine amino acid polymorphism of the L and M cone pigments: Effects on Rayleigh matches among deuteranopes, protanopes and color normal observers, *Vision Res.* (in press).

24. J. Neitz and G. H. Jacobs, Polymorphism of the long-wavelength cone in normal human colour vision, *Nature 323*:623–625 (1986).

25. R. W. Pickford, Multiple allelomorphs in color vision, *Nature 162*:684–686 (1948).
26. H. Kalmus, *Diagnosis and Genetics of Defective Colour Vision*, Pergamon Press, London, 1964.
27. A. Franceschetti, Die Bedeutung der Einstellungsbreite am Anamoloskop für die Diagnose der einzelnen Typen der Farbensinnestorunger, *Schweiz. Med. Wocjsch. 52*:2173–2179 (1928).
28. A. L. Nagy, Large-field substitution Rayleigh matches of dichromats, *J. Opt. Soc. Am. 70*:778–784 (1980).
29. T. P. Piantanida, A replacement model of X-linked recessive color vision defects, *Ann. Hum. Genet. 37*:393–404 (1974).
30. T. P. Piantanida, Polymorphism of human color vision, *Am. J. Optom. Physiol. Opt. 53*:647–657 (1976).
31. A. L. Jørgensen, S. S. Deeb, and A. G. Motulsky, Molecular genetics of X-linked color vision among populations of African and Japanese ancestry. High frequency of a shortened red pigment gene among Afro-Americans. *Proc. Natl. Acad. Sci., U.S.A. 87*:6512–6516 (1990).
32. S. S. Deeb, D. T. Lindsey, Y. Hibiya, E. Sanocki, J. Winderickx, D. T. Teller, and A. G. Motulsky, Genotype–phenotype relationships in human red/green color vision defects, *Am. J. Hum. Genet. 51*:687–700 (1992).
33. M. Neitz, J. Neitz, and G. H. Jacobs, Relationship between cone pigments and genes in deuteranomalous subjects, *Colour Vision Deficiencies*, Vol. 10 (B. Drum, ed.), Kluwer Academic Publishers, Dordrecht, the Netherlands, 1990.
34. H. R. Blackwell and O. M. Blackwell, Blue mono-cone monochromacy: A new color vision defect, *J. Opt. Soc. Am. 47*:338–349 (1957).
35. H. R. Blackwell and O. M. Blackwell, Rod and cone receptor mechanisms in typical and atypical congenital achromatopsia, *Vision Res. 1*:62–107 (1961).
36. M. Alpern, G. B. Lee, and B. E. Spivey, $\pi_1$ Cone monochromatism, *Arch. Ophthalmol. 74*:334–337 (1965).
37. J. Pokorny, V. C. Smith, and R. Swartley, Threshold measurements of spectral sensitivity in a blue monocone monochromat, *Invest. Ophthalmol. 9*:807–813 (1970).
38. G. Verriest, Les courbes spectrales photopiques d'efficacité lumineuse dans les deficiencies congénitales de la vision des couleurs, *Vision Res. 11*:1407–1434 (1977).
39. M. Alpern, What is it that confines in a world without color? *Invest. Ophthalmol. 13*:648–674 (1974).
40. J. Nathans, C. M. Davenport, I. H. Maumenee, R. A. Lewis, J. F. Hejtmancik, M. Litt, E. Lovrien, R. Weleber, B. Bachynski, F. Zwas, R. Klingaman, and G. Fishman, Molecular genetics of human blue cone monochromacy, *Science 245*:831–838 (1989).
41. W. D. Wright, Characteristics of tritanopia, *J. Opt. Soc. Am. 42*:509–521 (1952).

42.  L. Van Heel, L. N. Went, and D. Van Norren, Frequency of tritan disturb-
     ances in a population study, *Color Vision Deficiencies*, Vol. 5 (G. Verriest,
     ed.), Kluwer Academic Publishers, Dordrecht, the Netherlands, 1980.
43.  C. J. Weitz, Y. Miyake, E. Montag, E. Zrenner, L. N. Went, and J. Nathans,
     Human tritanopia associated with two amino acid substitutions in the blue-
     sensitive opsin, *Am. J. Hum. Genet. 50*:498-507 (1992).
44.  M. L. Applebury and P. A. Hargrave, Molecular biology of the visual pig-
     ments, *Vision Res. 26*:1881-1895 (1986).
45.  J. D. Watson, J. Tooze, and D. T. Kurtz, *Recombinant DNA: A Short
     Course*, Scientific American Books, New York, 1983.

# Introduction to Chapter 7

After our excursion into molecular biology, we return to the domain of psychophysics. But we have not said goodbye to the subject of color vision. It will return at the end of this chapter, and again in the last two chapters of the book.

As explained in Section VI of this chapter, the sine-wave grating patterns that have provided so much useful data are not ideally suited to studying the spatial properties of human vision. I spent many years seeking an ideal (or at least greatly improved) stimulus for this purpose. As this chapter recounts, I believe I eventually succeeded, but only after several interesting detours and a dead-end or two. Eventually I was able to make something which a young colleague calls, only half-jokingly, "the optimum stimulus." But the early parts of the story are of interest, too.

I first became interested in quasi-periodic circular targets as a graduate student, and they returned to haunt me, in various incarnations, for the next 30 years. My adventures with them are included here for several reasons: Chapter 7 is a narrative history as well as a scientific report. It is a cautionary tale like Chapter 2, but not about instrument development. This chapter provides an example of the ins and outs of experimental science as it is actually pursued in the real world of financial constraints, disappearing collaborators, flawed understanding, and faulty communication.

Nowhere else has the circular target story all been pulled together in one place, so it seems worth doing. Starting as an exercise in spatial vision,

this project expanded into spatiotemporal and, finally, spatiotemporal-chromatic interaction. During its 30-year saga, the author matured from neophyte to well-known investigator, and the stimuli he first thought equivalent to sine-wave gratings metamorphosed into something quite different, and even more interesting.

Finally, recent studies of retinal inhomogeneity (including my work with circular targets) lead appropriately to Chapter 8, where the elegant, systematic inhomogeneity of the visual process is probed more deeply by computer modelling and brain mapping.

# 7

# Circular Targets and How They Grew

## D. H. Kelly

*SRI International, Menlo Park, California*

Until the mid-twentieth century, visual science laboratories used mainly circular dots and disks as stimuli, without the benefit of spatial frequency analysis. A 2°-disk, for example, was the standard tool for isolating the performance of the high resolution part of the retina known as the *fovea centralis*. These circular targets were also used to study flicker fusion, contrast sensitivity, color perception, and every other kind of response that was measured in the laboratories of the day.

But then, along came Otto Schade. Working at RCA Laboratories (which many years later became part of SRI International), he measured visual contrast thresholds with sinusoidal gratings [1,2]. Ironically, although his work started a revolution in visual science, Schade seems not to have been particularly interested in the imaging performance of human vision per se. He collected these human data because they were essential to evaluate the performance of the nascent TV systems with which RCA was concerned.

Schade's stimulus patterns varied sinusoidally in luminance, in one direction (e.g., horizontally), but did not vary at all in the orthogonal direction. In this sense, they were "one-dimensional," like the temporal waveforms produced by audio oscillators. While evaluating lenses, a British astronomer named Selwyn had also made such visual measurements at about the same time, but his obscure publication [3] had little effect on the vision community. Schade, on the other hand, was an engineer, who understood

**269**

the power of linear systems analysis. It was this kind of theoretical analysis, more than Schade's data, that changed the course of vision research.

The story of visual science during the next decade or two became the story of sine-wave patterns and visual responses to them, both psychophysical and physiological. Theoretical modeling, both linear and nonlinear, was largely devoted to these sine-wave responses. As a consequence, visual targets with circular symmetry almost vanished from the scene.

## I. AN ENGINEERING APPROACH

This period followed the heyday of information theory. I had studied that subject, briefly, under Shannon, Wiener, and Fano at MIT, and was eager to make use of these new ideas. I had also enrolled as an engineering graduate student at UCLA in 1954, with the idea of treating the visual process as a communication system. This is not a radical idea today, but at that time most visual scientists were not trained in engineering concepts, and I felt somewhat isolated from the vision community.

At UCLA, I learned about linear analysis and integral transforms and their applications from such leading lights as J. L. Barnes, I. S. Sokolnikoff, and R. B. Muchmore. Among other things, I became well aware of the differences between spatial responses (with their various symmetry relations) and temporal ones (which must obey causality), notions that ultimately had important applications in vision.

I really wanted to work with sine-wave spatial patterns and was doing so at my job as a photographic engineer. But the apparatus needed to generate those patterns in a vision lab was very expensive at that time—not the sort of thing that either I or my engineering professors could afford. Temporal waveforms, on the other hand, required only a spinning-Polaroid machine that I could build myself (with some help from the mechanical shop). And that is how my Ph.D. thesis came to be on the subject of flicker sensitivity [4–7] instead of spatial vision.

## II. BESSEL FUNCTIONS

Nevertheless, I was determined to work in spatial vision as soon as I could. To that end, I wanted my thesis to say *something* about spatial vision, preferably something that would stake out a territory I was interested in. Pondering the richness of two-dimensional patterns compared to the poverty of one-dimensional waveforms, I thought about circular symmetry. The two-dimensional Fourier integral can extract the sine-wave frequencies and orientations that make up any arbitrary spatial pattern. But if the constraint of circular symmetry is imposed on that integral, its kernel collapses

from two sine waves to a circular target: $J_0$, a Bessel function of the first kind, order zero [8]. And no one was using targets like that in the analysis of any kind of imaging system, let alone the visual process.

Of course, the only patterns that can be analyzed (or synthesized) by this so-called Fourier–Bessel (or Hankel) transform are those with circular symmetry: rings, dots, disks, and the vibrations of circular membranes [8] (like drumheads). But the fact that those dots and disks had loomed so large in the history of vision made me feel that Bessel functions might play an important role in current studies. My thesis therefore included graphs of what I called "the generalized spatiotemporal stimulus configuration," namely, a circular $J_0$ target, flickering sinusoidally. Figure 1 shows a picture of the $J_0$ kernel, not flickering but suitable for the analysis of any stationary, circular spatial pattern. That was the approach I was trying to promote.

These $J_0$ patterns had other advantages over sine-wave gratings. The central maximum provided a bright spot that served as a natural fixation target. The contrast decreased as the square root of the radius, which served to emphasize the response of the fovea without introducing any sharp edges. But sine-wave gratings were much easier to make, and they were universally adopted. Such are the ways of science.

Several years later, I managed to build an apparatus to display $J_0$ targets and do experiments with them, at Itek in Palo Alto [9]. But the only way I could photograph a $J_0$ pattern in my student days was to trace a $J_0$ function in polar coordinates on white paper, cut it out, paste it on a black background, and spin the whole thing on a phonograph turntable while making a time exposure. (That is how Fig. 1 was made [10].) Even so, when the International Commission for Optics (ICO) met in Munich in 1962, I was there touting my universal stimulus. I also published a note about it in the *JOSA* [10].

## III. SINE-WAVE VERSUS $J_0$ DATA

But the $J_0$ thresholds measured with my new circular target apparatus in the early 1960s were disappointing [9], with or without flicker. By this time, contrast threshold data were available for noncircular, sine-wave patterns [11], and these showed much more sensitivity at high spatial frequencies than the $J_0$ data. In fact, the ratio between the two types of pattern threshold seemed to increase almost linearly with frequency, as shown in Figure 2.

The effect was confirmed by John Robson, who acted as a subject in both types of experiment: with sine waves at Cambridge and with Bessel functions at SRI. (This comparison was first made in 1966 but not published, because I hadn't known what to make of it.) Originally I suspected

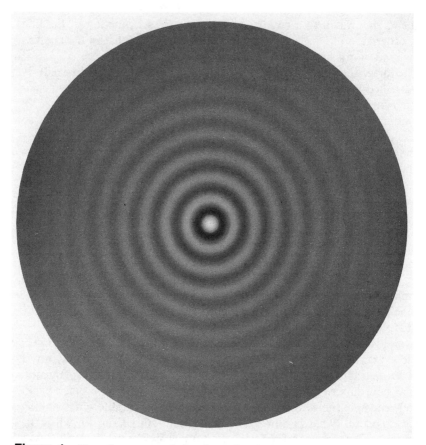

**Figure 1**  First $J_0$ target made by the author in 1960. This is the Fourier kernel for all two-dimensional patterns with circular symmetry. Although its contrast decreases with increasing radius, this pattern would be equivalent to a rectilinear, sinusoidal grating for testing isotropic, linear imaging systems. (From Ref. 10.)

some flaw in the calibration of my CRT display, but that could not have accounted for the main effect because later, when I was able to generate sine-wave patterns with the same apparatus, my sine-wave data [12] were just like everyone else's sine-wave data.

## IV.  ONE-DIMENSIONAL VERSUS TWO-DIMENSIONAL TRANSFORMS

So in place of my high hopes for Bessel functions, I was left with a scientific mystery: *Why* do the $J_0$ contrast thresholds differ in this systematic way

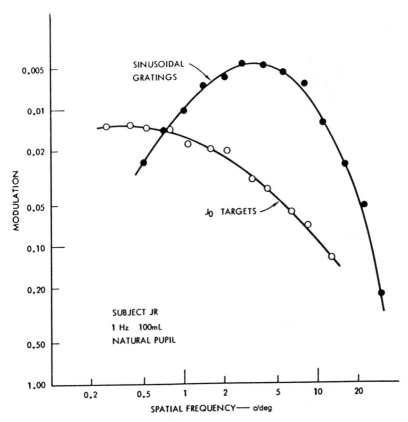

**Figure 2** Comparison of Bessel function and sine-wave contrast sensitivities made in 1966. (Sine-wave data from J. G. Robson, Cambridge University.)

from the sine-wave contrast thresholds? The first step toward a solution occurred when I heard from a young man named Henry Magnuski [13]. By this time the visual science community was all agog over the idea that spatial vision acted like an analog Fourier analyzer [14,15], an idea that was promptly dubbed "spatial tuning." Arguments raged: Could the same effects be explained in other ways? Did Fourier analysis *really* occur in the brain of the observer, or merely in the mind of the investigator [16]?

For his 1973 thesis at MIT, Magnuski had been experimenting with other patterns that varied in more than one spatial dimension (e.g., wiggly sine waves). He was convinced (rightly, it turned out) that the explanation for both his thesis data and my $J_0$ data lay in the essential differences between one-dimensional and two-dimensional Fourier analysis. (Up to that point,

the Fourier vision people had considered only one-dimensional cases.) In 1975, he and I coauthored a paper that made this point [13].

We postulated, as a generalization of the then-current Fourier models, that each pattern is detected in terms of the component of maximum amplitude in the *two-dimensional* Fourier transform of that pattern. This component is independent of the nominal frequency of a sine-wave grating, but it decreases with increasing frequency in the case of the $J_0$ target, just as the ratio of the two types of threshold data does. The same explanation also worked for data taken with an intermediate type of stimulus pattern, having a sinusoidal profile but circular symmetry [13].

This collaboration was completed after Magnuski had moved to the Stanford campus. It was supposed to be the first of many joint efforts on this subject, but I regret to say that my friend Henry Magnuski disappeared. Literally, and completely. I did my best to trace him through his Stanford and MIT connections, but they were no help. It seemed almost as though he didn't want to be found. I wrote one more paper in the series [17], but his influence was missing. (Hank, if you're out there somewhere, get in touch!)

## V. ORIENTATION SELECTIVITY

That was not the end of the Bessel function story, however. The Kelly–Magnuski paper was on the right track, but there turned out to be an important sequel to the two-dimensional explanation. In 1982 I was able to replicate the $J_0$–sine-wave comparison using an all-digital display [18]. This time all the data were taken in the same laboratory, with the same apparatus, at the same time; circular and rectilinear targets were even intermixed in a single session.

This more precise comparison showed that the ratio of Bessel function to sine-wave thresholds changed more slowly than the 1966 data had suggested, closer to the square root of the spatial frequency, as shown in Figure 3. Could it be merely a coincidence that the local contrast of the $J_0$ pattern, at a fixed point on the retina, also decreases as the square root of its spatial frequency? I thought not.

In Cartesian coordinates, the two-dimensional Fourier spectrum of any spatial pattern involves both "horizontal" and "vertical" frequency coordinates. But the same spectrum can be treated equally well in polar coordinates, where the radial coordinate represents the spatial frequency of a given sine-wave pattern and the angular coordinate represents its orientation. In these terms, the spectrum of a $J_0$ pattern is a thin annulus (i.e., a circular ring, with no preferred orientation), while the nearest equivalent

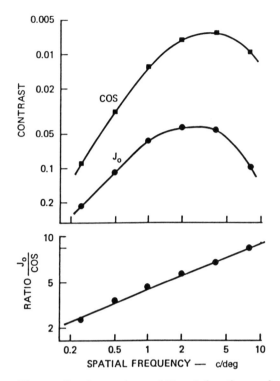

**Figure 3** Comparison of Bessel function and sine-wave contrast sensitivities made at SRI in 1982. The ratio of these two curves is well fitted by a power function with an exponent of 0.4. (From Ref. 18.)

sine-wave spectrum is two points on that annulus, 180° apart. This relation is illustrated schematically in Figure 4.

Kelly and Magnuski's explanation in terms of the maximum two-dimensional Fourier amplitude had to assume the existence of narrow-band, spatially tuned cortical units [13]. Models of such units were all the rage at that time, so we adopted them to explain the Bessel function versus sine-wave comparison. But it occurred to me later [18] that since both stimuli are already narrowly tuned in spatial frequency (and are being compared frequency by frequency), it is neither necessary nor helpful to consider the spatial frequency characteristics of the mechanism that detects them. Occam's razor removes the spatial-tuning implications that seemed so compelling when these data were first collected at the height of the Fourier fad.

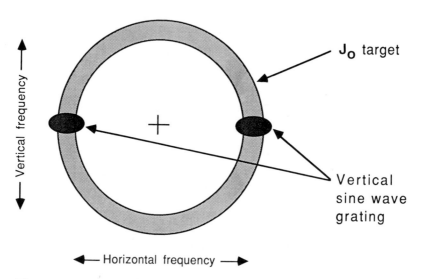

**Figure 4**   Schematic diagram of the Fourier spectra of sine-wave and $J_0$ targets. The widths of the blobs and of the ring depend on the size of the patterns.

What remains is the orientation selectivity of cortical units, which (unlike narrow-band spatial tuning) had been well established for many years. Orientation selectivity was sufficient not only to account for the effect, but even to make a modest prediction. Extremely narrow orientation tuning of cortical cells (say, ±1°) would imply that the ratio of Bessel function to sine-wave thresholds should vary precisely as the square-root function dictated by the stimuli (if they were well made). But both psychophysical and physiological data argue for a fairly broad orientation bandwidth (perhaps ±15°), which implies a ratio changing somewhat more slowly with spatial frequency than the square-root function. And that is just what my 1982 data [18] showed, as illustrated in Figure 3. With that nice result, I thought my concern with Bessel functions was finally over, after 22 years.

## VI.   RETINAL INHOMOGENEITY

But circular targets still had an important role to play in my later work on retinal inhomogeneity. The inhomogeneity of responses across a wide visual field is associated with the inhomogeneity of the retina. This is an important fact of visual science, but one that was often swept under the rug. Visual resolution, for example, varies by at least 3 to 1 over the retinal area needed to measure the contrast sensitivity at a low spatial frequency, when a

conventional sine-wave grating is centered on the fovea. And since visual resolution parallels the high frequency cutoff of the contrast sensitivity function, it seemed likely that the entire contrast sensitivity function varied across the retina in the same way. Thus even in the central retina, sine-wave threshold measurements had been confounded to some extent by retinal inhomogeneity.

## VII.  SINE-WAVE PATCHES

The ambiguities due to retinal inhomogeneity led some investigators to make the size of their foveal sine-wave target vary inversely with its spatial frequency, so that each contained a small, constant number of periods (e.g., 4–7 waves). The spatial bandwidth of these stimulus patterns was constant on a *log* frequency scale, instead of a linear one. This technique had the advantage of producing more believable results at low spatial frequencies without requiring the difficult construction of large high frequency targets. But I thought there must be a more straightforward way to compensate for retinal inhomogeneity in foveal contrast sensitivity measurements.

Clinical vision people think about the retina in polar coordinates, centered on the fovea. The radial coordinate is called "eccentricity," the angular coordinate, "meridian." These coordinates are very useful for studying retinal inhomogeneity because the spatial properties of the human visual system vary mostly with eccentricity, and relatively little with meridian. This organization of the retina is crucial to the developments described below.

Early attempts to measure contrast sensitivity as a function of eccentricity, using small patches of sine-wave targets, were beset by the target size problem in a new context. When target size was held constant, independent of eccentricity, the contrast sensitivity for any given spatial frequency was always maximum at the fovea, decreasing rapidly with eccentricity [19,20]. But when the target size increased with eccentricity in accord with the increasing scale of retinal structure, the size effect counteracted the loss of extrafoveal sensitivity [21]. (This use of the target size parameter is quite different from the foveal contrast sensitivity studies described above. There the size of the target varied inversely with spatial frequency. Here it does *not* vary with spatial frequency, but only with eccentricity.)

Compensating retinal structure in this way, in 1978 two groups independently published measurements of contrast sensitivity as a function of eccentricity, one under Koenderink in Holland [22] and the other under Rovamo in Finland [21]. Similar data were obtained for all meridians tested, at least out to 20° eccentricity. Plotted in log–frequency coordinates, these

contrast sensitivity functions maintained their shape and absolutely sensitivity but shifted toward lower spatial frequencies with increasing eccentricity. Those were very interesting results, because they seemed to reflect the constant shape and variable size of (what are now called P-type) retinal receptive fields.

## VIII. ANNULAR SINUSOIDAL TARGETS

Deciding to pursue these results still further, I asked the following question: If the retina is inhomogeneous, why are we all using homogenous stimuli? It occurred to me that a circular target with radially varying structure, mimicking that of the retina, might be much more appropriate. But how to determine what that structure should be? (By this time, laboratory computers were advanced enough to *make* the stimuli; the problem was to find out what the stimuli should be.)

To carry out the necessary pilot experiments, I devised a circularly symmetric version of the variable-size targets used by Rovamo's group [21]. Figure 5 shows one of these annular targets, designed for a median eccentricity of 6° (range, 4–8°). With stimulus patterns like this, we obtained a contrast sensitivity function of essentially constant shape (on a log–frequency scale) at median eccentricities of 0, 3, 6 and 12° [23].

As expected, these annular-average data were much like the single-median results of other investigators [21,22], but the circular target experiments were much nicer to do. The subject could easily maintain fixation at the center of the screen (Fig. 5), and the responses were less noisy because the periodic stimulus encompassed a larger area (the subject was also locked on target by image stabilization) [23].

## IX. THE INHOMOGENEOUS SPREAD FUNCTION MODEL

These annular contrast sensitivity data were well fitted by a modified exponential–Laplacian model of the contrast sensitivity function $f^p e^{-pf}$, where $f$ is the (local) spatial frequency and $p$ is a constant ($1 < p < 2$) that depends on the temporal properties of the stimulus [24,25]. The wavelength (or reciprocal frequency) of the peak of this contrast sensitivity curve was linearly related to the eccentricity at which it was measured [23,25].

To convert these annular data into a more general model, it was necessary to include the effects of varying the area of the target. How would circular target spatial responses from different parts of the retina add up? It turned out that targets like those in Figure 6, consisting of two or more annuli, added as the fourth power of their contrasts, a relation that also fits other area effects [26]. With a little trial and error, this relation can be

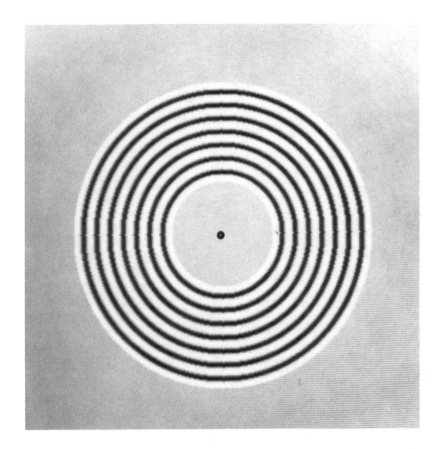

**Figure 5** Annular target designed to measure contrast sensitivity averaged over all meridians at a median eccentricity of 6°. The radial variation is sinusoidal, at constant amplitude. (From Ref. 23.)

combined with the reciprocity between frequency and eccentricity to make a complete (if somewhat cumbersome) model of contrast sensitivity as a function of both [25], hence to predict the sensitivity for any arbitrary circular pattern.

That model necessarily defines the contrast sensitivity at an arbitrary point (actually, around a circle) on the retina, which of course cannot be measured directly. However, we can make a logical interpretation of this extremely local form of contrast sensitivity by borrowing a concept from modern optics. There the point spread function is defined at a point in space, and its (two-dimensional) Fourier transform is known as the modula-

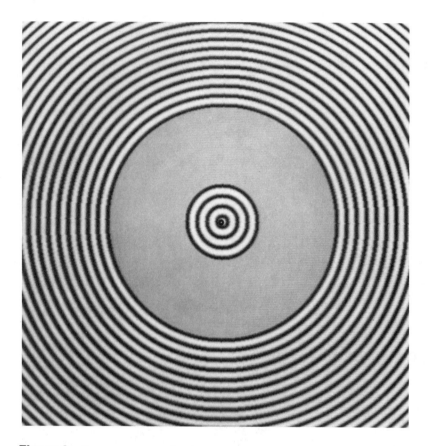

**Figure 6** Two-component circular target, designed to measure spatial additivity. (From Ref. 26.)

tion transfer function at that point. In our case, the local contrast sensitivity function has the form given above, and its inverse transform yields the kernel of a Laplacian spatial filter (shaped like a *sombrero*). Such a filter is very similar to the receptive field of a retinal (P-type) ganglion cell; and *that* is about as local a property as visual physiology can provide.

## X. CIRCULAR FM TARGETS

One of the end products of all this work was a set of inhomogeneous, circular targets like the one shown in Figure 7, with the smallest wavelength in the center, doubling at an eccentricity of 2.3° and continuing to expand out to the edge of the target. When I started working with these inhomoge-

neous patterns, some colleagues said, "Oh, Kelly is just fooling around with Bessel functions again." But the stimulus pattern of Figure 7 is *not* a Bessel function.

Both types of function are locally sinusoidal and circularly symmetric, but there the similarity ends. The Bessel function ($J_0$) stimuli varied in *amplitude* with radius, but their local spatial frequency was essentially unvarying. The inhomogeneity-correcting patterns were just the opposite: amplitude was constant but *frequency* varied with radius, more or less matching the properties of the retina. The retina does not have perfect circular symmetry, of course. But in view of the differences among normal subjects,

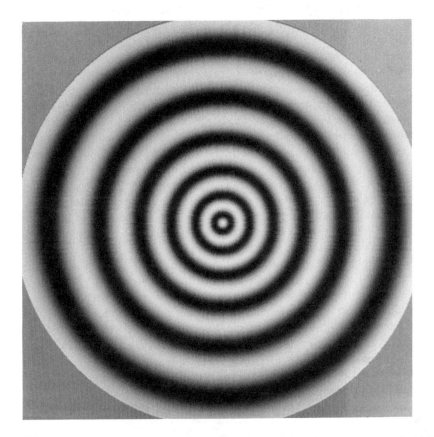

**Figure 7** Frequency-modulated circular target, designed to compensate for retinal inhomogeneity. Spatial frequency decreases with increasing radius, but amplitude remains constant (unlike the Bessel function). (From Ref. 25.)

that may be as good a match as we are likely to get. Certainly it is much better in this respect than any sine-wave grating patch.

## XI. CANONICAL CONTRAST SENSITIVITY FUNCTIONS

At this point, it seemed like a good idea to see how these inhomogeneous, circular targets would perform in measurements of contrast sensitivity. (Remember my 1966 disappointment with Bessel functions.) If the frequency modulation of the target does indeed match the spatial variation of retinal structure, then the contrast sensitivity function (CSF) measured in this way is a canonical function: apart from a scale factor, it represents the *form* of the spatial response anywhere in the (16°) diameter of the stimulus field.

Two preliminary decisions had to be made. First, how should we define the independent variable? For a sine-wave grating, the spatial frequency is usually constant over the entire stimulus pattern, but here it varies continuously with eccentricity. The spatial frequency at the fovea, which is the highest frequency in the target, should be most nearly comparable to the independent variable in earlier CSF measurements, so these new contrast data were plotted as a function of foveal spatial frequency [27].

Second, what sort of temporal variation should the new targets have? Now that we control the subject's fixation point by stabilizing the retinal image, visual percepts tend to fade out without some sort of flicker or motion of the distal target. Each has its own advantages. Sine-wave flicker is widely used, and its variation is orthogonal to any kind of spatial modulation, so that the spatial and temporal variables can be plotted independently. Flicker was used in this way for the annular zone measurements on which the inhomogeneous model was based [23].

On the other hand, motion is a more natural form of variation, in the sense that it is always present in ordinary, unstabilized vision. Even when the distal stimulus is not moving, normal eye movements keep the retinal image in constant motion. Fortunately, flicker and motion are closely related. According to the same principle that governs the formation of standing waves, two oppositely moving sine-wave patterns add up to a stationary, flickering one.

Although not so well known, it is also true that two flickering patterns can add up to a moving one if they are 90° out of phase in both space and time [28]. With the aid of this identity, we created a form of purely radial motion that seemed most appropriate for our inhomogeneous targets. Imagine each of the rings in Figure 7 expanding outward, increasing in wavelength and velocity as it goes, so that the flicker frequency at any fixed point is constant everywhere in the target. Reversing the phase of one

component reverses the motion (the rings contract instead of expanding). In either case, we defined the velocity (of the stimulus) as the asymptotic value at the center (just as we defined its spatial frequency).

Figure 8 shows a comparison of the CSF measured with this kind of motion (at a velocity of 0.19 deg/s) and the CSF measured with sine-wave flicker modulation (at a temporal frequency of 0.5 Hz). Both sets of data are superimposed on theoretical curves, derived from the model described above. The two stimuli are the same at 2.6 c/deg, where the two curves meet. But the bandwidth of the constant velocity response is narrower than that of the constant temporal frequency response, because the constant velocity technique creates a lower temporal frequency at lower spatial frequencies and a higher temporal frequency at higher spatial frequencies. Since the spatial and temporal sensitivities are both bandpass functions, multiplying them together results in a narrower passband than either has alone.

Since the velocity of 0.19 deg/s was chosen to fall within the range of

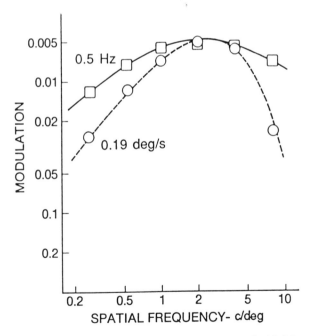

**Figure 8**  Contrast sensitivity curves measured with inhomogeneity-compensating targets (Fig. 7): squares, targets flickering in counterphase; circles, targets in radial motion. (From Ref. 27.)

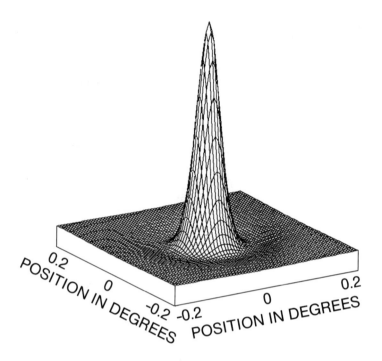

**Figure 9**  Two-dimensional, inverse Fourier transform of the narrower curve in Figure 8. The shape of this spatial response is very similar to that of retinal receptive fields measured electrophysiologically. (From Ref. 27.)

normal drift velocities of the retinal image [28], one could argue that the narrower curve in Figure 8 represents the (canonical) spatial filtering effect of retinal receptive fields, modulated by fixation-limited eye movements. At any rate, it seemed worthwhile to see what the Fourier transform of this curve would look like. Figure 9 shows the result, which strongly resembles a P-type retinal receptive field [27].

## XII.  MOTION IN DEPTH

Although our circular FM targets (Fig. 7) were originally designed to compensate for retinal inhomogeneity in the measurement of contrast sensitivity, they also proved to be useful for other studies. For example, we found that the radial motion of these circular waves produced a strong impression of motion in depth along the subject's visual axis. At high contrasts, the

aftereffects of this illusion were even stronger than those of the classic Plateau spiral on a spinning disk, presumably as a result of the increase of radial velocity with eccentricity in our stimuli. (Because the temporal frequency remained constant everywhere in the field, the radial velocity was always proportional to the local spatial period of the target [27].)

The illusory motion was in the forward direction if the stimulus velocities were centrifugal; backward, if they were centripetal. Both motions were accompanied by strong aftereffects, which persisted even at low contrasts. We studied the threshold elevation produced by these radial motion aftereffects (a standard method of quantifying aftereffects). At some spatiotemporal frequency combinations, the forward aftereffect turned out to be significantly greater than the backward one. We defined the "forward effect" as the ratio of the two threshold elevation ratios, which required the measurement of *four* thresholds for each target: forward and backward thresholds, in forward- and backward-adapted states [29].

The forward effect occurred only within a narrow (2-octave) range of spatial and temporal frequencies, as illustrated in Figure 10, where the centroid of the data occurs at 0.1 c/deg and 2 Hz. For another subject the centroid fell at 0.2 c/deg and 4 Hz. A third subject didn't quite complete the necessary conditions, but all three sets of data were consistent with the same (foveal) image velocity: 20 deg/s. That and the very low spatial frequencies involved suggested that the forward effect was velocity-tuned [29].

It was easy to show that the radial variation of the spatial frequency of the stimulus (see Fig. 7) was important. Merely shifting the subject's fixation from the center to the edge of the inhomogeneous target destroyed the (previously large) forward effect. A more elegant test was obtained by maintaining fixation on the center of the target and varying its radial gradient from normal, through zero (constant spatial frequency), to completely reversed. This reversal greatly decreased the forward effect for one subject; for another, it was destroyed. At zero gradient, however, a significant effect remained in both cases (implying that a Plateau spiral probably could be used to demonstrate the forward effect, as well).

Why should the forward effect exist? Given the presence of separate mechanisms for detecting forward and backward egocentric motion, evolutionary considerations suggest that the forward one should be better developed, since it would be used extensively in both pursuit and escape (whereas any of our ancestors who persisted in running backward through the jungle would not have survived long enough to have many offspring!). That may also help to explain why the forward effect occurs only at very low spatial frequencies. An effective collision-avoidance system should respond to those

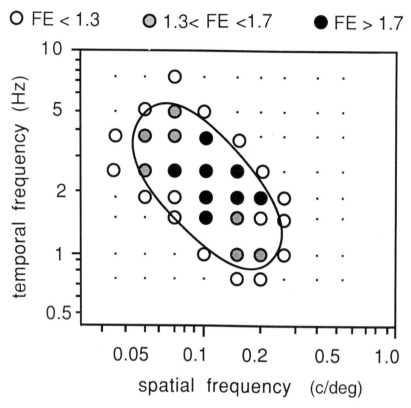

**Figure 10** Spatiotemporal frequency locus of the forward-motion-in-depth aftereffect, measured with targets like Figure 7. Most of the spatial frequencies involved are much lower than those plotted in Figures 2, 3, and 8. (From Ref. 29.)

spatial frequencies that most objects to be avoided have in common, and low frequencies are always present for an isolated object, regardless of its size, shape, or other details.

## XIII.  SPATIOCHROMATIC INTERACTIONS

My early experiments with circular targets, like other contemporary studies of spatial vision, used only achromatic (white-light) stimuli, for two reasons: first, the color video displays that were available in those days were not really good enough to be used for controlled visual stimulation; and second, it seemed simpler to begin by omitting the complexities of color vision. But in due course, the first caveat lost its validity; and the second

was actually somewhat illusory. A normal subject's color vision machinery is always functioning at photopic luminance levels, no matter what stimuli the experimenter chooses. (Note that "achromatic" describes a subjective appearance, not a wavelength distribution.)

The experiments reviewed below are not merely spatial vision studies or color vision studies, but inextricably, both. This double categorization may be frustrating if you think of the physical properties of the stimulus as separate and distinct dimensions, because the visual system doesn't keep them that way. Perhaps the interactions involved here will provide a bridge to some other chapters in this book.

## XIV. OPPONENT-COLOR RECEPTIVE FIELDS

White-light, inhomogeneity-compensated targets were used to obtain the receptive field function shown in Figure 9, but of course there is no such thing as a "white"-sensitive receptor cell. The spatial opponency that was inferred by this technique was presumably mediated by long-wave ("red"-sensitive) and middle-wave ("green"-sensitive) photoreceptors, with one type predominating in the center of the receptive field and the other in the antagonistic surround. To explore the effect of this red/green opponency on the spatiotemporal properties of retinal (foveal and parafoveal) receptive fields, we generalized the white-light procedure in the following way.

From two complete sets of threshold measurements, we calculated both center and surround responses, independently, as functions of spatial and temporal frequency. First we created isoluminant, red/green, circular FM patterns, like the white-light pattern of Figure 7 but modulated in chromaticity instead of luminance. (The red/green balance was adjusted to isoluminance individually for each subject.) The second set of stimuli were achromatic (yellow), obtained by shifting the red and green components of the isoluminant stimuli into (spatial) phase.

Contrast detection thresholds were measured for these chromatic (C) and achromatic (L) patterns. Knowing the spectral radiance functions of the red and green phosphors and the spectral sensitivity functions of the long-wave-sensitive (LWS) and middle-wave-sensitive (MWS) photoreceptors, it was possible to calculate the canonical center ($E$) and surround ($I$) responses from the L and C thresholds as functions of spatial and temporal frequency [30].

Several important assumptions were required for this calculation:

All relations are linear.
Stimulus inhomogeneity accurately cancels retinal inhomogeneity.
The total response of any given receptive field approaches zero at low

spatial frequencies, because the center and surround responses cancel each other.

Long-wave and middle-wave sensitivities of all subjects are adequately represented by the well-known Smith–Pokorny functions.

With these assumptions, no mathematical model of the receptive field was needed, hence no parameter fitting. Spatial and temporal responses were *not* assumed to be mathematically "separable." (Our data of course did not distinguish LWS-center, MWS-surround receptive fields from MWS-center, LWS-surround ones, so we had to use a calculation procedure that was indifferent to this distinction [30].)

The achromatic response $(E - I)$ of this R/G-opponent receptive field was calculated as a function of spatial frequency for all temporal frequencies, but no significant changes were found with temporal frequency up to 4 Hz, for any of our three subjects. Thus the (low temporal frequency) spatial response for each subject was taken as the average of all that subject's data for frequencies below 4 Hz. Although there were significant differences among subjects for these $E - I$, spatial frequency responses, each was transformable into a plausible receptive field function, much like Figure 9. That similarity would be expected if the same (P-type) receptive field system were shown to govern both color-opponent and spatially opponent responses, a hypothesis for which there is much other psychophysical and physiological evidence.

The success of these inhomogeneity-compensating stimuli led to their adoption for much of the vision work at SRI International. The circular FM targets illustrated in Figure 7 have been used in many current publications and others in preparation.

## REFERENCES

1. O. H. Schade, Electro-optical characteristics of television systems. I. Characteristics of vision and visual systems, *RCA Rev. 9*:5–37 (1948).
2. O. H. Schade, On the quality of color-television images and the perception of color detail, *J. Soc. Motion Picture Television Eng. 67*:6–12 (1958).
3. E. W. H. Selwyn, The photographic and visual resolving power of lenses. I. Visual resolving power, *Photog. J. (London) 88B*:6–12 (1948).
4. D. H. Kelly, Visual responses to time-dependent stimuli. I. Amplitude sensitivity measurements, *J. Opt. Soc. Am. 51*:422–429 (1961).
5. D. H. Kelly, Visual responses to time-dependent stimuli. II. Single-channel model of the photopic visual system, *J. Opt. Soc. Am. 51*:747–754 (1961).
6. D. H. Kelly, Visual responses to time-dependent stimuli. III. Individual variations, *J. Opt. Soc. Am. 52*:89–95 (1962).
7. D. H. Kelly, Visual responses to time-dependent stimuli. IV. Effects of chromatic adaptation, *J. Opt. Soc. Am. 52*:940–947 (1962).

8. I. N. Sneddon, *Fourier Transforms*, McGraw-Hill, New York, 1951.

9. D. H. Kelly, Frequency doubling in visual responses, *J. Opt. Soc. Am. 56*: 1628–1633 (1966).

10. D. H. Kelly, $J_0$ stimulus patterns for visual research, *J. Opt. Soc. Am. 50*: 1115–1116 (1960).

11. J. G. Robson, Spatial and temporal contrast-sensitivity functions of the visual system, *J. Opt. Soc. Am. 56*:1141–1142 (1966).

12. D. H. Kelly, Effects of sharp edges on the visibility of sinusoidal gratings, *J. Opt. Soc. Am. 60*:98–103 (1970).

13. D. H. Kelly and H. S. Magnuski, Pattern detection and the two-dimensional Fourier transform: Circular targets, *Vision Res. 15*:911–915 (1975).

14. F. W. Campbell and J. G. Robson, Application of Fourier analysis to the visibility of gratings, *J. Physiol. (London) 197*:551–566 (1968).

15. C. Blakemore and F. W. Campbell, On the existence of neurons in the human visual system selectively sensitive to the orientation and size of retinal images, *J. Physiol. (London) 203*:237–260 (1969).

16. G. Westheimer, Fourier analysis of vision, *Invest. Ophthalmol. 12*:86–87 (1973).

17. D. H. Kelly, Pattern detection and the two-dimensional Fourier transform: flickering checkerboards and chromatic mechanisms, *Vision Res. 16*:277–287 (1976).

18. D. H. Kelly, Motion and vision. IV. Isotropic and anisotropic responses, *J. Opt. Soc. Am. 72*:432–439 (1982).

19. R. Hilz and C. R. Cavonius, Functional organization of the peripheral retina: Sensitivity to periodic stimuli, *Vision Res. 14*:1333–1337 (1974).

20. J. G. Robson and N. Graham, Probability summation and regional variation in contrast sensitivity across the visual field, *Vision Res. 21*:409–418 (1981).

21. J. Rovamo, V. Virsu, and R. Nasanen, Cortical magnification factor predicts the photopic contrast sensitivity of peripheral vision, *Nature 271*:54–56 (1978).

22. J. J. Koenderink, M. A. Bouman, A. E. B. d. Mesquita, and S. Slappendel, Perimetry of contrast detection thresholds of moving spatial sine wave patterns, *J. Opt. Soc. Am. 68*:845–865 (1978).

23. D. H. Kelly, Retinal inhomogeneity. I. Spatiotemporal contrast sensitivity, *J. Opt. Soc. Am. A 1*:107–113 (1984).

24. D. H. Kelly, Motion and vision. II. Stabilized spatio-temporal threshold surface, *J. Opt. Soc. Am. 69*:1340–1349 (1979).

25. D. H. Kelly, Retinal inhomogeneity. III. Circular-retina theory, *J. Opt. Soc. Am. A 2*:810–819 (1985).

26. D. H. Kelly, Retinal inhomogeneity. II. Spatial summation, *J. Opt. Soc. Am. A 1*:114–119 (1984).

27. D. H. Kelly, Receptive-field-like functions inferred from large-area psychophysical measurements, *Vision Res. 25*: 1895–1900 (1985).

28. D. H. Kelly, Visual processing of moving stimuli, *J. Opt. Soc. Am. A 2*:216–225 (1985).

29. D. H. Kelly, Retinal inhomogeneity and motion in depth, *J. Opt. Soc. Am. A 6*:98–105 (1989).

30. D. H. Kelly, Opponent-color receptive-field profiles determined from large-area psychophysical measurements, *J. Opt. Soc. Am. A 6*:1784–1973 (1989).

# Introduction to Chapter 8

In this chapter we move from psychophysical studies of inhomogeneity into the neural architecture that underlies it, and the fascinating mathematics that govern the whole system. Since Dr. Schwartz is the leading exponent of this field (and of the kind of computer modeling that makes it tractable), we could not have a better guide. The reader may note that this architectural approach to the visual system neatly complements the finer-scale, receptive-field approach described by Martinez-Uriegas in Chapter 4; both have important roles to play.

When I first met Eric Schwartz, he had only recently taken the plunge into neuroscience, from a promising career in high energy physics that included a Ph.D. from Columbia and several publications in the field. To make the break, he went through a postdoc at New York Medical College and then moved to New York University School of Medicine.

In the late 1970s, I came across one of Dr. Schwartz's papers in *Biological Cybernetics*. I wanted to learn more about his work because I was fascinated by the prospect of a sophisticated mathematical model of the so-called retinocortical projection: the geometrical transformation from the retinal image to the cortical one, based on conformal mapping in the complex domain. Clearly this machinery plays a fundamental role in how we perceive the objects and events in the real world around us.

At that time it was my duty, as chairman of the Vision Technical Group of the Optical Society of America, to put together a symposium on current

**291**

exciting topics in visual science for the 1978 OSA meeting in San Francisco. What better way, I thought, to pick Eric's brain (both real and modeled) than to invite him to come to San Francisco and tell us all about it. (This was before the days of any official OSA interest in computer vision or computational neuroscience. Eric's talk was published in *Vision Research*.) By hearing him speak, I also learned that his talent for exposition is as great as his scientific insight.

Now I have done the same thing to him again, more or less. Eager to have an up-to-date report on his studies of visual brain architecture in the primate, I invited him to write it for me. Professor Schwartz is currently at Boston University in the School of Medicine (Anatomy and Neurobiology), the School of Engineering (Electrical Engineering and Computer Systems), and the Faculty of Arts and Sciences (Cognitive and Neural Systems), with a full schedule of teaching and research duties. Nevertheless, he somehow managed to find time to oblige me. I'm sure you will be glad he did.

In addition to reporting his own work, Eric has provided us with a masterful account of the history of this subfield, complete enough so that anyone who is interested can dive right in. I know of no comparable survey in the literature. In any case, this chapter has a little something for everyone, including a recent engineering application.

# 8

# Topographic Mapping in Primate Visual Cortex: History, Anatomy, and Computation

### Eric L. Schwartz

*Boston University, Boston, Massachusetts*

## I. INTRODUCTION

This chapter presents the history and an estimate of current understanding of the spatial architecture of primary visual cortex (V-1, striate cortex, area 17) in primates. Special emphasis is placed on experimental techniques, mathematical and computational analyses, and the relevance of V-1 architecture to current work in machine vision. An attempt has been made to provide a representative coverage of the primary literature, but completeness in this regard is not claimed. Rather, the intention is to provide an overview of the difficulties, both conceptual and experimental, that have characterized this field for the past 50 years, and to provide some insight into the importance of spatial architecture in visual cortex to both biological and machine vision.

History is divided into four periods in which the status of understanding mapping in V-1 is surveyed:

*Preclassical*: prior to physiological demonstration of cortical topography
*Classical*: initial demonstrations of topography, but no analytic characterization
*Middle*: first attempts at magnification factor data fitting and introduction of complex log model.

**293**

*Modern*: use of 2-deoxyglucose, awake behaving preparations, computer flattening, and conformal mapping

Then follows a summary of the detailed mathematical methods in current use for modeling visual cortex topography, consisting of three parts:

*One-dimensional*: use of scalar magnification factor to characterize V-1
*Two-dimensional*: parametric fits to the two-dimensional cortical map function using two and three parameters are presented, along with current experimental evidence
*High-dimensional*: incorporation of additional, nontopographic dimensions, such as ocular dominance and orientation tuning (protocolumns and polymaps)

Next, the characterization of psychophysically measured spatial scaling functions is reviewed briefly in terms of cortical magnification factor. Emphasis is on methodological problems with many of the measurements that have been performed.

Finally, we review computational applications of cortical architecture. Particular emphasis is placed on recent activity in building space-variant active vision systems and multiresolution vision systems, in which the design principles of primary visual cortex have played an important motivating role.

## II. HISTORY OF TOPOGRAPHIC MAPPING

### A. Preclassical Period

The existence of distinct scotomas caused, for example, by penetrating missile wounds of occipital cortex, suggested to Minkowski [1], Holmes [2], and Poliak [3] that there must be a maplike representation of the visual field in cortex. However, there appears to have been little further thought on this subject prior to the classical period described in the next section, when V-1 topography, as well as lateral geniculate nucleus (LGN) topography [4] and somatosensory topography [5] were directly demonstrated for the first time. This is curious, since there have been extensive speculations about the mental bases of vision for many hundreds (or thousands!) of years. (See Ref. 6 for a historical review.) The space-variant nature of our visual systems, which is evident to casual (if informed) self-experimentation, appears to have been little discussed prior to the 1940s and is, on the part of laymen, largely unknown today. The overwhelming majority of us believe implicitly, as can be demonstrated with a classroom full of students, that the visual world is constant, space-invariant, and Euclidean. The profound illusion that more peripheral locations have the same resolu-

tion as central vision is no doubt rooted in our experience that when we "look" at those peripheral areas, we do so with our foveal representation! Curiously, it appears that even among groups who are knowledgeable about vision (e.g., perceptual psychologists), there often is a tendency to conceptualize the visual field in terms of a distinct "fovea" and a "periphery," rather than to acknowledge the continuously changing, space-variant map that underlies our visual system. The detailed characterization of this continuous map is the main subject of this chapter.

## B.  Classical Period

In the early 1940s Talbot and Marshall [7] used electrophysiological techniques to demonstrate the existence of a well-defined topographic map in monkey visual cortex and provided some of the first speculations concerning the functional utility of such a representation. Nearly 20 years later, Daniel and Whitteridge [8] performed the second experiment in this area, using several species of monkeys and apes, and introduced one of the key terms in the field: *cortical magnification factor*. However, neither Talbot and Marshall nor Daniel and Whitteridge took the next step of providing an analytic fit to their data, an activity that did not begin until the 1970s, as will be shown after a brief discussion of these two landmark experiments.

### 1.  Talbot and Marshall

In 1941 Talbot and Marshall provided the first direct physiological evidence for the existence of an orderly map of visual space to the surface of primary visual cortex. They modified the standard Horsely–Clark stereotactic headholder to allow a wide angle of visual field to be projected onto the retina, immobilized the eye by sewing the conjunctiva to a fixed metal ring, and proceeded to plot the location of cortical stimulation sites referenced to retinal stimulation sites, using evoked potential recordings obtained from a "moist thread or an insulated needle." Using this apparently crude electrode technology, they produced a map of visual cortex that agrees reasonably well with later experiments.

Talbot and Marshall used the term "cortical discrimination," defined as a ratio of retinal distance (degrees) divided by cortical distance (millimeters). This is equivalent to the inverse of the "magnification factor" (later defined by Daniel and Whitteridge, to be discussed below. They stated: ". . . the spacing of contours is inversely proportional to discrimination in the cortex" [7, p. 1257] and reported that in cat, the cortical discrimination averaged 5 deg/mm at 30° and 1 deg/mm centrally. In the monkey, they found that the discrimination averaged 18 minutes of arc/mm at 5° and 2 minutes of arc/mm centrally. This measurement of foveal discrimination (inverse magnification factor in more modern terms) appears to be larger

than most later measurements of cortical magnification in the monkey, which generally have been in the range of 6–10 mm/deg, although Dow and his colleagues, working with behaving monkeys in a very accurate experiment, have reported peak values of cortical magnification in this range.

In addition to introducing the concept of (inverse) cortical magnification, under the term "cortical discrimination," Talbot and Marshall also introduced several other seminal ideas. They suggested that vernier acuity and stereo acuity might be related to the huge expansion in the central cortical representation, and they speculated in a similar vein about stereoscopic fusion, suggesting that ". . . disparate images . . . converge to common neurons at the cortex [7, p. 1261].

Using relatively crude physiological equipment, Talbot and Marshall obtained a relatively accurate map. They introduced the fundamental ideas of cortical scaling and magnification factor, as well as the notion that spatial representation of the visual field, at the cortex, might be of functional significance to vision.

## 2. Daniel and Whitteridge

Roughly 20 years later, Daniel and Whitteridge, using cortical evoked potentials (2 mm silver balls) as well as multiunit recording (electrodes with tip size between 10 and 2 μm), confirmed Talbot and Marshall's study. Daniel and Whitteridge introduced the term "cortical magnification," defined as the reciprocal of "cortical discrimination"—that is, the ratio of a cortical distance to a corresponding retinal distance (mm/deg)—and provided a plot of cortical magnification versus retinal eccentricity.

Curiously, Daniel and Whitteridge stated [8, p. 211] that

No simple equation has been found to fit the data. Neither plotting the data on a semi-log basis nor plotting reciprocals of the data gives a straight line.

But, in fact, the reciprocal of their data is fairly close to a straight line, and in the absence of any error analysis could be approximated as a linear function. Starting with the analysis of Schwartz [9], virtually all later workers in this area have made this approximation. The question of what constitutes a "fit" has only recently begun to be addressed and is obviously of central importance to this area (see below).

Daniel and Whitteridge also introduced the notion of "brain flattening." Since cortex is essentially a two-dimensional sheet [1200 mm$^2$ (per hemisphere, Macaque V-1) by roughly 2 mm thick], Daniel and Whitteridge constructed a three-dimensional clay model of cortex, then flattened it by orthogonal projection. Methods for representing cortical maps on flattened

surfaces have become an active area of research. Van Essen and Maunsell [10] used a "hand tracing" method to provide flattened models of V-1, as well as the entire extra striate visual cortex. Tootel et al. [11] using physical flattening via pressing cortex between glass slides, to provide flattened specimens of 2-deoxyglucose (2DG) labeled V-1. Our lab [12-14] developed computational methods to provide quantitative brain flattening in order to begin to provide estimates of the errors involved in measuring cortical topography (and see Ref. 15).

A second experimental statement of Daniel and Whitteridge is also of great importance. They stated that cortical magnification was both locally isotropic and globally symmetric:

Magnification factor measured radially over a small distance was found not to differ significantly from the magnification factor measured along the corresponding circumference . . . there is no significant difference between magnification factors for different radii.

Thus, although Daniel and Whitteridge made a clear distinction between local and global symmetry in 1961, many later workers in this area have confused the two. This point is of great importance, since it can be shown (see below) that local isotropy and global symmetry are in general mathematically inconsistent.

A good way to see this is to consider the derivative of the function $\log(z + a)$ on the horizontal meridian (i.e., the real axis) and on a vertical meridian (e.g., the upper vertical meridian, which corresponds to the positive imaginary axis in this model). These are

$$|f'| = \frac{k}{x + a} \qquad \text{for } x \text{ real} \tag{1}$$

$$|f'| = \left| \frac{k}{a + iy} \right| = \frac{k}{\sqrt{(y^2 + a^2)}} \qquad \text{for } y \text{ imaginary} \tag{2}$$

These differ by a maximum amount of $\sqrt{2}$ at $(a, 0)$ and $(0, a)$. Thus, there is a 41.4% difference in magnification at $0.3°$ on the horizontal and vertical meridians if the constant $a$ is $0.3°$. Correspondingly, the integrals of the horizontal and vertical meridians differ by about 30% for $a = 0.3$. These lengths can be evaluated by noting that the integral of magnification factor, as above, is an elliptic integral. Alternatively, the complex log function can be plotted, and a piece of string laid along the image of the different meridians! Therefore, Daniel and Whitteridge's report of local and global isotropy cannot be correct. This point will be established further in this chapter, under the detailed discussion of conformal mapping.

The issue of local isotropy, and cortical mapping in general, is further

confounded by the existence of ocular dominance columns, which essentially provide a double map instead of the single map conceptualized by Daniel and Whitteridge. It has been only in the last several years that computational tools for modeling such multiple maps, which we term *polymaps*,* have been developed [16]. These issues of local isotropy, and the existence of multiple columnar systems in V-1, are among the most difficult, both conceptually and experimentally, in this area. They are still a matter of debate, and we return to them later in this chapter.

Finally, Daniel and Whitteridge introduced a seminal idea in cortical physiology. They pointed out that the cortical distance corresponding to the minimal angle of resolution worked out to about 67 $\mu$m or "the distance occupied by about five cells in the densest part of layer IV of the cortex" [8, p. 218], independent of eccentricity. Plotting the minimal angle of resolution (in man) against inverse cortical magnification factor (in monkey), they showed that the two curves were almost identical. They concluded [8, p. 218]:

> The minimal angle of resolution would correspond to about 67$\mu$m in both the fovea and extreme periphery. Two peaks of excitation would have to be separated by this distance and by a corresponding number of cortical cells for them to give rise to separate sensations.

Daniel and Whitteridge sharpened the scaling argument introduced by Talbot and Marshall and laid the stage for the cortical hypercolumn model of Hubel and Weisel [17]. Moreover, this analysis presaged a large amount of psychophysical activity beginning in the late 1970s, which sought to relate various notions of cortical magnification factor with spatial scaling functions measured in experiments on acuity, stereo acuity, motion, vernier acuity, and stereo fusion.

## C. Middle Period

The classical period of work in the area of visual cortex topographic mapping was circumscribed by only two papers, published over the period of 1941 to 1961, outlined above. Beginning in the early to mid-1970s, work in this area began to pick up momentum, beginning with the analysis of feline retinal ganglion cell density and receptive field overlap. Burkardt Fischer approximated the density of retinal ganglion cell receptive fields in terms

---

*It should be emphasized that most cortical maps that have been studied have evidence of one or more submodalities in the form of columnar interlacing. Therefore the polymap is the prototypical cortical structure.

of an inverse linear function of distance from the fovea and pointed out that "an isotropic coordinate" system for the retina was obtained by integrating the retinal ganglion cell density function [18]. He suggested several different forms of logarithmic structure for an "isotropic" coordinate system, one of which was the complex logarithmic mapping whose detailed structure is discussed below.

Fischer did not relate his ideas to cortical magnification, nor to cortex at all. His model was for structure in "the optic tract" of the cat, and it was intended to provide an isotropic system in which equal steps of distance corresponded to equal numbers of ganglion cells in the cat retina. Fischer's work was the first to attempt to provide a two-dimensional model of any aspect of the visual system, and was, as we will shortly see, very close to providing a model for the cortical map, since it turned out that the cortical topographic map was (at least approximately) one of the "isotropic" representations of the retina that Fischer was conceptualizing.

Fischer's notion of an isotropic representation of the retina, like that of Daniel and Whitteridge, reached full expression the next year when Hubel and Weisel published their "hypercolumn" model, which suggested that equal areas of cortex (hypercolumns) represented invariant structures not only for topography, but also for ocular dominance and orientation representations (17).

## 1.  Complex Logarithmic Model

In 1976 I presented abstracts at the American Physiological Society and the Society for Neuroscience [9] reporting that a simple fit to Daniel and Whitteridge's cortical magnification data was close to inverse linear. It was suggested that a complex logarithmic map of the visual field to the surface of visual cortex provided a simple (two parameter) fit to the cortical map. Moreover, it was pointed out in these papers and in subsequent journal articles [19-21] that the local hypercolumn structure of cortex suggested that the geometric properties of the complex log function were consistent with a miniature recapitulation of the overall complex log topographic map. In other words, each hypercolumn (of which there are roughly 1000 in each hemisphere) received an afferent projection in layer IVc of the form of a miniature complete topographic map of the small patch of visual space represented by that hypercolumn cortical patch. Also, in this work, it was pointed out the size, rotation, and projection invariance properties of the complex log map suggested a possible role for these geometric features of the visual system in visual computation, and that retinal cell density seemed to match cortical magnification [21]. This work did not reach the mainstream of the vision community, however, until 1978, when Donald Kelly

generously invited me to present it at a symposium at the Optical Society of America, and shortly afterward with publication of a summary of these ideas in the journal *Vision Research* [22].

At the present time, the complex logarithmic approximation to cortical topography has been accepted as a reasonable approximation [23–25]. In fact, no one has yet provided an alternative two-dimensional analytic model.*

In recent years, our lab has developed more general modes of V-1 topography in terms of conformal mapping and has demonstrated experimentally that a conformal model provides an excellent fit to global cortical topography. We have constructed accurate numerical "brain flattening" algorithms and have begun to place "error bars" on the data and the fits, an activity that is noticeably absent in the literature spanning the half-century from 1941 to 1992! Obviously, it is not possible to talk about a goodness of fit without an error estimate, and, in fact, the original observation of Daniel and Whitteridge (that "no simple mathematical function was found to fit the data") is not meaningful in the absence of some error estimate. We will return to this issue later.

At present it is much less clear whether the local spatial structure of visual cortex, on the scale of a single hypercolumn, is also characterized by the complex logarithmic mapping. This idea was motivated by the observation of Hubel and Weisel [17] that "sequence regularity" characterized the hypercolumn geometry. They stated that thin (50 $\mu$m $\times$ 400 $\mu$m) slabs of cortex contained neurons responsive to a single orientation of stimulus and that these slabs (orientation columns) were stacked along the cortex in a highly regular, parallel fashion.

Consider the following question: What analytic function has the property that it maps regularly rotating "slabs" in one domain to parallel "slabs" in another domain? Since the complex log function has this property, it does seem possible that the complex log mapping, which clearly characterizes the global architecture of visual cortex, may well characterize the local architecture as well. This was the basis for my suggestion that the cortex may be a "concatenated complex log mapping" [9], and the structure of the vortex street (from hydrodynamics) was used as the paradigm of a net of local logarithmic mappings [20]. Variants of this model were subsequently proposed by Dodson [27] and by Cavanagh [28], but it is safe to say that

---

*Van Essen has constructed a linear interpolation of data points to provide a two-dimensional map, but no function was presented to model the data. Johnston [26] has suggested that the projection of a tilted plane matches the cortical map, an idea that had been discussed [22] in a publication that also pointed out that this approach works only outside the foveal representation. This approximation is poor; it cannot simultaneously fit the central and parafoveal representations.

relatively few workers in the mainstream of vision were much interested in this idea.

Recently, however, the new techniques of optical recording from visual cortex have provided dramatic images of the orientation column structure in visual cortex [29,30]. These workers have begun to describe the hypercolumn pattern in terms of "vortex" or "pinwheel" structures. And, in our lab, we have recently provided what we believe to be a fundamental mathematical insight [31–33] into the nature of orientation maps, cortical vortices, and the hypercolumn map. Briefly, we have found that if one constructs an orientation map in a planar domain (as V-1 is believed to be in terms of orientation-tuned neurons), and if the map is to be continuous in both orientation and topography, the production of local logarithmic or vortex patterns is unavoidable. This follows directly from a basic topological theorem (nonretraction of $S^1 \to R^2$). There will be no further discussion of this subject here, except to point out that the geometrical properties of the complex log are almost certainly involved in the detailed local structure of V-1 hypercolumns, as is indicated by the current vogue of using the term "vortex" to represent the hypercolumn, as well as for somewhat deeper mathematical reasons that are discussed in detail in the papers cited above.

## 2.  M-Scaling

In the late 1970s, Drasdo [34] and Rovamo and Virsu [35] provided fits to the spatial structure of human magnification factor, using a mixture of human and monkey data, and retinal and cortical measurements. Virsu and Rovamo [36] introduced the term "M-scaling" to refer to the idea that the spatial variation of visual acuity might parallel the curve of their "cortical-retinal" magnification curves, as also had been suggested earlier [19,21].

One problem with this work was that a mixture of cortical and retinal data was used to estimate the "M-curve." This is problematic, since it is only an assumption, even at the present time, that a measure such as retinal ganglion cell density is related in any way to a measure of cortical magnification. These are, in principle, completed unrelated physiological data. One consequence of this approach is that the fits obtained for the monkey by Virsu and Rovamo had a flatter variation with eccentricity than is currently accepted (see Ref. 37 for review). This is because retinal ganglion cell density, and human acuity, are relatively flatter than modern estimates for (inverse) cortical magnification factor. By mixing retinal and cortical data, Virsu and Rovamo obtained good fits to functions such as human acuity, but at the cost of a kind of circular reasoning. The question of whether retinal ganglion cell density, cortical magnification factor, and human visual acuity are matching functions can be determined only by studying each phenomenon separately, and obtaining separate functional forms and error

bars. This has not yet been done! The approach of Drasdo and Virsu and Rovamo, which has been to estimate human cortical magnification factor by mixing retinal, cortical, and psychophysical data, and then to compare them by "eyeball" estimation, has led to a great deal of confusion in this area. This issue will be returned to later in this chapter, in a discussion of Wassle's recent contributions to the question of homology between retinal, cortical, and psychophysical measurements of spatial scaling.

### 3. Ocular Dominance and Cortical Topography

An approximate back-mapping of the cortical ocular dominance column pattern, at the level of the retina, was presented in 1976 [9]. Slightly later, Hubel and Freeman [38] presented a two-dimensional estimate of cortical topography, by an ad hoc method of symmetrically stretching radii of a semicircle by the estimate of cortical magnification factor at each point. They then used this to estimate the structure of the ocular dominance column pattern, when projected by their map function back to the retina. They did not provide an analytic or numeric fit to these data, other than a one-dimensional magnification function.

Both these approaches suffered from one major flaw: the ocular dominance column pattern was viewed as an "image," and this image was mapped via a cortical map function to the (two) retinas. But this is not correct, since in fact both retinas map, completely, to one cortical hemisphere. Each of the retinal maps must be "squeezed," or otherwise made to fit, into a single cortical hemisphere. But the methods used by Schwartz [9] and Hubel and Freeman [38] simply mapped the ocular dominance column *image*, at the cortex, into its retinal representation, via an estimated map function. The issue of "shearing" or "warping" the ocular dominance column local topography was not addressed.

The details of exactly how the ocular dominance column submaps fit together to form the observable cortical map in layer IVc of primate cortex is of crucial significance to understanding the fine details of cortical topography. A recently developed algorithmic approach to modeling such "polymaps" [16] is briefly discussed later in this chapter.

## D. Modern Period

Beginning in the early 1980s, a variety of new experimental techniques were applied to studying V-1 topography, which are briefly reviewed here.

### 1. Awake Behaving Monkey Studies

The laboratory of Bruce Dow provided several important measurements of V-1 topography, using awake monkeys that were trained to visually fixate a target. All earlier experiments had been performed with animals whose

eyes were fixed, either by sewing them to a metal ring or by the use of curare derivatives to paralyze the ocular muscles.

As a result of allowing the monkeys to use their own ocular motor system to provide a stable reference for the topographic measurements, Dow and his colleagues avoided one of the principal sources of error in these measurements, namely, the error in physiologically plotting the representation of the fovea on a tangent screen or computer monitor.

Usually, a reversible ophthalmoscope is used to first plot the fovea, and then, by mechanically reversing the instrument, to project the ophthalmoscope beam on the tangent screen. This procedure is difficult: parallax, mechanical error, and difficulty in judging the exact center of the fovea contribute to an error Van Essen et al. have estimated to be about $0.5°$ [23]. In our work, we have been able to statistically regress out this eye fixation error and have found that an error of $0.5°- 1.0°$ is in agreement with our experience. But, because of the huge cortical magnification factor, an error of this size is a reasonable fraction of the cortex! Since no other lab, prior to our recent experimental work, had attempted to statistically correct for this error, we can assume that eye fixation plotting error is a significant source of error in estimations of the intercept of a linear approximation of (inverse) cortical magnification factor with the horizontal axis (i.e., visual angle).

Dow's methodology is notable for eliminating several of the major sources of variance associated with the use of paralyzed animals. For one thing, Dow and his collaborators obtained data from the central fovea (down to 15 minutes of arc), which appears to be a unique achievement in this field: Hubel and Freeman reported data only peripheral to $4°$, Van Essen reported data peripheral to $2°$, and Daniel and Whitteridge's data stopped at $1°$. This is important because the linear regression that is used to determine the parameters of the magnification function is very sensitive to data near the origin. Also, Dow's method, using an awake monkey to control eye fixation, presumably reduced to a negligible amount the usual error of plotting the position of an immobilized eye.

Dow's measurements suggested that magnification factor was locally isotropic. The observation of locally isotropic magnification is mathematically equivalent to the fact that the cortical map is conformal, as shown below. Dow fit the data to a two-dimensional conformal map function using the complex log approximation and reported excellent results.

## 2.  2-Deoxyglucose: Human Studies with Positron Emission Transaxial Tomography (PETT)

Prior to the late 1970s, all measurements of cortical topography were obtained via electrophysiological techniques, using either field potentials (Talbot and Marshall), or single- and multiunit recording (Daniel and Whitter-

idge, Dow, Van Essen, Hubel). In 1980 my lab at New York University Medical Center applied the 2DG technique to the measurement of cortical magnification in humans [39,40].

2DG provides a metabolic label, since active neurons promptly take up glucose from the extracellular fluid. 2DG is a glucose analogue that is not fully metabolized. If labeled with some radioactive nucleide, then an autoradiographic (tissue sections) or tomographic (e.g., PETT scanning) image of the distribution of active neurons within a stimulus interval of perhaps 20 minutes can be obtained. Using $^{18}$F, which is a positron emitter with a half-life of about an hour, our group synthesized [$^{18}$F] DG and injected it into human volunteers who were simulated with a computer animation of a pattern of logarithmically spaced rings and rays. We performed PETT scans of the subjects after the stimulation interval and then used tomographic techniques to reconstruct thick sections of their brains at seven levels. Because the PETT scanner used then had a resolution of about 15 mm, we were able to observe only a rough quadrantic portion of human V-1. Therefore, the focus of this early experiment was simply to provide a reliable signature of the human topographic map, which was achieved by stimulating alternate subjects with different stimuli and checking whether the predicted stimulus signature matched the data obtained from tomographic reconstruction of the pattern of neural activity in the brains of the respective subjects. This experiment, although successful, did not provide an estimate of human magnification factor because of the coarse resolution of PETT scanning.

More recently, Fox et al. [41] applied a slightly higher resolution PETT scanner (18 mm) to the same type of experiment, though the resolution of this scanner is far too coarse to permit observation of the details of the folded human cortex. Even with the monkey cortex, which is far less convoluted than human striate cortex, lack of attention to cortical folding would preclude even an estimate of cortical magnification! These investigators did not attempt to correct for the pattern of folding of cortex, nor in fact did they verify that their observations were applied to V-1 (instead, perhaps of some overlap of V-1 and V-2!). Therefore, their PETT experiment does not provide a usable estimate of human cortical topography.

## 3. 2-Deoxyglucose Studies in Monkey

The use of 2DG to study cortical topography really required application to animal experiments, in which serial sections could be acquired and the 2DG image developed autoradiographically. Serial sections with a lateral 2DG resolution of perhaps $100 \, \mu$m provide a volumetric resolution ($100 \, \mu$m$^3$) that exceeds that of even the best PETT scanners ($7000 \, \mu$m$^3$), by a factor of more than 300,000!

Tootell et al. [1] were able to produce outstanding 2DG images using a ring-and-ray pattern similar to that used in earlier PETT experiments [39, 40]. When these data were presented for the first time at the Association for Research in Vision and Ophthalmology (ARVO), there was a spontaneous standing ovation! Unfortunately, these excellent 2DG data were never analyzed to Tootel et al. to produce a two-dimensional estimate of the monkey topographic map.

Since the 2DG method produces a two-dimensional image of a stimulus pattern, at the surface of the cortex, it would seem that a two-dimensional fit would be the analysis of choice. In fact, a two-dimensional fit of the data of Tootel et al. [11], using the complex log function [42], was found to provide a "good approximation" [24] to the 2DG data. The use of 2DG to study cortical topography was further pursued in animal work, starting in 1984, by my lab at NYU Medical Center (in collaboration with Tom Albright, Amar Munsif, and David Rosenbluth), and this work has been analyzed via fitting a two-dimensional conformal mapping to the data, resulting in an excellent approximation to the two-dimensional cortical topographic map. This work is described below, after a brief discussion of the technical details underlying the notion of conformal mapping.

## III. MATHEMATICAL MODELING OF V-1 SPATIAL ARCHITECTURE

Having briefly outlined the history of an area that has obviously received intense and continuous experimental activity over the past 50 years, we now turn to a detailed analysis of the mathematics of topographic mapping. First, the nature of one-dimensional fits to cortical magnification is outlined. Next, it is shown that the simplest two-dimensional correlate of a one-dimensional inverse linear magnification curve is provided by the complex logarithm function. The mathematical details of this function are explained, and some quantitative estimates of the nature of space-variant vision, both in biological and computer terms, are provided. In particular, the number of "degrees of freedom," or equivalent pixels, of the human visual field, is estimated. Then, a generalization of the complex log function, using a numerical conformal mapping model is reviewed. Finally, the notion of cortical mapping, in the presence of multiple columnar systems (polymaps as in Ref. 16), is reviewed.

### A. One-Dimensional Models

Virtually all psychophysical approaches to cortical magnification factor have been based on the use of a one-dimensional map function, of the form

$$M_{\text{cortex}}(\theta) = \frac{k}{\theta + a} \tag{3}$$

where $M_{\text{cortex}}(\theta)$ represents the cortical magnification factor (i.e., the differential change in cortical position with respect to retinal eccentricity $\theta$) and $k$ and $a$ are two constants that specify the fit.

It is important to realize that magnification factor is essentially a "derivative." It represents the ratio of small changes in cortical location to corresponding small changes in retinal location. The question then, naturally arises: What is it the derivative of? We should first note that since there are two possible directions at each location in the cortex, and two independent directions in the retina, it is not immediately clear how to specify the ratio of cortical difference to retinal difference as a scalar function. This represents a mathematical difficulty that has largely been ignored in physiological and psychophysical studies involving the retinotopic map. The simple use of a scalar magnification factor, which is nearly universal, can hold only under limiting circumstances, which amount to an assumption of local isotropy. Since a map that is locally istotropic is also, by definition, a conformal map, there are very significant consequences to the usual assumption of scalar magnification factor. On the other hand, the isotropic nature of the map is an experimental question, which is not automatically true! To clarify this issue, we will embark on a brief but necessary digression concerning the nature of the derivative of a map from a planar region to a planar region, following an earlier exposition of this subject [43], in this context.

## B. Two-Parameter Fit to the Cortical Map Function: The Complex Logarithm

In Schwartz [9,19,22] it was shown that if one represents the cortical map function in complex variables as

$$w = k \cdot \log(z + a) \tag{4}$$

then the magnitude of the derivative of this map function is

$$|w'| = \left| \frac{k}{z + a} \right| \tag{5}$$

Figure 1 shows the geometry of this mapping, and Figure 2 shows approximations using this function to V-1 topography in several different species.

A function of a complex variable is by definition analytic, or conformal, which is equivalent to the assumption of local isotropy. This is the only condition under which the usual scalar magnification function is sufficient to characterize the cortical map.

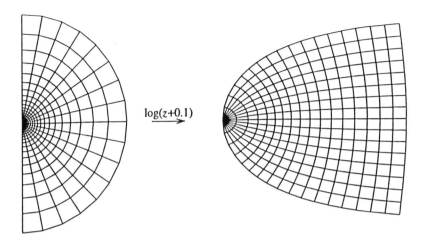

$\log(z+0.1)$

**Figure 1** The conformal mapping of the unit half-disk by log($z$ + $a$), shown here with $a$ = 0.1. The vertical meridian in the domain (half-circle as a model for the retina) is mapped to the curved boundary at left in the range (model of the cortex). In the central, or foveal, region the map is asymptotically linear, turning to a logarithmic geometry in the region $> a$. (From Ref. 71.)

The constants $k$ and $a$ may be determined by plotting inverse magnification factor against eccentricity, which is linear: intercept $= a/k$ and slope $= 1/k$. In this two-parameter fit, only the constant $a$ is of qualitative significance to the "shape," or the "foveal" extent of the map. The constant $k$ merely provides a normalization. However, if one is interested in the numerical value of magnification factor in units such as millimeters per degree, then both parameters are significant.

The physical interpretation of the two constants may be understood as follows. The constant $k$ is essentially a normalization factor, which for most purposes is uninteresting. The constant $a$ determines the extent of the linear regime of the cortical map, which we suggest should provide the definition of the term "fovea." Consider the asymptotic forms of the map function log($z$ + $a$):

$$\log(z + a) \simeq \log(a) + \frac{z}{a} \quad \text{for } z < a \tag{6}$$

$$\log(z + a) \simeq \log(z) \quad \text{for } z > a \tag{7}$$

For $z > a$ the map is essentially logarithmic, while for $z < a$, the map is essentially linear. Current estimates for the magnitude of $a$ are in the range of 0.3–0.8°, which corresponds roughly to the usual definition of the

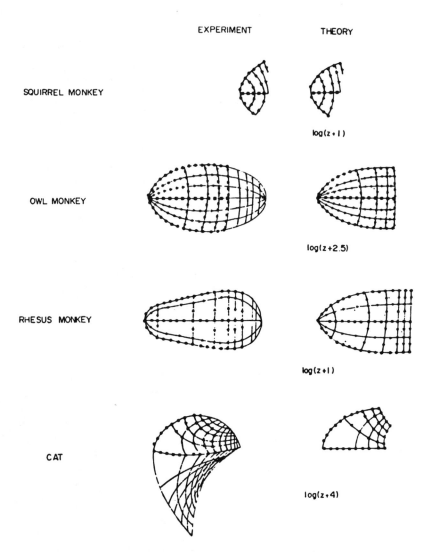

**Figure 2**  Comparison of the maps of Daniel and Whitteridge, Cowey (squirrel monkey) [112], Allman and Kass [113] (owl monkey), and Tusa et al. [114] (cat) with complex logarithmic approximations. The original experimental mappings are shown in the column labeled "experiment," and the complex logarithmic mappings in the column labeled "theory," where the constant $a$ has been chosen to give the best "visual" fit to the experimental data. (From Ref. 22.)

"fovea." It has been proposed [22] that this change in the behavior of the cortical representation, from linear to logarithmic, be used as a quantitative estimate of the size of the "fovea." In any case, the constant $a$ above is best understood in terms of the location of change in the geometric behavior of the cortical map.

In the psychophysical literature, another interpretation is in current use for these parameters. Cortical magnification factor is represented as [37]

$$M_{cortex}(\theta) = \frac{M_{cortex}(0)}{1 + E/E_2} \tag{8}$$

In this parameterization, $E_2$ is the eccentricity at which magnification has fallen by a factor of 2. The two descriptions are equivalent, since they are both linear functions.

Thus,

$$a = E_2 \tag{9}$$

$$k = M_{cortex}(0)E_2 \tag{10}$$

Here we use the $[k, a]$ parameter set, which explicitly makes the connection to cortical map geometry via the interpretation of $a$. The "halving" of cortical magnification factor in the interpretation of the $[M(0), E_2]$ parameter set suggests no physiological interpretation. However, the two descriptions are equivalent, since they model inverse cortical magnification factor as a linear, scalar function.

### 1. Geometry of Complex Log Function

Now, if one asserts that a scalar function is sufficient to model cortical magnification factor, one has implicitly assumed that the two-dimensional structure of the cortical map is given by a function of the form

$$w = k \cdot \log(z + a) \tag{11}$$

whose derivative (in absolute magnitude) is

$$|w'| = \left[\frac{k}{z + a}\right] \tag{12}$$

In fact, functions of the complex log type do provide a fairly good fit to all existing data. For example, as shown in Reference 22, the data of both Talbot and Marshall and Daniel and Whitteridge are approximately fit to a map function of the form $\log(z + a)$ with the constant $a \simeq 1°$, as shown in Figure 2. Dow et al. found that a function of this form provided a good fit to their data, using a constant $a \simeq 0.3°$. The data of Tootel et al. [11] are fit, to a "good approximation," by the same complex log function with $a \simeq 0.3°$. Van Essen et al. [23] reported an inverse linear magnification,

with constant $a \simeq 0.8°$, and Van Essen has stated that the complex log model is a good approximation, although there may be localized departures from isotropic mapping near the representation of the lower vertical meridian.

It appears that there is a rough consensus that primate visual cortex is, to a first approximation, a complex logarithmic structure characterized by a "foveal" constant $a \simeq 0.3$ to $a \simeq 0.9°$ [37].

The complex log mapping may be regarded as a warping of a conventional scene. This is illustrated in Figure 3.

## 2. Two-Parameter Mapping

One problem with the simple complex log fit is that it begins to fail around 15–20°, where the actual shape of the cortex requires that the boundaries of the map begin to close in to make a closed, vaguely elliptical surface (see below: Fig. 10 for the shape of the central 10° of cortex, and Figs. 6 and 9 for the shape of the entire cortex). Also, cortical magnification is somewhat sublinear beyond 20–40° of visual field. Both these problems can be simply addressed, however, by the use of a second logarithmic function, which requires one additional parameter, as suggested elsewhere [44]:

$$w = k \frac{\log(z + a)}{\log(z + b)} \; ; \; a \simeq 0.3°, \, b \simeq 50° \tag{13}$$

Thus, simple two- and three-parameter fits provide a good approximation to the topographic map structure in primate V-1. However, these fits, as well as the numerical conformal fit that is to be presented shortly, are based on the existence of "isotropy": the local cortical magnification must be a scalar (i.e., independent of local direction).

To fully understand the nature of "cortical magnification," we need to take a brief diversion into tensor calculus. It is necessary to take a close look at the nature of the "derivative" of a cortical map function [44]. Although this area is both obscure and elementary (in a mathematical sense), it is impossible to understand the details of topographic mapping without grasping the following argument, which has been largely ignored in both the psychophysical and physiological literatures.

## 3. Regular Mappings of Two-Dimensional Surfaces into Two-Dimensional Surfaces

For a regular map $F$: $\Re^2 \to \Re^2$; $F$: $(x,y) \to (f(x,y),g(x,y))$, the Jacobian is:

$$J = \begin{bmatrix} \partial f/\partial x & \partial f/\partial y \\ \partial g/\partial x & \partial g/\partial y \end{bmatrix} = \begin{bmatrix} f_x & f_y \\ g_x & g_y \end{bmatrix}$$

As mentioned in earlier work [43], it is instructive to rewrite the Jacobian in terms of its symmetric and antisymmetric parts:

**Figure 3**  Texture mapping of digitized image with complex logarithmic map. (From Ref. 71.)

$$2J = S + A = (J + J^T) + (J - J^T)$$
$$= \begin{bmatrix} 2f_x & f_y + g_x \\ f_y + g_x & 2g_y \end{bmatrix} + \begin{bmatrix} 0 & f_y - g_x \\ g_x - f_y & 0 \end{bmatrix}$$

It is further useful to rewrite the symmetric part as the sum of a diagonal and a traceless matrix:

$$S = \begin{bmatrix} 2f_x & f_y + g_x \\ f_y + g_x & 2g_y \end{bmatrix} = D + T = \begin{bmatrix} \text{tr} & 0 \\ 0 & \text{tr} \end{bmatrix} + \begin{bmatrix} 2f_x - \text{tr} & f_y + g_x \\ f_y + g_x & 2g_y - \text{tr} \end{bmatrix}$$

where tr represents the trace of the Jacobian (i.e. $\text{tr} = f_x + g_y$).

The traceless component of the Jacobian can be diagonalized by an orthogonal transformation $R$, since it is symmetric and positive definite, which we write explicitly:

$$RTR^{-1} = \begin{bmatrix} \lambda & 0 \\ 0 & -\lambda \end{bmatrix}$$

The differential structure of a regular mapping has been dissected into the sum of three geometric invariant components:

A rotation (the antisymmetric part $A$)
A dilation (the diagonal part $D$)
A shear (the traceless part $T$)

The shear component is a compression along one axis and an expansion of equal magnitude along another axis, of magnitude equal to $\lambda$. The directions of the principal axes are given by the rotation matrix $R$. In the case that the mapping has no shear, $T$ (the traceless, symmetric part of the Jacobian) is zero and the differential structure of the mapping is characterized by only two numbers: the rotation and the dilation. The dilation is the "magnification factor," and this is the single number that usually emerges from physiological or anatomical experimental work.

In the literature, the apparent compression of the cortical magnification factor (CMF) perpendicular to the axes of ocular dominance columns is sometimes expressed as a ratio of gain along the two axes. In the analysis above, if we consider only the symmetric portion

$$RSR^{-1} = RDR^{-1} + RTR^{-1} = D + RTR^{-1} = \begin{bmatrix} \text{tr} + \lambda & 0 \\ 0 & \text{tr} - \lambda \end{bmatrix}$$

and examine the ratio of the two nonzero terms, we obtain the "compression ratio" of the mapping.

Having provided the necessary analysis, we conclude by pointing out that the characterization of a neural map by microelectrode measurements

of "magnification" (i.e., by comparison of small changes in one neural layer with small changes in another) requires four such measurements at each point, to retrieve the Jacobian matrix. This has never been reported in any physiological experiment and would be technically difficult to accomplish. However, obtaining only a single magnification measurement at each point, as in conventional magnification experiments, is sufficient only if the mapping is conformal (i.e., if the "shear" component is zero). In the absence of a direct measurement of the Jacobian of the cortical map, our strategy has been to use numerical and analytic conformal maps to model the cortex. If these work, then the shear component is negligible and we don't, in fact, need to perform the very difficult experiment that would be required to provide the Jacobian. This strategy, which seems to be effective for primate V-1, will now be reviewed.

## 4.  Numerical Conformal Mapping

We have performed [45] a series of 2DG studies of primate retinotopic mapping, using computer reconstruction and computer brain flattening, together with numerical conformal mapping, to provide an isotropic map fit to primate topography in V-1. Before presenting some preliminary results of this work, we provide some background material on the properties of isotropic map functions and conformal mapping.

## C.  Application of Conformal Mapping to Cortical Topography

Conformal mappings may be defined in a number of equivalent ways, which emphasize different aspects of their geometric or analytic properties [46]:

Complex analytic functions $f(z) = (u(x,y), v(x,y))$, for

$$\frac{df}{dz} \neq 0$$

represent conformal mappings.

The real and imaginary parts of the map function satisfy the Cauchy-Riemann equations:

$$\frac{\partial u}{\partial x} = \frac{\partial v}{\partial y} \quad \text{and} \quad \frac{\partial v}{\partial x} = -\frac{\partial u}{\partial y}$$

A conformal mapping is locally isotropic. This means that an element of infinitesimal area is magnified equally in all directions. In the language of the preceding section, conformal mappings have no shear component. Infinitesimal angles are preserved by conformal mapping.

The real and imaginary parts of the map function are harmonic conjugate functions; that is, they satisfy the Laplace equation

$$\nabla^2 u(x,y) = \nabla^2 v(x,y) = 0$$

and their level curves intersect orthogonally.

This property provides important practical application to areas of potential theory (electrostatics, fluid mechanics, etc.) where the Laplace equation occurs.

The Riemann mapping theorem (see Appendix) guarantees the existence and uniqueness of conformal mappings between regions. It is of fundamental importance, since it states that given any two planar brain regions (e.g., retina and cortex), there is a unique conformal mapping between them which is specified by the "shape" of the regions, a single point correspondence, and angle specifying the relative orientation of the domain and range regions.

[Riemann]: Given a region, there exists a conformal mapping of this region onto the unit disk [46]. The mapping is made unique by fixing the mapping of a single point in the region onto the center of the unit disk, and fixing the orientation of the unit disk. (See Appendix for a further discussion of the Riemann mapping theorem.)

The use of this theorem in the present context consists in mapping two regions into the unit disk, which then implicitly provides the desired map function.

The Riemann theorem is perhaps surprising in that it does not seem intuitively possible that all the details of a two-dimensional map could be specified by a single point and orientation. However, this may be understood better by considering the one-dimensional analogy. If one species the boundary points of a curve (i.e., two points) and states that the curve must satisfy the equation

$$\frac{d^2 y}{dx^2} = 0$$

the curve must be a straight line (i.e., zero curvature), and we then know all the internal points only from the boundary conditions, which are simply the end points of the line. In two dimensions, the Laplace equation condition that is one of the possible defining characteristics of a conformal mapping, as summarized above, is a direct generalization of the specification of a straight line in one dimension. Conformal mappings thus are the generalizations to mappings of $R^2 \rightarrow R^2$ of the straight line as a mapping of $R^1 \rightarrow R^1$! This is why they are so widely used as a modeling tool in

engineering, physics, and mathematics. Conformal mappings are the simplest possible regular mapping in two dimensions.

## 1. Numerical Conformal Mapping of the Retina to the Cortex

Now we describe a method for constructing numerical conformal mappings from one finite region to another which is applicable when only the shapes of the two regions to be mapped (and a point and orientation correspondence) are known. This is the condition of most interest in the current physiological context.

In this approach, one of the regions of interest is triangulated (e.g., using a Voronoi method [47]). The second region may then be triangulated by mapping the nodes of the initial triangulation to the second region, then using the initial connectivity matrix* to triangulate the second region. It is important to point out, however, that this joint triangulation is potentially problematic. There is no guarantee that the connectivity matrix of a triangulation will describe a triangulation when its nodes have been mapped to a new region: some of its edges might then intersect, violating the definition of triangulation. For a given mesh, a joint triangulation can always be generated by adding pairs of points to the original point mapping, as proven by Saalfeld [48]. Saalfeld gives a constructive existence proof that the joint triangulation can be generated, but this method requires exponential refinements (subdivisions) of its triangles. In our experience, no special means of generating valid triangle maps has been necessary, since any reasonably well-chosen mesh size leads to a valid triangle map.

We begin with the case of mapping an arbitrary region to the unit disk and then discuss mapping between two arbitrarily shaped regions.

## 2. Mapping an Arbitrary Region to the Unit Disk

Henrici has surveyed existing numerical conformal mapping algorithms [49]. For arbitrary shaped regions (which are approximated by polygonal boundaries with large numbers of vertices), Symm's algorithm (Appendix) is preferable.†

The Symm algorithm is initialized with a description of the boundary of the region to be mapped and the point in this region that is the preimage of the center of the unit disk; it returns the mapping of the boundary and interior region to the unit disk.

To create a mapping from one region to another, we start by generating

---

*The connectivity matrix can be defined as a binary-valued Cartesian product on the set of points in the region. If two points are connected by an edge, the matrix entry is 1, otherwise 0. In this way the topology of the triangulation map is specified.

†We thank Nick Trefethen for helpful discussion on this point.

the mapping from each region onto the unit disk, either analytically or using the Symm algorithm. We then triangulate the range set from the second region mapping. Optimized point location [50] is used for each point in the range set of the first region mapping to determine which triangle from the range set of the second mapping contains that point. The affine mapping determined by this triangle and its counterpart in the domain of the second region mapping is used to map the included point from the first region range set to the second region. A cleaner solution would make use of a general method capable of mapping the unit disk to an arbitrary region, thus avoiding the numerical inversion of the Symm mapping. Some ideas on how this might be done are outlined by Saalfeld [49].

## IV. APPLICATION TO VISUAL CORTEX: COMPUTER SIMULATION VIA TEXTURE MAPPING

In the case of visual cortex, there is considerable experimental evidence that the mapping of the retina to the surface of primary visual cortex is approximately isotropic. Thus, to model the representation of a visual image on the surface of the cortex, we need to construct a conformal approximation to this map and to perform a conformal texture map of given visual field images. To illustrate this process, we show a numerical flattening we performed recently of the surface of primary visual cortex of the monkey.

In this work, we were able to identify a single point (the representation of the blind spot, or optic disk) in the eye and an orientation (the orientation of the horizontal meridian). These observations, together with the flattened representation (and its boundary), were sufficient to generate the cortical map function [51].

The agreement of this method of determining the cortical map, and direct microelectrode measurements of the cortical map function, is excellent. Figure 4 shows a natural scene, mapped via this conformal approximation. The details of its construction are outlined in the Appendix.

### A. Numerical Conformal Mapping of 2DG Computer-Flattened Cortex

During the long history of attempts at measurement and modeling of the primate V-1 topographic map, there has never been, to my knowledge, an attempt to assess the "error" in a particular functional fit.

In fact, there has been a very wide range in the reported values of the constant $a$ in the linear magnification fit: Dow has reported the smallest value (about $0.3°$), while Virsu and Rovamo and Tootel have reported

(a)

**Figure 4**  Texture mapping of high resolution scene representing nearly full range of human range (3 minutes of arc maximum resolution to 100° of field). In (b) and (d) is shown the "wire frame" that triangulated the retinal and cortical regions. A numerical conformal mapping estimated from an ocular dominance column reconstruction, as described in the text, was used to map the nodes of the "wire frame" model; then the interior of each triangular patch was texture mapped from retina to cortex, using a local bilinear approximation, resulting in the mapping shown at the bottom of the figure. In (c) is a lab scene that was digitized to an effective resolution of 16,000 × 16,000. In (a) is the cortical model of the data, which extended over more than 100° of visual field and resolved about 3 arc minutes in the center. The retinal view (c) contained a Snellen chart, which is not visible in this low resolution reconstruction but was resolvable in the digital image. The Snellen chart image in the cortex, seen in (a), occupies nearly one-third of the entire cortical surface. This simulation is unique in that it represents a simultaneous wide-angle and high resolution image model of the cortex. This necessitated the use of an extremely high resolution input frame (effectively 16,000 × 16,000). (From Ref. 14.)

values in the range of 1.5°–2°, and Hubel and Freeman [38] report 4°! Is this range of variance due to normal differences between animals or to error in experimental procedure? And, more to the point, how is it possible to compare different measures, such as retinal ganglion cell density, visual acuity, or stereo fusion area, with cortical magnification factor, when one or both of the derived curves has no error analysis supplied?

To provide a high precision estimate of the two-dimensional cortical

(b)

**Figure 4** (*Continued*)

map function, we set out several years ago to provide the following data and computational procedures.

## 1. Computer Flattening

To mathematically model the cortex, it is convenient to work in a planar model. Numerical methods for conformal mapping have been published for planar domains only. Differential geometry is best avoided in numerical problems, and the cortex is relatively flat. (We have measured the mean and Gaussian curvature of primate V-1 and find that curvature of cortex does not preclude an accurate flattening [12,13].) We have found that it is possible to flatten cortex with a mean local error of roughly 5% [14,52–54] and have applied this method to the reconstruction of primate ocular dominance columns and to primate topography in V-1. Figure 5 shows the wire frame model of a flattened cortex, reconstructed from serial sections. This experiment was from a macaque that had one eye enucleated and whose brain was subsequently stained for cytochrome oxidase, revealing the structure of the ocular dominance column pattern, which was computer mapped from digitized images of the serial sections into the flattened cortical representation [14]. Note the representation of the blind spot in Figure 6. The blind spot (optic disk) in macaques is located at about 17° of eccentricity on the horizontal meridian, as shown in Figure 6. We will return to the significance of this particular type of data shortly.

(c)

**Figure 4**    *(Continued)*

## 2.  Numerical Map Fitting

As outlined above, we have developed several fitting methods using complex logarithmic functions, and also a more general numerical conformal mapping method. We have also outlined the conditions under which local shear in the map function might be modeled, although we have not performed any numerical analysis of sheared mappings. Using the numerical conformal mapping procedure outlined above, and described in detail recently [55], we have modeled the details of a 2DG experiment which is now described.

**(d)**

**Figure 4** (*Continued*)

## 3.  2DG Measurements of V-1 Topography

2-Deoxyglucose is a metabolic marker. When radioactively labeled, it can be injected, and then, following some paradigm for stimulation, the brain can be imaged to detect the relative pulse density of neurons, in terms of their metabolic activity, following the stimulation.

2DG has been used in humans, using PETT scanning to reconstruct the pattern of firing [39,40]. The stimulus pattern in this case was a logarithmically structured stimulus, similar to that shown in Figure 7.

A similar use of this technique was provided by Tootell et al. [11], who used monkeys and physical brain flattening (i.e., pressing the opercular part of monkey visual cortex between glass slides). In this and subsequent accounts of this research, these workers modeled their data with a simple, one-dimensional magnification curve. Initially they claimed contradictions

**Figure 5**  Wire frame showing flattened polyhedral model of cortex, digitized from serial sections, and numerically flattened with our algorithm [53,54]. (From Ref. 53.)

with the complex logarithmic model and their data. However, a simple complex log fit to their data was subsequently published [42], followed by agreement that the complex log provided a "good" fit to their data [24]. Figure 8 shows the data, with a complex log model superimposed. This log map had an $a$ of 0.3°, in agreement with the data of Dow et al. It appears to provide a good fit to the data of Tootel et al., except for a region near the intersection of the inferior occipital sulcus and the calcarine cortex, where the 2DG images seem to be significantly sheared. This coincides with a region in which Van Essen [23] reported observing anisotropies (shear) in V-1 topography and also coincides with some of our recent 2DG computer-flattened models, as shown in Figure 9.

We are in the final stages of analyzing a series of 2DG experiments, using computer flattening and conformal mapping. The result from one experiment is shown in Figure 9. In this experiment, monkeys were shown stimuli like that of Figure 7, following paralysis, eye position plotting, and injection with $^{14}$C-labeled 2DG. Following about 40 minutes of stimulation, the monkeys were sacrificed, their brains were removed, and one hemisphere was physically flattened while the other hemisphere was blocked for subsequent coronal section on a cryostat. The autoradiography of the physically flattened hemisphere is shown in Figure 10. The computer-

**Figure 6**  Using a flattened cortical model of the type shown in Figure 5, the density of cytochrome oxidase was texture mapped from the original serial sections (obtained from a one-eye-enucleated monkey). This shows the ocular dominance column pattern. Note the representation of the optic disk, which is the dark region along the horizontal meridian. The data were hand-traced after computer plotting to provide a "black–white" representation.

flattened, reconstructed other hemisphere is shown in Figure 9. Both these figures correspond to the stimulus shown in Figure 7.

Using a single intersection of the ring-and-ray pattern as one of the constraining data needed to apply the Riemann mapping theorem to construct a conformal model of the data, as outlined above and elsewhere [55], the conformal map of the stimulus of Figure 7 was produced (Fig. 11). The superposition of this conformal model and the computer-reconstructed autoradiographic data are shown in Figure 12. It is clear that the agreement between the conformal model and the data is excellent. However there appears to be evidence of some shear in the lower corner of the map data, which is at the intersection of the inferior occipital sulcus and the lip of the calcarine sulcus. This is the same phenomenon seen in the data of Tootel et al. shown above (Fig. 8) and has also been described by Van Essen [23]. It is remarkable, however, that this feature, which appears to be common in macaques, is quite localized to the lip of the lower calcarine sulcus. This feature, which we call the calcarine anomaly, represents a localized departure from the otherwise excellent fit of an isotropic (conformal) map to V-1 topography.

**Figure 7**   Example of the 2DG visual stimulus used in the 2DG experiment discussed in the text.

**Figure 8**   The 2DG data of Reference 11, overlaid with a complex log mapping of constant $a = 0.3$, from Reference 42.

**Figure 9**   Computer-flattened macaque V-1, left hemisphere of monkey DG-14, texture mapped with 2DG pixel data following stimulation of monkey with the stimulus of Figure 7. The image of the boxes and rings and rays of the stimulus is visible in the data.

In this study, we performed a regression to find the best fit conformal map to our data. In the regression, we allowed both eye position and cyclotorsion to be the free variables, and the error function for the fit was the summed square difference of data landmarks (e.g., intersections of rings and rays) with corresponding conformal map landmarks. We used a nonparametric regression procedure (Nelder Simplex Method [56]) and were able to determine the best fit to the eye position and cyclotorsion of the paralyzed monkeys. It appears that this procedure has provided an excellent fit (Fig. 12). There is a significant error associated with plotting the retinal landmarks of paralyzed monkeys. Van Essen [23] estimate this error to be about 0.5° typically. In the data shown in Figure 9, we found a one-degree error, and we also obtained an estimate of 11° for cyclotorsion from the regression. This is in good agreement with the cyclotorsion of paralyzed monkeys and with our measured value for cyclotorsion in this particular case. We therefore feel that our regression procedure has allowed us to null out the significant error due to imprecise retinal plotting in these procedures.

In the near future, we plan to publish analyses for several monkeys and to provide an estimate of "error" for the whole procedure. At the present

**Figure 10**    Computer-flattened image as in Figure 9, showing the operculum of V-1, rather than the whole extent of V-1. This is the right hemisphere of monkey DG-14, prepared by physical flattening, rather than computer flattening. Note the eye-offset that is apparent in this figure: the central point with six rays emanating from it is apparently about one degree away from the nominal location of the fovea, which is at the intersection of the lunate and inferior occipital sulci (the "pointy" end of the operculum). This eye-offset error is in the expected range, as a result of error in plotting the center of the fovea. Note the large "cortical" effect of this relatively small retinal error. We have regressed out this eye position error, and the regression reports an error of about one degree. Independently, the regression reported a cyclotorsion of the eye of about 11°, which is consistent with the cyclotorsion measured during the experiment. Thus, we believe that we have been able, by studying left and right hemispheres from the same monkey, to "null" out the significant error introduced in the map estimate by errors in retinal landmark plotting.

time, we have hand-sketched "error bars" in Figure 12, to represent the distance between the computer-predicted feature and the actual measured feature in the map (features are corners of "boxes," intersections of rings and rays). It is evident that the average error is considerably less than 1

**Figure 11**   Numerical conformal mapping, prepared by choosing a single point correspondence in the data of Figure 9 to construct a numerical conformal mapping. Only the opercular extent of the mapping is shown.

**Figure 12**   Overlay of the computer-flattened 2DG data of Figure 9 and the numerical conformal mapping of Figure 11. "Error" bars have been sketched in to show a preliminary estimate of the reliability of the map function (the data have not been fully analyzed).

mm, over perhaps 10–15 mm of cortex. Since the error of brain flattening is roughly 5%, we feel that this error is about as small as is possible to achieve under these conditions.

In summary, the average error in this fit is considerably less than 10%, although there is an error of 4–5 mm (perhaps 30%) localized in the lower left corner of the operculum in Figure 12, in the region of the calcarine anomaly. Put another way, if we have a technique that reliably indicates the visual field coordinates of a single point in the cortex, then (if we have access to the anatomical "shape" of the cortical boundary), we can reproduce the entire cortical map to within an accuracy of roughly 1 mm. This somewhat counterintuitive result illustrates the power of these techniques.

What is the cause of the calcarine anomaly? We have not found any correlation to excessive Gaussian curvature of cortex in that region, although the intersection of the lip of the calcarine and the inferior occipital cortex is one of the most severely folded parts of the macaque visual cortex. Perhaps a shear may be introduced in the developmental events leading to the creation of the sulcal pattern of the cortex. Perhaps the cause lies in an idea suggested by Tootel et al. [11]: that in this region the compression of the ocular dominance column pattern is less than 2 : 1. It is difficult to say, although the location of this anomaly in the region of major sulcus folding, and its topographic location in the vicinity of about 8° on the upper vertical meridian, make it unlikely that the anomaly is driven by any functional considerations.

In summary, we offer these preliminary data as an estimate of the reliability of conformal approximations of cortical topography in V-1. We believe that this is the first time a regression or error analysis has been performed on the two-dimensional structure of V-1 topography.

## 4.   Application to Reconstruction of Human V-1 Topography

One major application of the use of numerical conformal mapping has been validated by the monkey data shown in Figure 12: namely, it provides an entirely new method for estimating topographic map structure in primates, as pointed out by Weinshall and Schwartz [51]. To reconstruct a conformal approximation to a topographic mapping, access to the following data will suffice:

1.   A single point correspondence
2.   The relative orientation of the two domains
3.   A flattened representation of the boundary of the cortex

This follows directly from the Riemann mapping theorem and is shown by construction in Figure 12, since the computer model in that figure was

constructed from a single point (ring-and-ray intersection) and the flattened cortical representation. Note that the alternative to this procedure is to perform an exhaustive (physically and figuratively!) point-by-point physiological mapping of differential magnification factor measurements. Difficult and error prone as this approach is in monkey research, it is impossible (for legal and ethical reasons) in human research. However, anatomical data on the V-1 boundary are readily available in both monkey and human data. (Magnetic resonance images are now capable of noninvasively providing submillimeter resolution of tissue density, which is sufficient to model the boundaries of human cortex, and to flatten human cortex using our flattening software, to excellent precision.)

Now, in the human, physiological mapping methods have been applied in only a few, very limited experiments. PETT scanning, even with current resolutions in the range of 5–7 mm, is much too coarse to provide a reliable estimate of the human map. But, human ocular dominance columns from postmortem examination of one-eyed patients have been reconstructed [57] using the same cytochrome oxidase stain used in the monkey experiment summarized in Figure 6.

To demonstrate the feasibility of this method, we used the columnar pattern, as shown in Figure 6, to measure the position of the optic disk, which is clearly evident in the figure. This provides us with a landmark at 17° on the horizontal meridian. We then constructed the unique conformal mapping that corresponds to this constraining data point. The result is shown in Figure 13.

By numerical differentiation, we have found that the magnification function obtained from this map is essentially indistinguishable from microelectrode estimates of V-1 cortical magnification [51]. Therefore, this approach provides a novel route to estimating cortical magnification factor, and one that is applicable to humans. Thus, by either reconstructing the ocular dominance column postmortem in one-eyed humans, or, perhaps, by using echo-planar magnetic resonance imaging (MRI) techniques to find a single visual landmark, followed by computer flattening of the MRI-measured sections of human cortex, we would be able to reconstruct a highly reliable estimate of human V-1 topography. Moreover, if this were done in an MRI paradigm, we would have the added benefit of a living subject, thus allowing psychophysical study of the individual whose anatomy has been characterized. An experiment of this kind is currently being planned. The basic calibration of the method, together with the necessary algorithms, has been provided in the context of the monkey work outlined above. If successful, it may be possible to provide the first reliable estimate of human V-1 topography. At the present time, we see no other viable route to this extremely important data.

**Figure 13** Numerical conformal map, made from a computer-flattened ocular dominance column preparation (Fig. 6), using the known location of the optic disk to constrain the complete conformal map.

## B. Corrections to the Archival Literature on Cortical Topography

At this point, we have reviewed the history of topographic mapping in primate V-1 and have shown a complete analysis of the mathematical structure of a simple regular mapping of a two-dimensional surface, such as the retina, into another two-dimensional surface, such as the cortex. Three different isotropic models have been outlined. All work well, with the numerical conformal mapping just shown providing the best performance. With the possible exception of a localized region near the calcarine–infero-occipital intersection, the primate V-1 map appears to be well characterized as an isotropic mapping. Before proceeding to analyze the consequences of the existence of higher dimensional mapping in V-1, particularly ocular dominance column structure, we briefly summarize some of the insights gained so far, in the form of a series of brief statements (lemmas). Then, each lemma will be used to clear up misstatements and misconceptions that have accumulated over the years in this field.

### 1. Some Lemmas on Isotropic (conformal) Maps

**Lemma 1 (Inverse linear magnification factor)** *The use of an inverse linear magnification factor scalar function to summarize a mapping is valid if and only if the mapping is locally isotropic. Otherwise, the magnification is summarized by the Jacobian of the map, a two-dimensional tensor function that geometrically represents an infinitesimal rotation, dilation, shear, and direction of shear. No direct measurement of the cortical magnification tensor has yet been performed, although the evidence in this chapter suggests that except for the region of the calcarine anomaly, cortical magnification is in fact a scalar quantity.*

**Lemma 2 (Complex log)** *There is only one two-dimensional conformal map function that corresponds to a magnification factor that is of the inverse linear form: the complex logarithm.*

**Lemma 3 (Global symmetry)** *The complex log mapping does not have the same magnification function on the vertical, horizontal, or other meridians. In fact, the assumption of global symmetry is generally inconsistent with local isotropy.*

**Lemma 4 (Conformal mapping)** *If the magnification factor is locally isotropic but not of the inverse linear form, a conformal mapping more general than the complex logarithm must be constructed. Such a map function may have a relatively complicated one-dimensional functional form and certainly does not have to be globally symmetric (i.e. the same on the vertical, horizontal, or other meridians). Moreover, such a map function is uniquely determined by the specification of a one-point correspondence between retina and cortex, the slope at this point, and the boundary of the retinal and cortical surfaces.*

Now, using these four lemmas, we can correct some misstatements.

### 2. Daniel and Whitteridge

As noted above, Daniel and Whitteridge claim that the cortical map is both locally isotropic and globally symmetric. That this cannot be true (unless the cortical map is the identity) follows directly from the Riemann mapping theorem. If the map is locally isotropic, then it is conformal (by definition). Therefore, the map is uniquely determined by a single point. Stating global symmetry provides in effect an infinite set of point correspondences, which can be true only if the map is a trivial identity.

### 3. Sakitt

Barbara Sakitt [58] published a paper titled "Why cortical magnification factor cannot be isotropic." But, this title is a contradiction of the Riemann mapping theorem: there are an infinite number of isotropic maps which can be constructed between two arbitrary, simply connected regions. In fact, Sakitt followed a construction similar to that of Hubel and Freeman,

of symmetrically stretching the cortical map along lines. This approach does not generate a conformal map.

## 4. Tootell

Tootell et al. [11], stated that since the vertical meridian is about 30% longer than the horizontal meridian in 2DG maps of V-1, the complex log mapping is not a good fit to cortical topography. Moreover, these authors suggested that this effect was rooted in the ocular dominance column pattern of V-1, since they do not believe that the left and right eye ocular dominance columns were "squeezed" by exactly a 2:1 shear to fit together, as measured by Le Vay et al. [59]; rather, they cite an apparent 30% shear to account for the lengthening of the vertical meridian.

This idea seems to be rooted in the same confusion of local and global isotropy outlined above. Global isotropy is not implied by the usual usage of the term "isotropic" map, and in fact, local and global isotropy are, in general, mutually inconsistent! Moreover, the 30% effect seen by Tootel et al. is in fact precisely that *predicted* by the complex log model, a point made in a subsequent paper addressed to these authors [42]. Tootell et al. [24] appear to have acknowledged this argument, in the form of an agreement that the complex log is a "good approximation" to V-1 topography. One consequence of this observation is that there is in effect little "residual" anisotropy caused by the ocular dominance column system. In other words, if the "net" cortical mapping is in fact isotropic, and we have shown data here to make that statement highly likely, then it appears that for everything to fit, the ocular dominance column system must be "squeezed" by close to a 2 : 1 factor.

In a more recent paper, the same authors [60] have escalated their position considerably, since they now claim that the cortical map is anisotropic (locally) by 100%. Their argument is that the ocular dominance columns are not "squeezed" at all and that the fitting together of two complete maps in V-1 causes a 100% shear! No two-dimensional map is presented to model this suggestion, nor is a great amount of data presented to support it. Moreover, the conceptual and computational issues of fitting together in a single cortical mapping multiple submodalities (such as ocular dominance and orientation columns) have only recently been addressed [16]. We now briefly review this aspect of cortical topography.

## C.  Higher Dimensional Models

### 1.  Columnar Structure and Topography

The entire preceding discussion was predicated on the notion that visual cortex represents a "regular" mapping of the visual field—that is, a well-behaved, continuous map whose Jacobian is nonzero and finite. In fact, the situation is considerably more complex. In the input layers of V-1 (layer

IV), there are two complete maps, one for each eye, interlaced in the form of thin strips, or columns. We have shown a computer-flattened texture mapping of this ocular dominance column pattern from our lab (Fig. 6).

In addition, there are at least two more independent columnar systems in V-1: one for orientation and the so-called cytochrome oxidase puffs, which tend to occupy the singular regions where all orientations in cortex come together.

Recently, we developed computational methods to represent the cortex, including arbitrary columnar substructure [16]. This algorithm is reviewed here, along with some computer simulations of recent binocular 2DG data, which are well modeled by this approach.

## 2. Protocolumns and Protomaps

The details of the protocolumn algorithm are quite complex and depend on the manipulation of several data structures from computational geometry. But the general idea of it is simple: we imagine that the submodalities of the cortex (e.g., left eye input, or orientation input at some specific angle), constitute a complete map of retinal space. We call these maps "proto-maps"; that is, they are the "regular" map before it has been "cut" into columns, which are then "squeezed" and packed together to make up the real, observable cortex. For ocularity, there are two protomaps: a left and a right eye protomap. For orientation, there are as many protomaps as distinct orientation values to be modeled. Thus, if we discretize orientation in terms of angular bins of 15° each, we would need to construct 12 proto-maps for the orientation system.

The advantage of this conceptualization is that the protomaps are "regu-lar" maps, which can be described by conventional continuum approaches, as we have outlined above.

To proceed with the algorithm, we then define "protocolumns." The protocolumns are constructed from the observed individual columns in the brain, by a warping transformation that expands the observed columns until they smoothly fill the cortex. This is sometimes called a "grow" opera-tion in computer graphics; we have used a Voronoi diagram method to actually compute the protocolumn pattern. Thus, the protocolumn pattern represents a form of "proximity' diagram. For a given "real" column, its unique protocolumn is the locus of points nearest to that real column. Thus, for a typical single ocular dominance column in cortex, its protocolumn is a somewhat "fatter" version of itself, whose detailed shape is a function of that column and its near neighbors (see Fig. 14). This construction is de-signed so that the complete set of protocolumns perfectly tessellates the cortex. We then are able to image-warp from a protocolumn to its actual column and thereby construct a two-dimensional simulation of the topogra-phy and columnar structure of V-1.

**Figure 14** Example of the protocolumn construction described in the text. Top: some of the steps of the algorithm that finds Voronoi polygons from the experimental column data. Bottom: the thresholded image of the ocular dominance column (left) and the corresponding protocolumn pattern (right). Each protocolumn is shaded with a different shade of gray, to help in visualization. Note that the protocolumns surround their corresponding columns, are about twice the thickness, and form a smooth, jigsaw-like tessellation of the cortex, which property follows from the definition of the Voronoi polygon construction used to create this protomap. (From Ref. 16.)

One consequence of this construction is that for "zebra skin"-like patterns, such as the V-1 ocular dominance column system, there is a roughly 2 : 1 compression between a column and its protocolumn. This agrees with an early estimate of the experimental "shear" within a cortical ocular dominance column [59] but is in significant disagreement with the recent estimate [60] that there is a 1 : 1 compression within a column, resulting in a 2 : 1 compression in the overall cortical map.

Figure 14 shows an example of the computation of a single protocolumn from its observed ocular dominance columns as well as the entire protomap of the left eye. Figure 15 compares a simulation of the protocolumn algorithm and a recent binocular 2DG experiment [61]. The agreement is good, but it should be stressed that there are few quantitative data available to constrain this fit.

Tootell et al. [61] in fact favor a model in which the protomap, to use our term, is actually isotropic and the "real" cortex is 100% anisotropic, and the local shear within an ocular dominance column is therefore something like 1 : 1. We favor a different model, in which the protomap is isotropic, the "real cortex" is isotropic, and there is a shear of 2 : 1 within an individual ocular dominance column.

We favor this type of model because, for one reason, it is very difficult to believe that there could be, in general, as good as fit as we have shown

**Figure 15**   Using the protocolumn algorithm and numerical conformal mapping, a binocular 2DG experiment [60] is simulated and compared to the data. On the left is a computer simulation, using the protocolumn algorithm to model the columnar structure and a conformal mapping to model the topographic structure of a line that was imaged on the left and right retinas of a monkey, whose cortex was then physically flattened and autoradiographically "developed." (Experimental data from Ref. 61.) There is a close resemblance between the protocolumn simulation on the left, and the experimental data on the right. Note the "rippling" of the cortical image, due to the ocular dominance column pattern. This is apparently because the images of the line are more than a single column pair apart on the cortex: that is, the cortical binocular disparity was greater than the size of a single hypercolumn. (From Ref. 16.)

in Figure 12 to a highly anisotropic cortex. Tootel et al. in fact have not provided any two-dimensional modeling to support, or to clarify, their conjecture.

And, to avoid confusing the reader at this point with notions of columnar shear, we point out that virtually all methods of measuring cortical magnification factor operate on a scale larger than the size of individual cortical columns, so that the small-scale columnar structure is essentially averaged out. However, if there were anything much different from a 2 : 1 shear within individual columns, this effect would summate coherently over many columns* across the cortex and would be accompanied by a large macroscopic effect. We see no evidence of this, with the exception of the calcarine anomaly, and therefore assert that the most likely state of the local cortical shear is roughly 2 : 1, with the direction parallel to the column boundaries having a magnification factor twice that in the direction perpendicular to the local column boundary.

To conclude this section, Figure 16 shows a computer simulation, using a numerical conformal mapping and our protocolumn algorithm [16] to simulate a binocular spatial mapping, at the level of layer IVc of V-1; the natural scene has been digitized to span the range from 0 to 100°, with a maximum resolution corresponding to about 3 minutes of arc.

## V. PSYCHOPHYSICAL–ANATOMICAL HOMOLOGY

A major theme of the literature on human retinocortical topography has always been the possible existence of scaling laws between psychophysical measurements and retinal and cortical anatomical measurements. Daniel and Whitteridge were likely the first to make this point, summarized earlier in this chapter, that the human minimum angle of resolution is similar in functional form to inverse cortical magnification. In later work, Schwartz [21] suggested that retinal ganglion cell density and cortical topography might be related by a particularly simple developmental rule: the retina (actually LGN) fiber input spreads across the cortex in the manner of an isotropic fluid. Fixing a single point then would be sufficient to provide a unique map.

During the 1980s many papers sought to link acuity, stereo acuity, vernier acuity, motion thresholds, and retinal receptor and retinal ganglion cell densities to cortical magnification factor. There are two major problems with this literature, however.

---

*Ocular dominance columns appear to be coherent, in the sense of running roughly parallel, over regions of the cortex that vary between several millimeters and perhaps 1 cm.

**Figure 16**    The joint application of full-scale topographic modeling of the retino-striate system (Fig. 4) with the protocolumn algorithm, illustrating the concept of "polymap," as described in the text. Top left: pair of (low) resolution 100° scenes of a hallway (a,d). Top middle: the corresponding left and right eye topographic mappings; a disparity of 5 arc minutes has been introduced (simple lateral shift of one image, relative to the other, by 5 arc minutes) (b,e). Top right: the left and right eye protomaps, with the image data from the center mapped into the ocular dominance column pattern (c,f). Bottom: the left and right eye images are ORed together to form a single image, which represents a simulation of a binocular stimulus, on the surface of the cortex, when a small binocular disparity is present (g). Note that a disparity of 5 minutes of arc is within the range of Panum's area and is perceptually significant. The effect of the disparity on the cortical image is to produce a "ripple" whose magnitude is proportional to disparity and whose "carrier" frequency is determined by the ocular dominance column spacing (see the "O" of the Snellen chart). Further into the periphery, the small disparity begins to have a negligible effect on the binocular "cortical image."

1.   There has usually been no error analysis performed on any of the data. This is particularly problematic given the wide spread in the measurement of all the quantities involved. For example, different workers have found values of the constant $a$, which characterizes the cortical map, between 0.3 and 4°. This is a variation of more than 1000%. A recent PETT experiment [41] claims that human $a$ is 6°! And none of these experiments provides an estimate of error.

2.   Human cortical magnification has never been reliably measured. Existing estimates of $a$, which tend to be in the range of 1.7–6° are based on extremely poor quality data and are many hundreds of percent higher than that found in monkey. The only reliable monkey measurements have been made with exhaustive microelectrode plotting and with 2DG analysis of serial sections. These techniques are not possible in human subjects. In fact, there are no techniques possible in human subjects, since careful microelectrode exploration is both illegal and unethical. Therefore human magnification factor is currently known by guesswork, not by measurement. This weakness greatly compromises the comparisons of human psychophysics to a largely unknown human magnification factor, or of monkey magnification factor to largely unknown monkey psychophysical data!

A recent review [37] attempts to rationalize this situation by suggesting that there are really two $a$ parameters, a retinal one in the range of 1.5–4.0° and a cortical one in the range of 0.3–0.8°. Table 1 summarizes psychophysical measurements and shows their relative $a$ values (called $E_2$ here) in slightly modified form.

The attempt to cluster the data is important, but it seems that the measurements in this field are simply spread over an extremely large range. For example, Wilson et al. [37] cite the data of Tootell et al. [11] as providing support for a value of 0.8° for $a$. But recently, it appears that the same data were presented with an analysis of 1.5° for $a$ by the same research group [60], which would move this measurement from one group of Wilson et al. to the other. And, recently, Wassle et al. [62] have provided evidence that the classical fits of retinal ganglion cell density have been contaminated by a background of displaced amacrine cells that have tilted the linear regression curves toward values of $a$ that are considerably too high. The new reanalyzed values of retinal ganglion cell density of Wassle et al. are in agreement with the recent $a$ of 1.5° [60], although evidently not in agreement with the value of $a$ of 0.8° from the same investigators using the same data set [11], and are in significant disagreement with the data of Dow et al.

There is clearly a problem here. One is reminded of the statement of Mark Twain: "The research of many learned men has already shed much

**Table 1**   Values of *a* from Psychophysical and Anatomical Sources

| Value of *a* | Species | Ref. |
|---|---|---|
| *a* ∈ [1.5°,4°] | | |
| Retinal cones | Human | 92 |
| Pβ ganglion cell density | Macaque | 93 |
| | | 94 |
| Ganglion cell density | Macaque | 62 |
| Inverse cortical magnification | Macaque | 60 |
| Cortical receptive field size | Macaque | 95 |
| Minimum angle of resolution | Human | 96,97 |
| | | 98 |
| | | 99 |
| | | 100 |
| Contrast sensitivity | Human | 101 |
| | | 102,103 |
| Slow velocity discrimination | Human | 104,105 |
| | | |
| *a* ∈ [0.3°,0.9°] | | |
| Inverse cortical magnification | Macaque | 95 |
| | | 11,23 |
| Optimal two-dot vernier acuity | Human | 106 |
| Abutting vernier acuity | Human | 107,108 |
| Vernier crowding zone | Human | 99 |
| Optimal three-dot bisection | Human | 109,110 |
| Stereo acuity | Human | 111 |

*Source:* After Ref. 37.

darkness on the subject. If they continue, soon we shall know nothing at all about it."

The source of the problem is easy to see: virtually all data in the visual system, from retina, through LGN, to V-1, V-2, and on to MT and V-4, scale in a very roughly linear fashion, as do most psychophysical data. Given the wide range of reported measurements, it is not hard to make arguments that sets of phenomena do or do not match, or even cluster into several groups. It appears that this situation will remain somewhat confused until investigators begin to publish error bars, or confidence limits on their data, to permit statistical comparisons of two curves. In the near future, we expect to publish such a result, based on the analysis of data like that shown in Figure 12. The progress made by Wassle's group in obtaining

more reliable retinal data is an important step toward clarifying the retinal component of this problem.

# VI. MACHINE VISION

## A. Vertical–Horizontal Pyramids

Variable resolution in spatial vision has been one of the principal themes in vision research for more than 30 years. Early in this era, this field bifurcated between "spatial frequency" enthusiasts and "space domain" partisans. There was a time when the Fourier transform was reified in vision, and it should be pointed out that a global convolution of this form, is, in a certain sense, the antithesis of a spatial map. There was also much contention among physiologists who preferred a spatial frequency interpretation to the space–domain receptive field interpretation originated by Hubel and Weisel. This contention reached its peak, if not its reductio ad absurdum, in a paper [63] showing that cortical simple cells were linear in their response to gratings but sinusoidal gratings were "better" stimuli, since a sinusoidal grating of a given amplitude had a larger cortical response than a slit of the same amplitude. It was later pointed out in a letter to *Science* that the normalization of a square slit and a sinusoid would be expected, on "energy" grounds, to differ by a factor of $\sqrt{2}$!

More recently, this contention has faded away. There are relatively few who still argue that a Fourier transform is somehow performed in the brain. In any event, the waning of this form of argument makes an interesting historical counterpoint to the area of cortical topography.

Thus, it has been pointed out [64] that the variation of receptive field size across the surface of the cortex might be considered to be a form of "horizontal" multiple resolution representation, while the variation in receptive field size at a single location in the visual field might be considered to be a form of "vertical" multiple resolution. If so, the two major features of spatial vision could be viewed from a unified perspective.

Donald Kelly has extensively explored this idea [65] and has studied multiple-resolution representation using Gabor functions, together with complex log mapping to represent the spatial structure of the visual field. This work represents the only computational attempt to date to unify the spatial frequency description of cortical receptive fields with the space-variant facts of cortical topography (see Fig. 17).

The theme of "vertical–horizontal" space variance in vision provides a major thread in the context of machine vision. In fact, it can be argued that the only efficient approaches to real-time practical machine vision have been, and more to the point, will be, based on space-variant architectures.

**Figure 17** Computer simulations of Gabor function and complex logarithmic spatial structure in V-1. This simulation shows the joint "horizontal" and "vertical" space-variant structure of V-1. The software used to produce this figure was programmed by John D. Peters of SRI International. (From Ref. 65.)

For example, Burt and his collaborators [66,67] have provided "pyramid" algorithms for machine vision for more than a decade. By and large, multiscale, or pyramid, approaches to vision appear to be the only practical means of realizing real-time performance. This is because most early vision processing can be performed on a coarse-to-fine grid, greatly decreasing the processing required, so that refinement at high acuity needs to process only a relatively small area of the sensor.

In the early work of Burt, the operative metaphor was that of "spatial frequency." A full image sensor was subsampled to provide perhaps four levels of a pyramid, with increasingly larger "receptive fields." Burt and Adelson [66] showed that this results in a total amount of pixels that was $\Sigma 1 + 1/4 + 1/16 + \cdots = 4/3$ larger than the original single resolution frame. Therefore, a multiresolution pyramid "costs" little more than a conventional image but provides a potentially large speed-up on processing.

However, the original image itself is of order $N^2$, where $N$ is a large number in the range of 256–1000 pixels. Obviously $4/3 \cdot N \cdot N$ is a large number if $N \cdot N$ is a large number! This is the principal bottleneck in machine vision. Thirty frames per second of 0.256 million pixels is more than 7 million pixels per second, and each pixel must be processed in real time with many hundreds of machine instructions to complete a machine vision task.

More recently, Burt [68,69], and others have begun to use a "truncated" pyramid, in which the higher resolution levels are computed on smaller regions of the sensor. The highest resolution level of this truncated pyramid thus exists on the smallest segment of the sensor area. In other words, this is a discrete approximation to a foveal architecture!

Yeshurun and Schwartz [70] used the term "space-variant vision" to refer to machine vision performed with a sensor whose resolution varies smoothly across its surface, like that of the human visual system. The use of such sensors is rapidly becoming an important factor in machine vision: Burt's truncated pyramid is one example, but more recently many other applications of space-variant vision have begun to emerge. In the next section, we review some work of our laboratory in this area, because it illustrates the potential of space-variant architectures in machine vision, and also because it may offer important insight into the nature of the constraints and architectural principles that are operative in human vision.

## B.  Computational Function and Cortical Architecture

The nature of computational function in visual cortex is, at present, almost completely unknown. Despite an impressive amount of knowledge at all levels of the nervous system, from the level of ion channels and membrane

biophysics, neural trigger features, columnar and topographic architectures, and multivariato visual function throughout extrastriate cortex, there is no confident answer, at the present time, to the question: What are the computational functions of the visual cortex?

However, we can speculate on several aspects of visual computation, which are supported by the particular form of space-variant mapping that occurs in the cortex. We review several of these proposals, which have been advanced over the years. To begin, however, we choose a system that beyond any reasonable doubt follows directly from the analysis presented in this chapter and has had practical consequences to the recent design of machine vision systems.

## 1. Ten Thousand Pounds of Brain

The human visual system is able to cover a wide visual field, and to achieve high maximum resolution, without the need for an unreasonably large number of spatial channels. The foveating, or space-variant, construction of V-1 provides a dramatic form of data compression. Just how dramatic this compression is can be seen from the following simple estimate. Suppose we wish to "cover" a solid angle that is comparable to human vision (let us say about 100° × 100°), with a maximum resolution of 1 minute of arc. If we were to attempt this with conventional video sensor technology, we would require our sensor to have 6000 × 2 × 6000 × 2 pixels (the factor of 2 × 2 is for sampling). Figure 4 simulated a 16,000 × 16,000 pixel scene with the map function estimate from monkey V-1, which is represented by a simulated cortical representation of 16,000 pixels in total. In other words, we achieved, in Figure 4, a compression of about 16,000:1, by the use of a space-variant sensing strategy similar to that used in primate vision [14].

In a more careful analysis of this compression factor [71], we have defined a measure of sensor quality, which we term $F/R$ quality, defined as the ratio of sensor field of view to maximum resolution, as outlined above. This is a measure of the spatial dynamic range of a sensor. Estimating a primate visual field of 140° (vertical) and 200° (horizontal), we estimated that the number of "pixels" in a complex log sensor such as the human retina is about 150,000. This number is consistent with the number of fibers in the optic tract (about 1,000,000), since we have not accounted for color, on–off and off–on pathways, noncortical afferents in the optic tract, and redundancy of sampling (see Chapter 4, which shows that orientation selectivity is a necessary consequence of chromatic decoding). We believe that a count of about $10^5$ "pixels" or "sampling units" or "spatial degrees of freedom" is consistent both with cortical topography and with the number of fibers in the optic tract.

Nakayama has also provided a estimate of the number of "pixels" re-

quired to encode contrast [72]. He obtained an estimate of 25,000 "pixels" [72] somewhat lower than ours, but he did not provide any details of his calculation.

The number of pixels in a conventional, space-invariant sensor (e.g., a TV sensor) of the same $F/R$ ratio, is 600,000,000.* These estimates for the space-variant and space-invariant pixel burden of vision sensors suggest that compression ratios of between 3500:1 and 10,000:1 are achieved.

Since the primate cortex is roughly 50% (exclusively) visual, and the human brain weighs about 3 pounds, we estimate that our brains would weigh many thousands of pounds if we were to maintain the same spatial dynamic range, but used a space-invariant, or nonfoveal architecture.

Since wide-angle vision with high acuity would appear to be of great selective advantage, and since a brain weighing 5000–30,000 pounds is not, it appears that we have identified at least one indisputable functional correlate of visual cortex spatial architecture.

## 2. Space-Variant Active Vision

As we began to outline above, the use of space-variant architectures in machine vision has come to be an area of increasing importance. Starting with the pyramid algorithms of Burt, in the early 1980s there has been an increasing realization in the machine vision community that multiresolution sensing may be critical to achieve high performance, real-time machine vision.

During the past several years, with support from the Artificial Neural Network Technology program of the Advanced Projects Research Agency (ARPA), we have built a machine vision system that utilizes the complex log geometry as its sensing strategy. The system we constructed has established extremely high performance on certain measures, which we now review.

## 3. CORTEX-I

We have constructed a miniature space-variant active vision system, using a complex logarithmic sensing strategy [74,75], which we call CORTEX-I. The benchmark application for this system was to acquire moving targets

---

*Shostak has estimated the following "pixel" estimates for the full visual field, using a space-invariant (nonfoveal) architecture [73]:

Solid angle of human vision: 15,000 $deg^2$ (180° (horizontal) × 135° (vertical))
Maximum resolution: 0.5 minute of arc
Sampling factor: 2
Space-invariant sensor size: 36,000 × 28,000 = 1,008,000,000 pixels

Shostak's estimate is larger than ours because he used an assumed 0.5 minute of arc, rather than a 1 minute of arc maximum resolution.

(automobiles), track them with the camera, and use pattern recognition techniques to read the license plates of the cars as they drove past the camera system. To accomplish this goal, a series of hardware and algorithmic problems had to be solved. At the hardware level, a novel actuator design was produced and implemented, called the spherical pointing motor. This design produced a 2-degree-of-freedom camera pointing device that was fast, very compact, and extremely inexpensive to produce. Additional hardware innovations were the production of subminiature camera and lens systems, a custom-built very-large-scale integrated (VLSI) sensor, and image processors based on digital signal processing. At the algorithmic level, it was necessary to develop attentional algorithms capable of locating in real time an object of interest (e.g., a license plate) in a complex scene containing moving objects, to track the object of interest, and to perform image processing and pattern recognition on the tracked object. This work is fully described in a recent series of papers [74–78].

The license plate reading benchmark was achieved [74] with a hardware system that occupied less than 0.5 cubic foot, weighed less than 10 pounds, and cost roughly $2000 in parts to build, including video camera, lenses, motors, and computer system. Figures 18, 19, and 20 show CORTEX-I, the custom "eye" spherical motor and camera system, and a sample of the license-plate-reading task, respectively.

The most notable aspect of this system was its ability to perform a difficult machine vision task, in real time, with the support of only 12 million instructions per second (MIPS) of processing power. This system is roughly 10–100 times smaller, cheaper, and computationally less powerful (in MIPS) than other contemporary machine vision systems. The reason for this economy can be traced directly to the use of a space-variant sensing strategy. Our system processed only 1400 pixels per frame, instead of the usual 64,000–256,000 pixels common in machine vision. In effect, we exploited the type of leverage outlined above for the human visual system (although not quite the same magnitude). And, the scaling down of our systems cost and size must be understood to apply not only to the sensor, but to the memory, the CPU power, and to almost all other aspects of the system.*

We are currently building a second-generation system, which will provide 200 MIPS or more, and which will be mounted on a miniature robot vehi-

---

*Like the human eye, and unlike conventional cameras, the log map sensor does not require high quality optics off-axis. This made possible very small and light lenses, which in turn allowed actuators to be very small and light. A number of synergistic benefits followed from the complex log sensor geometry.

**Figure 18**   The computer engine and camera of the machine vision system COR-TEX-I. On the top of the rack is mounted a miniature active camera system, shown in more detail in Figure 19. The rack shown contains three digital signal processors (DSPs), one microprocessor, and several boards of custom electronics, including motor control, communications, and camera control. At the time of writing, this system was the smallest functional active vision yet constructed, by at least an order of magnitude. The output images of this system (bottom) represent a face and a license plate. The system was successfully demonstrated to acquire moving targets (vehicles), to locate the license plates on the moving vehicles using a model-based "attentional algorithm," and to perform optical character recognition of the license plates in real time while tracking a moving target.

**Figure 19** "Spherical pointing motor" built to control the active vision system camera of CORTEX-I. The camera (center) is about 5 mm × 10 mm. The whole system is about 1.5 inches on a side.

cle. We expect the performance of this system to affirm the practical significance of space-variant image architectures.

## 4. Commodity Robotics

Machine vision and robotics have been disappointing in the marketplace. This is not because they have failed to perform at all. It is because the relatively modest performance that contemporary machine vision provides is not cost-effective. Almost all vision and robotic tasks are more cheaply performed, at the present, by human workers. We have recently argued that the availability of extremely low cost robotic and machine vision hardware, in the consumer price range, and with the functionality provided by the prototype CORTEX-I, will have a major impact on industrial and military applications, which we have likened to the impact of the low cost personal computer on computation in general. We have called this (so far hypothetical) phenomenon the PC-metaphor for machine vision, or the coming of "commodity robotics." For a number of years, we have predicted that high performance vision robots will ultimately use space-variant, active vision architectures: the factors of hundreds or thousands in data reduction that this provides are simply so great that any competition from a conven-

**Figure 20**  Frame from the final pattern recognition stage of CORTEX-I. This frame shows the optical character recognition algorithm classifying the characters on a stationary license plate, tracking the moving vehicle.

tional space-invariant system is unimaginable. Whether this will come to pass remains to be seen. However, judging by the rapidly increasing interest in machine vision groups to build active vision systems in general, and on space-variant or foveating systems in particular (see, e.g., Refs. 79–84), we feel confident that this trend will be realized within the next decade. And if it does, one more area of biological vision will have made an indisputable contribution to high performance machine vision.

## 5.   Special Geometric Properties of the Complex Logarithm

One area of great activity has been the application of the special geometric properties of the complex log function to visual computation. These properties were known prior to the realization that primate cortex possessed

complex log geometry, but they were linked to the Fourier transform, via the "Mellin transform" [85,86]. In the space domain, it was pointed out by several authors [9,19,87] that the complex log map possessed some intriguing properties of size, rotation, and projection invariance. These are summarized in pictorial form in Figure 21.

In a sense, the favorable size, rotation, and projection-invariant properties of the complex log map are bought at the expense of the severe breaking of translation symmetry that is implied by a space-variant mapping. At the

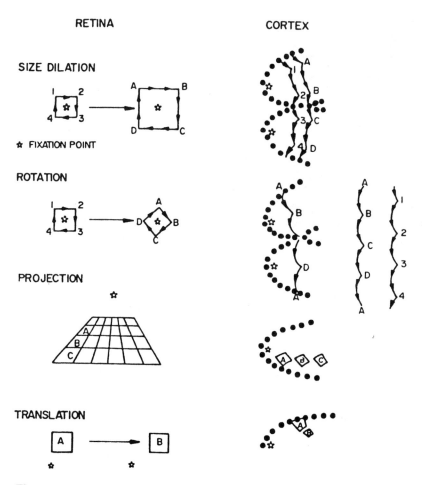

**Figure 21** Summary of the size, rotation, and projection-invariant properties of the complex logarithm. (From Ref. 22.)

present time, it is not known whether the symmetry properties of the complex log are significant. For one thing, they follow only on a complex log approximation to cortical topography that is valid outside of the foveal region (i.e., for visual angles greater than $a$, where our best guess for $a$ is about $0.5°$). Most likely, the geometric properties of the complex log mapping will find application in the simplification of optical flow, as sketched out in Figure 21 [22]. These aspects of the complex log have been most intensively investigated by George Chaiken [88], Carl Weiman [89], Guilio Sandini [80], and Ramesh Jain [90,91].

## VII. CONCLUSION

The means by which the brain provides a representation for spatial vision, or even whether the notion of representation is a viable concept, is at present unknown. A contingent of psychologists, cognitive scientists, psychophysicists, computer scientists, artificial intelligentsia, and worst of all, philosophers, has debated and argued over this issue for at least 20 years, with no end in sight. But the question of representation, in the brain, is the fundamental key to progress in understanding the nature of perceptual and cognitive brain activity. Until we know what, if anything, is being computed upon, the nature of the computation itself is one step further removed from our grasp.

In vision, the zeitgeist in this area tends to change once per generation. In the 1930s, 1940s, and 1950s, it appeared that spatiotemporal models were dominant. Lorenté de No introduced the notion of circulating temporal patterns of activity, the dramatic experiments of Talbot and Marshall drew attention to the notion of analog spatial representation, and the ideas of the gestalt psychologists, particularly Kohler, were intimately related to notions of analog spatiotemporal representation. Roy John and Walter Freeman developed notions of temporal coding to represent mnemonic and perceptual representations.

In the 1960s such young turks of the microelectrode as Barlow, Hubel, and Weisel overturned the dominant paradigm of analog representation in terms of a purely symbolic one: the single neuron feature extractor, representing perception and cognition in a purely nonspatial, hence purely symbolic, mode of the labeled "grandmother cell."

In the 1970s, psychophysicists took a turn at paradigm leadership, introducing the notion that "spatial frequency" was the underlying basis for spatial representation in vision, which in turn stimulated a parallel school of physiologists to investigate the same hypothesis.

In the 1980s there was a resurgence in interest in topographic mapping, stimulated in part by the availability of new techniques of experimental

measurement and partly by a spurt of papers that sought to compare the spatial variation of acuity, stereo, and motion measures with retinal and cortical anatomy.

In the 1990s it appears that space-variant architectures, typified by the pyramid, and the log map, are on the point of becoming important sensor architectures for machine vision, with the likelihood that future high performance robotic vision systems will be based on the same sensor architecture used by the primate visual system. Moreover, these systems are likely to be "active" (i.e., based on robotic actuation), emphasizing the importance of a whole range of biologically motivated algorithmic areas such as attention and ocular motion control.

At the present time, it seems that only the feature filter and the spatio-temporal modes of representation have survived as viable proposals for the nature of visual representation. The notion that the brain is somehow performing Fourier, or "harmonic," analysis seems to have faded away, with the (painfully slow) realization that the Fourier transform has an important, but very limited role to play in computational vision. The transfer of this idea to biological vision was a form of deus ex machina that has not stood up well to the observation that the moderate bandpass spatial filtering properties of the visual system are much better accounted for by a "pyramid" model, built over a space-variant mapping, than by a strict "Fourier transform" or "harmonic analysis" interpretation.* If so, the spatial structure of areas such as primary visual cortex are of fundamental importance to our attempt to understand the brain.

This chapter has reviewed attempts to model, and to measure, the topographic and columnar structure of visual cortex. Since columnar structure appears to occur jointly with topographic structure in cortical sensory systems, we have briefly reviewed constructions, such as the protomap, protocolumn, and cortical polymap [16], which have been introduced recently to make algorithmic sense of structures, such as V-1, which are both topographic and multimodal in a columnar fashion. Having introduced these ideas, we have a framework in which to understand visual cortex in terms of the simpler mathematical idea of "regular map" (i.e., a map with a well-behaved Jacobian), and we have reviewed the history, the mathematics (both analytic and numerical), and the current experimental status of modeling such neural maps. Preliminary data (Figs. 11–13) suggest that the topographic map of visual cortex is in fact quite well approximated by a

---

*The reader is alerted that this interpretation of the current status of the role of "Fourier theory" in vision may stimulate strong disagreement from some; it is presented here as an opinion of the current state of knowledge, if not a universal consensus.

conformal map whose structure is very close to the simple analytic model of the complex logarithm.

To fully present this idea, a fairly large amount of mathematical detail has been presented. The justification for doing this has been the primacy of this form of structure for understanding vision, and also the fact that the original papers presenting this work are scattered across several different literatures (computer graphics, physiology, neural modeling) in a way that makes it very difficult for the interested reader to obtain a full understanding of these methods. This chapter represents the first attempt to summarize all this material in one place, and the result is, clearly, quite a lot to expect of the reader. However, it would appear that coming to terms with the material presented here is, in the long run, an essential step in understanding the basic nature of spatial representation in primary visual cortex.

# APPENDIX

## Riemann Mapping Theorem

A typical statement of the Riemann mapping theorem is [46]:

> Given any simply connected region $\Omega$ which is not the whole plane, and a point $z_0 \in \Omega$, there exists a unique analytic function $f(z)$ in $\Omega$, normalized by the condition $f(z_0) = 0$, $f'(z_0) > 0$, such that $f(z)$ defines a one-to-one mapping of $\Omega$ onto the disk $|w| < 1$.

Our statement of this theorem is that uniqueness is specified by a point correspondence and an orientation. This is equivalent to the preceding statement: the point correspondence specifies the mapping of the point that maps into the origin of the unit circle $f(z_0) = 0$. The statement that $f'(z_0) > 0$ is equivalent to fixing the orientation of the unit disk, since it specifies that a (positive) scaling only, and no rotation, occur at this point. Other orientations of the mapping can be generated by multiplication of $f(z)$ by $e^{i\theta}$.

## Symm Algorithm for Conformal Mapping

Symm has described an integral equation method for computing the conformal mapping of a given simply connected domain onto the interior of the unit circle. This method performs well for a domain described by a large number of (polygonal) vertices. It is based on the observation that a solution for conformally mapping a given simply connected domain $D$ with boundary $L$, in the $z$ plane, onto the unit disk $|w| < = 1$, in the $w$ plane, in such a way that a particular point $z_0 \in D$ goes into the center $w = 0$, is provided (up to arbitrary rotation) by:

$$w(z) = \exp[\log(z - z_0) + \gamma(z,z_0)] \tag{14}$$

where $\gamma = g + ih$ and $g$ satisfies the boundary value problem

$$\nabla^2 g = 0 \quad \text{for } z \in D \tag{15}$$

$$g = -\log|z - z_0| \quad \text{for } z \in L \tag{16}$$

This identity can be understood by observing that $w(z_0) = 0$.

On the boundary ($z \in L$), $w(z) = e^{i[(\arg(z - z_0) + h]}$, i.e. $|w(z)| = 1$, so the boundary $L$ is mapped to the boundary of the unit circle.

For interior points $z \in D$, we have $w(z) < = 1$, since $|w(z)| = 1$ on the boundary, and $w(z)$ must take its maximum in this region on the boundary, by the maximum principle [46].

Thus, Symm replaces the problem of finding $w(z)$ to the problem of finding an analytic function $\gamma(z) = \log(w) - \log(z - z_0)$; essentially, the problem is transformed from the original domain to a complex logarithmic representation of it.

Symm then goes on to outline methods of finding $\gamma$, by means of setting up a set of Fredholm integral equations, which are numerically solved by standard methods.

One difficulty in implementing this work [46], not emphasized in it, is that line integrals of the argument of an analytic function are evaluated in this algorithm. Direct (i.e., naive) numerical implementation of the equations found in this reference is not correct; careful attention must be paid to ensuring that a continuous branch of the argument is used when a line integral of the argument of a complex function is performed.

## Conformal Mapping of the Retinal Image to a Flattened Section of the Cortex

The problem of conformally mapping the retina to V-1, for example, can be regarded as a problem of mapping the half-unit sphere (an approximation to the retina) conformally to a flattened model of the surface of visual cortex. For flattening of cortex, we use an algorithm developed in our lab which achieves an average error of roughly 5% in mapping a three-dimensional representation of visual cortex into two-dimensional form. The mapping problem is solved in our case by decomposing it into three steps:

1. Mapping the quarter-unit sphere (half of a retina) conformally to the half-unit disk.
2. Mapping the half-unit disk conformally to the unit disk, where the point in the half-disk that is mapped to the origin of the target disk is a parameter of this mapping, to be chosen dependent on the specific data.
3. Mapping the unit disk conformally to an arbitrary two-dimensional domain, the flattened brain data.

*Step 1*:   We use the following stereographic projection (which provides a conformal mapping of the quarter-unit sphere to the half-unit disk):

$$(\theta, \phi) \rightarrow \frac{\cos \phi \sin \theta}{1 - \cos \phi \cos \theta}, \frac{\sin \phi}{1 - \cos \phi \cos \theta} \tag{17}$$

where $\theta$ and $\phi$ are the corresponding eccentricity and azimuth of the unit sphere, and the output represents Cartesian coordinates in two dimensions.

*Step 2*:   The following transformation $T$ is a conformal complex transformation that maps the half-unit disk to the unit disk, where a point $z_0$ internal to the half-unit disk is mapped to the origin of the target unit disk, with a rotation of $\alpha$ radians: $T = H \cdot G \cdot F$, where

$$F = \frac{z - i}{z + i} \, G = z^2 H = \exp\left[i\alpha\left(\frac{z - z_0}{z - z_0'}\right)\right] \tag{18}$$

*Step 3*:   We use Symm's algorithm to conformally map a given simply connected domain onto the interior of the unit circle. The results of this approximation have been checked against direct microelectrode measurements of the map function of visual cortex [51] with excellent agreement.

## ACKNOWLEDGMENT

This chapter was prepared under support from the National Institutes of Mental Health (grant no. 45969), which is gratefully acknowledged, as is earlier support from the System Development Foundation, and from the Air Force Office of Scientific Research, Life Sciences Directorate, which supported the research reviewed here.

One of the first public presentations of this work was made in 1978 at a symposium of the Optical Society of America organized by Donald Kelly, to whom I am grateful not only for his interest then, but for his generous invitation to participate in the present volume, not to mention his editorial help and patience (!), which have been critical in completing this chapter. I am also grateful for his wise suggestion that I adopt a more modulated tone in my zealous attempt to "correct" the archival literature. My lapses in following this sound advice are deliberate and premeditated; they should, along with any errors in this text, accrue only to myself.

## REFERENCES

1.  M. Minkowski, Experimentelle Untersuchungen über die Beziehungen der Grosshirninde, *Arb. Hirnanat. Inst. Zurich* 7:259 (1913).
2.  G. G. Holmes, The cortical localization of vision, *Br. Med. J. ii*:193–199 (1919).

3. S. Poliak, The main afferent fibre systems of the cerebral cortex in primates, *Univ. Calif. Publ. Anat.* 2:107-207 (1932).

4. W. E. LeGros Clark and G. G. Penman, The projection of the retina in the lateral geniculate body, *Proc. Ry. Soc. London B114*:291-313 (1934).

5. W. H. Marshall, C. N. Woolsey, and P. Bard, Observations on cortical somatic sensory mechanisms of cat and monkey, *J. Neurophysiol.* 4:1-43 (1941).

6. Nicholas Pastore, *Selective History of Theories of Visual Perception 1650-1950*, Oxford University Press, London, 1971.

7. S. A. Talbot and W. H. Marshall, Physiological studies on neural mechanisms of visual localization and discrimination, *Am. J. Ophthalmol.* 24:1255-1263 (1941).

8. M. Daniel and D. Whitteridge, The representation of the visual field on the cerebral cortex in monkeys, *J. Physiol.* 159:203-221 (1961).

9. Eric L. Schwartz, Analytic structure of the retinotopic mapping and relevance to perception, *6th Ann. Meeting Soc. Neurosci. Abstr.* 6:1636 (1976).

10. David C. Van Essen and John Maunsell, Two-dimensional maps of the cerebral cortex, *J. Comp. Neurol.* 191:255-281 (1980).

11. R. B. Tootell, M. Silverman, E. Switkes, and R. deValois, Deoxyglucose analysis of retinotopic organization in primate striate cortex, *Science 218*: 902-904 (1982).

12. E. L. Schwartz and B. Merker, Flattening cortex: An optimal computer algorithm and comparisons with physical flattening of the opercular surface of striate cortex, *Soc. Neurosci. Abstr.* 15 (1985).

13. E. L. Schwartz and B. Merker, Computer-aided neuroanatomy: Differential geometry of cortical surfaces and an optimal flattening algorithm, *IEEE Comput. Graphics Appl.* 6(2):36-44 (1986).

14. E. L. Schwartz, B. Merker, E. Wolfson, and A. Shaw, Computational neuroscience: Applications of computer graphics and image processing to two and three dimensional modeling of the functional architecture of visual cortex, *IEEE Comput. Graphics Appl.* 8(4):13-28 (1988).

15. G. J. Carman and D. van Essen, Computational algorithms for the production of two-dimensional maps of cerebral cortex, *Neurosci. Abstr.* 11:1243 (1985).

16. Pierre Landau and Eric L. Schwartz, Computer simulation of cortical polymaps: A proto-column algorithm, *Neural Networks* 5:187-206 (1992).

17. D. H. Hubel and T. N. Wiesel, Sequence regularity and geometry of orientation columns in the monkey striate cortex, *J. Comp. Neurol.* 158:267-293 (1974).

18. B. Fischer, Overlap of receptive field centers and representation of the visual field in the cat's optic tract, *Vision Res.* 13:2113-2120 (1973).

19. E. L. Schwartz, Spatial mapping in primate sensory projection: Analytic structure and relevance to perception, *Biol. Cybernetics*, 25:181-194 (1977).

20. E. L. Schwartz, Afferent geometry in the primate visual cortex and the generation of neuronal trigger features, *Biol. Cybernetics*, 28:1-24 (1977).

21. E. L. Schwartz, The development of specific visual projections in the monkey and the goldfish: Outline of a geometric theory of receptotopic structure, *J. Theor. Biol.* 69:655-685 (1977).

22. E. L. Schwartz, Computational anatomy and functional architecture of striate cortex: A spatial mapping approach to perceptual coding, *Vision Res. 20*: 645–669 (1980).

23. D. C. van Essen, W. T. Newsome, and J. H. R. Maunsell, The visual representation in striate cortex of the macaque monkey: Asymmetries, anisotropies, and individual variability, *Vision Res. 24*:429–448 (1984).

24. R. B. Tootell, M. S. Silverman, E. Switkes, and R. deValois, Deoxyglucose, retinotopic mapping and the complex log model in striate cortex, *Science 227*:1066 (1985).

25. B. Dow, R. G. Vautin, and R. Bauer, The mapping of visual space onto foveal striate cortex in the macaque monkey, *J. Neurosci. 5*:890–902 (1985).

26. Alan Johnston, The geometry of the topographic map in striate cortex, *Vision Res. 29*, (1989).

27. V. G. Dodson, Neuronal circuits capable of generating visual cortex, *Perception 9*:411–434 (1980).

28. P. Cavanagh, Size and position invariance in the visual system, *Perception 7*: 167–177 (1978).

29. G. Blasdel and G. Salama, Voltage sensitive dyes reveal a modular organisation in monkey striate cortex, *Nature 321*:579–585 (1986).

30. Tobias Bonhoeffer and Amiram Grinvald, Iso-orientation domains in cat visual cortex are arranged in pinwheel-like patterns, *Nature 353*:429–431 (1991).

31. A. Rojer and E. L. Schwartz, Cat and monkey cortical columnar patterns modeled by bandpass-filtered 2D white noise, *Biol. Cybernetics 62*:381–391 (1990).

32. Eric L. Schwartz and Alan S. Rojer, Cortical hypercolumns and the topology of random orientation maps, Technical Report 593, Courant Institute of Mathematical Sciences, 251 Mercer Street, May 1991.

33. Eric L. Schwartz and Alan S. Rojer, A computational study of cortical hypercolumns and the topology of random orientation maps, *Soc. Neurosci. Abstr. 18*:742 (1992).

34. N. Drasdo, The neural representation of visual space, *Nature 256*:554–556 (1977).

35. J. Rovamo and V. Virsu, An estimation and application of human cortical magnification factor, *Exp. Brain Res. 37*:495–510 (1979).

36. V. Virsu and J. Rovamo, Visual resolution, contrast sensitivity and the cortical magnification factor, *Exp. Brain Res. 37*:474–494 (1979).

37. Hugh Wilson, Dennis Levi, Lamberto Maffei, Jyrki Rovamo, and Russell DeValois, The perception of form, *Visual Perception: The Neurophysiological Foundations*, Academic Press, New York, 1990.

38. D. H. Hubel and D. C. Freeman, Projection into the visual field of ocular-dominance columns in macaque monkey, *Brain Res. 122*:336–343 (1977).

39. E. L. Schwartz, Positron emission tomography studies of human visual cortex, *Soc. Neurosci. Abstr. 7*:367 (1981).

40. E. L. Schwartz, D. R. Christman, and A. P. Wolf, Human primary visual cortex topography imaged via positron-emission tomography, *Brain Res. 104*:104–112 (1983).

41. P. T. Fox, F. M. Miezin, J. M. Allman, D. C. Van Essen, and M. E. Raichle, Retinotopic organization of human visual cortex mapped with positron emission tomography, *J. Neurosci. 7*:913–922 (1987).

42. E. L. Schwartz, On the mathematical structure of the retinotopic mapping of primate striate cortex, *Science 227*:1066 (1985).

43. E. L. Schwartz, Anatomical and physiological correlates of human visual perception, *IEEE Trans. Sys. Man Cybernetics SMC-14*:257–271 (1984).

44. E. L. Schwartz, Cortical anatomy and size invariance, *Vision Res. 18*:24–58 (1983).

45. David Rosenbluth, Amar Munsiff, Tom Albright, and Eric Schwartz, Computer reconstruction from 2DG serial sections of the topographic map of macaque visual cortex, *Soc. Neurosci. Abstr. 18*:742 (1992).

46. L. Ahlfors, *Complex Analysis*, McGraw-Hill, New York, 1966.

47. S. Fortune, A sweepline algorithm for Voronoi diagrams, *ACM Symposium on Computational Geometry*, Association of Computing Machinery, 1987.

48. A. Saalfeld, Joint triangulations and triangulation maps, *ACM Symposium on Computational Geometry*, Association of Computing Machinery, 1987, pp. 195–204.

49. P. Henrici, *Applied and Computational Complex Analysis*, Vol. 3, Wiley, New York, 1986.

50. F. P. Preparata and M. I. Shamos, *Computational Geometry: An Introduction*, Springer-Verlag, New York, 1985.

51. D. Weinshall and E. L. Schwartz, A new method for measuring the visuotopic map function of striate cortex: Validation with macaque data and possible extension to measurement of the human map, *Soc. Neurosci. Abstr.*, p. 1291, 1987.

52. E. L. Schwartz, A. Shaw, and D. Weinshall, Flattening visual cortex at image resolution: Quantitative computer reconstruction of the macaque ocular dominance column pattern. *Soc. Neurosci. Abstr.* p. 1293, 1987.

53. E. Wolfson and E. L. Schwartz, Computing minimal distances on arbitrary polyhedral surfaces, *IEEE Trans. Pattern Anal. Machine Intell. PAMI-11*: 1001–1005 (1989).

54. E. L. Schwartz, A. Shaw, and E. Wolfson, A numerical solution to the generalized mapmaker's problem, *IEEE Trans. Pattern Anal. Machine Intell. PAMI-11*: 1005–1008 (1989).

55. Carl Frederick and Eric L. Schwartz, Conformal image warping, *IEEE Comput. Graphics Appl. 10*:54–61, 1990.

56. W. H. Press, B. P. Flannery, S. A. Teukolsky, and W. T. Vetterling, *Numerical Recipes in C: The Art of Scientific Computing*, Cambridge University Press, New York, 1988.

57. J. C. Horton and E. T. Hedley-White, Cytochrome oxidase studies of human visual cortex, *Phil. Trans. R. Soc. London B304*:255–272 (1984).

58. B. Sakitt, Why the cortical magnification factor in rhesus monkey cannot be isotropic, *Vision Res. 22*:417–421 (1982).

59. S. LeVay, D. H. Hubel, and T. N. Wiesel, The pattern of ocular dominance dominance columns in macaque visual cortex revealed by a reduced silver stain, *J. Comp. Neurol. 159*:559–576 (1975).

60. R. B. H. Tootell, R. Switkes, M. S. Silverman, and Susan L. Hamilton, Functional anatomy of macaque striate cortex. II. Retinotopic organization, *J. Neurosci. 8*:1569 (1988).

61. R. B. H. Tootell, S. L. Hamilton, M. S. Silverman, and Eugene Switkes, Functional anatomy of macaque striate cortex. I. Ocular dominance, binocular interactions, and baseline conditions, *J. Neurosci. 8*:1531–1568 (1988).

62. H. Wassle, U. Grunert, J. Rohrenbeck, and B. B. Boycott, Cortical magnification factor and the ganglion cell density of the primate retina, *Nature 341*: 643–646 (1989).

63. R. L. DeValois and K. K. DeValois, *Spatial Vision*, Oxford University Press, London, 1988.

64. E. L. Schwartz, Image processing simulations of the functional architecture of primate striate cortex, *Inves. Ophthalmol. Vision Res. (suppl.) 26*(3):164 (1985).

65. D. H. Kelly, Retinocortical processing of spatial patterns, *SPIE Trans. Hum. Vision Electron. Imaging 1249*, February 1990.

66. P. Burt and Theodore Adelson, A Laplacian pyramid for data compression, *IEEE Trans. Commun. C-8*:1230–1245 (1981).

67. C. H. Anderson, P. J. Burt, and G. S. van der Wal, Change detection and tracking using pyramid transform techniques. *Proceedings of the SPIE Conference on Intelligent Robots and Computer Vision, 1985*, pp. 72–78.

68. P. J. Burt, Algorithms and architectures for smart sensing, *Proceedings of the DARPA Image Understanding Workshop, 1988*, pp. 139–153.

69. P. J. Burt, Smart sensing within a pyramid machine, *IEEE Proc. 76*(8):1006–1015 (1988).

70. Y. Yeshurun and E. L. Schwartz, Shape description with a space-variant sensor: Algorithms for scan-path, fusion and convergence over multiple scans, *IEEE Trans. Pattern Anal. Machine Intell. PAMI-11*:1217–1222 (1989).

71. A. S. Rojer and E. L. Schwartz, Design considerations for a space-variant visual sensor with complex–logarithmic geometry, *10th International Conference on Pattern Recognition*, Vol. 2, pp. 278–285, 1990.

72. K. Nakayama, The iconic bottleneck and the tenuous link between early visual processing and perception, *Vision: Coding and Efficiency* (Colin Blakemore, ed.), Cambridge University Press, New York, 1990. pp. 411–422.

73. S. Shostak, The ultimate motion imaging system: What—and when? *Advanced Imaging*, pp. 39–41, 1992.

74. B. Bederson, R. S. Wallace, and E. L. Schwartz, A miniaturized active vision system, *11th IAPR International Conference on Pattern Recognition*, Specialty Conference on Pattern Recognition Hardware Architecture, The Hague, Netherlands, August 1992, pp. 58–62.

75. R. S. Wallace, P.-W. Ong, B. Bederson, and E. L. Schwartz, Space variant vision, *Int. J. Machine Vision* (in press, 1993).

76. B. Bederson, R. S. Wallace, and E. L. Schwartz, Calibration of the spherical pointing motor. *Proc. SPIE conf. on Intelligent Robots and Computer Vison* (1992).

77. B. Bederson, R. S. Wallace, and E. L. Schwartz, A miniaturized Active Vision System, *Machine Vision and Applications*, 1993 (in press).

78. Ben Bederson, Richard Wallace, and Eric Schwartz, Two miniature pan-tilt devices, *IEEE Robotics Autom.* (1993) (in press).

79. Giulio Sandini and Paolo Dario, Active vision based on space-variant sensing, *International Symposium on Robotics Research*, 1989.

80. G. Sandini, F. Bosero, F. Bottino, and A. Ceccherini, The use of an anthropomorphic visual sensor for motion estimation and object tracking, *Proceedings of the OSA Topical Meeting on Image Understanding and Machine Vision, 1989.*

81. J. van der Spiegel, F. Kreider, C. Claiys, I. Debusschere, G. Sandini, P. Dario, F. Fantini, P. Belluti, and G. Soncini, A foveated retina-like sensor using CCD technology, *Analog VLSI Implementations of Neural Networks* (C. Mead and M. Ismail, eds.), Kluwer, Boston, 1989.

82. C. F. R. Weiman, Exponential sensor array geometry and simulation, *SPIE Conference on Digital and Optical Shape Representation and Pattern Recognition, 1988.*

83. Carl F. R. Weiman, Video compression via log polar mapping. *SPIE Symposium on OE/Aerospace Sensing, 1990*, pp. 1–12.

84. Aijza A. Baloch and Allen M. Waxman, Visual learning: Adaptive expectations, and behavioural conditioning of the mobile robot *Mavin, Neural Networks 4*:271–302 (1991).

85. J. K. Brousil and D. R. Smith, A threshold-logic network for shape invariance, *IEEE Trans. Electron, Comput.* EC-16:818–828 (1967).

86. D. Casasent and D. Psaltis, Positron, rotation and scale-invariant optical correlation, *Appl. Op.* 15:1793–1799 (1976).

87. C. F. Weiman and G. Chaikin, Logarithmic spiral grids for image-processing and display, *Comput. Graphics Image Process. 11*:197–226 (1979).

88. G. M. Chaikin and F. R. Weiman, Conformal computational geometry for machine vision, *Proceedings of the 5th International Conference on Pattern Recognition*, 1980.

89. C. F. R. Weiman, 3-D sensing with polar exponential sensor arrays, *SPIE Conference on Digital and Optical Shape Representation and Pattern Recognition, 1988.*

90. R. Jain, Complex log mapping and the focus of expansion, *ACM Siggraph/ Sigart Interdisciplinary Workshop*, (Badler and Tsotsos, eds.), Elsevier, North Holland, 1986, pp. 137–142.

91. R. Jain, S. L. Bartlett, and N. O'Brien, Motion stereo using ego-motion complex logarithmic mapping, *IEEE Trans. Pattern Anal. Machine Intell. PAMI-3*:356–369 (1987).

92. G. Osterberg, Topography of the layer of rods and cones in the human retina, *Acta Ophthalmol. suppl. 6*:1–103 (1935).

93. V. H. Perry and A. Cowey, The ganglion cell and cone distributions in the monkey's retina: Implications for central magnification factor, *Vision Res. 25*:1795–1810 (1985).

94. S. J. Schein and F. M. de Monasterio, Mapping of retinal and geniculate neurons onto striate cortex of macaque, *J. Neurosci. 7*:996–1009 (1987).

95. B. M. Dow, A. Z. Snyder, R. G. Vautin, and R. Bauer, Magnification factor

and receptive field size in foveal striate cortex of monkey, *Exp. Brain Res.* *44*:213–228 (1981).

96.   T. Wertheim, Über die indiretkte Sehscharfe, *Z. Psychol. Physiol. Sinnesorgane* *7*:172–189 (1894).

97.   F. W. Weymouth, Visual sensory units and the minimal angle of resolution, *Am. J. Ophthalmol.* *46*:102–113 (1958).

98.   G. Westheimer, The spatial sense of the eye, *Invest. Ophthalmol. Visual Sci.* *18*:893–912 (1979).

99.   D. M. Levi and S. A. Klein, Vernier acuity, crowding and amblyopia, *Invest. Ophthalmol. Visual Sci.* *23*:398–407 (1982).

100.   N. J. Coletta and D. R. Williams, Psychophysical estimate of extrafoveal cone spacing, *J. Opt. Soc. Am.* *4*:1503–1513 (1987).

101.   J. Rovamo, V. Virsu, P. Laurinen, and L. Hyvarinen, Cortical magnification factor predicts the photopic contrast sensitivity of peripheral vision, *Nature* *271*:54–56 (1978).

102.   J. Koenderink, W. A. van de Grind, and M. A. Bouman, Perimetry of contrast detection thresholds and moving sine wave patterns, *J. Opt. Soc. Am.* *68*:845–865 (1978).

103.   A. B. Watson, Estimation of local spatial scale, *J. Opt. Soc. Am.: A* *4*:1579–1582 (1987).

104.   S. McKee and K. Nakayama, The detection of motion in the peripheral visual field, *Vision Res.* *24*:25–32 (1984).

105.   M. J. Wright, Spatiotemporal properties of grating motion detection in the center and the periphery of the visual field, *J. Opt. Soc. A* *4*:1627–1633 (1987).

106.   G. Westheimer, The spatial grain of the perifoveal visual field, *Vision Res.* 22:157–162 (1982).

107.   B. Bourdon, *La Perception Visuelle de l'Espace*, Scheicher, Paris, 1902.

108.   D. Levi, S. A. Klein, and A. Aitsebaomo, Vernier acuity, crowding and cortical magnification, *Vision Res.* *25*:963–977 (1985).

109.   Y. L. Yap, D. M. Levi, and S. A. Klein, Peripheral hyperacuity: Three dot bisection scales to a single factor from 0 to 10 degrees, *J. Op. Soc. Am. A 4*: 1557–1561 (1987).

110.   S. A. Klein and D. M. Levi, Position sense of the peripheral retina, *J. Op. Soc. Am: A* *4*:1543–1553 (1987).

111.   G. Westheimer and M. Fendick, Effects of practice and the separation of test targets on foveal and peripheral stereoacuity, *Vision Res.* *23*:145–150 (1983).

112.   A. Cowey, Projection of the retina onto striate and prestriate cortex in the squirrel monkey, *Saimiri sciureus, J. Neurophysiol*, *27*:366–293 (1964).

113.   J. M. Allman and J. H. Kaas, Representation of the visual field in striate and adjoining cortex of the owl monkey (*Aotus trivirgatus), Brain Res, 35*: 89–106 (1971).

114.   R. J. Tusa, L. A. Palmer, and A. C. Rosenquist, The retinotopic organization of area 17 (striate cortex) in the cat, *J. Comp. Neurol. 177*:213–236 (1978).

# Introduction to Chapter 9

Like Chapter 2, this chapter and the next are concerned entirely with engineering applications. Dr. Crane applied our knowledge of visual optics and the oculomotor system, whereas Professors Schreiber and Glenn must deal with the mysteries of perception. Most of Crane's instruments are used in vision laboratories, whereas the machinery of the next two chapters is aimed at the communications marketplace. But the task of all three was to bring some fundamental results of vision research into the world of commercial feasibility. In this chapter we look at the problems involved in creating portable device-independent color reproduction.

When I persuaded Bill Schreiber to join me in the Research Department at Technicolor Corporation in 1953, it was a great feather in my cap. For one thing, I was just an engineer with a lowly B.S. degree, while he held a Ph.D. (albeit a brand-new one) from Harvard. By the time I had surrounded myself with a few more Ph.D.'s, it began to seem essential that I go back to graduate school and get one myself.

More to the point, Dr. Schreiber was hired specifically to carve out a new research direction for Technicolor: image processing and picture coding (we called it "bandwidth compression" in those days). Now before you can code pictures, you have to know something about their statistics, and that was what Bill had been measuring for his thesis at Harvard. He was now ready to put theory into practice, and Technicolor seemed like a logical place to sponsor the development of a real-time compression system. I knew nothing

about his field (apart from a two-week summer course under Shannon, Wiener, and other stars of information theory), but I wanted to learn. I got credit for a considerable coup in recruiting Schreiber, while he developed a life long interest in the visual process.

Unless you have lived through the experience, it is hard to convey the sense of excitement and foreboding, verging on panic, that the advent of commercially feasible television produced in Hollywood. If you were the head of MGM or Paramount, you could only wring your hands and try to make deals with the TV people. But Technicolor was already a high-tech place; if you were Herbert T. Kalmus, our president, you could imagine leapfrogging the whole nightmare by an engineering *tour de force* (such as the one that brought you to Hollywood in the first place). In this ambience, Technicolor and image coding was a marriage made in heaven (at least for several years), and I had been the officiating minister.

Just for the record, Bill's efforts did result in a 4-to-1 bandwidth reduction, in real time. To appreciate what a feat that was, you must realize that there were no computers and no digital circuitry usable for this development. It was all done with analog circuits and vacuum tubes! A/B tests and demonstrations used off-the-air TV signals from an antenna on the roof. (If only we had had today's tools back then!)

Dr. Schreiber left Technicolor in 1959 to become a professor at MIT, and I have followed his subsequent adventures when I could, with great interest. He has received many high honors for his work in television, laser scanner design, facsimile, and graphic arts, including the David Sarnoff Gold Medal from the Society of Motion Picture and Television Engineers. One of his most elegant accomplishments, partly because it blends some very old and some very new technology, is the one he will describe for you here.

# 9

# Color Science and the Graphic Arts

## William F. Schreiber

*Massachusetts Institute of Technology, Cambridge, Massachusetts*

## I. INTRODUCTION

It is not generally known that the "tech" in Technicolor, is the same "tech" as in "MIT," and that the Technicolor Motion Picture Corporation was a spinoff from Kalmus, Comstock, and Westcott, a still-extant Cambridge consulting corporation. As a graduate student at Harvard, I was assisted by a technician who had worked with Dr. Kalmus, the founder of Technicolor, before the company moved west. I was later recruited to Technicolor by Don Kelly.* He introduced me to colorimetry and Jones diagrams, and I got a lot of practical experience watching much of the Technicolor Research Department working to stabilize the dye-transfer process.

When I came to MIT in 1959, Arthur Hardy, one of the founders of colorimetry, was still professor of physics. Among many important things, he told me that it was a great idea to get to work at 8 A.M. and that he had once won a large bet with the president of a dyestuff company by producing yellow and blue colors that, when mixed, gave dark red. He also claimed he could make the glow of a cigarette seem to be green. (I never saw that demo, but I did find yellow and blue theatrical gels that made red.) When Hardy retired, I inherited his GE recording spectrophotometer, serial num-

---

*Don remains quite persuasive; he convinced me to contribute this chapter.

ber 1, and had one of my students replace its hand-made phototube with a 14-stage photomultiplier. I had used serial number 2 at Technicolor.

All of this is simply to explain why an electrical engineer might know something about color. Although I was introduced to it very much from the standpoint of colorimetry, there was always a strong practical bias — the objective always was to produce beautiful pictures. My mentors taught me that tone scale is the most important aspect of image quality. They also taught me that two colors with the same tristimulus values look alike under similar viewing conditions* and that if the actual output is a colorimetric match with the intended output, everyone is satisfied. (I still hold these views as articles of faith, since they have been confirmed time after time.) This is in spite of the fact that simultaneous contrast, which has been understood for nearly 200 years, can make almost any color look like almost any other color.†

When my laboratory at MIT first started working seriously on color in 1976 under the sponsorship of the Providence Gravure Company, I think it is fair to say that most color printing, even of the highest quality, was done with little regard for colorimetry or any other aspect of color science. Providence wanted to computerize its process so that it could escape from the burden of producing five or more photographic generations to get to press, and to reduce the cost of retouching and makeovers. (Providence was generally satisfied with its final color quality.) The Helio-Klischograph,‡ Dr. Hell's wonderful machine that was the Providence workhorse, was a good deal more scientific than strictly photographic color separation, but there was still a great deal of trial and error. At that time, at R. R. Donnelly in Chicago, more than half the cost of making gravure

---

*Hereafter, in this chapter, when we refer to "appearance," it is understood that the viewing conditions have been standardized.

†In the 1960s I saw a remarkable demonstration of this by Ralph Evans, then research director of Kodak. At a show, he projected a series of beautiful slides at a leisurely pace. When he came back to the first one, we were amazed to see that it was as blue as a robin's egg! What Evans had done was to shift the color balance a little bit from slide to slide, until the last one was actually quite yellow. As a result of adaptation, it appeared normal.

‡This machine produces cylinders for printing by the rotogravure process, often used for high volume color printing such as the magazine sections of Sunday newspapers. It is essentially a gigantic drum-type facsimile machine, in which originals are placed on a scanning cylinder and corresponding printing cylinders are made by engraving a series of closely spaced small holes (cells) in the surface of the latter by means of rapidly oscillating diamond styli. The amplitude of the oscillations, hence the depth (and ink-carrying capacity) of the cells, is controlled by the electrical signal derived from the scanning cylinder. Since the Klischograph takes an electrical input, it is well suited to being driven from a computer.

cylinders was due to retouching and makeovers. *National Geographic*, which did its final color correction on the press, was discarding about 25% of the 13 million copies it printed every month.

Some proposals for more scientifically based processing had been made before we started. Pobboravsky of the Rochester Institute of Technology (RIT) developed an empirical mathematical model to transform CIE values* to ink amounts in 1962 [1]. Korman and Yule (Yule later served as a consultant on the MIT project) used lookup tables to do this conversion somewhat later [2]. Pugsley and others at Crosfield developed methods to use digital lookup tables (LUTs) to implement the transformations of the analog color computer in a drum scanner [3]. Sakamoto at Dai Nippon Screen had some interesting patents using lookup tables [4]. Warren Rhodes of Xerox wrote a comprehensive review paper on the subject in 1978 [5]. Except for the Crosfield LUTs, none of these proposals had been fully developed and none, in our view, dealt with all the problems and met all the requirements of commercial printing.

Another source of inspiration for improvements in color printing came from the motion picture industry, where printing simulators had been in use since the early 1950s. The system at Technicolor, for example, had a soft proof based on a three-CRT additive display that at a distance of 5 or 6 feet was quite indistinguishable from a rear-projected transparency. The entire photographic and chemical process was accurately simulated in analog hardware.† Hazeltine eventually made a very successful commercial negative timer similar to the Technicolor device. I thought of these machines 25 years later at a color conference when one of the attendees maintained that it was impossible to match inks with phosphors!

One of the earliest, and easiest, decisions on the Providence project was therefore to have a very accurate soft‡ proof — one so good that the operator's decisions made on the basis of the display would be correct. The long turn-around time in conventional proofing is a major reason these processes

---

*The Commission Internationale sur L'Eclairage (International Commission on Illumination) values specify the appearance of colored light (such as from light sources or as light reflected from a surface) under standardized viewing conditions independent of the physical constitution of the light. Two stimuli that have the same CIE values match in appearance.

†The so-called negative timer was designed and built at Stanford Research Institute under contract with Technicolor. Although entirely analog and open-loop, and thus requiring very careful maintenance, it worked very well, producing completely acceptable results by the second trial in almost every case. Such simulators are now common in both motion picture and still color printing.

‡That is, a nonpermanent image on a CRT, not a permanent image on paper.

are so slow and laborious. While everyone agreed about the desirability of soft proofing, virtually no one believed it could be done, in spite of the successful experience in photography.

What else can color science contribute to the graphic arts? This question can best be explored by reviewing color printing before the advent of computer-based systems. Many of these systems are still in use and, with enough skill and patience, excellent results can be obtained.

White light passes through a transparency and is then divided into red, green, and blue (RGB) components. The magnitudes of these three are considered to be related to the amounts of cyan, magenta, and yellow (CMY) ink to be deposited on the page. This makes a certain amount of sense if we assume that the RGB light values indicate roughly the amount of CMY dyes in the film, and if we further assume that the CMY inks on the paper behave something like the dyes.

Whether in purely photographic media or by use of a scanner, the operator proceeds to "correct" the light values to make the picture come out right. Some guidance for the correction is given by the pattern of unwanted absorptions of the dyes in the film and the inks to be put on the paper, although no sufficiently accurate and complete model of the physical process is available. The basic color correction that is used is a form of masking* in which the RGB colorhead signals are subjected to a 3 × 3 linear matrix transformation. With it, red, green, blue, cyan, magenta, yellow, white, and black are made to print properly.

Even if such a procedure were accurate, it would not be sufficient. If printing machines had the same gamut (both color and dynamic range) as transparencies, and the latter were of good quality, the main task of the printer would be to reproduce (i.e., to match) the input. However, neither of these conditions exists. It is nearly always necessary to compress the gamut of the input to fit within the much smaller gamut of the output. In addition, the operator is called on to change some colors in the original to correct exposure and scanner errors, to achieve "preferred reproduction," and to match sample colors.

In any practical system, there are also mundane operations to be carried out that have little to do with color rendition, such as controlling scanners and printers, enlargement, reduction, rotation, combining pictures with other pictures and with typography, silhouetting, and a seemingly endless variety of special effects.

---

*Masking is the original photographic method of correcting for unwanted absorptions of dyes or inks in the print. When separations are being made, the original transparency is sandwiched with low contrast negative images, called masks, which precorrect for the extra absorptions by appropriately reducing the density of the separations.

It is this entire process that we want to replace with one that is faster, more accurate, and easier to learn and to use. We want to base the new system on science, that is, the physics and psychophysics of color reproduction.

Before listing all the things wrong with the conventional process, it is well to note that highly skilled craftsmen can get excellent results, albeit at very high cost, if they are willing to take the time and trouble. It would be out of the question for casual users of desktop publishing systems to use similar procedures, even if they were willing to take the time and trouble. Nevertheless, for any new system to be acceptable, it must be able to provide the same good results as older systems.

## II. DEFICIENCIES OF CONVENTIONAL PROCESSES

The main problems of conventional color correction are that the operator works in the dark (i.e., does not see the results until much later), the controls are entirely in terms of ink amounts and therefore do not do precisely what is desired, and the operator must remember an enormous amount of information about the behavior of ink, paper, and press. The result is that the overall color rendition is often unsatisfactory, and one must therefore resort to painstaking local correction, which requires cutting masks to confine corrections to single objects. (Such masks are unrelated to those used to obtain global corrections for unwanted absorptions.)

We have already pointed out the desirability of a soft proof for immediate feedback to the operator. Lacking such a proof, conventional printers use a catalog, or dictionary, of their colors. The color book has patches with a large number of different combinations of ink amounts. The scanner always has an indication of the ink amounts that will result for each point in the image with the current settings of all the knobs. While this is better than nothing, the appearance of colors in such a book is often far from their appearance in an image, because of simultaneous contrast effects. In addition, it tries the patience of any operator, no matter how careful, to check the rendition of enough points in the picture after each adjustment. Such checking is necessary because changing one color with these methods invariably changes others as well.

A major part of the operator's difficulty is the result of excessive dependence on the characteristics of the scanners and printers. While it is true, of course, that even old-style color correctors are ultimately concerned with the appearance of the results, they actually work with amounts of ink. If a color is wrong, they think of fixing it by adjusting the dot percentages (i.e., the amount of each ink) of each separation. Even for a highly skilled operator, such corrections are only approximate at best, and it is virtually

impossible to fix both the color and the tone scale at the same time. Many cycles of trial and error are necessary.

Conventional operators also get into troublesome details of ink and press behavior, such as gray balance, dot gain, trapping, and ink coverage.* As we shall see, all this is quite unnecessary with modern methods.

To top all this off, the behavior of different inks is sufficiently dissimilar that the same corrections do not work in every case. For example, when separations are sent to newspapers and magazines in the case of national advertising, they are always accompanied by paper proofs to show what the pictures are supposed to look like. Even so, the results are quite variable, as can readily been seen by looking at the same ad in different publications. I used to collect examples of this to show just how striking the differences are.

Although, as we have said, it is possible to get excellent results with traditional methods, the results are often quite poor, despite the expenditure of a great deal of money. In the case of pictures that are separated by the publication, not printed from supplied separations, the results are even more variable. Kodak used to hold an annual contest in which the same original was provided to many newspapers and prizes were then awarded on the basis of results. The winning efforts were exhibited side by side at the convention of the American Newspaper Publishers Association. What this contest demonstrated was that the existing methods, in the hands of all but the most skilled and most patient operators, yield extremely variable results, many of which are really awful.

There is one way to get fairly good results without too much trouble, even with conventional methods, and that is to attempt to print subject matter only within a very restricted range of color and contrast. Once the process has been set up to get acceptable results with sample pictures, it will continue to produce as long as the pictures are quite similar in these respects. Yearbook printers, for example, use one set of corrections on all pictures, depending on the client to provide pictures that will give acceptable results. They sell this service on the basis of "we give back what you give us." It is also true that many operators turn too many knobs in a vain

---

*Dot gain* is the tendency for halftone dots to change size from stage to stage in the printing process. Although dots can get larger as well as smaller, with the usual adjustments, enlargement of dots is more common; hence the term. *Trapping* is the tendency of the amount of ink laid down to depend on the amount of (wet) ink already deposited on the page. *Ink coverage* is more jargon. Coverage is the sum of the amounts of all the inks, each expressed as a percentage of the maximum possible. With four colors, the maximum coverage is 400%. Usually, no more than 270% would be used on account of problems with trapping and drying.

attempt to get perfect results. Professor Miles Southworth, head of the School of Printing at RIT, who has long experience in this matter, always advises his clients to "set it and forget it" for most of the controls.

## III.  A BETTER WAY

The first step in improving the process is the acceptance of the basic color-matching idea of colorimetry. That is, the appearance of a color patch on the page, under standard viewing conditions, can be accurately predicted by its tristimulus values; these values can be measured with an instrument other than the human eye.

The second step is to accept that a given mixture of inks on a given paper produces a given appearance and therefore a given set of tristimulus values. Of course, the printing process must be stable enough to ensure that a given set of input data to the printer does, in fact, produce the expected amount of inks.

The third step is to perform editorial corrections in terms of appearance rather than in terms of ink amounts. Not only is this more natural and much easier for the novice, it mostly divorces the editorial correction process from the ink behavior. The implication is that if we know what we want the color to look like, we can find the right ink mixture for any particular printing process and thereby achieve "device independence."

The final step is to provide a display good enough to enable operators to make correct judgments.

If we take these steps, we can remove much of the trial-and-error aspect of color printing—the part that for decades was passed off as art—and reserve for the human operator only the judgments that are better made by people than by machines. For the most part, such judgments comprise deciding on the appearance of the final result, given the limitations of the equipment. We can use the machine to do everything else, in particular to deal with the physical characteristics of the scanner, printer, ink, paper, and so on. The separation of these two aspects of color correction, one to be carried out by machine, which involves extensive number crunching, and the other to be executed by a human operator with machine assistance, goes a long way toward rationalizing the process.

This separation of the process into two parts cannot be graven in stone. As our knowledge of what the operator does improves, and as data processing becomes cheaper and faster, it no doubt will become possible to automate at least some of the judgments now thought to require uniquely human capabilities. Nevertheless, for the foreseeable future, high quality color printing will continue to require a certain amount of human interven-

tion. It should be the aim of the designers of computer-based systems to make this intervention as easy and fast as possible.

## IV. IMPLICATIONS OF THE FOUR ASSUMPTIONS

1. *We must relate the tristimulus values to the representation of colors at every point in the system.* To operate a system based on the assumptions given in Section III, the quantities we deal with in the correction process must be tristimulus values or invertible transformations of tristimulus values. For example, one file may contain such data related to the original transparency or print, another may relate to the appearance of the final page, a third to the display. Still others may relate to intermediate or alternate representations. Note that any three numbers can be thought of as tristimulus values. Given the reference white and the three primary colored lights, any set must therefore correspond to some color. To be most useful, the primaries and the reference white should be the ones used in the system, and particularly for the display.

Even if this is not precisely the case, the sets of numbers can be quite useful. For example, if a set of numbers is with reference to a different set of primaries, the set can readily be converted by a $3 \times 3$ linear matrix conversion. If two image files are with reference to the same primaries, even if not the system primaries, they can still be compared.

2. *We must accurately characterize the performance of scanner, printer, and display.* To ensure that the system values correctly relate to the appearance of input, output, and displayed images, all three must be colorimetrically calibrated. This is absolutely required in the case of the printer but less important for the scanner and the display. The display can be used to compare images even if it is somewhat off-color. Small errors in the scanner can be corrected in the system. However, if printer errors are unknown, there is no assurance that "corrected" images will be printed correctly.

3. *The display is of central importance.* Correct operator judgments can be made only if the entire image can be seen at one time, and if the operator (a) receives very rapid feedback as to the effect of the adjustments and (b) can rely absolutely on getting the expected results. Other aspects of the system can be more or less convenient, but a display with these characteristics is essential for getting the benefits of a computer-based system.

4. *We must provide an easy way to do editorial corrections.* In performing as aesthetic judge, the operator's essential task is to change the appearance of images from what they are when scanned in to what the

operator wants them to look like when printed. That means that the operator must be able to see what is wrong from observing the display and must be provided with appropriate controls to make the desired changes. Color balance and gradation are two obviously essential parameters of correction. Specific colors may need to be changed to match samples and to achieve "preferred" reproduction. Since high contrast and high saturation almost always improve image quality, and since both are limited by the gamut of the printing process, it must be easy to take the gamut into account during adjustment.

## V. SOME TROUBLESOME DETAILS

### A. The Scanner

Scanners, of course, must have appropriate resolution, signal-to-noise ratio (SNR), dynamic range, geometrical accuracy, speed, and convenience. With respect to color reproduction, it would be preferable if the RGB outputs were the tristimulus values of the original image, or were easily related thereto. No doubt, such scanners will eventually become commonplace. In the meantime, we must be concerned with the degree of departure from this preferred performance.

If the colorimetric errors of the scanner are very small, they can be ignored and corrected during the editorial process. If desired, a 3 × 3 linear matrix transformation can be used to make a first-order correction, or a three-dimensional lookup table (LUT) can be used to make a more precise correction. A limitation on the degree to which such algorithmic transformations can correct scanner errors is set by the metamerism due to the scanner's spectral responses. If these responses are much different from those of the human visual system, the errors will depend, more or less, on the colorants used in the original image. In that case, there is no unique transformation from scanner signals to tristimulus values; a separate transformation is required for each type of input material.

Besides color errors, which are always present to some degree, each scanner has a gradation characteristic. Signals linearly proportional to transmittance or reflectance are a poor choice from the standpoint of SNR. For decades, the graphic arts have used a quasi-logarithmic transfer characteristic that is approximately uniform in perpetual terms. It is very helpful to know what this characteristic is. If it is fixed, it can be measured by means of scanning a step tablet.

Some scanners designed for the desktop market make corrections for the input image, usually for the minimum and maximum density. While this would be quite helpful if no other adjustments were to be made, it

is inappropriate for full-scale processing systems that have much better gradation controls. If image density is out of control of the operator, and not conveniently measured, there is no choice but to correct it on a picture-by-picture basis.

## B. The Display

The cathode-ray tube is a nearly perfect additive color-mixing device. RGB signals that are directly proportional to phosphor luminance are precisely the tristimulus values of the displayed color, with respect to the primaries (the phosphor colors) and the white point. The latter is the color of the screen when all three phosphors (or input signals) are at their maximum values. Knowledge of this physical behavior greatly simplifies printing. When the displayed image is satisfactory and is known to be within the gamut of the printer, one simply converts RGB values into ink values known to produce the color.

Purely by happenstance, the transfer characteristics of CRTs are such that quasi-log input signals produce a nearly linear relationship between phosphor luminance and RGB values. This characteristic is also very close to the "gamma-corrected" signals normally used in television. It is thus quite easy to display colorimetrically accurate images.

To make the CRT look like the printed page requires more than the correct phosphor luminances. It is absolutely essential to control the viewing conditions, and therefore the state of adaptation of the operator's eyes. To see how large this effect can be, it is only necessary to turn the room lights on and off while observing a television screen. One way to control adaptation is to work in a dimly illuminated room and to surround the screen with a self-luminous border of reference white, several inches in width. Attempts to compensate for other viewing conditions by adjusting the gradation of the image generally do not yield sufficient accuracy.

There is another strong reason for operating in as dark a room as possible. The CRT screen is not really very bright, and it is hard to see details unless the room is dark. In addition, the dynamic range of the screen, which is barely high enough in the dark, is reduced in the presence of ambient light. Brighter screens that are less troubled by room light would help a great deal.

When it is impossible or inconvenient to work under these ideal conditions, pictures can be corrected by comparison with reference images known to print correctly. In fact, an argument can be made that the comparison method is more accurate for matching colors than absolute judgments made, effectively, by comparison with reference white. However, what cannot be seen cannot be compared; the display must at least clearly

show the tones and colors that are to be corrected. (This is particularly difficult in the shadow regions.) The closer the viewing conditions are to ideal, the more accurate the judgments will be.

## C.  The Printer

For a system based on color science, the printer simply translates input signals into ink amounts. Under stable conditions and with a given paper, each combination of inks yields a color with known tristimulus values. The relation between input signals and tristimulus values characterizes the printer completely from the colorimetric point of view. (Of course, many other printer characteristics, not related to color rendition, are essential to good quality, just as in the case of scanners.)

The printer characteristic is determined by printing a sufficient number of color patches and measuring the results with a colorimeter. The data, which we can call the color database, are used to calculate the contents of a LUT, which is then used to translate from the RGB values of a desired image into the ink amounts that will produce it. To limit the size of the LUT, a relatively small table is used along with interpolation.

To get sufficient accuracy in this translation, there must be enough measurements in the color database and enough entries in the table. A reasonable criterion is an error of one just noticeable difference (JND) over the entire color space. It appears that 100–200 properly spaced colors is sufficient for a three-color system and 500–1000 for a four-color system. Some LUTs have been made with as few as 512 entries, but 4–32 k is more usual.

Note that the translation of the LUT automatically accounts for all vagaries of the press, provided they are constant. Dot gain, gray balance, trapping, and other problems that must be painstakingly resolved in conventional systems are all precompensated by a properly made LUT. Of course, if any of these effects produces a chaotic color database, it will be impossible to create an accurate LUT. Such problems must be sufficiently resolved by process adjustments to permit a printer characteristic that is smooth and preferably monotonic.

## D.  Editorial Corrections

Long experience in the graphic arts shows clearly that color balance, gradation, and selective color correction are the most important tools to be made available. Local color correction, long practiced in conventional processing and used to change the color of single objects in the image, is much less important in computer-based systems, since the overall color rendition is so much more accurate. There is some application for tools that permit matching a color in the image with a sample color designated by its tristimulus,

Munsell, or Pantone values. There is also some need to match an image color with a color in a reference image.

The primary purpose of color balance adjustment (which has nothing to do with "gray balance" as known in conventional systems) is to compensate for the lighting of the original scene. This is best done by calculating, from the scanner output, what the red, green, and blue exposures of the original were, changing them as needed, and recalculating corrected scanner signals.

Gradation adjustments are best done just as in conventional systems. Because the printer's dynamic range is almost always much less than that of the transparency, it is desirable not to waste any of it. Some light tone is thus usually chosen to print as paper white and some dark tone at the maximum density. Further adjustments, such as contrast, brightness, and incremental contrast in various sections of the tone scale, should not affect these end points.

Selective color correction maps the entire color space. A straightforward way to do this is to divide color space into a number of overlapping regions and to permit independent shifts of luminance, hue, and saturation in each region. Care must be taken to smooth the region-to-region adjustments. One purpose is to improve overall color rendition, after scanner corrections have been made. Adjustment for "preferred reproduction" (e.g., reddish faces and deep blue skies) is also performed at this point. This part of the mapping can be used for all pictures. Another function is to match sample colors, which is a picture-by-picture operation. A final function is to get the highest possible quality within the gamut of colors that can be printed. This is such a significant problem that it deserves its own section.

## E.  Nonprintable Colors

All printing processes have a definite gamut, or range of colors, that can be reproduced. The gamut is affected by the inks, the halftone dot pattern, the paper, and the state of adjustment of the machine. The maximum density is limited by the physics of surfaces and the minimum density by the whiteness of the bare paper. Thus the dynamic range, with the best paper and regardless of inks, is generally less than $100:1$. Poor ink and paper can make it much smaller. On the other hand, the luminance of the real world may have a dynamic range as high as $10,000:1$, while transparencies may go as high as $1000:1$. Dyes in film behave better than ink on paper.

For all these reasons, many colors found in transparencies cannot be printed. A good deal of gamut compression is required. Compression of the density range is fairly well understood. When this is carried out, all the remaining nonprintability can be thought of as excess saturation. However,

compression of the chromatic range is much less well understood than compression of the tone scale. Simply reducing the saturation uniformly usually results in images deemed unsatisfactory because of lack of "colorfulness." As mentioned earlier, high saturation and high contrast, both of which usually improve quality, also increase nonprintability.

Although it is conceivable that some chromatic compression might be done automatically, much of it is highly subjective and depends on personal preference and custom. It seems a good rule to try to change colors as little as possible while shifting them into the printable gamut, at the same time preserving detail in the regions of the image where colors must be moved. If nonprintability is indicated on the screen, it does not take long to remove most of it and still get good pictures by means of hue-by-hue nonlinear compression of both saturation and luminance. In the Providence project, we found that, if most of the nonprintable colors were manually removed in this manner, the remaining nonprintable colors could simply be moved to the closest point on the surface of the printable gamut. This algorithm was built into the RGB-to-CMYK LUT, and generally produced good results.

## F. The Black Printer

Black ink is used in printing primarily to save money by reducing the amount of colored inks and substituting black. This also reduces the total amount of ink on the press and puts more of the imagery in the black, thus reducing the effect of misregistration. There may be a small extension of the tone scale. Black should not be used simply to produce a particular color; modern LUTs are so accurate that any desired printable color can be obtained without resorting to such measures.

If the inks were perfectly transparent (i.e., if no scattering in the body of the ink or reflection at ink surfaces took place), we could simply reduce the density of all colored inks by a percentage of the smallest of the three densities and add an equal amount of black. The percentage removed is called the undercolor removal (UCR) percentage. However, real inks behave in a much more complicated manner—so complicated that the amount of colored ink to be removed and the amount of black to be added can be accurately determined only by empirical means.

Because of the difficulty in getting the right color if a lot of black is used, printers had grown accustomed to using very little, except in the darkest areas of the image. Until a few years ago, no printer believed that 100% UCR was possible. Many just added a little black in the dark areas to raise the contrast. With the advent of accurate color databases and LUTs, however, it was found that a great deal of black can be used, with resultant large savings in the cost of colored ink.

Since perceived color has only 3 degrees of freedom, there is no unique combination of CMY and K that matches a given RGB. Instead, there will be a continuum of combinations with varying amounts of black, ranging from some minimum to some maximum. Many different constraints can be added to choose among the possibilities, and the resulting colors are entered into the LUT.

## VI. THE PROVIDENCE PROJECT

The first implementation of the scheme discussed here was at MIT under sponsorship of the Providence Gravure Company, beginning in 1976. The objective was a complete prepress system for gravure printing, including page composition and imposition, something that was not then commercially available. A complete system was built and installed at Providence, and test pages were printed in the *Boston Globe* magazine section in the early 1980s [6]. A large number of other printing tests were made. All the novel features were demonstrated. The ability of the system to produce high quality results on the first try without any retouching was confirmed. Successful results were obtained by programmers employed by the sponsor and by MIT graduate students, none of whom had had any prior experience in color work.

The system was based on the DEC PDP 11/34 processor augmented by a good deal of special-purpose hardware. The editorial correction process was completely interactive, the screen being fully updated every 1/60 second. Operations were carried out in a dimly illuminated room, all concerned agreeing that the screen provided a sufficiently faithful prediction of the appearance of the final page to enable the operator to make correct decisions. The system was not foolproof, however: it was found necessary to observe the screen very carefully to make sure the entire image area was satisfactory. The particular correction functions made available to the operator were deemed satisfactory for most subject matter, although improvements certainly could have been made. The construction cost of the system, including the Klischograph and scanner interfaces (but not the Klischograph itself or the scanner) was about $300,000.

Figure 1 is a block diagram of the conceptualized editing process. Scanned images are digitized and stored in TV resolution as well as full resolution. Editing is implemented in the color translation module (CTM) under control of the knobs on the operator's panel (Fig. 2). The edited image appears on the TV display, blinking in regions of nonprintable colors as detected by the excess gamut alarm (EGA). A comparison with the original image in the comparison display of Figure 3 is often very helpful. When the operator is satisfied with the results, the full-resolution image is

**Figure 1** Scanning and editing in the Providence system. The original material is scanned at appropriate resolution and a TV version is displayed and interactively edited. The full-resolution version is then modified in the same manner, coded, page-composed, and stored on disk. A comparison display of the original plus edited images helps the operator achieve the desired result. (From Ref. 6.)

read from the disk memory and processed by the CTM. Page composition and coding follow this step, the edited and coded page files being stored on disk.

At engraving time, the pages are read from disk (Fig. 4), decoded, and converted to ink amounts by the ink correction module (ICM), whose contents are computed from the results of a large printing test. For each RGB address, the LUT in the ICM contains the amounts of ink required to give the RGB appearance. The data then are formatted for the engraving machine and converted into analog form to drive the engraving heads.

Figure 5 shows the interface of the system installed on top of the electronics console of the Klischograph. The cylinders shown are about 2 meters long and 1 meter in circumference, holding 32 magazine pages.

## VII. ELECTRONICS FOR IMAGING

Recently, Electronics for Imaging, Inc., a new company in San Mateo, California, has introduced a version of the system that runs on a MacIntosh

**Figure 2**  Control panel for interactive editing. The principal controls are color balance, gradation, and selective color correction. For the latter, the hue range is divided into seven overlapping sectors, each of which can be altered in hue, saturation, and luminance. In addition, one particular color "neighborhood" can be identified by hue range and saturation range and independently changed in hue, saturation, and luminance. It is also possible to add separately a vector increment of any direction and amplitude to chromaticity, in shadows, midtones, and highlights. (From Ref. 6.)

and outputs to a wide range of color printers. The system consists of one software module, *Cachet*, that implements the editorial correction features, and another, *Eficolor*, that performs the conversion from appearance variables to colorant amounts. The latter requires a so-called device profile, which characterizes the printer. Profiles have been made for many different printers using all the popular printer technologies. Postscript printers require, in addition, a hardware/software printer controller called *Fiery*. Separations for offset printing can be saved on disk and then printed by a variety of methods. Additional software is required for page composition.

The very inexpensive Cachet system is intended primarily for desktop publishing, where it can be used by operators with little color experience. To keep equipment costs down and to make the system usable in the normal office environment, editing is done by comparing the picture under adjustment with a similar reference picture, known to give acceptable results on the same printer, displayed side by side on an ordinary computer monitor. This has proved as satisfactory as the much more accurate (and expensive) display of the Providence system. As in the older system, good results can be obtained most of the time after a short training period.

Editing in Cachet is done with a series of screens. Figure 6 shows the screen for gradation and color balance. Color balance is effected by placing the cursor on a selected point on the color plane. Gradation adjustments are done moving moving sliders along six scales, which permit independent selection of white point, black point, brightness, contrast, highlight contrast, and shadow contrast.

Since Cachet is a software system designed to operate on any computer color monitor, we cannot rely on the colorimetric accuracy achieved on the

**Figure 3**   The comparison display of the Providence system. The image being edited is displayed on a colorimetrically calibrated monitor on the left, while the original (print or projected transparency) is displayed at the right. A close visual match was achieved.

**Figure 4** The output process in the Providence system. Composed and corrected pages are retrieved from disk, decoded, and converted into CMYK values by the ink correction module, a form of lookup table. The data are converted into the specific form required by the Klischograph engraving machine by the interpolator, formatter, and analog/digital converter. (From Ref. 6.)

**Figure 5** The Providence installation: the system interface (labeled "Pages") installed above the electronics console of the Klischograph in the Providence engraving room. The cylinders are about 2 meters long and more than 1 meter in circumference. Usually, 32 magazine pages are represented on each cylinder, of which there are four for four-color printing.

**380**

**Figure 6** The tone and color palette in Cachet, used to adjust color balance and gradation in the EFI Cachet system. These operations are performed on signals in RGB form.

**Figure 7** MultiChoice in Cachet. If the operator so desires, six versions of the working image can be displayed simultaneously, each showing a different degree of change for the particular parameter being adjusted. MultiChoice can be applied recursively to achieve the desired result without any direct adjustment of the particular parameter.

monitor in the Providence system. Instead, the working image is displayed on the screen, as shown in Figure 7, along with a reference image having similar characteristics and known to print correctly with the particular process being used. It is found that even if the monitor is not absolutely accurate, good results can be achieved simply by matching the working image with the reference image with respect to the parameter being adjusted (e.g., brightness, contrast). Another feature, called *MultiChoice*, causes the display of six variants of the working image with respect to the parameter being adjusted. The best one can be chosen and the operation repeated with smaller and smaller increments until the desired result has been achieved.

## VIII. CONCLUSION

Color science has made important contributions to the graphic arts. The central problem now being addressed successfully is the processing of color images to produce excellent printed results on a wide variety of printing machines. These results can be achieved by operators without extensive experience, although they must have normal color vision and some sense of what a good picture looks like. The fundamental principle of these new systems is that processing is carried out in terms of the appearance of the images rather than their physical constitution. Thus the display plays a central role. No detailed knowledge of ink and press behavior is required of the operator, although the scanner, display, and printer must be fully characterized by objective measurements. This achieves a large degree of device-independence, although the gamut of the printer must be considered during the editorial process.

An important characteristic of such systems is that the operator makes only aesthetic judgments. The computer automatically deals with the characteristics of the devices. The development of these systems would not have been practical before the advent of low cost integrated circuits of steadily increasing image-processing power. Full interactivity is required for the best results. At the present time, small general-purpose computers are almost capable of doing this.

## REFERENCES

1.  I. Pobboravsky, An engineering approach to color reproduction variability in a controlled printing environment, *Proc. Tech. Assoc. Graphic Arts*, pp. 127–166, 1962.
2.  N. Korman, U.S. Patents 3,612,753, 3,674,364.
3.  P. C. Pugsley, Prepress picture processing in the graphic arts industry, *IEEE Trans. Commun. COM-29*(12):1891–1897 (1981).

4. Sakamoto, U.S. Patents 4,060,829, 4,127,871.
5. W. L. Rhodes, Proposal for an empirical approach to color reproduction, *Color Res. Appl. 3*:346–361 (1984).
6. W. F. Schreiber, A color prepress system using appearance variables, *J. Imaging Technol. 12*(4):200–211 (1986). See also U.S. Patent 4,500,919.
7. *Seybold Report on Desktop Publishing*, Vol. 7, No. 2, October 1992.

# Introduction to Chapter 10

In some ways, the author of this chapter has the most difficult assignment of all. Each of the other contributors was writing about a *fait accompli* — work that he and others had already done. But I asked Professor Glenn to look into his crystal ball, to forecast what popular display systems would look like in the next century, and how they might take advantage of the spatiotemporal-chromatic interactions that are described in Chapters 3, 4, and 5. If anyone can do that, he can.

If you grew up in the days of black-and-white movies and no television, as I did, you may be astonished by the progress of real-time displays in just one or two generations, when you think about it. I do think about it, sometimes, because I was privileged to play a small role in that progress as a Technicolor researcher for 15 years. Today, we take wide-screen movies and color TV pretty much for granted, but the display revolution continues to affect our daily lives. Never mind all the expensive gadgetry for military command and control systems; the future of so-called high definition television (HDTV) for the home makes headlines in my newspaper.

The new world will be all-digital, of course. I am suitably impressed by the manipulations that can be performed on still pictures, in color, by even such a plebeian computer as the Mac II in my lab. But these feats pale compared to the real-time processing of moving images that surely lies in the future of commercial communications. What is new, as I mentioned in the Preface to this book, is that these developments in digital processing

are increasingly based on a more sophisticated understanding of how the visual process works.

As a leader of this trend, Dr. William E. Glenn is uniquely qualified to give us a survey of its current status and future prospects. His illustrious career includes a Ph.D. from the University of California at Berkeley and subsequent positions at Lawrence Radiation Laboratory, General Electric Research Laboratories, and CBS Laboratories, where he served as vice president and director of research. After a period as director of the Science and Technology Research Center at the New York Institute of Technology, he came to his present position as director of the Communications Technology Center at Florida Atlantic University. He has received more than 100 patents and many awards for his outstanding work in unconventional photographic and TV systems over the years, including HDTV systems. Like the author of the preceding chapter, Dr. Glenn is a recipient of the David Sarnoff Gold Medal from the Society of Motion Picture and Television Engineers.

Some of the remarkable properties of human vision discussed in this book, and elsewhere in the literature, have not yet been pressed into service for the development of future displays, and for that we make no apology. Speaking as a vision researcher, I hope we always keep at least a few jumps ahead of the display developers; that is as it should be. But I find it very exciting that these applications have gone as far as they have. So will you, when you read Bill Glenn's chapter.

# 10
## Real-Time Display Systems, Present and Future

**William E. Glenn**

*Communications Technology Center, Florida Atlantic University, Boca Raton, Florida*

## I. INTRODUCTION

For more than a century, display system designers have been trying to produce images that are as close as possible to replicas of the real world. Researchers studying visual perception have been trying to figure out how the visual system, including the brain, detects and processes images. These two fields of study in the past have had very little formal interaction. Empirically, display system designers have taken advantage of many of the properties of vision by changing the system in ways that made the image look better. Visual perception researchers have found displays, particularly electronic displays, to be an invaluable tool for performing psychophysical experiments aimed at understanding how the visual system works. Experiments of this kind are described in the early chapters of this book.

Only recently (at the Topical Meeting on Applied Vision, held in San Francisco by the Optical Society of America in July 1989) have system designers and vision researchers established formal interactions to apply the results of vision research to electronic display systems. Obviously, a display system needs to display a scene as the visual system can perceive it. Consequently, a thorough understanding of the limits of visual perception is vital for the efficient design of display systems.

Recent advances in digital processing now make it possible to manipulate electronic imaging signals almost any way we want. The existence of digital

frame stores allows us to build temporal filters as well as two-dimensional spatial filters. We can now multiply and divide signals easily—a process that has been avoided in analog signal processing.

Solid state matrix addressing and a variety of new ways of modulating and generating light have all made possible the production of displays that can finally free us from the limitations of the cathode-ray tube. Modern display technology can treat motion rendition and flicker as separate issues.

Displays can physically be more like a picture or a window rather than a box.

Our present television system has been designed to give optimum performance within the technology restrictions that existed around 1950. A typical living room dictates a viewing distance of about 9 feet. The largest cathode-ray tube that can be produced economically is about 3 feet on its diagonal. Some early psychophysical studies by Baldwin at Bell Labs in 1940 [1] analyzed what resolution an image had when one reached the point of diminishing returns under these viewing conditions. The field rate of the image was determined by flicker perception of the rapid decay that was required of the CRT. This field rate determined the bandwidth that was required. Bandwidth was, and still is, a precious commodity at the frequencies that are usable for terrestrial transmission.

When the National Television Standards Code (NTSC) color system was designed, it was known that color signals should be isoluminant. However, analog circuits could not easily multiply and divide signals. Consequently color difference signals* were used as a compromise solution. Color difference signals are not isoluminant; they approximate isoluminant signals only for colors with low saturation (pastels).

Today digital processing and digital transmission make it possible to compress a much higher resolution image into the available bandwidth. We also can provide noise-free and ghost-free reception. Large displays can be made that do not flicker. Digital processing can allow the use of isoluminant color signals. In short, over a period of a few years we have started eliminating most of the barriers that have prevented us from bringing the "real world" electronically into the living room. With all the new technology at our disposal, we can now reevaluate the entire electronic imaging system.

As a baseline, Table 1 lists the properties of our present color television transmission system.

---

*In television practice the color signal used is the difference between the amplitude of a primary color and the amplitude of luminance (brightness). This is referred to as a "color difference signal."

**Table 1** NTSC Color Standard

| | |
|---|---|
| Aspect ratio | 4 : 3 |
| Scan format | 525 lines per frame |
| | 483 active lines displayed |
| | 320 TV line resolution horizontally and vertically on a test chart |
| Scan rate | Interlaced scan |
| | 525 lines per frame |
| | 262.5 lines per field at 59.94 fields per second |
| Transfer curve | $V = I^{1/2.2}$ |
| (light $= I$; video signal $= V$) | |
| Signal distribution and transmission | Analog |
| Color | Color difference signals |
| Color resolution (test chart) | 320 TV lines vertically |
| | 40 TV lines horizontally |
| Color signal | Composite quadrative modulated 3.58 MHz carrier (spectrum shared with top 1.2 MHz of luminance signal) |
| Sound signal | Analog |
| Display | Cathode-ray tube: brightness about 75 foot-lamberts |

High definition television (HDTV) has been defined as a system that is at least twice the resolution on a test chart of standard 525-line television. Several other aspects have met with international agreement, including aspect ratio and the use of digital stereo sound. There probably will be many HDTV systems in use whose parameters depend on the application. One production format currently being used to produce program material for transfer to 35 mm film for theater release can be converted to other electronic formats for distribution and display. In addition, several digital HDTV transmission formats are being evaluated for terrestrial broadcast. HDTV video recordings and high definition computer displays will probably use other formats. Table 2 shows the parameters that are generally agreed on in the United States.

This chapter describes in terms of visual perception the techniques that have been used to produce efficient, high quality display systems. It then projects how future display systems will be able to take advantage of the visual sciences and physical sciences to improve their performance and efficiency.

**Table 2**   HDTV Format

| | |
|---|---|
| Aspect ratio | 16 : 9 |
| Test chart resolution | > 640 TV lines per picture height |
| Display refresh rate | > 59.94 per second |
| Signal distribution and transmission | Digital |
| Color resolution | > 320 TV lines red–cyan |
| | > 160 TV lines blue–yellow |
| Color signal | Digital component (separate from luminance) |
| Sound signal | Digital > 2 channels |
| Display | ? Many options |

## II. FIELD OF VIEW, SHARPNESS, AND RESOLUTION

First, let us consider how we view a moving image. Studies of viewing habits [2] have revealed that given a choice, observers will choose a rather narrow range of distances from which to view a given image resolution. A 525-line television image is normally viewed at 7 ± 2 screen heights. The limiting resolution of projected motion picture film produces the same resolution on the viewer's retina when the viewer is seated at the center of the theater.

High definition television was originally designed to provide the same viewing experience (sharpness, contrast, field of view, etc.) as the motion picture theater [3]. These are much higher performance requirements than current standard television.

The term "sharpeness" implies a subjective impression of an image. While people frequently think of sharpness as being determined by resolution, that is only one of many factors that give an impression of sharpness. The contrast ratio, the modulation transfer function at the midspatial frequencies, and the transfer curve between light into the camera and light out of the display (frequently referred to as the overall gamma) all are important in producing an impression of sharpness.

Resolution, on the other hand, is a physical measure. When discussing the image as perceived by a human observer, we generally use cycles per degree (c/deg) to define resolution, since this set of units can be related to the size of the pattern on the viewer's retina. Television engineers use the term "TV lines per picture height" to define resolution. On a test chart they count both the black and the white lines; consequently, it takes two TV lines to make a cycle. Sampling theory indicates that it also takes at least two scanning lines to produce a cycle (the Nyquist limit of resolution). For a television display, one must divide the number of TV lines of resolution

by 2 to get cycles per picture height. One must then know the viewing distance to determine the number of cycles per degree perceived by the viewer. The limiting resolution as measured by a test chart occurs when the contrast of a spatial frequency on the display drops below the threshold contrast sensitivity of perception by the viewer at that spatial frequency. The threshold contrast sensitivity curves are discussed in detail in earlier chapters in this book.

It is important to realize that projected 35 mm film in a typical theater actually has a test chart limiting resolution of only 750 television lines per picture height. This resolution limit is imposed more by the projector than by the film. When the cold film hits the film gate in the projector, its temperature rises rapidly and the film buckles. Projectors must use a rather large aperture lens with a very short depth of focus to get enough light on the screen. The motion of the film from buckling exceeds the depth of sharp focus of the lens. Seventy-millimeter film buckles even farther than 35 mm film. Although 70 mm film has better resolution on the film, the projected image does not have significantly better resolution. The main advantage of 70 mm film is that it can pass more light and produce a larger, brighter image. It is only with special film-handling machinery such as in the projectors used in IMAX or Omnimax theaters (or similar projectors produced by N. J. Engineering) that high resolution moving images can be projected. The projectors prevent the film from buckling by using a vacuum to suck the film flat on a quartz optical gate. Standard projectors using 35 mm film, 70 mm film, or HDTV displays have a preferred viewing distance of 3.5 ± 1 screen heights. This is twice the field of view of standard television viewing. It is the same resolution image on the viewer's retina but twice the field of view.

Why is it that viewers choose this rather narrow range of viewing distance?

When an observer is viewing a moving image, there is an optimum resolution on the viewer's retina to perceive the information in the image. The region of high acuity in the human fovea is only about 1 degree. A plot of cone cell density as a function of eccentricity is shown in Figure 1 [4]. A large fraction of the neurons in the visual cortex are devoted to processing the information in the fovea. At a close viewing distance, only a very small part of the projected image (< 1%) falls on the fovea. Consequently a viewer will move back to increase the portion of the image that subtends this small solid angle. The viewer will stop moving back when the resolution on the display starts to exceed the resolution of the eye. We can understand when this happens by referring to Chapter 3. All information that has lower contrast than the threshold contrast sensitivity functions shown in Chapter 3 is imperceptible to the viewer. At 22 c/deg, this threshold contrast is a

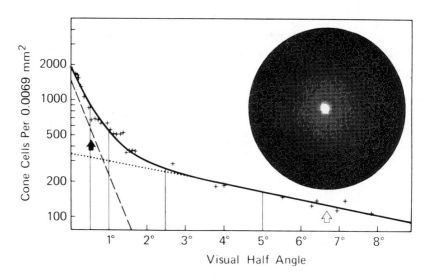

**Figure 1**  Distribution of cone cells in the human retina. (From Ref. 4, after Østerberg.)

factor of 3 higher than at its best sensitivity, around 4–6 c/deg (see Fig. 1 or 11 in Chapter 3). The contrast required increases rapidly above this spatial frequency. Consequently, a large part of the information above 22 c/deg will not be detected. This compromise between increasing the portion of the image that falls within the fovea and still not exceeding the resolution limits of the visual system results in the rather narrow range of viewing distance that places the limiting resolution around 22 c/deg on the viewer's retina.

The important factor here is the limiting resolution of a test chart. The test chart resolution for a given scan format is determined by the number of scanning lines. As shown in Figure 2, at the optimum viewing distance, the scan line spacing (in millimeters) will be the same for all scanned images. The HDTV image will be larger simply because it has more lines. HDTV results in the same resolution image on the viewer's retina but with a larger field of view.

The consequences of this fact are indicated in Figure 3. At a typical 9-foot viewing distance, a 24-inch diagonal display is optimum for 525-line television, while a 63-inch display is optimum for HDTV. With a 33-inch screen, the traditional shadow mask CRT is at the limits of this technology. We cannot meet the cost, size, and weight objectives for a much larger display with a CRT. Better projection displays or direct view hang-on-the-wall panels must be developed.

Cathode-ray tubes or direct view, active-matrix liquid crystal display (LCD) panels are adequate for computer displays. Viewing conditions for computer displays are quite different from those for entertainment viewing. Computer displays are viewed at reading distance (with reading glasses if you are over 40). The typical 30° field of view can be achieved with a rather small screen. That does limit the number of simultaneous viewers of such a display, but this limitation is seldom encountered for computer viewing.

There has recently been some discussion of ultra-high-definition elec-

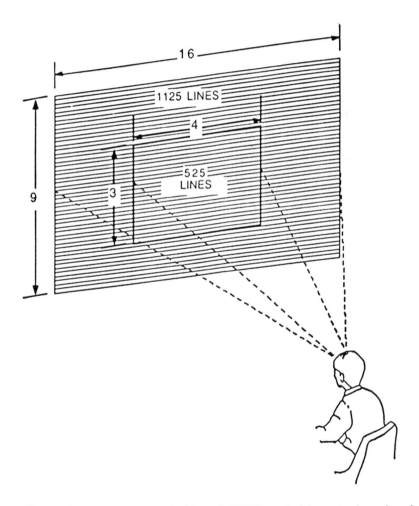

**Figure 2** Relative sizes of 525- and 1125-line television set when viewed at a distance of 9 feet.

## RELATIVE SIZE OF DISPLAYS

(9' viewing distance)

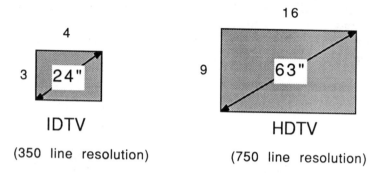

IDTV

(350 line resolution)

HDTV

(750 line resolution)

**Figure 3**  Relative size of standard (IDTV) and high definition (HDTV) images at the same optimum viewing distance.

tronic displays with 2000 lines or more [5]. From the viewing preferences discussed above, one would conclude that the preferred field of view would exceed 60°. This is approaching the viewing experience of Omnimax or IMAX theaters, which have a horizontal viewing angle of about 80° in the center of the theater.

## III.  DISPLAY ASPECT RATIO

One difference between current television standards and current motion picture practice is the aspect ratio (i.e., the ratio of horizontal to vertical dimensions) of the image. Figure 4 compares the shape of the two image regions in the visual field to the fovea (region of high acuity) and the parafovea (region of medium acuity); these are both circular. The limit of the field of view for binocular viewing has an aspect ratio of about 2 : 1 (about 180° horizontally and 90° vertically). At the preferred viewing distance of standard television, it subtends about 9° vertically. This is not much bigger than the round parafovea. The 4 : 3 aspect ratio is only slightly wider than it is high. The motion picture industry has found that as images were made to subtend a wider field of view, the preferred aspect ratio got wider. This ratio would reach a limit of 2 : 1 as the image reached the limits of our visual fields. It is not surprising that as the field of view of an image increases, its aspect ratio should be increased.

We have repeated the viewer preference experiments of NHK [3] for a field of view that corresponds to that of motion picture viewing and HDTV

viewing. In these experiments we kept the area of the display and viewing distance fixed. We also kept the number of pixels in the image constant. We used the same program material in many two-alternative, forced-choice comparisons where the aspect ratio was the only variable. We were careful to use program material that would not crop any important information for any of the aspect ratios. Our results [6] confirmed the preference also found by NHK to be around 5 : 3. The slightly wider aspect ratio of 16 : 9 was chosen for HDTV production as a better compromise between television practice and theater practice.

One of the fringe benefits of high definition television in the home has to do with screen size. We know how big things are, even when we view a display. We know that you can't get people into the 2-foot cube of a TV set. A drama looks like a puppet theatre. For the 63-inch display that is preferred for HDTV, people appear to be life size. This produces an additional aspect of apparent reality that is not present in either standard TV or the motion picture theater.

## IV. NUMBER OF PIXELS REQUIRED
## FOR A GIVEN SHARPNESS

As mentioned above, high resolution displays other than those on computer monitors probably will be either projected or shown on flat panels. Because

ASPECT RATIO

**Figure 4**  Preferred aspect ratio as a function of field of view.

of the large screen sizes, the projectors must have a great deal of light output, whether for use in the home (with high ambient light conditions) or in the theater (with very large screens). Cathode-ray technology probably will be replaced by matrix-driven light valve projectors or matrix-driven large flat panels. The limit to the resolution of such displays is primarily the production yield in manufacturing defect-free panels with more than 2 million pixels. What can be done to reduce the number of pixels for a given perceived sharpness?

There has been considerable discussion in committees about the desirability of using square pixels [7]. Is that important in producing a sharp image? Baldwin performed a series of experiments to evaluate this in 1940 [1]. We repeated these experiments using digital rather than optical techniques [6], and our results verified his. A pixel can have an aspect ratio as high as 3:1 either way without significantly affecting the number of pixels required for a given perceived sharpness compared with square pixels. Consequently, from an image sharpness point of view, keeping pixels square is by no means a critical issue.

In aircraft simulators it has been very difficult to produce displays that have high perceived resolution over the entire field of view (typically 180°). System designers have consequently developed "area-of-interest" displays [8]. These displays take advantage of the fact that our visual systems have good acuity over a very small portion of our field of view. By using an eyetracker and head motion sensor, it is possible to determine the portion of the scene that is imaged on the viewer's fovea. Only that portion of the scene is displayed in high resolution; the remainder is displayed at low resolution. As long as there is no obvious discontinuity between the areas of high and low resolution, the image is indistinguishable to the viewer from a complete high resolution display.

In our laboratory we did experiments [6] to see whether the gains obtained in area-of-interest displays could somewhat reduce the number of pixels used in a display that could have many viewers and no eyetracker.

Eye-tracking experiments have shown that most of the time, for most program material, the viewer's eyes are directed at the center half of the image (one-fourth of the area) [9]. We felt that if images had high resolution in this center area, we could slowly reduce resolution as the images approached the edges without the viewers noticing the reduction in the number of pixels. We compared a number of variable resolution images with fixed resolution images in a two-alternative, forced-choice procedure. When the choice was 50-50, we simply counted the number of pixels in the two images. To our disappointment, for images with a 10–20° field of view, the number of pixels required for the variable resolution image was exactly the same as for a uniform resolution image. This surprising negative

result probably occurred because the field of view was not much larger than the parafovea with the normal eye motion you have in viewing moving images. This concept might be reevaluated if super-high-resolution displays with a field of view exceeding 60° are proposed.

One of the properties of vision that has been studied at length by the vision research community is the "oblique effect" [10]. Our visual systems are not axially symmetric in acuity. Diagonal lines are not perceived as sharply as lines in the cardinal directions. Even when lens astigmatism is eliminated as a variable, there is still a measurable oblique effect. The vision research community is more interested in neural causes of the oblique effect, but astigmatism can cause an oblique effect optically. There is a preferred orientation of astigmatism because of the pressure of the eyelids. Consequently, observers are very precisely corrected for astigmatism before being used in oblique effect experiments (more precisely than is usually done by an optometrist fitting a pair of glasses).

We thought that it would be more relevant to display design if we tested people "as they come," with their vision corrected by their optometrists [11]. The threshold contrast sensitivity functions of these observers for oblique and cardinal gratings are shown in Figure 5. As you might expect, we found a somewhat higher oblique effect than was recorded for the accurately corrected observers. In our contrast sensitivity experiments the spatial frequency for equal threshold contrast at high spatial frequencies for diagonal gratings was 0.7 that for cardinal gratings. From this we would conclude that if a display is to match the distribution of acuity of the visual system, it should have a polar plot of resolution as shown in Figure 6. This has its best resolution in the cardinal directions and its worst resolution on the diagonal.

Standard analog television, television that is cardinally sampled, and displays that arrange their pixels in rows and columns all have the best resolution on the diagonal and the worst resolution in the cardinal directions. This is exactly backward! The distribution in standard television is shown in Figure 7. To match the distribution of the visual system, one must rotate the sampling pattern by 45°. This results in samples that are offset by half a pixel on adjacent lines. The samples are now in lines on the diagonal.

Printers have known for 100 years that printed images look sharper with the halftone dots on the diagonal. Wendland and Schroeder [12] have reported a significant improvement in image sharpness for sampled images by the use of diagonal sampling, as is done in printing, rather than cardinal sampling. Diagonal sampling produces an axial distribution of resolution that matches the distribution we found for viewers with an oblique effect typical of the correction practices of optometrists.

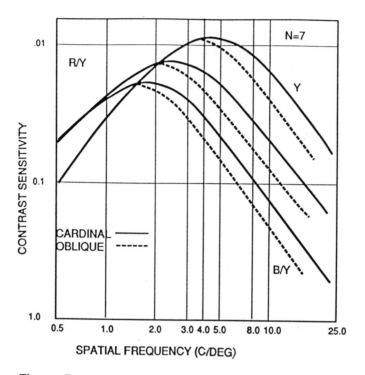

**Figure 5** Threshold contrast sensitivity for static luminance gratings (Y) and isoluminance chromaticity gratings (R/Y, B/Y) averaged over seven observers.

"Sharper" is a subjective measure, not a quantitative measure. We were interested in finding out how many pixels it would take to produce images with diagonal sampling that looked the same in sharpness as a cardinally sampled image. We compared images, at normal viewing distance, in a two-alternative, forced-choice experiment [6]. The diagonally sampled images had a fixed number of pixels, and we varied the number of pixels (resolution) of the cardinally sampled images. When the choice was 50:50, we counted the relative number of pixels. Diagonally sampled images took 0.7 as many pixels to produce an image with the same perceived sharpness as the cardinally sampled images.

In these experiments we also made similar tests using hexagonal sampling. With hexagonal sampling the number of pixels required was 0.83 times as many as with cardinal sampling. This indicated that the oblique effect and the fact that images normally have more vertical and horizontal lines than diagonal lines favor the use of diagonal sampling over other patterns. This is a very promising result. What else can we do?

**Figure 6** Polar plot of threshold contrast sensitivity at 22 c/deg.

## V. SCANNING PROCESS AND LINE FLICKER

Let us compare the properties of progressive rather than interlaced scanning. In progressive scanning, lines 1, 2, 3, 4, etc. are scanned in sequence. This is the most obvious way to scan an image. When television standards were established, it was found that progressive scanning at 30 frames per second produced an image that flickered. Film had solved this problem by "double shuttering": that is, a frame was displayed twice before the film was pulled down to advance to the next frame. Consequently, television systems were designed to display half the lines in the first $\frac{1}{60}$ second and the other half in the next $\frac{1}{60}$ second to provide a complete frame using interlace. For an interlaced scan, lines 1, 3, 5, etc. are scanned for the first field and then 2, 4, 6 for the second, interlaced field. Interlace, invented as a way to reduce flicker and still get good motion rendition, produces an update of vertical detail information at only 30 frames per second—thus saving transmitted bandwidth.

**Figure 7** Polar plot of limiting resolution of analog television or cardinally sampled television.

Certain spatiotemporal properties of the visual system are very relevant here (see Chapter 3). Our perception of detail (high spatial frequencies) is slow. Consequently, updating the vertical detail in a ⅟₃₀-second frame is adequate. However, perception of flicker and motion at low spatial frequencies is fast. A field rate of 60 fields per second updates low spatial frequencies at a temporal rate high enough to give good motion rendition and, fortunately, this temporal frequency is high enough to minimize the perception of large area flicker. The interlaced fields produce a 263-line grating, which is in counterphase flicker at 30 Hz. However, since the perception of detail is slow, the visual system does not see this counterphase flicker at normal viewing distances.

Some current digital compression systems take more direct advantage of the spatiotemporal properties of perception. Using frame stores, detail information is updated more slowly than low resolution information. This

technique is referred to as 3-D subband coding [13]* (two-dimensional spatial frequency bands are filtered temporally to produce a third set of temporal bands). Interlace is a crude form of 3-D subband coding. It, however, has a number of undesirable artifacts that are not present in the modern version using frame stores.

Interlace does not save bandwidth as much as is often felt. Sampling theory indicates that the highest resolution the scanning system can produce in the vertical direction is half the spatial frequency of the line structure. In other words, if every other line is white and the ones in between are black, this is the highest spatial frequency you can have vertically. This limit is known as the Nyquist limit of resolution. In experiments viewing interlaced images at RCA labs [14], Kell et al. discovered that the resolution that could be achieved was never as high as the Nyquist limit. The resolution was always lower by some factor, and this factor has been referred to as the Kell factor. Typically the vertical resolution of an interlaced camera is 0.7 that of a progressively scanned camera.

The original work by Kell attributed the loss in resolution to the sampling process; however, it has been shown that the loss in resolution of such a high factor is actually a result of the performance of the camera. The reason is that the original camera tube must be completely discharged every field ($\frac{1}{60}$ second). It does not simply scan every other line, the way the display does. If it did, the exposure time of $\frac{1}{30}$ second for a pixel would give objectionable motion smear. Even for film that has a frame rate of 24 per second, the shutter opening gives an exposure time of less than $\frac{1}{48}$ second, which prevents motion smear. In motion picture film, a shutter was used to block the light while the film was being pulled down. This pull-down time required approximately $\frac{1}{48}$ second, which reduced the exposure time from $\frac{1}{24}$ second to approximately $\frac{1}{48}$ second. This shorter exposure time turned out to be important in producing sharp moving images. To produce good motion rendition, television cameras also must have short integration times: $\frac{1}{50}$ or $\frac{1}{60}$ second is adequately short. Consequently, an interlaced television camera, whether it is a tube camera or charge-coupled

---

*In 3-D subband coding an image is divided into spatial frequency bands, typically octave bandwidths. For example, the full image is spatially filtered to form an image of half-resolution. This is subtracted from the full image, leaving only the highest frequencies as the top band. The lowest resolution band is then spatially filtered again to produce an image of one-quarter resolution. This is subtracted from the lower resolution image to produce a second band, and so on. Each band is then temporally filtered and transmitted at an appropriate frame rate that is determined by the temporal response of the visual system to the spatial frequencies in the band. Reconstruction is done by adding the bands back together again after they have been scan-converted to the highest frame rate (typically 60 Hz).

device (CCD), discharges 2 frame lines each scan. It really is superimposing two 263-line images displaced by one frame line. As a result of this process, the height of the line in the camera is actually $\frac{1}{263}$ of the picture height rather than $\frac{1}{525}$ of the picture height. This makes the resolution vertically considerably lower than the Nyquist limit for a 525-line image. So compared with progressive scan at 60 frames per second, interlace scan has reduced the number of lines every sixtieth of a second by a factor of 2. This had the desirable result of reducing the bandwidths by 2; however, at the same time it reduced the vertical resolution because of the poorer Kell factor.

If both the camera and the display are scanned progressively at 60 frames per second, it takes 0.7 times as many pixels to get the same resolution. Here we have another large gain. By using diagonal sampling combined with progressive scanning, we can cut the number of pixels a factor of 2 for the same sharpness. 3-D subband coding can give the same spatial and temporal response at the same bandwidth as interlace without the adverse artifacts. The sensor and display can be made with half as many pixels using these two techniques combined.

## VI. MATRIX DISPLAYS

To provide the large displays that are necessary for high definition television, the primary candidates are in the category of matrix displays: matrix-addressed, light-emitting flat panels or matrix-addressed light valve projectors. The information on matrix-addressed displays is accessed by means of rows and columns of address lines that are controlled by solid state switching rather than by scanning with an electron beam. A typical matrix-addressed display is shown in Figure 8.

One requirement of matrix addressing is a very high nonlinearity at every pixel, since half the voltage appears across the row or column at pixels that are not addressed. In the case of many displays, the nonlinearity is produced by the display material itself. For example, in plasma displays or electroluminescence, the nonlinearity is provided by the light-emitting material that appears at every pixel. Currently there is a great deal of activity in the area of liquid crystal displays. In the case of supertwist liquid crystals the nonlinearity is produced by the liquid crystal itself. Liquid crystal displays do not generate light, as is true in the case of plasma displays or electroluminescent displays. They act as light valves and control light, which is emitted either by back-illumination for direct view panels or by a projection lamp in the case of projectors. A light valve projector is like a slide projector with an electronically controlled slide.

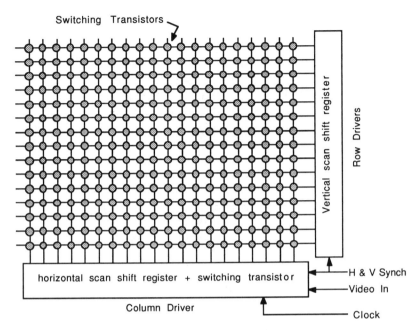

Active Matrix Addressing

Supertwist liquid crystals do not have a high enough nonlinearity to give good contrast for very high resolution displays. So for very high resolution displays, a transistor is used at every pixel to produce the necessary nonlinearity. When the matrix display uses a transistor at the pixel, it is referred to as an active matrix display. The active matrix liquid crystal display has been a very successful technique in recent developments.

Matrix-addressed displays are basically different from the cathode-ray tube in that they must be scanned progressively at 60 frames per second, for the following reasons.

In a matrix display, if a pixel is displayed without change for ⅓₀ second, moving objects will appear to smear as the eye tracks them. To get adequate motion rendition, the display time should be less than ⅕₀ second. If a pixel is displayed for only ⅙₀ second every ⅓₀ second in an interlaced display, it will have half brightness, since the duty cycle of each pixel will be only 50%. Consequently matrix displays need a progressive scan at more than 50 frames per second to operate efficiently and also to produce good motion.

Manufacturers of active matrix LCD light valve displays always scan them progressively.

For an interlaced picture source, the most common display method is to simply do the inverse of the camera. The display is scanned progressively, two lines at a time for one field, and then this process is repeated in the next field displaced by one line. This process, however, entails the Kell factor loss of 0.7 compared with a progressive scan at 60 frames per second.

## VII. AREA FLICKER

One property of perception that is very important in high definition displays is the perception of flicker. High frequency flicker perception depends on brightness and field of view. Flicker is more perceptible at high brightness in wide fields and in peripheral vision [15]. The motion picture theater has a wide field of view and a shutter that interrupts the light at 48 Hz. At the screen brightness of television, flicker would be intolerable in a theater. In fact, this is what limits the brightness that can be used in the cinema. The brightness is kept below the perception threshold for flicker at 48 Hz for a wide field of view. Three-bladed shutters have also been used with film, which increases the flicker frequency to 72 Hz. However, since the pull-down time is constant, a three-bladed shutter results in lower efficiency and, consequently, a reduction in the light output of a projector. Three-bladed projectors are seldom used for this reason. In either case, the highlight brightness of a film projector is relatively low. This has a secondary effect of requiring very low ambient light in a theater to get good contrast.

As high definition displays produce a wider field of view, even 60 Hz flicker becomes more perceptible at television screen brightness. Figure 9 is based on an illustration in a paper by Murch and Mead [16] that shows the temporal frequency at which flicker is no longer perceptible. The edge of the screen is 15° off-axis for HDTV. Computer displays are currently viewed with an equally wide field of view. Consequently computers have gone to a progressive scan at 72 Hz to avoid area flicker and interline flicker.

Fortunately, the displays of choice for high definition viewing in the future do not flicker. They try to get a duty cycle as close to 100% as possible. Because of the decay time constant of phosphors, matrix displays do not decay exponentially, the way cathode-ray tubes do. To provide high brightness, matrix displays leave a pixel on at full brightness for the entire field interval and, for the next field, it changes very rapidly to the new intensity value. Frame rate can now be determined by motion rendition

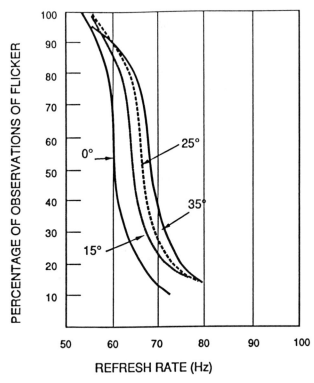

**Figure 9**   Flicker perception as a function of temporal rate and retinal eccentricity for high temporal frequencies. (After Ref. 16.)

requirements, not by flicker. Actually, as systems advance, frame rate loses its meaning. To depict motion, displays will need to update the low spatial frequency information with temporal sampling intervals of 50 or 60 Hz. However, flicker will no longer be a system design factor. The transmission or recording of information can then take advantage of the properties of visual perception to change information in the display's electrical memory only as needed.

The rate at which information is updated depends on the visual system's ability to process motion and the eye's ability to track moving objects. By using exposure times less than ¼₈ second, film has managed to have adequate depiction of motion at 24 frames per second. Current compression systems using motion vectors manage to have adequate motion rendition with temporal sampling rates as low as 7–15 frames per second. These

systems can also take advantage of the fact that the visual system has a slower temporal response to high spatial frequency luminance and to color than it does to low spatial frequency luminance. Since most of the information is in these areas, where the visual system's performance is slow, compression systems can take advantage of this circumstance in reducing the amount of information that is transmitted.

## VIII. COLOR

One of the remaining properties of a modern display is color. Color rendition using the three primaries has been covered in the preceding chapter. If one compares the threshold contrast sensitivity curve of luminance and isoluminance color, one can determine that the resolution for isoluminant color perception is lower than the resolution for luminance perception (see Chapters 3 and 4). Many color systems take advantage of this property by sending the color information at lower resolution.

The present NTSC color transmissions take advantage of this lower spatial color acuity by sending color with a low horizontal resolution. Color perception for isoluminant color is also slow. If one compares the temporal response of isoluminant color on the contrast sensitivity curves that are being temporally modulated in counterphase flicker, one will see that the temporal response of isoluminant color gratings for 5 c/deg is roughly half the temporal response of luminance gratings of the same spatial frequency. Compression systems can also take advantage of this ratio, provided they use isoluminant color [17].

Unfortunately, current television practice does not use isoluminant color. It uses color difference signals such as red minus luminance (R − Y) or blue minus luminance (B − Y) instead. When the present NTSC color system was developed, it was very difficult to process the signals using ratios with analog circuits. Isoluminant color signals would be red divided by luminance (R/Y) or blue divided by luminance (B/Y). Our present color system works very well in black and white, where the color difference signals are zero. It works very poorly for saturated colors, since a large part of the luminance signal is carried by the low resolution color difference signal. For a black and white image, all the luminance information is carried by the luminance signals, since the color difference signals are zero. However, as the color becomes more saturated, a larger and larger fraction of the luminance signal is carried by the band-limited color difference signals. The reasons for this are rather complex and are explained in Reference 17.

However, as an example, let us consider a high contrast image that is a

saturated blue. In this case, the blue signal, which is applied to the blue part of the display, has 90% of its voltage from the band-limited color difference signal and only 10% of its voltage from the luminance signals. None of the artifacts that appear with the use of color difference signals occur when isoluminant color signals are used. Subsampling color either spatially or temporally cannot be done successfully without artifacts unless we use isoluminant color. The video signal processing described in Reference 17 uses the difference of the logarithms of the color signals to produce the color ratios for the isoluminant color signals. It is interesting to note that as described in Chapter 4, this is exactly the way the visual system derives the color opponent signals from the logarithm of the signals from the cones.

Now with digital processing it is very easy to process signals of luminance and isoluminant color [17]. When designing compression systems, you can take advantage of the fact that isoluminant color perception is slow. This cannot be done if nonisoluminant color difference signals are used. Our visual systems have very good temporal response for low resolution luminance. If color signals have a large component of luminance, the image will have motion artifacts in saturated color areas when the color difference signals are sent at a slow rate.

## IX. CONTRAST RATIO

One of the important factors in the design of display systems is contrast ratio, the ratio of the brightness of a highlight area compared with black areas. Loss of contrast is frequently interpreted as loss of sharpness. Maintaining high contrast is very difficult in displays for a number of reasons. Ambient light shining on the screen is the most common problem in maintaining a high contrast ratio. The blacks in the image can be no blacker than the screen brightness with the display turned off. It is particularly hard to get the brightness of black very low on a white front-projection screen. If ambient light is present, the only way to get a good contrast is to have a very high highlight brightness. This is why a brightness of 100 foot-lamberts or more is frequently required when viewing displays in a room with normal ambient illumination. Black matrix back-projection screens and some forms of direct view matrix panels have better ambient light rejection.

Another loss in contrast results from very small losses in spatial frequency response in midspatial frequencies for the display system. At lower spatial frequencies only 1 dB loss in response is very objectionable in making images appear "soft." For moving images the small losses in contrast at low spatial frequencies due to the integration for a field interval of the

camera or display have been shown to be more important than the loss in limiting resolution [18].

In an experiment described in Reference 18, we were interested in determining the contrast required in a display as a function of spatial frequency. We used a pattern of white stripes with varying spatial frequency and varied the brightness of the black spaces between them. Figure 10 shows the contrast ratio between the white and black stripes at which the observer could barely see that the black stripes were no longer perfectly black. This contrast was one just noticeable difference from a contrast of about 200:1 (the limiting contrast of our experiment). If a display system always exceeds this contrast ratio at all spatial frequencies, one cannot see the difference between that contrast and a higher contrast.

At spatial frequencies from 1 to 6 c/deg, the most common degradation in contrast is the loss in spatial frequency response, either electronically or optically, of the display system. At lower spatial frequencies, the most common loss is ambient light shining on the screen. Our experiment did not include the following condition, which requires an even higher contrast ratio: if highlights cover less than about 10% of the screen area in a dark field, a contrast of about 300:1 is required [19]. Unfortunately, this condition frequently does occur in motion picture scenes. With presently available displays, such scenes can be perceived at this contrast only in a darkened room.

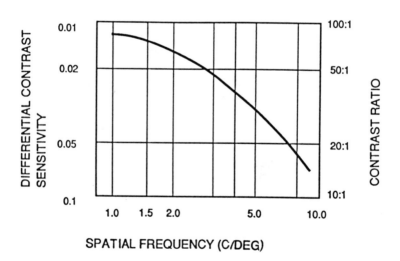

**Figure 10** Sensitivity for detection of differences in contrast ratio for square-wave luminance gratings of varying spatial frequency.

Another aspect of display systems that must be considered consists of brightness and color uniformity. The threshold contrast sensitivity functions for brightness and isoluminant color are discussed elsewhere in this book (see Chapter 3, Fig. 11). Figure 11 shows a similar set of measurements [20] for gratings that cover the entire field at the field of view of standard television and HDTV (6° and 24°). These plots confirm the observations of many display system designers. Brightness variations from center to edge of a display (very low spatial frequencies) are not very critical. Many displays have variations of 10–20% without being objectionable. Color shading across a screen is more noticeable (the static low spatial frequency contrast sensitivity to color is higher than the sensitivity to luminance). In the region about 5 c/deg, however, a luminance variation of only one part in 200 can be seen. Maintaining this degree of uniformity, particularly with matrix displays, requires a very tight manufacturing tolerance. In the past our tolerance of image nonuniformities of this magnitude has been masked by the electrically generated noise and film grain in our images. However, modern electronic display systems, with digital recording and transmission links, can produce images so clear that the limit of uniformity is in the display device. A system that achieves this uniformity with imperceptible noise produces incredibly realistic images.

Table 3 summarizes the properties of a display required to obtain defects below or near the limits of perception when viewed at about three screen heights. It is only within the last few years that it has been possible to produce images and display systems that come close to meeting the requirements of our visual systems.

## X. CONCLUSION

Understanding visual perception will continue to be a vital requirement in the design of imaging systems. In the past we have sometimes devoted needless effort and cost to reproducing information we cannot see. By exploiting the limits of visual perception and scene statistics, modern compression systems leave out more than 97% of the information in an R, G, B image and reproduce an image indistinguishable from the original.

However, the visual process is extremely sensitive to many other properties of images that distinguish electronic images from the images in the real world. The properties of our visual system have always been a critical part of the overall system between the camera and perception of visual images. Vision research, digital signal processing, and new display technologies have made possible dramatic strides in the improvement of electronic displays. It is only recently that complete imaging systems have been able to

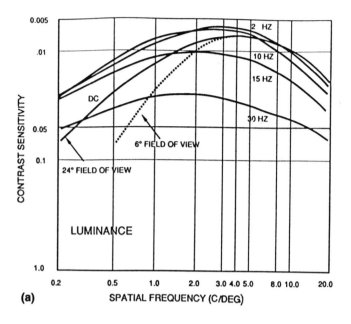

(a)

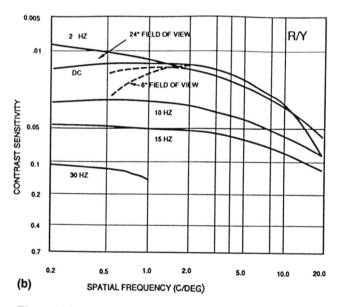

(b)

**Figure 11** Dynamic contrast sensitivity function for dc and counterphase flicker at 2, 10, 15, and 30 Hz for (a) Y, (b) R/Y, and (c) B/Y.

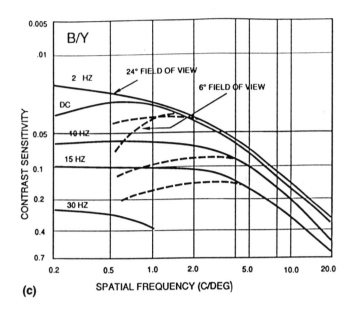

(c)

**Table 3** Display Requirements for HDTV Display at 3.5 Screen Heights Viewing Distance to Keep Artifacts Below the Threshold of Perception

| | |
|---|---|
| Resolution | > 700 TV lines |
| Highlight brightness | > 100 foot-lamberts (consumer display) |
| | > 29 foot-lamberts (theater display) |
| Response time | < 10 ms |
| Small-area uniformity | ± 0.25% |
| Large-area uniformity | ± 10% |
| Contrast ratio | 300 : 1 |
| Signal-to-noise ratio | > 200 : 1 |

come so close to reproducing our perception of the real world that we can almost forget that we are not really part of the displayed environment.

## REFERENCES

1. M. W. Baldwin, The subjective sharpness of simulated television images, *Proc. IRE, 28*:458–468 (1940).
2. N. E. Tanton and M. A. Stone, HDTV displays: Subjective effects of scanning standards and domestic picture sharpness, British Broadcasting Corp., London, 1989.
3. I. Yuyama, Fundamental requirements for high definition television systems, large screen effects, Part II, *NHK Technical Monograph*, No. 32, June 1982.
4. D. H. Kelly, Effects of the cone-cell distribution on pattern-detection experiments, *J. Opt. Soc. Am. 64*, (11), 1523–1525 (1974).
5. Super-high-definition imaging, Topical Session of the Society for Information Display International Symposium, Seminar, and Exhibition, Seattle, WA, May 16–21, 1993.
6. 1992 NASA Year End Report, Contrast NASW 4557, Research and development program in advanced video systems for space and earth based applications, submitted by Florida Atlantic University, principal investigator, W. E. Glenn, September 1992.
7. The use of square sampling grids (square pixels), excerpted from Report of the Task Force on Digital Image Architecture, Society of Motion Picture and Television Engineering, 1992.
8. G. B. Browder and W. S. Chambers, Eye-slaved area-of-interest display systems — Demonstrated feasible in the laboratory, Flight Simulation Technologies Conference, Atlanta, Sept. 7–9, 1988.
9. G. S. Elias, G. W. Sherwin, and J. A. Wise, Eye movements while viewing NTSC format television, Society of Motion Picture and Television Engineers, Psychophysics Subcommittee white paper, 1984.
10. S. Appelle, Perception and discrimination as a function of stimulus orientation: The oblique effect in man and animals, *Psychol. Bull. 78*:266–278 (1972).
11. W. E. Glenn, K. G. Glenn, and C. J. Bastian, Imaging system design based on psychophysical data, *SID Dig. 26*:71–78 (1985).
12. B. Wendland and H. Schröder, On picture quality of some signal processing techniques, *J. Soc. Motion Picture Television Eng. 93*:915–922 (1984).
13. J. W. Woods (ed.), *Subband Image Coding*, Kluwer Academic Publishers, Boston, 1991.
14. R. D. Kell, A. V. Bedford, and G. L. Fredendall, A determination of optimum number of lines in a television system, *RCA Rev. 5*:8–30 (1940).
15. D. H. Kelly, Retinal inhomogeneity, *J. Opt. Soc. Am. A 1*(1):107–113 (1984).
16. G. Murch and D. Mead, Flicker in displays, *Human Factors Research Report*, Techtronix, 1984.
17. W. E. Glenn, K. G. Glenn, and T. L. Glatt, Logarithmic A/D converters used in video signal processing systems, presented at the 132nd Technical

Conference and Equipment Exhibit of the Society of Motion Picture and Television Engineers, Oct. 13–17, 1990.

18. W. E. Glenn and K. G. Glenn, Discriminations of sharpness in a televised moving image, *Displays Technol. Appl.* 6:202–206 (1985).

19. G. Berggren, E. Wetmore, and G. Nash, The Sony high-definition dual-purpose screening room, presented at the 134th Technical Conference and Equipment Exhibit of the Society of Motion Picture and Television Engineers, Toronto, Ont., Canada, Nov. 10–13, 1992.

20. W. E. Glenn and K. G. Glenn, The design of systems that display moving images based on spatio-temporal vision data, *J. Imaging Technol., 15*(2) April (1989).

# Afterword

Like most literature, this book can be taken as a linear exercise in time — one word following another. Perhaps that is the way you arrived at this point, plowing straight on through. Or perhaps you skipped around, sampling only what interested you most. However you got here, may I suggest that you try something totally different the next time you open the book?

Because, of course, the various parts of visual science are not linearly related, like beads on a string. A better analogy would be a meshwork in n-dimensional space, where there is not necessarily a "best" way to get from point A to point B. Every *visionik* I know has a unique combination of interests that guide his or her path. Knowing something about the territory, perhaps you will make your own map and follow it wherever it leads, even if it leads from Section 6 in one chapter to Section 3 in another. The table of contents is explicit enough to help you browse. I hope you will be suitably rewarded.

To change the figure of speech one last time, you might come up with a truly gourmet recipe this way. Good hunting, and *bon appetit.*

*D. H. Kelly*

# Index